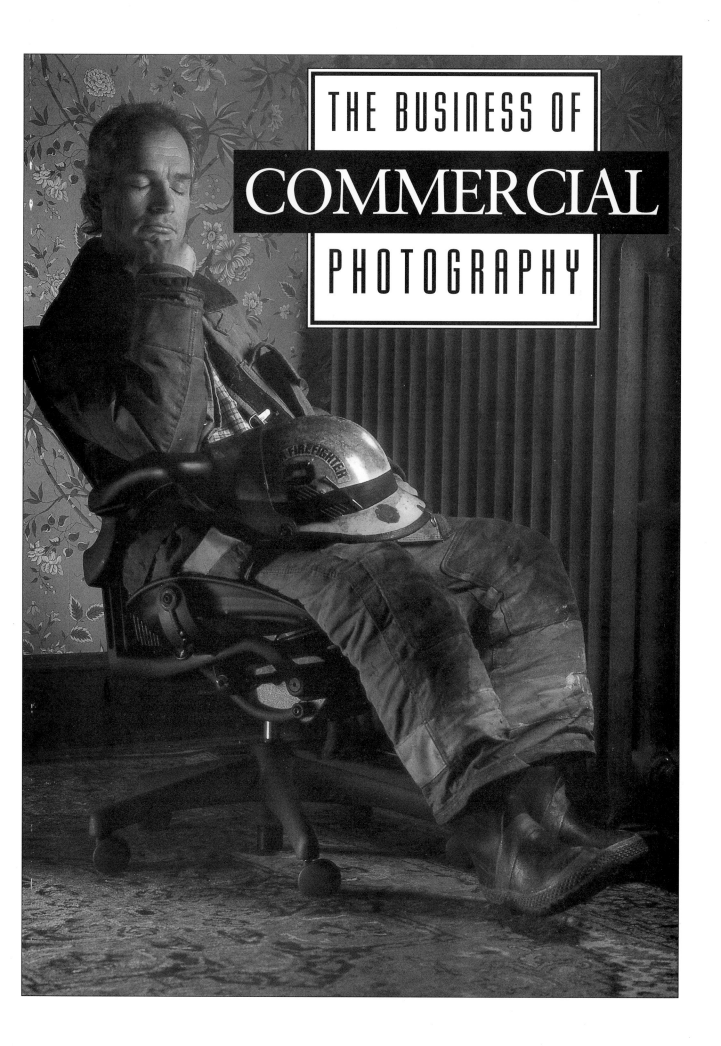

THE BUSINESS OF
COMMERCIAL
PHOTOGRAPHY

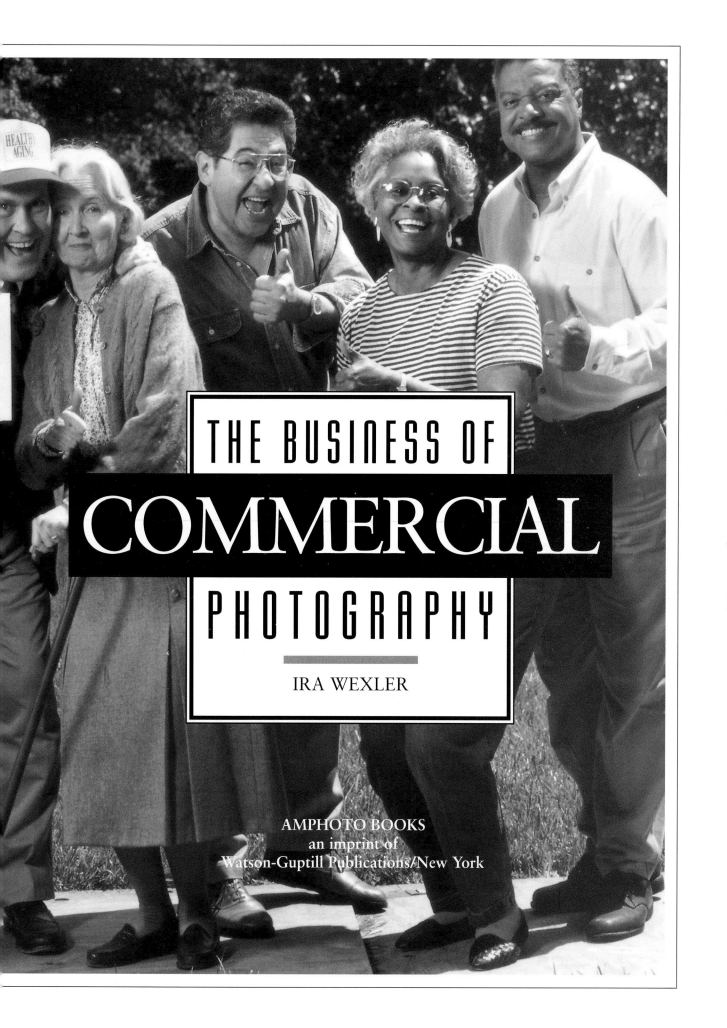

THE BUSINESS OF COMMERCIAL PHOTOGRAPHY

IRA WEXLER

AMPHOTO BOOKS
an imprint of
Watson-Guptill Publications/New York

Ira Wexler has been a commercial photographer for more than 30 years. He began his photography career in Phoenix, Arizona, shooting pigs, cows, and sheep at livestock shows. He is predominantly self-taught although he has benefitted from the tutelage of Ernst Haas, Art Kane, Pete Turner, Michael O'Neill, Jay Maisel, and others. Following a two-year sojourn in Denver, he moved to Washington, D.C., in 1971 to become the official photographer for Stephen Stills, of Crosby, Stills, & Nash fame. In 1972, he opened a photography studio there.

He was founding president of ASMP/Mid-Atlantic's Washington, D.C., chapter and spent several years on ASMP's National Board of Directors. He has received close to 100 national and regional awards for his work, he has written for trade publications for many years. A well-known industry professional, he is a frequent lecturer to trade and student groups, and lives in Washington, D.C., with his wife and three children.

Picture information:
Half-title page © Ira Wexler
Title page © Ira Wexler
Page 9 © Ira Wexler

Senior Editor: Robin Simmen
Project Editor: Alisa Palazzo
Designer: Bob Fillie, Graphiti Graphics
Graphic Production: Hector Campbell

Copyright © 1997 Ira H. Wexler
First published in 1997 in New York by Amphoto Books,
an imprint of Watson-Guptill Publications,
a division of BPI Communications,
1515 Broadway, New York, NY 10036

Library of Congress Cataloging-in-Publication Data
Wexler, Ira
 The business of commercial photography : a professional's guide to
 marketing and managing a successful studio, with profiles of 30 top
 commercial photographers / Ira Wexler.
 p. cm.
 Includes index.
 ISBN 0-8174-3612-X (hardcover)
 1. Photography—Business methods. 2. Commercial photography.
 3. Photographers—Marketing. I. Title.
 TR581.W48 1997
 770'.68—dc21 97-6491
 CIP

Manufactured in Malaysia
1 2 3 4 5 6 7 8 9 / 05 04 03 02 01 00 99 98 97

This book is dedicated to everyone who gave me love, encouragement, inspiration, support, and friendship: To my gentle wife, Marsha, who put up with me while I struggled for nearly four years to produce this effort; to my wonderful daughter Sasha, who helped enormously with her good cheer and assistance; to my little guy, Jordan who gave his love, hugs, and understanding; to my big guy, Chaz, a never-ending source of wonder; and especially to my Mom, who has been there for me from the beginning.

Special thanks to Rob Rowe and his staff at Chrome Photographic, for their great work.

To everyone who selflessly helped me on my journey these past 30 years, particularly those who are no longer with us—Joel Fried, Ben Rose, John Bowden, Art Kane, and especially Ernst Haas—this is my way of giving back some of what was given to me. Lastly, to the lovely and talented Robin Simmen at Amphoto Books, who indeed has the patience of Job.

CONTENTS

THE BUSINESS

PROFILES

INTRODUCTION

There is a strong new wind blowing through the commercial photography business. It's one of discovery, offering the promise of dazzlingly new technologies and capabilities not yet imagined. With this wind comes a new excitement of greater proportion than at any time in the century and a half since photography was invented.

Over the horizon, just out of sight, lies wizardry beyond our imaginations. A reinvention, reorientation, and rejuvenation of our industry is taking place. The future is now, and we're on the verge of nothing less than a renaissance in image-making. There is a frontier mindset amongst photographers, especially those who were born and brought up after the advent of television. While parts of our industry are suffering devastating transformations as we adjust to the new realities of image manipulation, online media, clip disks, and smaller budgets, there are also new, fresh, and exciting things happening. Change is afoot.

When I was asked by Amphoto to write this book, I wanted to "download" the experience I've gained laboring in the trenches for three decades and to share how I've learned to do business. My much larger and more important goal, however, was to capture the knowledge and passion of the 30 incredible photographers with whom I had the distinct pleasure of speaking for the second half of this book. In the pages ahead, you'll find my harvest—a collection of valuable information and insight based on my 30 years and, more importantly, on the rich experience of the 30 photographers I profiled. Together this comes to roughly 600 years (and 31 careers' worth) of experience!

Over the three years it's taken to write this book I've talked to some incredibly wonderful and talented image-crafters, heard a few good jokes, gotten a mild case of carpal-tunnel syndrome, burned up a laptop computer, and walked away with a pretty clear picture of the state of the commercial photography industry. There are a multitude of paths available to interested photographers. All of the photographers profiled here have built their businesses in the context of their own unique visions and aesthetics; none are 100 percent wrong, none are 100 percent right. They each chose the path that was right for them, and you must do the same.

There is, however, one unifying factor that ties each and every commercial photographer together. Despite our diversity and uniqueness, we all need to work together to support and perpetuate the standards, ethics, procedures, and policies that will ensure that we remain professionally viable. No single group has worked harder or longer to this end than the American Society of Media Photographers (ASMP). There are other groups that are on the same path, such as Advertising Photographers of America (APA), and the new kid on the block, Advertising Photographers of New York, whose presidents (past and present) include two of our interviewees, Barbara Bordnick and Michel Tcherevkoff.

After nearly 30 years of commercial work, during which time I've made almost every mistake imaginable, it appears that there is indeed a "body of knowledge," called experience, that I can impart to others. I'm not talking about the technical side of our industry—the lights, cameras, and lenses—but rather the *business* side of it. Getting work, getting clients, getting paid, getting ahead. Reaching your goals—whatever they might be. This body of knowledge can provide a guide to maneuvering the often tricky waters of our industry and help ensure that the decisions you make are the best ones for reaching your individual long term goals.

This is a book to help, mentor, and guide you toward better business practices, and to enable you to enjoy a more successful career. The 30 world-class photographers who've made it to the top offer valuable insights, explain how they reached their goals, and share thoughts on how you might reach yours.

In reading these pages, you'll come to understand that every photographer faces the same problems you do. Every aspect of the photography business is undergoing wrenching changes. For most of the past 150 or so years, photography has plodded along with relatively few significant changes in film and equipment technology. The same basic stuff that made images appear on glass in the 1800s is still found in the latest high-tech films on the market today. However, the past 10 years have seen more change than ever before in our industry.

Perhaps most importantly, the computer has come of age and is affecting every one of us. Digital imaging, once considered "pie-in-the-sky" stuff, is now available to anyone with an affordable desktop computer and the appropriate peripherals. Software, which once was available only to high-end users with million-dollar systems, is now available off-the-shelf for less than the cost of a lens.

The market for assignment photography has also changed, with perhaps three quarters of traditional assignment jobs gone forever to stock, clip disks, and online image distribution—and it's only going to get worse. The good news, though, is that new markets and submarkets appear daily as we morph into the 21st century. Digital imagery is poised to remake every nook and cranny of the business. My goal here is to help you find the right information to accompany you on your personal journey into this new world of commercial photography.

THE BUSINESS

PLANNING YOUR BUSINESS: PRACTICAL ISSUES

Running a business is just as important as developing a style. You need both or you're not going to make it.

—ELLE SCHUSTER, COMMERCIAL PHOTOGRAPHER

Ernst Haas, the legendary photo-colorist and teacher, used to tell his students that he loved photography because it was one of the few things that he could still do by himself. Fortunately, this can still hold for anyone entering the photography business today. You can set up a commercial photography operation to accommodate virtually any style of living imaginable; you can live in New York City, Baltimore, or Bora Bora and you can present any style of work, any vision of yourself, and any level of organization you want.

While there are, roughly, 30 photographers out there at the very top of the profession who execute the highest levels of work, demand the greatest monetary compensation, have the opportunity to work with the best art directors and designers, and produce international, award-winning work, there are also those successful and talented photographers who work with good art directors, make a good living, and help support their families on an increasingly significant regional and local level.

You will find successful photographers of every creed at every level of the business, from Larry Lee, who works virtually alone, carries a minimum of equipment, travels the world, and shoots stock as well as assignments, to more traditional image makers, such as advertising and editorial shooter Gregory Heisler, who maintains a large studio and staff. Some photographers even maintain studios on both coasts, and some studio operations include a plethora of full-time assistants, producers, stylists, makeup artists, in-house sales representatives, and prop makers, along with scads of the latest equipment.

DEFINING YOUR FOCUS

When it comes to setting up your photography business, you can go it alone and be a *sole practitioner*, or you can set up a large organization with a considerable staff. (See page 18 for specifics on company structure.) It's all up to you. You might want to operate a small one-person outfit in which you do all the marketing, promotion, management, floor-sweeping, and, of course, photography, or you might opt to luxuriously concentrate solely on making images while leaving the day-to-day administrative and selling duties to others. It all comes down to your vision, and to determine just what your vision is, you should ask yourself the following questions: What kind of business do I want to create? Where do I see myself in five years? Where do I see myself in 10 years? Your business can be anything you want it to be, you just need to figure out exactly what you want first.

Commerical photography is a wondrous and creative pursuit, because what you're ultimately selling here is your own personal vision—the unique and exciting way in which you alone see the world. The 30 photographers profiled in the second section of this book all run their careers in different ways, but they all have one important rule—to follow and remain true to their individual concepts and beliefs. While they all use cameras, lenses, and light meters to bring their visions to fruition, they all offer their own unique aesthetic and their own way of producing visual solutions. In order to really be set up to succeed you must find your own voice and also love what you do. If you're not having fun, you should find something else to do that is fun.

As to the logistical aspects of the commercial photography business, you can economically and comfortably work out of a home office, or you can take your operation to the very highest of levels, rent a gargantuan studio in a large city, hire a mega-staff, and incur mega-expenses. It's up to you. If you prefer, you could generate a good income on a regional or even local level and work alone, or possibly only with help from a spouse or one partner.

Whether you operate from a small studio in your basement or a million-dollar high-tech photo palace in the heart of Manhattan, there will still be common business issues that you should be aware of. No matter what kind of creative work you do or where you do it, this is still a business, like any other business. You must take care of your operation; if you treat it well, it will take care of you. If you fail to do so, you may find yourself out on the street.

According to the U.S. Small Business Administration, most people aren't adequately prepared to go into business for themselves; initial mistakes are usually survivable, but to thrive requires skill, discipline, and hard work. The commercial photography profession requires a focus, a concentration of effort. It might seem to be a purely creative, artistic venture, but the art aspect is just the icing on the cake. It's the business operations that are the cake.

The path to commercial photography success isn't always an easy one. You have to be at the right place at the right time with the right stuff, labor long and hard, have great business management and acumen, and, oh yes, do great work and give your clients exemplary service. It also doesn't hurt to be smart, creative, and informed enough to deal with the ten thousand problems that will attack your sanity on a regular basis. This book aims to give you the tools to help you with all these things.

Note that I won't be talking about technical issues here, such as what kind of cameras you need or which is the best F-stop; I'll assume you have a solid knowledge of the technical side of photography. These days, with high-end chips (really miniaturized computers) routinely built into "smart" cameras and lenses, it's easier than ever to take pictures. However, in today's dynamic business environment, it's never been more challenging to succeed.

SHIFTING GEARS WITH THE CHANGING MARKETPLACE

Today, the industry bears only a faint resemblance to the commercial photography business of the 1950s, '60s, or even early '90s. According to Daniel Roebuck, founder and former proprietor of Onyx, a Los Angeles agency representing numerous photographers, this is a very challenging time for photographers, who are "using 19th-century technology at the end of the 20th century." Photography has already changed a great

deal, and it will undoubtedly continue to do so, especially over the next few decades. One obvious and influential factor affecting this change is the ever-onward march of technology. Virtually everyone, everywhere feels the effects of this evolution; in fact, there are many new technologies percolating as you read this.

More than at any previous time, clients who buy commercial photography are now able to know more about subscribers, prospects, advertisers, and customers. The science of zip-code demographics allows clients to target highly directed marketing efforts toward the specific socio-economic audiences that would be most interested in their products and services. It's not uncommon to open up a major magazine to which you have a subscription and see an ad with your name printed in it. Welcome to the world of target marketing.

With computer-generated exit information (data gleaned from cash register transactions and bar coding) from retail outlets, clients can see what products are selling best at which locations. Armed with this and other data, advertisers and marketers no longer have to aim broad marketing campaigns at a large, undefined nationwide target audience. They now know who is buying what where and for how much. Advertisers no longer sell to one huge market; now they aim their promotions at smaller special-interest groups. According to Richard Weisgrau, executive director of the American Society of Media Photographers (ASMP), "This narrow-casting (as opposed to *broadcasting*) has brought on the gradual demise of the generic image," and introduced niche marketing to small, distinct population groups, which can be targeted through a greater variety of mediums than were previously available.

According to the 1990 census and recent U. S. Bureau of Labor statistics, there are more than 100,000 photographers out there competing for the same jobs. And, thanks to photography schools, workshops, adult education facilities, and other training grounds, the competition is stiffer than ever. It's also estimated that nearly 100,000 photographers go out of business each year.

It's much harder to prosper in the commercial photography business today than it was during the industry's Golden Years (the 1950s through the 1980s), and it's only going to get worse. On the other hand, there is an abundance of future opportunity for the growing commercial photography field, what with the burgeoning needs of the electronic marketplace that includes multimedia and the much-touted Internet.

Helped along by ever-rising paper and postage costs, much of the focus of the marketplace is slowly shifting away from the traditional printed page to these various electronic mediums. Still, with Internet development currently in the state that television was

in the early '50s and multimedia off to a slow, halting start, I wouldn't bet the farm on these new mediums just yet. PC Data, an industry monitoring organization, estimates that only four percent of the CD-ROM developers out there are actually making money. Industry giants who put their multimedia chips on the table and lost big time include media maven Time Warner Inc., which lost a stunning $30 million in the multimedia arena in 1994.

There's a lot going on out there. With this changing technology comes great opportunity, increased competition, demanding clients, and ever-rising costs, so it's more important than ever to maintain focus on the business aspects of your business. If you work diligently and operate in a consistently professional manner, you can thrive.

YOUR SUPPORT TEAM

The president has a small, inner circle of staff members who advise him and keep him focused on his goals; this group is traditionally known as the "kitchen cabinet." They are the people the president consults when making strategic decisions. To have your very best opportunity to succeed, you'll need to assemble your own kitchen cabinet to help guide your business forward to meet your goals.

Business management requires a long and complex chain of skills, experience, and specialized knowledge. It's the extremely rare practitioner who is truly a know-it-all. You may be the worlds' greatest talent behind the camera, but you can't be an expert at everything you do. You'll have to line up some help as you grow. It's natural to be reluctant to incur what at first seem to be unnecessary and frivolous expenditures in starting a new business. Many people consider engaging the services of an attorney, an accountant, and other advisers to be needless expenses, but the bottom line is that the earlier in your career you consult these professionals, the more likely you'll be to avoid costly mistakes in the future.

Select your kitchen cabinet carefully. You should choose advisers whom you trust completely, can call on with questions, and, most importantly, feel safe and confident with. Team members might include, among others, an attorney (or possibly several attorneys each with different specialties), an accountant, a banker, a financial planner, a stockbroker, and an overall business manager. They should be professionals of the highest possible caliber, with solid reputations and impeccable credentials. You'll be counting on them as they help guide you through the business world.

Depending on your personal relationships with them, you might pay your cabinet members fees, such as hourly rates to accountants, attorneys, or business managers. Or, if they are friends or family members, they might provide help on a non-fee basis.

Your kitchen cabinet is the support staff that advises you and helps you grow your business.

ATTORNEYS

All lawyer jokes aside, the truth is that attorneys are a necessary part of any business endeavor. It's important to have good legal support *before* a problem arises. As the old Army maxim of the five P's goes: Prior preparation prevents poor performance. We live today in a very litigious climate. Individuals and companies sue and get sued over issues that are often astoundingly trivial and frivolous. Many photographers have been taken to court over problems having to do with performance, copyright, licensing, usage, and other sticky issues. Winning or losing can often mean the very survival of your enterprise. Having a good attorney in your corner can mean everything.

There are many legal items to deal with when setting up your commercial photography business. For example, you should consult with your attorney about your city's zoning regulations. If you violate these laws, you could be fined or closed down. In addition, you might need to deal with other state and local issues, such as obtaining necessary certificates or licenses, such as business licenses, occupancy certificates, or resale licenses. Also, you may need to register your company name with the state, and you may be required, by the jurisdiction in which you're operating, to have a sales tax number. If you have employees, you may be responsible for a wide range of things,

such as withholding income and social security taxes, and complying with minimum wage and employee health and safety laws. A lawyer will help you through all this.

In business today, it's more important than ever to leave a good, solid, user-friendly paper trail behind everything you do. Exercise diligence in going over your clients' paper trails, too. For example, when you receive a purchase order from a client, which you always should to protect yourself prior to doing any work, review it carefully. If you've been around for a while, you should be able to tell what's going on in a job from the fine print of a contract, work order, or purchase order. If you're less experienced, you may want to have your attorney review these forms or contracts for you. The cost of an hour or two of an attorney's time is relatively inconsequential compared to any potential legal liability. You may want to consider having several attorneys in your rolodex, including the following types.

PRIMARY ATTORNEY

Also referred to as a legal *heavy hitter,* this is a good, solid, corporate or general practice lawyer who can advise you on the various aspects involved in setting up your business and handle general, day-to-day operation issues.

COPYRIGHT SPECIALIST

These attorneys provide a range of services having to do with the properly licensed usage of images and the various usage infractions and abuses that can arise in the course of business, such as clients using images for purposes other than those specified.

While most clients are reputable and honest, occasional infractions occur. When they do, it's advisable to have a copyright specialist on hand. See Resources for the names of two good specialists.

Two good choices are Chuck Ossola in Washington, DC, who is affiliated with ASMP—the American Society of Media Photographers, or the venerable John DiJoseph, based in Arlington, Virginia, who I've used and who has represented many nationally prominent photographers.

BASIC ATTORNEY

Perhaps a friend who is an attorney; this is a lawyer who would be willing, for example, to write a letter or two for you to help you "get the attention" of clients who flagrantly avoid paying you for work you've done in good faith. Or this lawyer might advise you on local jurisdictional matters, such as licensing your business. Ideally, this "lesser" attorney is someone who you can call for help and who won't start billing you the second you do; this isn't someone who would function as your trial attorney (that's your primary attorney).

There are many other specialists you might need to call, depending on the problem, challenge, or question at hand. Whatever the situation (and as with all kitchen cabinet members), the best way to find good legal support is through referrals from friends, family, or other photographers or business acquaintances.

ACCOUNTANTS

Any business is no more or less than a number on a spreadsheet—the number at the bottom of the far right-hand column to be specific. This particular number is also known as the legendary "bottom line." Your enterprise, like any business, exists for one reason: To make a profit. Unless you've just won the lottery or are independently wealthy, this is the only genuinely accepted measure of your true success. And, if you're in debt at the end of the year, you don't have a business, you have a hole in your pocket. To help guide you through the morass of federal, state, and local tax laws, and to ensure that you're taking every available legal tax-saving advantage, you'll need a good accountant.

Getting referrals from colleagues, friends, relatives, and anyone else is the best way to identify the accountant who's right for you. Carefully review and examine all credentials and experience. You should also try to find an accountant with experience in the commercial photography business and a comprehensive understanding of the industry's perplexities and peculiarities.

A small percentage of commercial photographers choose to do their accounting work themselves, and this is certainly fine. Indeed, with computer software tax packages getting better, easier to use, and cheaper each year, you may want to consider doing your own taxes to save some money. However, you'll ideally want to spend your time concentrating on making images, not updating your general ledger. Additionally, with tax laws changing each year, good accountants will make it their business to keep track of the complex and convoluted demands of the Internal Revenue Service, which can have a profound effect on your bottom line.

It's totally foolish to expend the energy and money to set up a business without keeping good records. Of course, it's easier to avoid keeping good accounts, but in the long run, when city, state, or federal tax officials come knocking at your door—and they always do—your life will be much easier if you've kept organized records. The following is a list of some of the items you should retain for your financial records, but for a complete list of the business receipts that you're required to keep on file, contact state and federal tax authorities.

- Canceled checks
- Paid bills

- Duplicate bank deposit slips
- Purchase receipts or sales slips (for any work related items you purchase)
- Receiving reports (manifest lists of goods you receive, such as shipments of photo supplies)
- Invoices sent to customers
- Receipts for cash paid out (petty cash)
- Any documents that substantiate entries in your records

As you begin to achieve greater success with your photography, you may find that you have less and less time to devote to good record keeping. When you get to that point, it's critical that you hire someone to perform these necessary tasks; although you'll be incurring fees for this person's services, it's more than worth it because the professional advice you may receive can frequently help increase your profits.

Your accountant should develop a record keeping system that is suitable for your photography operation and train you in updating and maintaining those records. From these records your accountant will develop your financial statements and tax returns. There are dozens of record keeping methods out there, ranging from the complex to the very simple, but luckily you only have to set up a system once. According to the National Society of Public Accountants, a basic record keeping system should be reliable, easy to understand, accurate, consistent, and designed to provide information on a timely basis, and might include:

- Records of transactions, receipts, disbursements, sales, purchases, and other items
- Accounts payable records
- Accounts receivable records
- Petty cash records
- Payroll records

If you're diligent, hard-working, and a bit lucky, you'll soon have checks coming in, but that doesn't mean you should immediately run out and order the Ferrari. Some of that money belongs to the IRS, and some of it will probably go to pay the state tax folks, as well. Even if you pay all your taxes promptly the IRS may decide to pay you a call anyway, just to keep you in check. This is what's called a random audit. You might do everything right and still come up at random as a good, solid audit candidate on an IRS computer, or you might get flagged by the IRS as they watch some strange demographic grouping, such as tax-evading dentists claiming bogus home offices.

Accountants range from those working in storefront chains around the country providing basic financial help to individuals offering very expensive customized services. For the simple situations, you might consider purchasing a tax preparation computer program, such as Turbo Tax for Windows-based PCs. However, while it's nice to save money by doing your own taxes, you should consider that with constantly changing federal and state tax laws, perhaps the only way to take full advantage of every available tax break is to consult an accountant, whose business it is to stay on top of the mountains of information and regulations surrounding complex tax issues. Personally, I prefer using small accounting firms that have one or two accountants because these outfits offer individualized service and reasonable costs.

Obviously the size of your photography business will have a direct bearing on the kind of accounting services you'll need, although some accounting and recording keeping procedures are universal. A studio with multiple assistants, managers, sales representatives, and stylists will have very different needs from a one-person enterprise run out of a home office.

Some bookkeeping and tax issues can be quite elaborate and challenging to deal with; laws and requirements vary from state to state. If you're doing business in multiple jurisdictions that are in close proximity to one another, your accounting picture can become especially complex. For example, in the nation's capital, photographers routinely do business in Maryland and Virginia as well as in the District of Columbia. This can get very confusing when it comes to sales tax and other things, because there are different regulations for different states and jurisdictions.

In addition to tax preparation and basic bookkeeping issues, some photographers use their accountants for more long-range issues, such as financial advice and planning, and estate (or retirement) planning. Good accountants should be people with whom you are compatible, who are creative to the full extent that the law allows, and who genuinely believe that your success is inexorably tied to theirs.

BANKERS

As you grow, so will your banking needs. During the course of the development of your business, you'll meet many challenges, come to many crossroads, and experience many opportunities. In addition to having a separate company checking account, you'll need to have an understanding banker who supports your enterprise and believes in what you're doing. A good relationship with a banker in your community is critical to the success of your business; unless you've just won the lottery, you'll need capital to run your operation, and one of the best places to start looking for that capital is with your banker. So for this reason, it's important to choose your banker wisely and cultivate a strong professional relationship with him or her.

David H. Bangs, previously a commercial loan officer and the author of *The Business Planning Guide* (Upstart Publishing, 1996), feels that banks don't really make loans to small businesses but to small business *owners*. To better understand how bankers determine

which customers to take on, consider what Bangs calls "The Five C's of Credit." They are:

Character. What is your track record? Your credit history?

Capacity. How much money can you safely borrow? (How much money can you borrow without impacting other areas of financial responsibility?)

Capital. How much of your own money is at risk?

Conditions. What are the prevailing and anticipated economic and competitive conditions? Is the economy getting stronger, weaker, or remaining the same? Is the photography industry thriving or shrinking?

Collateral. What hard assets do you have to back up a loan?

Some of the qualities to consider when selecting a bank and a banker are a willingness to assume risk and a bit of progressiveness—a recognition that, in our rapidly changing world, risk is a matter of careful analysis, not merely of traditional soundness. Try to find a banker who is knowledgeable about service businesses in general and, ideally, about the photography industry in particular.

It's important to cultivate your relationship with your banker. Be clear about your plans and goals, especially if these don't involve out-of-the-ordinary expenditures. Demonstrate your professionalism, your success, your work. Don't be secretive; don't try to conceal difficulties or problems. (Bankers, like lawyers, adhere to a policy that includes not betraying confidences.) Mutual frankness is the first basis of good banking relations. In concert with your accountant, to earn and keep your banker's respect, be forthcoming with the details of your accounting system; make sure this financial information provides a good picture of how your business is really faring and what it costs to produce your work. Show your banker annual audits, financial statements, and pro forma statements.

GETTING A LOAN

Two standard types of loans are *short-term* and *long-term*. Short-term loans are paid back in less than one year and include working capital loans, accounts receivable loans, and revolving credit lines, called *lines of credit*. Long-term loans generally are loans with maturity periods of more than one year but usually less than seven. They're usually given for major business expansions, buying real estate, acquisitions, and, in some cases, start-up costs; they can include equipment loans, commercial mortgages, short-term loans, and vehicle loans.

In addition to looking for long-term loans, you may find yourself in need of short-term capital requirements to boost the cash flow through your studio for a month or two. One option in this situation is to open a line of credit with your bank; this will allow you to borrow money only as needed (keeping interest payments low) and pay back the loan as excess funds come into your business. Some bankers will consider giving short-term loans based on specific receivables, if they feel secure with you and your company.

Approval of a loan request depends on how well you present yourself, your business, and your financial needs to a lender. Lenders want to make loans, but they want to make *good* loans—ones they know will be repaid. Aside from considering your "Five C's of Credit," as previously mentioned, the best way to improve your chances of obtaining a loan, according to the Small Business Administration, is to prepare a written loan proposal containing the following key elements:

- General information, including your business name, the names of the principals, and their social security numbers.
- Purpose-of-loan statement detailing exactly what the loan will be used for and why it's needed.
- Explanation of the exact amount of money you need to achieve your purpose.
- Business description, including the history and nature of your business, its age, number of employees, if any, current assets, and other core descriptive information. Keep it concise and factual.
- Ownership structure description providing details on your company's legal structure.
- Management profile providing information about each principal in the business.
- Market information defining your product and market. This identifies your competition and explains how your business competes in the industry; it also profiles your customers and explains how you satisfy their needs.
- Financial information providing a balance sheet and income statements for the past three years. (If you're just starting out, provide a projected balance sheet and income statement.) Also included should be a personal financial statement for yourself and other principal owners of the business.
- List of collateral, which would include all collateral pledged to the bank as security for the requested loan. Note that lenders prefer collateral that can be easily liquidated (just in case your business doesn't make it). For example, bankers love real estate collateral; in fact, they have a saying: "You can't get hurt with dirt."

A lender's primary question when reviewing a loan request is, Will this loan be repaid? To help determine this, a loan officer may order a copy of your business credit report from a credit reporting agency, such as Dun & Bradstreet or TRW (see Resources for contact information). It's helpful if you work with credit

reporting agencies to help them prepare an accurate picture of your business.

Using the credit report, plus the loan proposal information you've provided, your banker will then consider a number of other issues. For example, Have you put your own money into your business? You should have already invested at least 25 to 50 percent of the loan amount you're asking for. No one will finance 100 percent of your business, unless the lender is your mother. Have you paid your bills on time? Do you have a solid credit rating? (This is extremely significant.) Also, does your paperwork look good? Does it demonstrate that you understand your business and are absolutely, positively committed to its success? And finally, of course, the lender's ultimate question is, Will this business generate enough cash flow to make the monthly loan payments?

FINANCIAL PLANNERS

According to the Small Business Administration, money is what fuels all companies. Without question, one of the best ways to ensure successful cash flow management is to utilize effective cash flow planning. With a little preparation, you'll find that you can avoid most financial difficulties. To be competitive, all small business owners must plan ahead and be 100 percent ready for any and all future events and market changes. If you pay this issue no heed, you may well become part of the 90 percent of all businesses that fail in the first five years of operation.

Listed below are the aspects of your business that you should consider when doing any financial planning. Note that you probably shouldn't expect a profit for the first eight to ten months of operation, so you should be sure to give yourself enough leeway or cushion in your financial planning and projections.

Start-up Costs. You should estimate all your initial expenses, such as fees (start-up fees from your accountant, lawyer, electrician, etc.), licenses, operating permits, telephone deposit, office equipment, and promotional expenses.

Projected Operating Expenses. To determine these costs, include all salaries, rent, utilities, office supplies, loan payments, taxes, legal services, insurance premiums, and your own normal living expenses.

Projected Income. It's critical that you estimate your sales on a daily and monthly basis. From sales estimates, you can develop projected income statements, break-even points, and cash flow statements. You can use marketing research to help you predict initial sales.

Cash Flow. You should always be aware of where your cash is. The cash that you have on hand (not the projected profits) pays all your bills. Even though your business may look great on the balance sheet, if your cash is tied up in receivables, or equipment, your business is technically insolvent.

You should make a list of all anticipated expenses and projected income for each week and month. If you see a cash flow crisis developing, you can then cut back on everything but the necessities. There are a number of good computer software programs available now, such as Quicken (for PC) and MYOB (for Mac), that can help you mind your money and keep track of investments and interest.

Once you've made some profits, you'll need to put them somewhere so that they can grow, mature, and, most importantly, not shrink in the face of inflation. Most of us, however, are not experts in financial planning, so I'd strongly recommend seeking the advice of a well-informed, professional financial planning specialist, such as a representative from a major stock brokerage house, for example. A good, trustworthy financial adviser is key.

As in the case of all members of your kitchen cabinet, you'll want to find someone whose personality works well with yours. Ideally, it should also be someone who won't be irritated if you call with questions and won't bill you for every little query you may pose. Try to find someone with whom you can work well and who's interested in your long-term success, not just in making enough commission to cover the next payment on the Mercedes. Ask your friends, relatives, and business associates and see who they recommend.

You may know a family member who plays the stock market and has intimate knowledge of what's going on in the world of finance. While you can certainly take advantage of this advice, you should also seek guidance from a professional who has a broader, more impartial, and global knowledge of investments.

RETIREMENT
Part of good financial planning is looking down the road toward retirement. Retirement is a somewhat fuzzy concept in the photography industry. Photographers are often productive and capable of great work on into their very senior years, and there's certainly no reason why an 80-year-old photographer can't still be active, in the absence of physical ailments.

Of course, older photographers may find that their energy levels have diminished somewhat. Whether you shoot stock, assignments, or anything else, you simply won't have the energy to hustle like you did when you were 30 or 40, so you should start planning early on to ensure that you have money coming in when you hit the "Golden Years." And, the sooner you start socking it away, the better. According to insurance industry statistics available from the U. S. Department of Health and Human Services, out of every 100 Americans working today, by the time they reach age 65, 36 people will be dead, 54 will be totally monetarily depen-

dent on others, 5 will be still working, 4 will retire financially independent, and only 1 will be wealthy.

What's a photographer to do? The answer is simple: Pay yourself first, and save your money. Try saving a percentage of your gross intake, say 25 percent for starters. If you can't comfortably do that, try saving less—perhaps 20 or 15 percent. If you don't feel the pinch at 25, try 35 percent. Keep it liquid and in an interest-bearing environment. Your financial planner or accountant can best advise you on this.

BUSINESS MANAGERS

Rock stars have them, and maybe you should, too. Business managers can be like ever-present lifeboats, standing by whenever you see rough water ahead. They can also function like the ringmaster at the circus, keeping their eyes focused on all the facets of your business, including your standard operating procedures (which cover how you do business, collect money, and get advances, and whether you own or rent your workspace, have a car phone, and open a second studio in Los Angeles).

A business manager looks at the big picture and assumes the role of helmsman of your ship of business. This individual might be a banker, a friend, a mentor, a family member, an accountant, or a formal business manager who is available to you for a monthly retainer, hourly fee, or some other arrangement that works for your situation. Ideally, your business manager should advise you on buying or leasing cars, computers, studio space, and the like, and should also tackle more important and complicated issues, such as how to deal with slow-paying clients. This should be someone who has a good track record, good business sense and acumen, and who is readily accessible either via meetings, lunches, or phone calls.

Whether you have a formal business manager or have a member of your kitchen cabinet function as a one for your studio, this may be the single most important source for advice that you'll have available to you. A business manager will help keep you out of trouble and guide you on your path to success.

INSURANCE AGENTS

Insurance is a necessity in any business. Without proper overall insurance protection, you risk losing your business. It is just as precarious a situation as living without health insurance, when you may find yourself unable to work, in seriously degraded health, and, worst of all, facing enormous (and often insurmountable) health care bills.

Running a business is tricky enough without rolling the dice on a daily basis, gambling that you won't have any insurance-related problems. While insurance is a significant cost in your budget and is getting more expensive all the time, the truth is that no business can afford to be without it. To be certain that you have all the necessary coverage under properly written policies and at the lowest possible costs, you'll need a competent, reliable insurance agent who you can work with to develop a realistic insurance plan that covers your particular needs.

Many insurance agents offer specialized plans tailored specifically to the needs of photographers; these can cover such diverse things as liability insurance on the job, insurance against breakage (of props or other things) while on location, and loss of rental equipment for shoots, as well as the traditional coverage for your photographic equipment. Check with your local agent or contact the American Society of Media Photographers for information on insurance packages.

Some of the different types of coverage you may need include insurance for business earnings, casualties, comprehensive liability, burglary and theft, fire, water damage, and, of course, equipment (covering cameras, lights, computers, and the like). Other policies include car insurance, income disability insurance, and "key person" insurance, which after the untimely death of the head of a company, provides funds to tide the company over during the search for a replacement and continues any necessary health insurance coverage.

It's important to divulge all information about your company when negotiating for insurance. Insurance companies are renowned for voiding coverage (typically at the moment it's critically necessary) on grounds of misrepresentation and fraud. Make certain that the insurance companies you select are legally able to do business in the state where your property (or "risk") is located and that they are financially sound. There should be no doubt about their ability to pay all losses in full. In fact, you should always seek out information about a company's reputation for settling losses fairly and promptly, and examine your policies when they are issued.

Worker's compensation insurance (also known as "workmen's comp") is required by many states. (This is the insurance package workers get through their place of employment.) If you expand your commercial photography business and hire employees, you'll be hearing an increasing demand for insurance as part of the employee benefits package. Many businesses provide group life insurance or group disability insurance for their employees, and health insurance has become a common employee benefit.

HEALTH INSURANCE

Even if you are your only employee, health insurance is a must. With rising doctor and hospital stay costs, it's an ongoing challenge to find good, comprehensive medical coverage at an affordable rate. Unfortunately, this is a significant business expense that's difficult if not impossible to avoid. It can also be a very confus-

ing and difficult sea of information to navigate. Basically, there are three main types of health insurance on the market today, which are outlined below.

Fee-for-Service Plans. Increasingly unaffordable for many consumers, this medical coverage features a deductible amount, after which the insurance company pays a portion—usually 80 percent—of the bill for covered services. After you reach a cap (generally about $5,000) each year on your out-of-pocket expenses, the insurance company picks up the tab. These plans offer freedom of choice in medical providers and hospitals, which can be especially important if you need a specialist or must be admitted to a highly specialized facility. One thing to examine when choosing this type of plan is the lifetime maximum benefit cap, which might not adequately cover catastrophic illness or injury (two of the main reasons for getting health insurance in the first place).

Preferred Provider Organizations. Commonly referred to as PPOs, these plans combine elements of fee-for-service policies with health maintenance organization (HMO) ideals. PPOs generally limit the doctors and hospitals that you can go to (and still receive coverage), making them similar to HMOs, and they cut deals with certain doctors and hospitals to provide health care at a reduced price. Unlike HMOs, however, with PPOs you're still covered if you go to a doctor or hospital that's not on the full-coverage list—you just receive lower benefits.

Health Maintenance Organizations. Called HMOs, these plans are seen by some as the wave of the future because they truly control costs and are successful at lowering prices for both consumers and insurers. In an HMO you receive all of your medical care in return for a premium; with no deductibles, you make co-payments of only $10 or $15 per office visit or prescription. This full coverage has it's price however—you give up your freedom of choice. Except in cases of life-threatening emergencies, the only doctors and hospitals you can use (and receive full benefits with) are those in the HMO network.

The issue of insurance is large and complex, and insurance expenses, although necessary, can be very brutal, adding significantly to monthly overhead. Some commercial photography businesses choose to "self-insure," which saves monthly premiums in the short run. This refers to the practice of providing your own coverage, either by depositing money in an account on a monthly basis to cover any needs that might arise, or by only purchasing "catastrophic" coverage for times when you might be hospitalized or ill for an extended period of time (as opposed to just breaking an arm or having the flu).

If you choose this option, however, you may be rolling the dice on the financial success or failure of your business in the long run. If, for example, you have a lot of incidental needs, you may end up paying more by self-insuring, rather than simply paying for coverage for yourself and your family. The best bet with all types of insurance is to work with a reputable insurance agent who is familiar with the commercial photography business and will continually survey all the available insurance products to ensure that you're getting the best coverage for the smallest premiums.

LEGAL CONSIDERATIONS

One of the most basic decisions you'll have to make when setting up your business is what type of company structure you will operate under. You can choose to be a sole proprietorship, a partnership, a corporation, a subchapter S corporation (which many photographers use), or some other legal entity. Each has good and bad aspects. The basic issue is to find the option which works best for you in terms of preserving your assets, protecting yourself from potential liability, and ensuring that you are able to legally extract as much profit as possible from your business.

Which kind of business identity you select can have a profound effect on how much money you are able to walk away with at tax time. No matter which structure you select, it's imperative that you seek the advice of your attorney and accountant to ensure that you are aware of all the advantages and disadvantages in any given situation.

SOLE PROPRIETORSHIP
This is the simplest company structure—a business that is owned and operated by one individual, who is in total control. No new legal entity is created; you simply hang out your shingle and go into business, either alone or with employees (but without any co-owners). Different jurisdictions have different requirements for starting a business, so you should check first with your local government.

A sole proprietorship operates under centralized authority, which offers quick action and decision-making and allows an individual to do business almost anywhere in the United States. As a sole proprietor you aren't bound by restrictive laws, corporate charters, or partnership agreements, and this enables complete freedom in operation. This company structure also affords you the greatest amount of privacy and often has significant social security and income tax advantages. (For example, you don't have to pay corporate taxes.) Disadvantages include unlimited liability for the owner, along with the fact that a sudden death or disability can have drastic effects on business. Furthermore, any prevailing domestic and economic factors in the owner's personal life can directly affect the stability and durability of the organization.

PARTNERSHIP

A partnership is when two or more people go into business as co-owners, sharing profits and losses equally. The advantages to this company structure lie in the ease and speed of its formation, and in the relatively small setup cost. A partnership can also usually secure a greater accumulation of capital than a sole proprietorship, due to the personal liability of both the partners.

Other potentially important advantages are a division of labor, with the opportunity for each partner to be responsible for different jobs (thereby alleviating the work load), and the fact that by its very nature, policy-making in a partnership is less one-sided and tends to be more balanced. A partnership can also afford a better personal relationship with customers and employees than a corporate structure, because partners are more likely to provide more hands-on involvement in their business; it is often more personal than a corporation. Customers can see the genuine concern that the partners have for their clients.

Partnership does have its disadvantages however, the most significant being that the death, withdrawal, or bankruptcy of a partner (or numerous other unpredictable elements) can terminate the arrangement. There are also difficulties in removing one partner from the company, and significant potential for lack of agreement in any decision-making; complications can arise if a decision deadlock occurs (typically, you need a majority vote for ordinary business decisions and a unanimous vote to change the basic nature of the partnership, but this depends on the structure of the partnership).

Finally, problems or changes in the lives or personal fortunes of the partners can have devastating effects on the partnership, and there is unlimited liability for each partner. Partners may even be required to use personal assets to pay the firm's debts. Some of these problems can be avoided by setting up a limited liability partnership, which limits the personal liability of the partners to the amount they have invested in the business. Creditors must be notified of any limited liability arrangements in the partnership articles.

CORPORATION

A corporation's structure represents the greatest possible separation of business and personal identity, both legally and financially. The corporation is a separate entity with a separate legal existence from its owners and stockholders. The many advantages here include tax benefits and limited personal liability. Attorneys speak of a "corporate veil," which can effectively protect the officers and owners of a corporation from personal liability, although in a small (or "close") corporation, owners may have to personally guarantee loans made by the corporation.

Incorporating your business may make the acquisition of capital easier, and interest (control) in a corporation can be more readily transferred to another interested party (than in a partnership). Additionally, management can continue despite changes in ownership. Depending on the state in which you incorporate, and the specifics of your business situation, you may also be able to get significant tax savings by setting up your operation as a corporation. However, there are numerous disadvantages to consider, including the complexity of the required financial and legal paperwork, and the filing of many reports (for tax purposes) and various tax returns. In general, it can be expensive to set up a corporation, and there's quite a rat's nest of federal and state regulations to comply with. Check with your local government for specific requirements.

SUBCHAPTER S CORPORATION

A variation of the corporation structure is the subchapter S (or small business) corporation.
If a corporation passes a number of the requirements of the local jurisdiction, it may be eligible for sub S status. This transition affects only the tax status of the company. Under subchapter S of the IRS code, a corporation will be taxed essentially as if it were a partnership; profits or losses appear on the tax returns of the stockholders (in proportion to the shares of stock they own), with the corporation filing only an informational return.

In all other respects, a subchapter S corporation is indistinguishable from a standard corporation. Consult with your accountant and attorney to determine if this is the best and most appropriate form for your commercial photography business.

LICENSES

You'll feel a definite impact on your commercial photography business if you fail to get properly licensed to do business in your jurisdiction. Requirements vary, so it's a good idea to check with your accountant, attorney, or business manager to find out what kind of paperwork you'll need to file, where you have to file it, and how much it will cost to set up shop in your area.

One of the advantages in being licensed is that you'll obtain a resale number, which will exempt your business from certain types of sales taxes (depending on local jurisdiction requirements). The theory behind these exemptions is that you don't need to pay sales tax on items—such as seamless paper, film, plastic slide sheets, and photographic prints—for which you are not the end consumer. The end consumer will pay the tax on these items.

As a commercial photographer, you may not be directly contracting with the end consumer. For example, if you're working with ad agencies or design firms (who take your work to the end client), you'll need to obtain a tax resale number from them for your

PROPERTY RELEASE

For good and valuable consideration herein acknowledged as received, the undersigned, being the legal owner of, or having the right to permit the taking and use of photographs of, certain property designated as_____ , does grant to _____ ("Photographer"), his/her heirs, legal representatives, agents, and assigns the full rights to take and use such photographs and copyright same, in advertising, trade, or for any purpose.

The undersigned also consents to the use of any printed matter in conjunction therewith.

The undersigned hereby waives any right that he/she/it may have to inspect or approve the finished product or products, or the advertising copy or published matter that may be used in connection therewith, or the use to which it may be applied.

The undersigned hereby releases, discharges, and agrees to save harmless and defend Photographer, his/her heirs, legal representatives, and assigns, and all persons acting under his/her permission or authority, or those for whom he/she is acting, from any liability by virtue of any blurring, distortion, alteration, optical illusion, or use in composite form, whether intentional or otherwise, that may occur or be produced in the taking of said picture or in any subsequent processing thereof, as well as any publication thereof, even though it may subject the undersigned, his/her heirs, representatives, successors and assigns, to ridicule, scandal, reproach, scorn, and indignity.

The undersigned hereby warrants that he/she is of full age and has every right to contract in his/her own name in the above regard. The undersigned states further that he/she has read the above authorization, release, and agreement, prior to its execution, and that he/she is fully familiar with the contents thereof. If the undersigned is signing as an agent or employee of a firm or corporation, the undersigned warrants that he/she is fully authorized to do so. This release shall be binding upon the undersigned and his/her/its heirs, legal representatives, successors, and assigns.

DATE

(WITNESS)

(NAME)

(ADDRESS)

INDEMNIFICATION AGREEMENT

(MODEL) hereby agrees to protect, defend, indemnify and hold harmless (PHOTOGRAPHER) from and against any and all claims, losses, liabilities, settlements, expenses and damages, including legal fees and costs (all referred to collectively as "Claims"), which (PHOTOGRAPHER) may suffer or to which (he/she/it) may be subjected for any reason, even if attributable to negligence on the part of (PHOTOGRAPHER) or any other entity, arising out of or related to any act, omission or occurrence in connection with the creation, production or use of any image or the performance of any service relating to this Agreement or its subject matter. This provision shall apply to Claims of every sort and nature, whether based on tort, strict liability, personal injury, property damage, contract, defamation, privacy rights, publicity rights, copyrights or otherwise. (MODEL's) obligations under this provision shall survive the performance, termination or cancellation of this Agreement.

DATE

(ADDRESS)

(NAME)

records to avoid having to charge them tax. It's best to check with your accountant for sales tax information for your area.

PROPERTY AND MODEL RELEASES

If you're shooting at or in front of a location that belongs to someone else, and the spot is distinctly visible in your image, you may need to consider having the owner of the site sign a property release form. This will specify what the property is, who it belongs to, and that you (as the photographer) have permission to use it in your photograph.

To facilitate this process, you might offer the owner some financial inducement. This could be as small as $25 or $50 or, for more elaborate properties and projects, might be a four-figure amount! Regardless of the grandeur of the locale, having a signed property release will give you peace of mind and show your client that you are thorough, organized, and have their best interests at heart.

As with locations, I recommend that whenever possible you have models sign model release forms, too. At the end of an assignment, professional models from established agencies will generally produce a voucher for you to sign that will specify how much time they spent on the shoot, the name of the person who should receive the bill, and a brief model release. You should then have all models complete your separate release, as well.

If you're using amateur or non-professional models, such as your client's employees, you'll just be using your model release forms. Even if you're working for a corporate client and the models are the company employees, you should use model releases. In a worst-case scenario, a model you're using for an ad or a corporate brochure could become disgruntled at some point in the

ADULT RELEASE

In consideration of my engagement as a model, and for other good and valuable consideration herein acknowledged as received, I hereby grant to _____ ("Photographer"), his/her heirs, legal representatives and assigns, those for whom Photographer is acting, and those acting with his/her authority, and permission, the irrevocable and unrestricted right and permission to take, copyright in his/her own name or otherwise, and use, re-use, publish, and re-publish photographic portraits or pictures of me or in which I may be included, in whole or in part, or composite or distorted in character or form, without restriction as to changes or alterations, in conjunction with my own or a fictitious name, or reproductions thereof in color or otherwise, made through any medium at his/her studios or elsewhere, and in any and all media now or hereafter known for illustration, promotion, art, editorial, advertising, trade, or any other purpose whatsoever. I also consent to the use of any published matter in conjunction therewith.

I hereby waive any right that I may have to inspect or approve the finished product or products and the advertising copy or other matter that may be used in connection therewith or the use to which it may be applied.

I hereby release, discharge and agree to save harmless Photographer, his/her heirs, legal representatives and assigns, and all persons acting under his/her permission or authority or those for whom he/she is acting, from any liability by virtue of any blurring, distortion, alteration, optical illusion, or use in composite form, whether intentional or otherwise, that may occur or be produced in the taking of said picture or in any subsequent processing thereof, as well as any publication thereof, including without limitation any claims for libel or invasion of privacy.

I hereby warrant that I am of full age and have the right to contract in my own name. I have read the above authorization, release, and agreement, prior to its execution, and I am fully familiar with the contents thereof. This release shall be binding upon me and my heirs, legal representatives, and assigns.

DATE

NAME

WITNESS

ADDRESS

SIMPLIFIED ADULT RELEASE

For valuable consideration received, I hereby grant to _____ ("Photographer") the absolute and irrevocable right and unrestricted permission in respect of photographic portraits or pictures that he/she had taken of me or in which I may be included with others, to copyright the same, in his/her own name or otherwise; to use re-use, publish, and re-publish the same in whole or in part, individually or in any and all media now or hereafter known, and for any purpose whatsoever, for illustration, promotion, art, editorial, advertising and trade, or any other purpose whatsoever without restriction as to alteration; and to use my name in connection therewith if he/she so chooses.

I hereby release and discharge Photographer from any and all claims and demands arising out of or in connection with the use of the photographs, including without limitation any and all claims for libel or invasion of privacy.

This authorization and release shall also inure to the benefit of the heirs, legal representatives, licensees, and assigns of Photographer, as well as the person(s) for whom he/she took the photographs.

I am of full age and have the right to contract in my own name. I have read the foregoing and fully understand the contents thereof. This release shall be binding upon me and my heirs, legal representatives, and assigns.

DATE

NAME

WITNESS

ADDRESS

future and leave that company (your client) in disgust. This person might harbor so much resentment toward their former employer that he or she refuses to be in your brochure or ad. If you don't have a signed release, you won't be able to use that image, and you may not be able to produce your client's brochure. However, if you do have a release, you're covered against contingencies such as this. Always using releases is a good protective habit to get into.

While releases should certainly be comprehensive, they should also be relatively simple in appearance. I prefer releases that are the size of half a sheet of typewriter paper. They look very unthreatening, however they still do the job. Releases that look too complex and detailed are apt to send some models scurrying to their attorneys before signing. Whatever form your model release takes, it's helpful to include some reference information in it, such as which frame the model

is in and who the job client is. To be 100 percent legal, you should make some sort of payment, also called "consideration," to the model; a release is a contract, and without consideration, you have no contract.

To correctly process a model release, have the model sign the form, and attach a Polaroid image of the shot in which the model appears to the release. Give the model a check for payment, and then when the check comes back from the bank at the end of the month, attach it (or a copy of it) to the model release. You now have a properly executed release, a record of which shot the model was in, and proof of payment.

CREATING A BUSINESS PLAN

In any professional endeavor, you'll need a road map to get your enterprise where you want it to be, and a business plan is that road map. Going through the

process of formulating a plan will help you to clearly define exactly what you're doing and will prepare you for whatever comes your way. It will also make you think about everything that it takes to be successful in the photography industry, from start to finish, and force you to take an objective and critical look at your business goals and ideas.

A business plan can be formal or informal, depending on what works for you. There are advocates of either approach. You can struggle with a detailed plan that fills an entire notebook, or you can keep it all in your head, grab your portfolio samples, hit the phones, and start making appointments to show your work. However, you may find it advantageous to have a formal business plan if you'll be seeking funding (especially from a bank). It will show any potential investors that you're serious about your endeavor, that you've taken the time and energy to think things out, and, therefore, that you're a good candidate for a loan.

A plan is a flexible document that will change as your business grows. If you produce one when setting up your commercial photography operation, you won't regret it; a solid business plan is a beacon that will guide you on your journey to success. A simple business should incorporate the following elements or descriptions (in roughly this order):

Introduction. This should describe your business and the services you provide, characterize the need for those services, and outline the superior qualifications of your firm's founders.

History and Goals. In this section, introduce the reader to the company's purpose (why you started it) and goals in terms of professional and service aims.

Market Analysis. This should be a discussion of the industry and a summary of the need for your services. Describe the market you plan to serve and its consumers. Also, list *your* major customers and competitors. Discuss service timing as it relates to demand based upon such factors as seasons, political administrations, and any other changes.

The Management Team. This should include condensed résumés of your management team (you can attach any necessary longer versions of résumés and letters of reference) and descriptions of each person's responsibilities. Also mention any outside experts, such as accountants, attorneys, and business managers, and include a photo of the team.

Advisors or Board of Directors. Here you should outline the general structure and responsibilities of your advisors or board, describing your reasons for selecting representatives with certain expertise (such as technical or business experience not possessed by the founders, for example).

Professional and Service Support Resources. Discuss your plans for selecting professional and service agencies, such as insurance companies and bankers, and describe the reasons for choosing them (indicating special needs of your shop and how they fulfill them).

Service. Highlight the competitive features and advantages of your services; indicate the costs attributed to each stage of the production and sales processes. You should explain the current state of the industry and your plans for dealing with any future industry changes, such as rapidly evolving technologies.

Marketing Strategy. Describe your marketing plans for selling your services to each different customer group you've targeted; outline elements of promotional strategy, including overall image-building, and discuss pricing methods and objectives.

Growth Opportunities. Maintain a list of improvement ideas; explain how you will incorporate them in a testing, evaluation, and eventual implementation process. You should also show alternative funding sources (aside from your main funding source) for the development of these ideas.

Special Characteristics. Mention or explain any special aspects and/or motives of your business; for example, these could be your reasons for selecting your specific marketing plan, your great location, or your proximity to customers.

Summary. Use this section to highlight key events in the past and possible future (one to three years) development of your studio. Mention any awards won, achievement of sales goals, introduction of new services, hiring of critical staff members, and the like; feel free to utilize charts, diagrams, or tables to "illustrate" these events.

Supporting Documentation. This can include sales forecasts; cash flow statements; income statements; balance sheets; projected staff and office/studio requirements; explanations of the legal structure of the company; and résumés, reference letters, personal financial statements, and compensation packages for key personnel. It is basically the back matter of your plan.

Tax and Profit Plans. These show potential tax liability based on projected profit. Have your accountant or tax attorney help you with this.

Market Surveys and Reports. These help to clarify the information included in your Market Analysis section. They can be informal, such as the results of a phone survey you conducted of the anticipated spending of prospective clients, or more formal with reports from area governments on the state of local industry.

Related Newspaper and Magazine Articles. To provide further supporting documentation, attach those articles that discuss future prospects for the industry.

While business plans generally contain certain set elements, you can certainly adapt them to fit your general needs, too. In general, try to keep the overall look or presentation of your plan fairly conservative. A banker I work with told me his theory that the "glitziness" of the business plan cover is inversely proportional to the quality and content of the plan itself. He had seen plans, from people seeking funding, in beautiful gold stamped, leather-embossed binders, as well as ones in plain brown wrappers, and found that the plainer presentations often made more sense than the fancy ones.

There are a number of helpful business reference books out on the market that you can find at any large bookstore. I list a few of my favorites on page 190 in the Resources section. There are also a number of computer software programs on the market that will help you create a business plan, including Ronstadt's Financials (for Windows) created by Robert Ronstadt.

GOAL SETTING

Setting goals is an important part of any successful business, and commercial photography is no exception. Unless you have specific goals, and plans on how to reach them, you could be left in the dust. Whatever your goals, you should break them down into manageable steps, and focus on short-term as well as long-term objectives. It's also important to spell them out, write them down (with the date), and refer to them frequently in order to stay focused and track your progress. This is a critical point of good planning; it forces you to be specific and provides you with a focus.

Everyone has different ways of determining their goals. Atlanta-based advertising photographer Tim Olive heads for a mountain cabin several times a year for a day or two to clear his head and sit down to focus on goals for the coming months and years. He lists goals for different areas of his life, including professional, personal, family, and artistic objectives, and writes them down.

One helpful goal-setting technique to consider is the *management-by-objective* method, or MBO. MBO refers to the setting of business goals combined with sufficient plans to ensure progress. This strategy employs periodic goal setting, performance review, and analysis, all within specific time periods.

Some experts suggest breaking down the goal-setting process into separate categories covering regular work, problem solving, development, and innovative goals. *Regular work* goals focus on day-to-day activities and the improvement of efficiency. *Problem-solving* goals center on identifying major problems that hamper performance and establishing plans to eliminate them. *Development* goals aim to improve skill levels of yourself and any employees you may have. And, *innovative* goals seek out new ideas for running your business. For information on management-by-objective techniques and other good advice, send $.50 to the U.S. Small Business Administration publications department (see Resources for address).

Whatever your method, specific goal-setting works. The word *specific* is key, however. General objectives, such as "I want to be rich," will be a lot less compelling than more precise goals, such as "By next October 15th, I will have my own 3,000 square foot studio, will have won five national awards, and will have $30,000 in the bank." Two great reference books for goal-setting and self-actualization are Anthony Robbins' *Awaken the Giant Within* (Simon & Schuster, 1992) and Napoleon Hill's classic *Think and Grow Rich* (St. Martin's Press, 1987).

Other great business resources are the federally operated SBA's Small Business Development Centers, which are regionally located around the country and offer a range of affordable, excellent business courses. Call the SBA for information. (See Resources.)

KEEP TRACK OF YOUR SUCCESS

To help gauge your goal-reaching progress, it helps to have objectives that are measurable. Only then will you know how you're proceeding. Another benefit of having assessable goals is that it's easy to tell when you've reached them. You can then go out, celebrate, and determine your next series of aims. You'll enjoy a sense of accomplishment and well-being when you hit the mark you've set for yourself. And, you'll be steering yourself toward what you really want, not just drifting aimlessly without knowing what's ahead.

To stay on course, you may want to consider employing some accountability devices. For example, try to keep daily accomplishment records and monthly scorecards of what you've done to move ahead. At the end of each day, ask yourself what you did that day to further your photography career. It's a compelling strategy. Reviewing a month's worth of daily accomplishment records will give you a very clear view of how effective you've been in working toward your goals. Only when performance is measured can it be altered. As your enterprise grows and prospers, you'll want to reevaluate, redefine, and update your goals to reflect your changing business environment.

MARKETING PLANS

An important component of any professional endeavor is the marketing plan, which can prove to be a vital tool in business growth. It might include an analysis of market opportunities (who's buying what), a statement

of market objectives (for example: To dominate the studio illustration market in Kansas City), the implementation of promotional tactics (such as giving away free cameras with each shoot), and a strategy to make it all happen.

A marketing plan might also include your goals for an upcoming period of time, be it a month, a quarter, a year, or longer. It could also detail such diverse items as how much money you'll be putting out for promotion, what kind of promotion you'll be doing and what message you'll be sending out to prospective clients, how many people you want to reach, where you'll be advertising, and other factors. A marketing plan can be exquisitely delineated and detailed, following strict guidelines, or it can contain more informal, yet still defined goals; photographer Scott Morgan's plan includes an overall goal to "work with the best people, on the best, most aesthetic jobs."

You can certainly build a business without written plans. Many successful photographers report that they never write down their marketing plans. Some make it up as they go along. The discipline and challenge of being more strategic and committing plans to paper can only help clarify and illuminate your thinking and help you to achieve long-range objectives. A good plan is nothing more than thorough thinking on paper, and the advantage to it is that it allows you to look ahead, do some planning, and be ready for all possible contingencies.

One great reference for formulating a marketing plan is William Bygrave's *The Portable MBA in Entrepreneurship* (John Wiley & Sons, 1994). There are also some good computer programs available, such as The EZ-Write Marketing Plan Writer for both Mac and PC platforms. Check with your local computer supply store.

TRADE ASSOCIATIONS

The basic purpose of a trade association is to unite people in an industry so that they can speak out on important issues with one, more powerful voice. Trade associations also create public awareness about industry goods and services and about the benefits of using association members (which might be that members adhere to stricter trade standards, for example).

You should plan to join a photographers' trade association, such as American Society of Media Photographers (ASMP), Advertising Photographers of New York (APNY), or Advertising Photographers of America (APA). In the commercial photography industry, the preeminent group is ASMP, which has been dedicated to teaching photographers about better business practices for the past 50 years. Organized in 1944 to promote high professional standards and ethics, as well as the interests of commercial photographers, ASMP now counts more than five thousand members

worldwide in 37 chapters. APNY, an association whose members are some of the most sought-after advertising photographers, is also becoming a strong voice for the specialized interests of advertising photographers.

The American Society of Media Photographers has historically taken a very proactive stance in regard to business. Early victories include taking on media giant Time, Inc., to fight for photographers' rights (and winning). In addition to meetings and seminars, ASMP provides ongoing business assistance to members in areas of legal support, education, and industry practices. Also available to society members is the *The ASMP Business Bible* (put out by ASMP), which contains some of the best state-of-the-art business advice out there. Every commercial photographer, whether already established or just starting, should be a member of ASMP.

Started originally as an offshoot of ASMP, Advertising Photographers of America is another great organization for advertising photographers. APA seeks to be more focused specifically on the world of advertising photography.

There are certainly other professional photography trade groups to join, however ASMP, APNY, and APA represent the largest associations for commercial photographers.

RAISING CAPITAL

One key to setting up a successful operation is your ability to obtain and secure appropriate funding. Raising capital may be difficult, complex, and, frankly, frustrating, but it's the most basic of all business activities. If you're informed, well prepared, and have planned effectively, raising money for your business won't be a totally painful experience, and there are a number of things you can do to prepare for it.

Running a successful commercial photography business takes sound financial management, which involves savvy and planning. This is often the most difficult aspect of starting up a company. Businesspeople often raise too little money and then don't have enough funds to see themselves through their first rough times. They also tend to purchase unnecessary business items, thereby using up their profits. Then, when they run short of money, they find themselves warding off angry vendors and subsisting for months without a paycheck.

The expenses associated with beginning a business are considerable. It's going to take some money—usually more than you think—to get yourself started. Sitting down with your kitchen cabinet to help determine what kind of cash you'll need on hand as you struggle to get set up will prove to be time well spent. You must plan and look carefully into the future; go over the full array of your expenses—photography

equipment, work space, phones, fax machines, and computers are only the beginning, and most visible, needs you'll encounter in setting up. You must also consider your salary (Are you prepared to support yourself on your savings for as long as a year?), advertising costs, and incidentals, such as business cards, letterheads, forms, and medical bills, among others.

Your start-up capital requirements will vary, depending on what kind of operation you envision. Beyond the basics of cameras and lighting equipment, your needs might range from simply keeping a few hundred dollars on hand for film and processing for your next assignment to having extended funds available to cover rent, staff salaries, and general overhead items, such as postage, insurance, and shipping costs. At a minimum, it's nice to be able to cover basic expenses for three to six months when starting a new commercial photography business. This gives you time for the business to "percolate," catch on, and head down the road to success.

Don't leave your finances to chance or guesswork. Make a detailed list of everything you'll need to start your operation. Estimate your start-up costs *and* monthly expenses. Then, try to predict your sales for the first year or so. (The first year may be somewhat slow, so don't overestimate your billings.) If you don't think that your projected sales will cover your expenses, consider the following questions. Do you have a personal line of credit? Is a loan possible? Can you fund your business with whatever credit cards you may have? What's the comparative cost of funds from these and other sources? Even if you have adequate capital, it's always wise to make contingency plans.

According to the Small Business Administration, most new businesses begin with a primary source of capital coming from personal savings and other forms of personal equity. Many entrepreneurs also look to private sources, such as friends and family, when starting out or expanding; this money is frequently loaned at no (or very low) interest, which can be beneficial. Venture capital firms provide initial start-up and other needed money for new companies, typically in exchange for an equity position in your firm; this means that they give you capital in exchange for, say, a percentage of ownership in your business.

There are numerous other sources of capital to consider, however. One popular option is debt financing from a commercial bank, credit union, or other institutional lender. While these institutions are notoriously reluctant to advance loans to start-up companies, they may provide such funding if you offer sufficient collateral or guarantees. Despite their reluctance, banks are in the business of making money, and the way they do this is by lending money. However, the financial inexperience of small business owners leads lenders to turn down many small business loan requests.

To successfully obtain a loan, you must be prepared and organized. You must know exactly how much money you need, why you need it, and how you can pay it back. Your task is to convince your lender that you are a good credit risk. Requesting a loan when you're not properly prepared sends a message to lenders that you're a high risk.

Loans can take the form of term notes, lines of credit, or some sort of revolving credit plan, depending on the circumstances. You will most likely be asked to provide security for your loan, which might take the form of stocks, bonds, savings, or other securities. As I mentioned earlier, a favorite collateral of bankers is real estate. Other places to seek funding include credit unions, your family, home equity loans, venture capitalists, and the SBA, which offers a range of business loans, both short- and long-term, to business owners and entrepreneurs.

You should be prepared to personally guarantee your loan. Lenders will often look for security in the form of an interest in all of the borrower's assets. If the loan ultimately goes into default, the lender may take possession of the collateral and sell it. Proceeds are then applied to the cost of repossession and sale, and to the rest of the unpaid loan. Any additional amounts would be turned over to any low-priority, secured creditor and, ultimately, to the borrower. In some cases, lenders will insist on guarantees from additional parties.

There are also serious tax ramifications to consider when securing loans and making personal guarantees. Wherever you find funding, do your homework. Read all the fine print, and consult your attorney, accountant, and business manager.

SETTING UP SHOP

Life's work well done. Life's victory won. . . .
—EDWARD HAZEN PARKER

To achieve success in any field requires time, commitment, and passion. It also requires the right tools. Aside from the most obvious implements, such as cameras and lenses, there are other basic tools that are highly necessary, including phones, computers, and simple office equipment. Most important among these things is having a quiet workspace where you can think clearly, plan marketing strategies, keep track of assignments, and process billing.

For some commercial photographers, this space can be the corner of a spare bedroom; for others it's a formal office space with all the trimmings. For many, it's something in between these two options. Regardless of which type of workspace you choose, you'll need a comfortable, calm place in which to do business, so make sure that your space is right for you.

WORKSPACE

Where you work depends on your lifestyle, work style, needs, income, and clients. Many successful, world-renowned photographers work out of their homes. Duane Michals, who is highly respected worldwide for both his personal and commercial professional work, says that he never wanted a large studio with six assistants. That's okay, and these days it makes some degree of sense.

You don't really need to set up a formal photography studio. There are no definite rules about this. Many photographers feel that they can't afford the rent on the size studios they would want. To cover the monthly overhead, they might have to take jobs that they really don't want. One solution is to rent a studio only when you need it. Patrick Fox, of Fox Studio in Minneapolis, has 6,000 square feet for hire. "I think it's almost impossible to invest in a studio on your own now—the struggling stage is much longer," he says. A smaller studio is much more cost effective.

Of course, the most cost-effective space is your own home. Twenty-five years ago, working out of your house bore a certain stigma—an implication that perhaps you weren't successful enough to afford real office and studio space. Today, working from your home makes significant economic sense for many photographers, both in urban and rural settings. Advertising photographers Al and Joy Satterwhite elected to move from New York to bucolic Concord, Virginia, literally in the middle of corn and wheat fields. They were able to significantly improve the quality of their lives and still maintain successful careers. That they could do so and continue to prosper is a testament to technology, FedEx, and fax machines.

Similarly, Seattle ad photographer Chuck Kuhn is able to sit in his living room and "watch the whales" pass by his home on Bainbridge Island. Many photographers choose to work from home. I've done so for most of my 30-year career. (It's great to be able to come down to the office at five in the morning in your pajamas if you want to.)

Comfort aside, a legitimate home office also makes powerful economic sense. You can legally write off many home office expenses, although you should be sure to check carefully with your accountant and/or the IRS first, because there is enormous IRS scrutiny into the legitimacy of home offices. Your local jurisdiction may also place restrictions on what kinds of business activities you may legally conduct from your home. It may, for example, be entirely legal to keep books and records in your home office, but illegal to shoot, process film, and make prints there. Or, you might need to get a special license to operate from a home office. The best course of action, again, is to check with your attorney, accountant, and business manager.

The other option is to rent studio facilities. European photographers have been doing this for years. There's a proliferation of rental studios, and in some cities, you can rent enormous space for as low as $20 per hour. When looking for good, cheap rental space, be creative; consider using dance studios, or video and film production houses. You might find the best deals in unexpected places. Also, look under the heading of "Studio Rental" in the yellow pages, or check the classified section of the trade magazine *Photo District News*.

If you're fortunate, your city (or the nearest city to you) might have some great affordable studio spaces in old commercial districts. Baltimore, for example, is one such city. It's packed with architecturally wonderful spaces, such as the 1830s Mill Center textile mill complex that houses many photographers and designers.

STUDIO VS. LOCATION

Whether or not you have a photographic specialty will affect what type of workspace best suits you. A number of the world's most successful photographers believe that it's best to choose to specialize on either *studio* or *location* photography. Without a specialty, these photographers say, you'll be lost and you'll have difficulty creating what marketers call a unique selling position or USP (see page 55). Others, who have dazzling careers centered around the concept of not specializing in any one area, feel that this is nonsense.

As far as workspace is concerned, studio and locations photographers have very different needs, and so the type of work you do will determine the type of workspace you choose. If you're primarily a location shooter, you probably won't need to maintain a studio; if you specialize in tabletop photography, on the other hand, you might never leave your studio. If you are primarily a location shooter but do occasional studio assignments, you might consider renting a studio only when you need it, as I sometimes do.

Some photographers opt not to specialize. Craig Cutler, for example, is equally at home doing tabletop photography as he is taking architecture shots or anything else. My advice is to do the kinds of work that you like to do—it's your *vision* that makes you special, not the subject matter or some imposed marketing classification.

At one time, if you said you were a studio photographer, the implication was that you didn't shoot on location; if you said you were a location photographer, the assumption was that you didn't do studio work. However, with today's technology and the realities of smaller markets, the fine line between studio and location has blurred.

Can a studio photographer shoot studio work on location? Certainly! Can a location photographer shoot in a studio? Absolutely! It's not where you shoot; it's what you bring to the shoot. Don't limit a

buyer's perception of your capabilities by labeling yourself a specialist. It's your skills and personal aesthetic that set you apart.

EQUIPMENT

I once heard someone say that the reason we all get into photography is because we're all "equipment freaks," and there just might be a ring of truth to that. Did you ever see a brand spanking new Leica or Nikon glistening in the sunlight, without a scratch on it? Or how about those little craterlike holes in the black rubber material that lines the sides of a Mamiya RZ? A lot of effort goes into the design of equipment today, and to be a player today, you need a lot of equipment to get into the game.

The equipment and material resources you'll need to set up your business will depend in large part on the kind of work you'll be doing. Given the wide range of work out there (from editorial to corporate to advertising to underwater food photography) and the huge amount of both traditional and digital equipment available, I won't get in to which camera and lighting systems to purchase; there are so many factors to consider that it would take a few hundred pages to do the subject justice and you should already have some ideas about your preferred equipment. My general advice in picking equipment is just to analyze your goals, speak with colleagues, talk to professionals at camera stores, and read the reviews in the trade publications to gather as much information as you can.

In the 1950s, if you wanted to be a photographer all you really needed was a camera, a couple of lenses, a speedlight (a precursor to today's on-camera flash), and a business card. Bingo—you were in business! Assignments were somewhat simpler; editorial work was still king and often more lucrative. Of course, that was before affordable, effective work-till-you-drop transportable strobe lighting, fax machines, and computers. Today, you'll need all these things and more to be 100 percent ready for business.

The "electronic cottage" we've been hearing so much about for the past 20 years is finally here. You can work anywhere or go virtual and work nowhere, but wherever you are, you'll have to work with machines. Here are some office items to consider, both basic and more specialized.

Phones. These days, with photography buyers busier than ever, your first investment should be a good quality telephone system. As with all things in life, there are phones, and then there are *phones*. It's best to have a minimum of two voice lines coming into your office or studio. Consider getting a primary line that rolls over onto a second line, so that your clients don't hear the ubiquitous call waiting beep every time they're on the phone with you. If you want, you can

increase your capacity by adding call waiting to that second line, while keeping the first one beep free. Look for a model with volume control, clear buttons, and a minimum 10-number speed dial memory. You also might want a speakerphone feature for those times when you want hands-free operation.

Fax and Modem Lines. Consider having a separate, dedicated phone line for your fax machine; to start you can share this with your computer modem line. Then, if you find that you're always surfing the Internet when you need to receive faxes, you can look into getting a second line.

Fax Machines. There are two ways to go here. One is an integrated solution of hooking up your computer with an inexpensive fax/modem board to save the expense of a separate fax machine; the alternative is to get a separate fax machine. When fax machines first came on the market they cost a great deal. You can still spend a lot of money if you opt for a plain paper machine, however you can also get a very serviceable machine at an office supply discount superstore for less than $300.

For a computer-based fax modem, you'll spend roughly $100 to $200, depending on features, and then face installation aggravation. It might make more sense to go for a separate machine, especially if you use your computer a lot. Also, if you want to fax a preprinted piece (such as a sample photo layout) with a computer fax modem, you'll need to spend additional money for a scanner (because you'll have to scan the item into the computer before you can send it).

Filing Systems. In life there are "pilers" and "filers." Whichever system you use is fine, as long as it works for you. Keeping things in order is a basic office necessity, whether you have to pull out three-year-old records for an IRS audit (let's hope not) or dig out negatives for a rush print order. File cabinets come in all shapes, sizes, and prices, and in addition to providing organization, they will also protect your data and negatives. When first setting up shop, consider buying used equipment.

Computers. In any business, and especially in the commercial photography industry, computers are basic operating equipment. There's a staggering array of affordable computer equipment available for both PC and Mac formats, with prices dropping daily and capabilities increasing consistently. IBM's first PCs carried a two thousand dollar price tag; today, that same amount of money will buy you a PC that will absolutely knock your socks off.

Aside from facilitating electronic imaging (see chapter 3), and image control and manipulation, computers can also help you manage your business with a contact management database of your customers and prospects, and software to help with writing estimates,

invoices, stock photo delivery memos, proposals, and business plans. With the proliferation of inexpensive portable laptop computers, many photographers are now able, for little more than the cost of a 35mm camera body, to take their offices, client lists, and full capabilities on the road with them.

Software. The options here are staggering. At a minimum, you'll need a good solid word-processing program, such as Lotus WordPro (my favorite and rated the world's fastest windows-based product), WordPerfect, or Microsoft Word. Other software choices include spreadsheet programs, such as Microsoft Excel and Lotus 1-2-3; contact management programs, such as Act!; and studio management programs, which are becoming more and more indispensable, such as PhotoByte (from Vertex Software), Studio Manager, InView, and others. Read *Photo District News* and other trade magazine publications for ads, demos, and more information about new software.

CASH MANAGEMENT

Once your business is up and running, studying your working capital regularly lets you monitor the financial health of your enterprise. Don't confuse *working capital* with sales revenues; they're not the same. Working capital is the difference between your business' current assets and current liabilities. According to *Entrepreneur* magazine, the components that make up working capital are:

- Cash and liquid assets (which includes all incoming cash from sales or other sources)
- Accounts receivable (the moneys owed you by your clients)
- Inventory (since commercial photography is primarily a service business, this may come down to what you *predict* you'll earn in the coming period—either a month, fiscal quarter, or year)
- Accounts payable (the amount you owe suppliers, such as labs, courier services and camera stores)
- Debts (payment you have made to lenders)
- Operating expenses and taxes (which include such items as utilities, rent, marketing, insurance, professional fees, other monthly operating costs, and salaries)

Unlike people with nine-to-five office jobs and standard paychecks with standard deductions, photographers get checks from clients for work done—whenever that may be—and it's up to them to dole out money to vendors, suppliers, assistants, the IRS, and ourselves. It's easy to get a check for a job and pay everyone else but ourselves. One of the most important pieces of advice I can offer is to *pay yourself first*.

Cash flow, which is the movement of funds in and out of your bank account, is often a challenge to deal

with and manage. You'll need money in the bank to cover business expenses, promotion costs, taxes, equipment, and unforeseen emergencies, and you'll want to have enough money to smooth out the inevitable peaks and valleys of work flow (those times when the phone just isn't ringing). Good financial planning helps. Without it, or adequate capital, any business will suffer (and possibly fail) no matter how much work is coming in. Don't let this happen to you. Even though you may have all the technical skills necessary to succeed, you can never ignore cash. I would also recommend that you not count your money until the check is in your hands and has cleared the bank.

To execute good cash flow management you'll need three main financial statements: the balance sheet, the income statement (also known as profit and loss or P&L), and the cash statement. To best understand cash flow, you have to understand these statements.

Balance Sheet. This describes what your company owns (its assets) and who put up the money (liabilities and net worth). Assets are listed in order of liquidity; liabilities in order of claim (the order in which they are to be paid). These two amounts always balance (equal each other) because the same dollars show up on the asset and liabilities and the net worth sides (assets minus liabilities equals net worth). Balance sheets reveal a lot about your business situation at a given moment in time, although they won't tell you how you got to that point or how to proceed in the future.

Income Statement. Most business transactions have two parts, a cash component and a noncash component. The income statement records the noncash element. When you make a sale, the income statement shows that you provided services for a promise to pay, but it won't record the payment, or cash, portion of the transaction. The income statement also shows depreciation on company assets such as cameras, lights, darkroom equipment, and computers. But depreciation has nothing at all to do with cash—it's just an indication of how much value an asset has lost as a result of wear and tear during the period covered.

Cash Statement. This shows what came in and went out of the bank during a covered period and is absolutely essential to proper cash flow management. Always insist that your accountant supply you with this data—it's critical.

The biggest and most deadly mistake you can make is to confuse net income, or profit, with cash. Funds on the income statement are *not* spendable. They're only promises. Once you know what each statement is designed to show, you can get a more comprehensive grasp on the location of your cash.

For example, let's consider accounts receivable on a balance sheet. Let's say you started the year with $15

in accounts receivable. If you sell $100 worth of services that year, this goes into accounts receivable (and is a noncash item on your income statement, which will list revenues of $100). Let's also assume that sales are your only source of revenue and your expenses are as follows: cost of goods sold, $40; depreciation, $5; taxes accrued, $5; expenses, $30. That's a total of $80 in expenses. To derive net income, you subtract total expenses from revenues to get $20 ($100 - $80). This reveals your net income or profit at $20 for that period.

Let's assume further that you had some incoming cash: clients paid off $18 of what they owed you. That's $18 less that is due you in accounts receivable. So, at the end of this period, accounts receivable would be $97 ($15 + 100 - $18). In spite of all this additional revenue in accounts receivable, you still don't have more cash to pay suppliers, employees, or lenders. Yet, the income statement still shows a profit of $20. It's this contradiction between profit and cash that has the potential to quickly do in your business. If you forget about cash when revenues pile up, it may come back to haunt you because all the great jobs and profit in the world won't save you if you can't pay your bills.

CONTROLLING YOUR CASH FLOW
Cash is the lifeblood of your business, and cash flow management is the key to your success. According to Oliver Hagan, a professor at Baldwin-Wallace College in Berea, Ohio, "Lack of management expertise is the most common cause of business failure. And, most management failures are due to the twin evils of undercapitalization and inadequate cash flow." Cash flow mismanagement will kill your business; unless you keep your eyes open, you may be hemorrhaging money and not even know it. It's important to conserve cash and consider the cash impact of all your business decisions.

Attaining good cash flow management is a two-stage process. For the long term, you should try to develop a consistent, workable cash flow management approach to keep your business strong. For the short term, you need to identify and cure immediate cash flow problems that can affect your daily operations. If you don't have enough start-up capital and encounter a slow billings period, you might find yourself in a position of negative cash flow. Unless you've planned for this and have reserve funds available, you may have to look to lines of credit, bank loans, credit cards, or other short-term financing to attain temporary operating cash.

Hopefully, however, you'll have set aside some money for any emergencies, as well as slow periods. Depending on the amount of reserve cash you have and the length of time before you'll need it, you can put it into short-term investments, such as savings or money market accounts, certificates of deposit, trea-

sury bills, or other interest-bearing financial products. Whichever you choose, make sure you put your hard-earned extra money into top-grade investments. There are also a number of other strategies you should consider when managing your cash flow.

Collect Receivables. Phone the people who owe you the most money, and try to resolve any problems on the spot. If you can't get cash flowing immediately, set up a payment schedule.

Chip Away at Overhead. Focus closely on "fixed" expenses, and see what you can cut. One technique is to review every canceled check for the past 90 days and decide if the expense was really necessary.

Don't Overpay Estimated Taxes. For many small businesses there are choices of standards on which to base quarterly estimated taxes. Work with your accountant to make sure you pay the *least* amount required by the Internal Revenue Service.

Reduce Personal Expenses. Your salary or expense account may be a very significant cash drain. See if you can cut back.

Stay On Top of Billing and Collection. Send invoices with work that goes out. Talk to your banker about ways to speed collections. Investigate getting paid by wire transfers. Open your mail every day, and deposit your checks promptly.

Organize Payment of Bills. Analyze all available discounts and pay all nondiscount bills as late as possible without jeopardizing vendor relations. Use your cash as long as is possible.

Reevaluate Company Practices. If some clients are always late paying their bills, consider dropping them, and instead of focusing only on increased sales, seek out new business that will help your cash flow.

Look Ahead. Maintain an adequate line of credit and, most importantly, a good relationship with your banker.

ALTERNATE CASH RESOURCES

Occasionally, you may need more cash, immediately, to operate your business. Hopefully, you'll have planned well and saved up for contingencies such as this, but if you haven't there are a few other sources of funding to consider.

SAVINGS

In general, you never want to break into your personal savings. However, you may need just a slight infusion of cash for a short period of time. In these cases, it's all right to loan yourself some money, especially if you absolutely, positively know that you'll have funds coming in soon to cover your self-loan.

BORROWING FROM THE BANK

This is when it's handy to have a solid relationship with your friendly, neighborhood banker. Banks routinely make short-term loans to their best customers (those who have accounts or CDs there, or use other bank services). Ideally, you should present a receivable, or series of receivables, to your banker to assure him or her that you do indeed have in-coming funds.

Generally, photography studios are not known as dream collateral (in the event that you default on your loan). Bankers don't want to be running pawn shops selling used camera equipment. However, if your banker likes you, he or she may be willing to make you a short-term *signature loan* (for which you put up zero collateral, with your signature or "word" as your bond that you'll perform as promised).

Making a successful transaction or two like this is a worthwhile exercise. It will raise your banker's confidence in your reliability and your ability to pay; you'll have a track record of performing according to your promises, and you'll be "bankable."

VENDOR CREDIT

This is what you get when you open an account with a vendor (you buy from them on credit), then get billed at the end of the month with an invoice that's due in 30 days. Basically, you're getting free use of your vendor's money for 60 days. As with bank loans, pay your supplier bills on time, but also know how much leeway you can get from suppliers (regarding payment of money you owe them) without earning black marks on your credit report. When working with new vendors, you might consider speaking to their bookkeepers to learn what their terms are and how much payment lag time they'll really allow before becoming unhappy.

It's normal business practice in the photography industry to work with payment terms of *net 30*—meaning payment is due to vendors within 30 days of receiving the invoices for their goods and services. Some vendors bill on a two-week (or semimonthly) schedule, while others ask for money due on receipt of the invoice. However, these vendors will also wait 30 days to get paid (although they won't put it in writing and don't prefer it), because they realize that net 30 is normal trade practice.

A growing commercial photography business needs support and trust from a range of vendors. How important are vendor relations? Very. In the end, what you do as a photographer—produce layouts, photographs, prints, contracts, etc.—depends on having good credit with your vendors, whether they're photographic paper suppliers or your local FedEx office. They make your job easier and are critical to your success. Only work with ones who consistently demonstrate that they really want your business and demand the same great service as you.

Guard your reputation with vendors and everyone else with whom you have business dealings. Your most valuable asset in this industry is your standing, whether it be with your vendors, your peers, your clients, or with the outside world in general. If you don't develop a reputation for paying your bills on time and, on a more vital level, being good for your word, it's going to cost you.

If you ever have a legitimate cash problem, call your suppliers immediately and talk to them. Explain why you'll be unable to meet their stated payment terms (for example, you're having a temporary problem with a client who's late in paying you) and that you wanted to let them know as soon as possible. Say something simple and concise like, "We had an unexpected emergency that gobbled up all our cash," or, "We just had to pay out a small fortune to the IRS for taxes," or something else that's a sincere reflection of your situation. Keep it honest, clear, and brief. Then tell them when and how much you will pay them. Don't be afraid to propose some sort of payment deal, such as partial payment down and X amount of dollars per month for X months. Most vendors will appreciate that you called them and saved them having to track you down. It also demonstrates a willingness and a desire to clear up your debts.

CREDIT CARDS

Open the pages of *Inc., Entrepreneur,* or *Success* magazines and you'll find stories about people who've used credit cards to finance their businesses when no one else would loan them capital. Credit cards do provide a short-term source of capital, but this can be very expensive money to use. Interest rates can run up to over 21 percent per month, so while credit cards are accessible and convenient, the costs can often be staggering.

If, however, you look at this type of funding as money that you must repay in a short time period (30 days, or whatever the billing and grace periods are for your particular card) and you can pay off the balance when the bill comes without incurring interest charges, this might be a good source of extra money.

GOVERNMENT LOANS

Like credit cards, these loans also provide money that's very costly to use. The government agency involved here is none other than the Internal Revenue Service. Surprised? Didn't know that the IRS makes loans? They don't really; these "loans" are actually the money that you should have used to pay your taxes but instead used to settle other pressing bills. So essentially, you're using the government's money.

You may be borrowing some of the most expensive money in town if you fail to pay your taxes on time. It comes with a penalty and interest at a rate that'll make you wince. The government doesn't like to be kept waiting. Once it's determined that you're delinquent in paying taxes, payment is due immediately in full, including those interest and penalty charges. However, you may be able to strike up a deal to formulate some sort of payment plan with the IRS; in fact, the way it frequently works is that you tell them what payment schedule you're capable of following, and if it's not unreasonable, they accept it.

This money gets more expensive by the minute, though, because there are added interest and penalties involved when you stretch out the payments. Plus, you must also agree, in writing, to file and pay all future taxes on time. If you fail to honor this agreement, you'll receive a letter asking for a list of your assets, along with notice of a lien being filed in your name. In the end, you *will* pay the IRS. So know that if you use their money to pay your bills, it's going to get very expensive.

DISCOUNTING

The best way to get extra funding to feed the cash flow monster is to collect your own incoming monies —your receivables—before they're actually due. How do you convince clients to pay you not just on time (which is generally net 30 days) but early? Make them an offer they can't refuse, which would be a discount for early bill payments. State or offer your discounts at the bottom of your invoices, under the word *terms.* This refers to the deadline for making payment on the invoice. All your invoices should list your terms somewhere (including when payment is due, any discounts you offer, and late payment penalties), otherwise you're offering no terms and your clients will pay you whenever they like. Some standard business terms include:

- Net 30—full payment of bill due within 30 days
- Due on receipt—full payment due on receipt of the invoice
- 2/10/N30—a discount of 2 percent on the bill, if payment is received within 10 days. It may not sound like much, but 2 percent of a large invoice can be significant.
- 5/5/N30—a discount of 5 percent of the total bill, if payment is received within 5 days. This is generally going to get more attention than a 2-percent discount.

Offering a discount is a very viable and economical way to get your money faster. It creates a win-win situation for everyone; you get paid earlier and your client saves some money on a bill that, in theory, they would have been paying soon anyway (net 30 under normal circumstances).

A successfully presented discount offer—one that yields fast payment—is one that gets a client's attention. If you're sending your work, include the invoice, and call attention to the discount in a large-type cover

letter. Or, when speaking with clients, inform them of your discount procedures. Let them know that they can attain significant savings if they turn their invoices around quickly (within the discount period). Some buyers will jump on discounts. Others are just not set up to react quickly to these offers, no matter how attractive the reductions are. (Be aware of companies that pay you late *and* take the discount; this is known in the trade as an "unearned" discount.)

The best way to find out if clients will take advantage of discounts is simply to call their accounts payable departments. Courteously track down the person who will be writing out your check. Explain that this is the first time you've worked with their firm, and that it's your company policy to inquire as to what their normal bill-paying time is and to find out if they take advantage of discount offers. The accounting person you speak with may be very interested in saving money and may help you get your invoice into their accounting system rapidly. Or, you may find that there's no way whatsoever to get paid quickly, no matter how large of a discount you offer.

Another possible response from clients might be, "I'll have to check and see how our cash flow is today and get back to you." This is good. It means that they want to take advantage of your discount offer but are waiting for money to come in. At the very least, you'll learn how they pay their bills, when they write checks, whether they need purchase order numbers on invoices, and the like.

FACTORING
Another option to consider when casting about for available dollars to improve your cash flow is factoring. It involves selling your accounts receivables on an individual invoice basis. Factoring turns assets into cash without borrowing money and can be an effective tool to keep in your cash management repertoire. You can factor all your invoices or just some of them—whenever you need to raise cash.

This is how it works: After you complete and deliver a job to a client, but before you bill them for it, you send the invoice to a factoring house, along with any expense backups (receipts for any expenses that are to be reimbursed by the client) and purchase orders. Once the factoring house has received your invoice and checked out your client's credit, the factor will officially "purchase" the invoice from you and pay you (on average) 62 percent of the total bill amount.

Then, instead of paying you, your client pays the factoring house and once this is done, the factoring house will send you the balance of the invoice amount, less a factor's fee, which typically runs from 4 to 18 percent (depending on the amount of your invoice and time your client took to pay it). Your client receives your invoice just as if you had sent it to them, only it will be stamped with "Pay to Creative Capital Corporation," or whatever the name of your factoring house is.

Factoring houses sometimes advertise in trade presses, such as *Photo District News*; I recommend Creative Capital Corporation, which I mentioned above. (See Resources for address.) In general, factors have three prerequisites for buying invoices:

- The work billed on the invoice must be completed and delivered.
- You cannot have already billed the client for the work.
- The client involved must be a reasonable credit risk.

To use a factoring house you must be signed up with one. This entails completing a Uniform Commercial Code (UCC) form, which factors supply and which legally empowers them to purchase your invoices and collect from your clients. It's basically a license to factor, but not an obligation to do so.

Some photographers let their clients know that they'll be using a factoring house. However, most clients don't know what "factoring houses" are and, frankly, are too busy to listen to your explanation. Furthermore, some clients may look at your use of factoring as an indication that your business isn't on solid ground. The fact is, though, that the more work you do, the more money you'll have outstanding, and every business has a legitimate need for cash. When I need to use a factoring house, I find that the following explanation usually allays any client doubts: "You'll receive an invoice for this work from Creative Capital Corp [or whatever your factoring house is]. They sometimes do billing for me."

CASH ADVANCES
This is not the kind of cash advance you get from using your bank card in an ATM, nor is it what you get drawing down funds from a home equity loan or line of credit. It is an up-front or advance payment from a client for, traditionally, expenses on a job that you're about to start. And, it's a great source of funds to improve cash flow.

Advance payments have become trade practice in many industries. Years ago, asking for an advance had dark overtones. In implied that you were not well capitalized, were in need of money, and, therefore, were poorly managed and perhaps not the best photographer for the job. Now, it's become standard business practice to ask for, and receive, advances; one third and 50 percent of the bill are the most common advance amounts requested.

If you're going to ask clients for an advance, inform them from the start that this is how you do business. Don't surprise your clients; they won't appreciate it. Put your advance request terms on the front of your invoice, and/or spell it out in a cover letter accompanying the invoice.

HIRING STAFF

When you first set up your business, you may be doing all the work yourself. As your business expands, however, you'll need to consider freeing yourself from the more mundane and routine tasks so that you can concentrate on the real meat and potatoes of your job—producing your best images to get the best assignments.

While many photographers choose to go it alone and function as one-person operations, others surround themselves with capable and talented people who manage the day-to-day pre-production, post-production, and marketing efforts that are all part of a successful commercial photography business. Many of the photographers profiled in this book maintain staffs that include assistants, receptionists, stylists, set builders and carpenters, electronic imaging specialists, producers, and other specialists. In this fast-paced industry, the support staffers work together very closely for the common good of their studio.

When hiring workers, keep in mind that it's simply not advisable to hire people unless the added revenue that they bring in will be significantly greater than the cost of their salaries. And, beyond the actual monetary cost involved in hiring employees, you need to factor in the supervisory or management costs involved in training and directing them. In theory, it's great to have someone to perform the routine but requisite tasks that would take you away from your photography and thereby affect the amount of billings you're able to achieve. In practice, however, it's imperative to evaluate exactly what you're getting from hiring staff. One short-term solution to the problem is to consider hiring someone on a temporary, freelance, or part-time basis.

Horror stories abound about photographers who treat their assistants and staff poorly. Nothing will strip away the loyalty, hard work, and devotion of a potentially hard worker than demeaning treatment. And, such behavior also generally doesn't sit well with clients. They don't like to be around people who treat other people with little or no respect. Some clients won't pursue professional relationships with photographers like this, no matter how good the work is. According to Al Croft of Croft and Associates, a management consulting firm in Wheaton, Illinois:

> The best thing any small business owner can do is to make sure employees understand the important part they play in the organization, and create an atmosphere that encourages them to be conscious and proud of the contributions they make to the company. Giving employees a sense of self-worth is a very important aspect of staying in business.

A good staff is one of your most valuable assets, and you should take care in its hiring. These people may well be meeting your clients, prospects, and vendors, and it's critical to protect the hard-won reputation of your studio. A good starting point for finding the right people is to first determine the tasks you want prospective employees to perform. This will be time well spent, because it will enable you to screen out applicants who aren't qualified.

After determining what the staff responsibilities will be, you should actively try to attract the right people. Don't wait for them to come to you—it could be a long and fruitless wait. Ask for referrals from friends and colleagues, as well as instructors at local colleges and universities. Try calling employment services and professional associations, such as the American Society of Media Photographers (ASMP). Also consider putting up a notice at local photo labs.

Always interview prospective employees, and there are certain critical points to cover, such as detailed information about any previous employment and job responsibilities. You should try to learn how much autonomy they had and how closely they were supervised. The interview process is also a great opportunity to gain insight into the attitude and personalities of job candidates. More than one "dud" has been hired based on a great résumé, only to be let go after the new employer discovered a previously unseen rotten attitude. Some relevant interview questions for potential new employees might include:

- Why are you interested in this job?
- Why have you decided to leave your present job?
- What would you like to be doing in two years?
- What would you like to be earning in two years?
- What have been the biggest successes and failures in your past job history?
- What risks did you take in your previous employment, and what were the results?
- If you ran into the following problem [you supply a hypothetical one] how would you handle it?
- How do you go about making important decisions?
- What do you do when you're having trouble solving a problem?
- What strengths do you think you can bring to this position?
- What are some of your hobbies and interests?

Be aware that there are a few topics you want to avoid; asking questions in these areas could run you afoul of the Equal Opportunity Employment Commission (and possibly additional state or federal laws). They are anything related to:

- Religion
- Age
- Marital or family status
- Sexual preference
- Criminal records
- Physical handicaps
- Financial affairs

It's a good idea to keep the names of a few qualified job applicants in your files even when you don't have a vacancy. When you come across someone who would fit well in your organization, tell them that you'll keep them in mind in case an opportunity arises in the near future. Then when it becomes time to fill a spot in your company, go back to these files.

Training your staff is a continual process. Don't expect too much from new hires in a short period of time. Allot sufficient time and attention to training, and allow new employees to learn by performing under actual working conditions. Follow up on training, delineating important points and keeping new staff member apprised of any new developments and procedures. Always take care of your employees; you need them to survive. Treat them with respect, and pay them in a timely fashion. Afford them dignity, no matter what job they do for you. Everyone takes pride in their work and, when properly acknowledged, will work hard.

In a commercial photography business, every staff member is a vital part of the process, but none is more important at shoot time than the photographic assistant. While some assistants can be full-time staff members, others might work part-time or as freelancers. You should be aware of any differences between state laws regarding assistants as employees and laws regarding them as independent contractors. Many states view assistants as employees, and in many cases, the IRS will agree with them. This is especially the case if you provide any direction on job performance, such as when to report to work, how and where to place equipment, and which tasks to perform.

You should also be aware of all requirements for withholding taxes so that you avoid facing penalties at a later date. Additionally, there is the issue of worker's compensation insurance, which is frequently mandated by law. Check with your accountant and attorney for accurate information on these issues.

Generally speaking, it's more important to have employees with great attitudes than with lots of experience. Experience can be acquired, but a good attitude is something that's either there or not. The best way to find and keep good workers is to make a firm commitment to their best interests—compensate them fairly, give them authority and responsibility, and recognize and reward their good work.

THE RIGHT ATTITUDE

No one really talks about it, but commercial photography is a business of emotional highs and lows. Photographers try to be aloof and above it all. They will say, "Oh, it doesn't matter that someone else got that amazing job I was after. It doesn't bother me at all," and then go home, beat the dog, yell at the kids, and be an emotional mess until the next victory comes along.

Photographers want very much to succeed and to work with great people on great projects. They put a lot of themselves into each job or potential job; they invest the very fiber of their beings. Because of this, it's important that you know just what it takes to keep yourself mentally upright. Is it a matter of work coming in? Awards on the wall? Cash in the bank? Clients telling you how terrific you are? Decide up front exactly what's significant to you, and ignore the rest.

Little things mean a lot. Try each day to find one small victory. It will give you the energy to move ahead with vigor. Your victory *du jour* might be something as small as positive client feedback or something as big as a job for which you're finally being paid what you're worth. If you seek out these daily victories, you'll feel better, longer. Of course, there will be both victories and defeats; when defeat comes your way, be resilient and hang in there for the next victory.

Consider creating a victory log in which to keep track of the good things that happen to you and your business. Ask yourself every day what you did that day to increase your bottom line. When you hit a brick wall of rejection and defeat, you'll be able to look at this record of past victories and realize that you are indeed on the road to success and that the slow periods will pass.

There are many opportunities for anguish in this industry. Many of us have sensitive egos and, in a way, are all somewhat vulnerable to the pitfalls of the business. For example, you're at a printer's office, and you see a fat brochure that they've printed for your favorite client, who you've worked for loyally for years. The book is packed with photographs, only they're not yours. Or, you're called for a great assignment by a new client to whom you've been marketing heavily. You're excited. The client's excited. You can smell, taste, and feel the work. Everything's great. Then the client calls back to say that the company president has another photographer he really wants to work with (who happens to be the CEO's nephew, fresh out of photography school).

To maintain your sanity, just try to stay above it all and do the best you can. Strive to work with people whom you admire and who treat you with dignity and respect. Seek work from calm peaceful people; it makes life much simpler.

In this business, it's best to keep a level head. No matter how much money you make or how many great jobs you produce, this industry can drive you bonkers. Take time to have fun. You can have the most billings of anyone on the block, but unless you take some time to "smell the roses," you can easily wind up in a dangerously unstable mental state.

STAYING FIT
Commercial photography can be very stressful, with deadlines, crunch projects, impossible clients, and the

other 101 forces that can drive you absolutely nuts on any given day, and stress can take it's toll on your energy, vitality, and physical health. Staying fit may be the best ammunition in your daily battles to attain your goals.

Some things you might consider for enhancing both physical and mental health include regular exercise, good vitamins, and an avoidance of drugs, tobacco, and alcohol. Go to the gym, take walks, ride your bike, practice yoga. Choose whatever works for you, but do something to de-stress. The benefits of following a consistent exercise regimen that fits your lifestyle are staggering. Jim Loehr, a sports psychologist, recommends these everyday strategies for strengthening your mind and body.

- Get physical. Expose your body to physical exertion. Any form of exercise will help. Walk up and down some stairs, ride a bike, go in-line skating.
- Sleep seriously. Sleep is the best form of recovery, so keep regular sleep habits. Try to go to bed and wake up at the same time every day, and get seven or eight hours of rest each day.
- Laugh a lot. Studies show children laugh 400 times a day on average, compared with 15 laughs for adults. Humor actually relaxes the body and relieves stress. Listen to comedians on tape or read a funny book.
- Be a performer. Even when you're down, summon positive feelings and project an outward appearance of confidence and happiness. Then, when you're off duty, take time to recover with rest, nutritious food, and a long chat with a good friend.
- Adjust your eating habits. Eat five or six small meals each day rather than three big ones. Complex carbohydrates, such as whole grains, vegetables, and fruits, can help stabilize your blood sugar levels and reduce the possibility of their adversely affecting your mood.

Nutrition is especially important. Your motivation, happiness, and overall well being are all directly affected by what kind of fuel you put into your body. It can mean the difference between feeling fatigued and downright drowsy around mid-afternoon, or feeling like you have enough energy to jog from New York to Miami throughout the day.

"You need to be personally very happy to succeed," says advertising and editorial photographer Brett Froomer. If you're not happy, you won't have that edge, that extra something that separates you from the rest of the pack. A crucial part of survival in this business is being a "whole" person, spiritually, mentally, and physically. You need to feel good and feel good about yourself, your work, and your progress toward your goals.

Don't let anyone deter you from your dreams. People who reach for the top don't dwell on their problems; they focus on their successes. We're continu-

Don't let time management matters get "in your face." Plan times for work and times for relaxation, and stick to your plan. You'll need time away from work to rest and regroup. If you control time and don't let it control you, you may avoid unnecessary business stress.

ally faced with great opportunities that are brilliantly disguised as unsolvable problems. Obstacles are what you see when you take your eyes off your goals. My personal credo is: No problems, only challenges.

Studies have shown that people are dramatically more successful if they're optimistic. In his book *Learned Optimism: The Skill to Conquer Life's Obstacles, Large and Small* (Random House, 1991), author Martin Seligman writes that optimism and pessimism come from our "little voices"—our inner selves talking to us. Those little voices speak to us all the time, broadcasting either optimism or pessimism. The pessimistic voice leads us to depressive reactions, while the optimistic voice leads to more energy and success. Although we may not be optimists naturally, we can learn to be optimistic.

When our little voices speak with pessimism, we often assume that they're right. And while our inner voices are right sometimes, at other times they're not. The pessimistic voice talks about internalization and permanence and says, Clearly it's my fault and it'll never change. The optimistic voice, on the other hand, says, It's external, temporary, and changeable. In other words, you have the power to fix things tomorrow if

Having a good mental outlook can help you turn liabilities into assets, as this medal winner shows us. You can overcome obstacles and be victorious with the right attitude.

you work on them today. If you make a conscious effort, you can choose to be optimistic.

It's easy to get very cranked up and stressed out in this business. To endure day after stress-filled day, it's critically important to have a life outside your professional photography studio that provides you with peace and satisfaction. If you have no mechanism to relax, you'll be in danger of burning out.

Whether it's personal photography projects, volunteering at a homeless shelter, raising turtle doves, or just plain walking, you'll have more energy and feel better about life, yourself, and your commercial photography business if you have some recreational outlet that charges you up.

REALITY CHECK ON COMMERCIAL PHOTOGRAPHY

"To say that the business is suffering would be an understatement," according to ASMP executive director Richard Weisgrau, in a recent annual report to society members. "Prices are down, and the volume of work has decreased." The commercial photography business of the past 30 or 40 years is gone. The good

news, however, is that there's a big, bright future ahead that's full of opportunity for those who position themselves to take advantage of the oncoming changes.

Times are tough right now for commercial photographers, especially for those just starting out. There's more competition than ever before, and the number of new photographers entering the field each year is staggering. The market for assignment photography gets steadily smaller, and the enormous global popularity of stock photography has virtually eliminated a large percent of assignment projects. Finally, and most significantly, buyers are demanding more return than ever before on smaller, tighter budgets. On the other hand, photographer representative Howard Bernstein (see industry insight on page 58) feels that the business is exploding. He says there are more print magazines than ever.

According to Craig Aurness, CEO of Westlight, a major West Coast stock house, this is a time of tremendous change in the commercial photography industry. In the stock photography arena, evolving multimedia and Internet expansion will cause an increased demand for in-depth coverage of a particular subject rather than traditional concentration on a single stock image.

It's a much rougher world out there. Work is harder to find, budgets are smaller than ever, and pay rates have absolutely not kept up with the increased costs of doing business today. In fact, many commercial photographers can no longer afford to be in business. Clients now demand a degree of accountability that would have been laughed at 20 years ago. As Brett Froomer reports, clients are now demanding receipts for a $3.50 cab ride.

Sean Callahan, founding editor of *American Photo* magazine, said recently in *Forbes* magazine that "photographers will be struggling to maintain their place in the sea of change while photography itself is reinvented." *Forbes* also predicted that as new technologies make their way into the marketplace, editorial photographers will be among the winners, with stock photographers who shoot generic images getting the short end of the stick. Commercial photography is becoming a business of technology, and in order to succeed, photographers must be open to the new technologies.

In spite of these tumultuous changes in the profession, one thing is certain: Success in commercial photography is attainable. Life is 10 percent what happens to us and 90 percent what we do with it. Prosperity is available to anyone with imagination, foresight, and good business sense. Still, one thing's for sure—you must always be committed, hardworking, focused, and do your best.

MAKING TECHNOLOGY WORK FOR YOU

If you want to avoid being swept away by technological change, you have no choice but to embrace it.

—WILLIAM F. HAMILTON, DIRECTOR OF THE WHARTON SCHOOL'S MANAGEMENT AND TECHNOLOGY PROGRAM

Presently, there's a definite shift occuring in the way people buy, sell, and use photography. Technology is driving these changes that photographers are feeling in their studios, job assignment lists, and paychecks. Both assignment photographers, who will find a severely shrinking pool of potential jobs in the marketplace, and those who now make a considerable portion of their income from the sale of stock photography and want to continue doing so in the future, will have to act now to acquire a broad understanding of the tools and techniques that advanced technology is bringing to the commercial photography business. Those who fail to keep up with these changes will find their income dwindling in the coming years.

Technology is on its way to becoming the backbone of the commercial photography industry, with business management, image-making, and distribution functions taking a backseat to the computer. Armed with a properly equipped computer that has the capability to keep track of clients and get you all the information you need to keep your photography operation on a profit track, you can have enormous firepower.

This chapter is not a technology primer; I'm not going to explain brand names or what a modem or a scanner is. What I will talk about, though, is the state of all the state-of-the-art tools. I'll cover what's out there and what's on the horizon. It's a wonderful picture. Technology is a fast-paced, rapidly changing arena. What's new and exciting today will be outdated tomorrow. For example, industry sources say that the ratio of chip performance to price continues to double about every 12 months.

New technology is being introduced at an ever-increasing rate, so it's hard to classify and define. In fact, it's all changing nearly too fast to talk about intelligently. To learn about specific technological data, you can do research by reading industry publications, talking to colleagues, and, above all, keeping an open mind.

Although some experts predict that we won't see the full benefits of the much touted Internet, linking every business, classroom, and home in the United States, until the year 2015, the technological picture looks drastically different than it did just a few short years ago. Visions of the future resemble nothing less than a brave new world in which you either reap the benefits of the changing technologies around you, or wonder what happened to your business and your checkbook.

Technology is reinventing itself every 18 months like a lobster shedding its shell and moving into a newer, better, larger, faster home. And, even that 18-month window is changing, getting continually shorter. As a business owner, you'll find yourself involved in a variety of different activities every day, enabling you to allocate relatively little time to any one particular task. Because of this, you must be able to access and process a large amount of diverse information. An understanding of the mechanics and capabilities of computers and software technology is crucial.

Before selecting a software program, you'll need to choose between two basic computer formats: PC or Mac. While Apple's venerable Mac has very strong inroads into the graphics and digital photography markets, the PC offers you more for your money. PCs offer a veritable cornucopia of software choices for accomplishing just about any task imaginable. Additionally, they are evolving at a faster rate than Apple-type computers mainly because they're more widely used and there is a greater demand for both hardware and software improvements.

When I first computerized my commercial photography operation back in the digital dark ages of the 1980s, there was so little business management software available that I hired a consultant to advise me and seriously considered having an application custom-made. However, I then discovered photographer Tim Olive's Studio Manager program, which was just the on-target office support solution I needed.

Once I was up and running, having a computerized business gave me enormous firepower; it was like having a couple of extra people working for me, but without the salaries and management challenges that come with employees. For commercial photographers who prefer to go it alone, without a sales representative or studio manager, computerization is essential. And, with today's market competition, it's possible to buy an eminently workable PC machine for under $1,000, with prices dropping regularly. The $2,500 you spent back in the '80s for the then-state-of-the-art IBM PC XT with the big 20 mg hard drive will now get you a lightning fast machine with all the trimmings. In the Mac world, Apple-approved clones are now on the market, bringing true price competition to the ongoing PC-Mac debate.

PC VS. MAC

Often, your choice of computer will influence your entire overall office setup. There's all sorts of fancy machinery out there, and if your pockets (or those of your bank) are deep enough, you can hook up with a snazzy Silicon Graphics or Dicomed workstation. In the end, however, for most of us it comes down to making a simple choice between a Macintosh or a Windows-based PC unit.

Certainly, electronic imaging (EI) and electronic graphic design both started and grew on a Mac platform. However, in spite of the fact that Mac computers dominate the graphic design field and have an extremely firm grip on the EI market, Apple Corporation just isn't doing that well stockwise compared to the worldwide entrenchment of the PC and the proliferation of Windows software now fortified with new Mac-like graphical user interface.

One alternative to choosing between a Mac and a PC is to get both platforms in one computer, such as with the Apple PowerPC. This computer's earliest Windows-running incarnations weren't worth a hill of beans, but they've come a long way and continue to improve the speed at which they'll run Windows programs. The PowerPC machine is based on a new RISC (reduced instruction set computer) processor called PowerPC 601, which was developed together by IBM, Apple, and Motorola. Until now, RISC chips were found mainly in expensive machines, but as technology advances, PCs are becoming blindingly fast and incredibly affordable. It's definitely another step for-

ward as we see the desktop PC merge with high-end workstations.

Things are changing so fast that no matter what you buy today, it will be obsolete tomorrow. There is always a better machine right around the corner. My advice is to invest your money in the best machine you can afford today, use it for a year or two, and plan on upgrading after that. The traditional mumbo jumbo of commands that used to be necessary to get a PC up and running is pretty much gone, thanks to the newest Windows operating system and the advent of "plug-and-play" systems, which virtually allow users to bring peripherals (printers, modems, etc.) home from the store, plug them in, and go.

Plug-and-play features allow for a quick system set up, and coupled with today's smarter software, it's a whole new ballgame. Kodak has figures showing that, as of now, only 40 percent of all photographers are computerized. For those few photographers who aren't, it's safe to come out of the closet now and get your machines. With today's better, faster, cheaper, easier-to-learn-and-run computers, it's a whole new world.

THE LAPTOP ALTERNATIVE

Imagine the following situation: You get a message on your voice mail from a new client who's considering you for a great job; they want to hear from you immediately with a rough price estimate and an idea of your availability. Regardless of whether or not you're far from your office or are only a one-person outfit without the assistance of a full-time studio manager and staff, you have to respond with the necessary information immediately.

If you're armed with today's laptop portability, you'll have everything you need with you wherever you go. You'll be able to go over the job specifications in your motel room on the road, noodle up an estimate proposal, and fax or e-mail it directly to your potential client. You could even make use of products such as M-message, which automatically plays back messages with simultaneous voice, graphics, and text components when recipients open their e-mail messages. Today's laptop technology can rather effectively turn a one-person operation into a lean, mean, mobile business machine.

On the portable front, the performance gap between desktops and laptops has all but closed in the past few years. High-end Powerbooks and Windows portables now sport Pentium and PowerPC processors, CD-ROMs, removable hard drives, dazzling large 12-inch (and larger) active-matrix displays (screens), and other glitzy features. The question isn't whether or not you can be mobile, but how mobile you want or need to be.

If you're a location photographer and travel a great deal, you may want to consider getting a laptop.

Admittedly, you'll lay out more for a portable than you would for a similarly featured desktop system, but the ability to work and communicate from the road is absolutely invaluable. Once you're set up to go virtual, you'll never go back. Desktops offer considerably good color monitors (in the 15- to 21-inch range), along with full-size keyboards and the ability to attach almost any peripheral accessories you might need (even the less portable ones).

Battery life has been hyper-extended, with a number of high-end machines now offering capabilities in the seven-hour (and longer) range. Dell Computer even offers greater battery power than this for some of their latest models. The original, clunky nicad camera batteries, which we all grew to hate and which were the power sources for the first "luggable" computers, are slowly being replaced by more advanced power sources. This is good news and just in time, because as portables become more feature-laden and sport stuff like monster active-matrix screens, onboard CD-ROM drives, and multi-gigabyte hard drives, they require more operating power.

Portable computers that once were quite heavy are now becoming slimmer and trimmer, often weighing as little as three pounds. Most models accomplish this low weight by eliminating an onboard floppy drive. If you decide to go portable, and opt for a machine that runs Windows programs, you'll probably find that your new machine has a PCMCIA slot, which is an opening on the side of the machine that accepts credit-card sized peripherals. (These are the same storage mediums that digital cameras use to hold images.) With PCMCIA capability, you can plug in a modem (if your machine doesn't have a built-in one) or add extra storage capability, flash memory, and other features.

PCMCIA technology is slowly making its way over to desktop computers, too, which means that you'll be able to plug a PCMCIA card in to your laptop, fill it with data, and transfer it to your regular office computer. Obviously, the latest top-of-the-line technology will cost the most, but if you wait a few months, that $6,000 laptop will be considerably cheaper; something newer and better comes on the market, on average, every six months. However, no matter what machine you prefer, don't wait forever—get the best that you can afford today and get wired now!

BUYING A LAPTOP
There's a cornucopia of laptop information appliances on the market. Luggables, the first portable computers, were quite heavy and are now obsolete. However, more streamlined laptop models are everywhere and have even become the favorite loot of robbers; thieves are stealing laptops at hotels and grabbing them off the x-ray machine belts at airports.

For help with laptop-buying decisions, pick up a copy of the latest computer buying guide. Familiarize yourself with what's out there, come up with a list of features you want, and then shop around to find the best deal on a suitable machine. Your list of parameters might include some of the following.

- Maximum weight of under six pounds
- Advanced power supply that lasts over a few hours
- Two PCMCIA slots
- Large active-matrix display
- Full-size keyboard
- Customer service or support via a toll-free phone number
- Price of less than $4,000
- CD-ROM

Whatever your needs, you should be able to find bargain machines out there. For commercial photographers on the move, nothing can take the place of the firepower of a portable computer. You can do business virtually anywhere, anytime.

ESSENTIAL SOFTWARE OPTIONS

Having a computer in your office and studio has become a requirement today. It's as basic as having a telephone or fax machine. If you aren't presently using a computer for such fundamental tasks as word processing, contact management, and making spreadsheets, you're probably still imaging on glass plates and processing film in your *dark tent*. Even if you're not taking advantage of electronic imaging and digital retouching, if you want to succeed in the commercial photography business, you must be computerized.

Computer software can be overwhelming at first, but you can start out slowly and learn more as you go along. With word processing software, for example, you don't have to understand every feature in your program; simply master the few skills that you need immediately, such as writing a letter. When you need to do something else (like check your spelling), hit one key to access the *help* feature and learn about that function. Bingo—you're computerized!

Another learning approach is to sit at your computer for a weekend and go through the onboard tutorial that comes in most software programs. Or, you could take a night or weekend computer course at your local community college. The neat thing about computers is that you can definitely walk before you run and learn at your own pace.

No matter what your orientation, computers will change your life for the better. They will expand your capability and enable you to get more done in a faster, more efficient manner, thereby freeing up more of your time. Sound good? Well, that's just the beginning. Below I'll outline some of the many things you can do with your computer to increase your effectiveness and productivity. The majority of these products or features are available for both Mac and PC formats.

WORD PROCESSING

This is the one thing that just about everyone does with their computer. The written word is the most basic form of communication, and word processing makes writing easy and elegant. Editorial, composition, and spell check are just some of the beneficial features of a word processing program.

Every time you send out job estimates for possible work, you should include a written cover letter stating who's doing what for how much, and you should always check the letter for any spelling or grammatical errors. You can use the computer for this and for reviewing all memos, notes, and contracts as well. My personal favorite is Lotus WordPro. With this program, what you see is truly what you get; it is consistently top-rated for speed and features and is available as a stand-alone product or as part of Lotus SmartSuite (a group of products that comes bundled together).

E-MAIL AND THE INTERNET

E-mail is becoming more and more essential for doing business and keeping in touch with people. Even if you're only just getting accustomed to voice mail, you need to be able to send e-mail messages to (and receive them from) your clients and prospects. Plus, a cool additional benefit of this feature is that it also enables you to stay in touch with friends and family members who have e-mail. You'll even have your very own e-mail "address," which you can select yourself; mine is <irawex@erols.com>.

E-mail is a great way to "work the crowd"—to maintain contact with potential clients and let them know about your new capabilities and projects. It's truly different than calling, writing, or faxing because it's very low-key and unintrusive; recipients can read e-mail messages at their convenience. Even if you don't yet think computers are for you, you'll love e-mail. Just to give you an idea of what you can do with the Internet, if you're headed to Butte, Montana, for a shoot, for example, you could look up the local weather there and book your airline tickets.

FAXING

With an internal fax modem (one on your computer), your faxing abilities can be staggering. With the proper circuit board inside your computer, you can send and receive faxes directly from your desk without having to spend money on a separate fax machine. And, if you have a laptop, you can fax from the road anywhere that there's a phone line. The world is your oyster. You'll need some special software for this, but your computer may come with it. I highly recommend WinFax PRO from Symantec.

SOFTWARE SUITES

These are groups of related computer programs sold as one interacting package. Suites, such as Lotus

SmartSuite, are available with bundled software products (also sold together) that are highly integrated, which means that data is easily transferred from one application to another. SmartSuite is a robust package that features award-winning products, such as the legendary Lotus 123 spreadsheet package; Lotus Freelance, a drawing and graphics package; Lotus Approach, a state-of-the-art database; Lotus WordPro, the word processing program; and Lotus Organizer, a top-rated personal information manager, which keeps track of contacts, appointments, notes, and the like.

DATABASES

Databases enable you to organize and sort any kind of alpha-numeric information, such as lists of names, equipment, or numbers, into formats that highlight the type of data you need. For example, with a database you could organize a client list by last name, first name, zip code, dollars spent, or any other parameters you can conjure up. A database can be a formal affair, such as a compendium of clients, a roster of prospects, or a schedule of upcoming assignments, or it can contain less formal information, such as a list of great shooting locations or your inventory of photography props.

Value your client list highly; it's the currency of your business and the lifeblood of your future success. Maintain it, update it, back it up (so that you don't accidentally lose it), and clean out inaccuracies regularly. If you do, you'll find that you can accomplish just about anything. Even if you're looking for help in an area in which you have no contacts, you probably know somebody who knows somebody who can get you what you need. This is where your database comes in handy. It's your personal network—your reliable source file.

Some photographers even use database software to construct custom-made invoices, setting up fields to contain relevant specific information. However, regardless of what you use it for, a database is basically a tool to help you organize and view useful packets of information.

PERSONAL INFORMATION MANAGERS

Also called PIMs, these programs are wonderful pieces of software that can make a significant difference in managing your busy life. Lotus Organizer, the software industry's leading personal information and time manager, enables you to schedule appointments, track to-do's, maintain address lists, manage contact relationships, and more. Its daybook-style user interface is familiar and appealing with a robust list of features, including auto phone dialing with contact information and it can also provide links to the Internet.

CONTACT MANAGEMENT SOFTWARE

ACT! and other contact management computer programs enable you to keep track of large numbers of

ACT! - [MKTG]

File Edit Schedule Phone Write Report Lookup View Window Help

2 of 2

Lookup:
Everyone

Group:
ALL

Total: 2

12:53PM

9/13/96

Company	HDK&A ADVERTISING WORLDWIDE	Address	60 PARK AVENUE SOUTH
Contact	JOE FRAMISH		Suite 1600-B
Phone	212-979-6234 Ext 1400		
Fax	212-979-2345 CC 1	City	NEW YORK
Title	CREATIVE DIRECTOR	State	NEW YORK
Dear	JOE	ZIP Code	10022

Call	9/22/97	9:45AM	RE	CONFIRM PRE-PRODUCTION MEETING RE IBM SHOOT
Meeting	9/22/97	2:30PM	RE	PRE-PRODUCTION MEETING - BRING SALLY/PRODUCER
To-do	9/15/97	10:00PM	RE	GET PURCHASE ORDER

Last Results	SENT PORTFOLIO TO ABBEY FIRTH - SENIOR ART BUYER 9/9/97		
ID/Status	ADVERTISING	Assistant	CHERYL
User 1	LAST JOB: DuPont Shoot/Calif.	User 4	
User 2	Cel tele: 201-882-8887	User 5	HOME TELE 201-977-6699
User 3	Fiance: 201-786-1880 (Robin)	User 6	
User 7	PREVIOUSLY AT J WALTER THOMPSON/CHICAGO		
User 8	LIKES MACANUDO CIGARS		
User 9	SINGLE DAD, DAUGHTER SANDY/AGE 24 AT UMD/STUDY'S ENGINEERING		

Start | ACT! - [MKTG] | Lotus Word Pro - [ibak] | SM - SMLOAD | 12:53 PM

ACT! software, from Symantec, is a highly rated, robust contact management program that can help you keep track of all your clients and prospects. As the screen at left shows, with it you can maintain notes on all sorts of useful customer data, such as addresses, phone numbers, upcoming appointments, number of children, and previous jobs. It's available for both Mac and PC formats.

Tom Zimberoff's PhotoByte studio management program works for both PC and Mac formats. See box on page 42 for more on PhotoByte.

clients and prospects with a depth of detail that's truly dazzling. ACT! is incredibly useful for recording names, addresses, phone numbers, and any other type of information; it allows you to keep notes from conversations and meetings and automatically creates a history of your interactions with people (clients, for example) and a log of your contact with them. You can schedule meetings and calls, keep to-do lists, and view your calendar by day, week, or month. Printouts are available in 20 formats to fit in any style daybook organizer. It also comes with a built-in word processor and report generator, and you can use it to create letters, labels, and envelopes, and send messages out via fax or e-mail.

ACT! is available for a wide array of computer formats, including PC, Mac, PowerMac, Psion (a handheld palmtop computer), Newton PDA (Personal Digital Assistant), and even Lotus Notes. For photographers on the go, ACT! Mobile Link offers the ability to access information even when you're on location. Other contact management programs include Goldmine, Sharkware, and Lotus Organizer97.

DEDICATED STUDIO MANAGEMENT SOFTWARE
Studio management programs, such as photographer Tim Olive's pioneering StudioManager application, make life much easier for commercial photographers. These single-entry systems allow you to enter client information once and then use it across an entire array of features, such as invoicing, estimating, and writing delivery memos and stock submissions. Management

software saves time and money, and increases effectiveness; it also gives lone photographers (who don't have the staff resources of larger studios) the firepower equivalent of two or three assistants.

There are a wide range of programs available for both PC and Mac platforms. PhotoByte is a good one, and there are a number of others to choose from. To find out more about them, pick up a current issue of *Photo District News* magazine and call some of the software vendors listed there. Many companies offer demos (free trial versions). You can even ask vendors for names of photographers in your area who use their product and then talk to these people to get information on how the programs are working for them.

Note that, when researching software, it's critical to learn what kind of (hopefully free and responsive) cus-

THE PHOTOBYTE EDGE

INDUSTRY INSIGHTS FROM TOM ZIMBEROFF

Tom Zimberoff heads Vertex Software, a company that produces PhotoByte studio management software. With PhotoByte, he feels he's selling a philosophy as well as a computer program. Here he explains the inspiration for his program and offers advice on pricing and on managing a commercial photography business.

PhotoByte gives you the same control over your business that you insist on in your art. You don't have to be able to balance your checkbook, but you should have a handle on the pulse of your company, especially in the areas of marketing and sales. The commercial photography industry is an ever-growing mass of data and details. PhotoByte can increase efficiency, helping you to be more productive and profitable.

I was originally inspired to create PhotoByte because I needed to organize my own commercial photography operation; I didn't like the idea of hiring somebody, but I still understood the importance of having thorough information to use in monitoring my business. After realizing that what I wanted didn't exist, I decided to design my own computer program and spent a lot of time fussing around with prototypes. Colleagues asked for copies and became *de facto* testers. Although I didn't start out intending to market software, I got raves from my "testers" and decided to market PhotoByte.

As to the state of pricing in the commercial photography market today, there's no conspiracy among clients to make photographers accept certain pay rates or practices. It's simply that photographers willingly capitulate. My philosophy is that you can't get something unless you ask for it. If photographers are afraid to ask for something, they're operating out of fear, and somebody else is going to get the job. There's no reason to be afraid; the worst that can happen is that clients will say "no." But if everybody starts to ask [for something], pretty soon it's going to be normal to get it.

Certainly, there are many more photographers than there used to be, and they're all driving down prices because they're afraid to ask for fees commensurate with the media usage that their pictures provide. As a result, they're not making any profit.

Imagine the following: Let's say a client wants to pay the cheapest possible price and says he's only got a budget of $250 for a job that traditionally brings in $500. An inexperienced photographer might say, "Gee, this client's only paying half what I was going to ask. Oh heck, I'll do it anyway."

Two important things have happened here. One, this photographer has just become a $250 photographer with this client and lost money because he's not making a profit on his time or materials with only $250. And two, now the client expects to get this kind of job for $250 instead of $500. If he can't find somebody else who'll do work for $250, he'll go back to that first photographer. He'll never pay more.

This is what drives rates down. This is where the pressure comes from—not from the clients. It's self-imposed; it's suicide. If you're operating a business, you need to determine what your profit margin is. You need to know where you are, who you are, and where you want to be. That's imperative.

It's also important to understand that there's a fundamental difference between the revenue you take in as profit (on markups) and your fees or salary. Profit comes from marking up expenses you bill to your clients, and this money is different from what you earn in fees. You should consider your fees to be your *salary,* while you should consider your markups to be your *profit,* which you use to cover general and overhead expenses like buying new lenses or taking out ads in the *Creative Black Book.* If you don't take that money out of your profit, you have to take it out of your salary, and by doing that, you lower your standard of living.

Photographers need to become better businesspeople. I speak to hundreds of photographers, and I constantly try to make this message clear: If you don't "grow" your company, it will become moribund, and somebody else will get your revenue. If you only have talent, you have no business in commercial photography.

tomer support the company provides. Will there be over-the-phone assistance when you're going absolutely crazy trying to find solutions to a problem, or will you have to send a fax and wait a day or two for a reply? Keep all this in mind.

PRESENTATION SOFTWARE
This software is a useful adjunct to basic computer programs. It enables you to produce great presentations, which you can customize for your specific needs. Some packages come with tools to automate

the production of charts, graphs, and slides. For someone who needs to generate attractive yet affordable "graphics," presentation software offers enormous in-house capability.

Microsoft PowerPoint is one of the best presentation software packages on the market. An easy-to-learn program, it lets you produce custom-made data and graphics slides using prepared templates. Output is available in multiple formats, including paper, overhead projection transparencies, and 35mm color slides. One of the best functions of the program is its ability to construct "slideshows" (series of graphic screens, displayed as "slides") that run on your laptop or on clients' computers (if they have the proper software) and use special effects such as wipes, fades, textures, and fills. You can import graphics from other sources, and PowerPoint's onboard help function makes navigating this powerful software a piece of cake.

FINANCIAL SOFTWARE

This is one area in which computers really shine. While there are some great integrated productivity packages designed specifically for commercial photographers that do just about everything except jump up and down with you when you get that big assignment, there is a trend among some software vendors to *not* include financial modules in their programs.

Quicken, from Intuit, owns the financial software market. Its easy-to-use interface presents you with what looks like a real checkbook on-screen, so it's simple to understand and run. Quicken prints actual checks, pays bills, and reconciles bank accounts in far less time than it takes to do these things manually. In addition, this relatively inexpensive product is available both for PC and Mac computers and goes a great way toward helping you organize your finances and prepare for doing your taxes. With major financial institutions rapidly expanding the availability of home banking (enabling you to access your accounts on your computer and do your banking from you home or office), Quicken is an essential addition to your hard drive.

QuickBooks, another financial computer program from Intuit, generates invoices, tracks customer payments, and provides the same bill-paying and check-writing ease that it's sister product, Quicken, does. In addition, it has some interesting and useful cash management tools.

FOTOQUOTE PRICING SOFTWARE

Photographer Vince Streano, in conjunction with Cradoc Bagshaw, has designed a fantastic software program called fotoQuote, which is an easy-to-use, utterly essential guide to stock photography pricing and related policies. No studio should be without it. It will be your life preserver in many challenging negotiation situations, and it provides you with the right answers at your fingertips.

Pricing stock can be challenging. fotoQuote software and Jim Pickerell's handbook, Negotiating Stock Photo Prices, *can help. (See Resources for more information.)*

The latest Windows version makes pricing stock photos outrageously simple. Just follow a few easy steps to indicate information on usage type, print run size, reproduction size, rights, and duration of licensing terms, and the program supplies you with an appropriate price for your work. fotoQuote also features coaching tips and other amentities. If you only have one piece of software on your computer, this should be it! (See Resources.)

UTILITIES

This is a group of programs that many people overlook, especially when they're first getting computerized. It includes anti-virus, systems protection, and data recovery programs. Sometimes your need for utility software doesn't become apparent until you have a problem; consider looking into these options *before* you run into trouble.

Norton Anti-Virus. This program provides state of the art anti-virus protection in a 32-bit environment and eliminates viruses before they become a problem. It's fast and does the job.

Norton Utilities. This is an invaluable suite of facilities that includes the most advanced, comprehensive tools available for system protection and data recovery. It became famous for its "undelete" options, which let you recover deleted files just in case you've changed your mind. In the event of a crash, it provides a "rescue disk" to get you up and running quickly, while automatically repairing damaged resources and restoring your data. It also optimizes and defragments (removes files from) your disks to improve access time and enhance the chance of full recovery in the event of a crash. Activating the Norton System Doctor sets up your system to self-tune, automatically launching the appropriate utility to correct a problem.

UnInstaller. This is a product (from MicroHelp) that helps you remove software from your computer.

Software programs have become incredibly complex; during standard installation procedures, bits and pieces of programs scatter themselves throughout your hard drive. If, for any reason, you later want to remove a program from your computer, you'll have to find all its fragments and ensure that you've wiped them out completely. It takes a bit of wizardry to yank out all the unwanted parts and assure that the remaining software in your system operates without problems. It's dangerous to just start deleting files from your hard drive; erasing the wrong files can wreak havoc on, and crash, your system. UnInstaller instantly, cleanly, and safely removes unneeded applications and all references to them. It's the safest and most thorough way to clean Windows programs. UnInstallers' Orphan Finder removes remnants of applications you've manually deleted before using UnInstaller.

THE INTERNET

When IBM acquired Lotus Development Corporation several years ago, IBM chairman Louis Gerstner, Jr., pronounced that "the era of the stand-alone personal computer is passing. People now want to use their systems to communicate and work with others." The long-awaited and much touted "electronic cottage" (where we both live and work) may finally be here, thanks to cheaper, faster computers and the vaunted Internet.

The Internet's development today has been compared to the early stages of television in the 1950s, with just a few channels and a few industry biggies (such as Lucille Ball, Ed Murrow, and Jackie Gleason) still scratching their heads wondering if the medium was viable. It's still in its infancy, and we've yet to experience even a fraction of what will eventually be possible.

Even without all the improvements that are sure to come, today's Internet enables anyone, anywhere to be connected to the entire world. It's now possible to compete in the business arena on an international scale—from your home! This is the true gift of technology. With Internet access available for a nominal monthly fee, worldwide markets are now within everyone's reach; witness, for example, the outrageous global explosion of "home pages" (both business and personal web sites) on the Internet's World Wide Web.

Not too long ago, having a web site meant spending big bucks and finding someone who knew how to program a web site in HTML (hypertext markup language) an obscure (for most of us) computer language that, among other things, can let you travel from one web site to another using hypertext links. Now, creating, designing, installing, and managing your very own site on the World Wide Web has become a total no-brainer thanks to user-friendly software like Microsoft Front Page, which enables programming without hav-

ing to work in HTML and offers "drag and drop" home page construction tools instead.

More than ever before, photographers and clients are making use of the Internet's vast possibilities as a trading post for marketing photography. While web sites may not yet be the best venues in which to promote photography, as more and more art directors, designers, and picture editors plug in, the Internet will become a much more effective photography showcase.

VIRTUAL MARKETING

Marketing has changed since the days when legendary photographer and marketer Steve Steigman (whose most famous image is a still-used Memorex ad showing a man in a chair literally being blown away by the sound coming from speakers in front of him) delivered carrier pigeons to 50 of the hottest advertising agencies in New York with instructions to "release your bird if you want to see Steve's book." Now, the world is available on your desktop via the Internet. While there is certainly some hype out there about computer abilities, the Internet has the potential to reach a global audience with your marketing message in a way that nothing has before.

With Creative SourceWeb (an Internet advertising resource for photographers and illustrators), for less than $500 a page, your book can be accessible to buyers worldwide. Of course it's not about to replace real portfolios, but it's a place to stake out territory and a means to let people know you exist. Anyone, at any time, with a modem and a browser can look at your work and call for your book.

This is true leverage, providing a potent presentation of your work 24 hours a day internationally. You don't have to make phone calls; you don't have to send out anything. You can be sleeping while someone thousands of miles away is looking at your work; they can get information about you, send you e-mail messages, contact your rep, and access any other data that you've designed into your page. You can organize your site to include different portfolios, such as one for people, one for places, and one for things, and you can include personal, as well as commercial, work.

Some photographers opt for a simple web site approach, choosing to display digital portfolios showing commercial and personal work. In this way they don't have to do any programming and it can involve fewer images. Others choose to show larger numbers of images, by putting up thumbnails (small versions) of images available for review online; users then choose what interests them and view expanded imagery. Still others have sites that are of such great magnitude they look more like magazines. Sites like these can be challenging to design and construct.

You don't have to go all out on your web site; the low-tech approach allows you to design and maintain your own site yourself and still provides buyers with

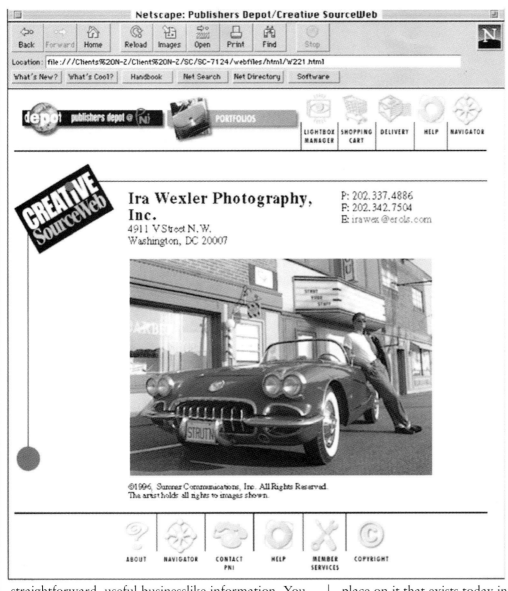

CREATIVE SourceWeb

Ira Wexler Photography, Inc.
4911 V Street N.W.
Washington, DC 20007

P: 202.337.4886
F: 202.342.7504
E: irawex@erols.com

©1996, Sumner Communications, Inc. All Rights Reserved.
The artist holds all rights to images shown.

ABOUT | NAVIGATOR | CONTACT PNI | HELP | MEMBER SERVICES | COPYRIGHT

Creative SourceWeb offers easy-to-use web advertising. Photography buyers worldwide can view your portfolio images on the Internet and then contact you to see your actual book and discuss assignments and stock projects. For photographers who haven't yet built their own web sites, this is an easy way to get exposure on the Internet. Photographers who do have web sites can consider buying display space here as an adjunct to a personalized site. Because there are many offerings for potential photography buyers, it might make sense to bring buyers to your space on the SourceWeb and then have a "hot link" to an individualized site.

straightforward, useful businesslike information. You can still include links to different portfolios, essays, client lists, stock photo libraries, access to search engines like Yahoo, and information on copyright matters. Your site can be as individual as you and your work. As the Web becomes more accepted by the industry as a significant and meaningful marketing tool, creativity in web site design and content will compete for the attentions of photography-buying Web-surfers.

Other facets of the Web include online "malls" of photographers' work (some of which include images from illustrators, graphic and industrial designers, animators, and ad shops, as well as photographers) and sites devoted to single industries (for example, fashion, with listings of photographers, makeup artists, and other related professionals). You don't have to rush out tomorrow to establish a Web presence, but you should learn about the Internet, its possibilities, and what others are doing with it. As the Internet develops, we'll eventually see the robust resource market-

place on it that exists today in print sourcebooks. The future is coming.

DOING IT DIGITAL

Just a few years ago, if you needed to digitally retouch a photograph—for example, remove a tree or enhance the color of the sky—you went to one of a small number of high-end printers who had invested millions in an incredible imaging system made by the dazzling Israeli company Scitex. You had your image "Scitexed," and you ended up with separations, not chromes. It was a pricey procedure, with costs hitting $500 and up per hour. Now, for an investment of less than the cost of a used Chevy, you can do the same retouching work on your desktop computer.

Other desktop capabilities include the ability to output high-quality digital prints and create copies of your CD-ROMs (from a master copy). Years ago, I looked into delivering a CD-ROM product to potential buyers. After discovering that the process included

mastering, paying a fortune for those copies, and other adjunct steps, I decided against it. Now, however, you can go down to your local computer superstore, buy off-the-shelf hardware and software, and produce the little disks in the privacy of your own office. Image manipulation work that you once had to send out to be done, you can now do (with the proper, affordable equipment) cost-effectively in your studio. It's getting easier and cheaper all the time.

The cool thing about technology is that things are evolving and improving all the time. Just take a look at the advertisement pages in the back of *Photo District News* magazine. You'll find camera shops that once sold only traditional tools of the trade—cameras, lenses, film, enlargers, paper—looking like electronic supermarkets. Scanners, digital backs, digital cameras, storage media are all featured in ads now. Stores still sell film and paper, but the emphasis is definitely on electronics and emerging technology.

Camera companies such as Nikon, Minolta, Fuji and Canon are now selling the digital equipment of tomorrow in addition to their traditional fare. Even Polaroid has jumped on the bandwagon with a line of high-quality scanners and printers. It is now possible to scan prints and transparencies at high resolutions, providing, as Nikon modestly states on product literature, "uniquely faithful color reproduction from both negatives and slides . . . [and] highly efficient, economical, state-of-the-art solutions."

Will we one day have to go to the Smithsonian to see a camera that uses film instead of digital storage media? Maybe. For example, look at film recorders; traditionally the pricey domain of service bureaus and film processing labs, they are becoming standard equipment for photographers doing electronic imaging.

PHOTO CD

Kodak, an admittedly late starter in the electronic advancements area, originally designed PhotoCD technology to enable consumers to display photographs on their televisions. To Kodak's delight, the idea took off with PhotoCD hitting a home run and being warmly embraced by the professional market as well. With this inexpensive technology, commercial photographers can provide digital images to their clients without having to invest in digital equipment. They can digitally archive client images. This is a great selling point in a business in which selling points are becoming more and more important. It gives market-savvy photographers another service to offer their clients to make their lives easier; now collections of photos can be stored in visual databases.

With these images stored in visual databases, the challenge becomes finding a single, needed image in the sea of stored pictures. To remedy this, databases of images, such as Adobe's Fetch, Kodak's Shoebox, and others, index and store information about the contents

of specific disks, permitting extensive keyword searches. For example, you could search using the following criteria: [Locate] Beaches horizontal color not Atlantic. The image database would find and display all images matching these criteria. The success of searches like this depends directly on the thoroughness and amount of the descriptive information put into the database about the photographs.

PhotoCD disks hold roughly 100 35mm or 25 larger-format images. The larger format mode offers considerably higher resolution—nearly four times that of the 35mm mode. The system works with virtually any film—positive, negative, black-and-white, or color—and images can be scanned in a verbatim mode, which captures the pictures exactly as they appear, or in Scene Balance Algorithm (SBA) mode, which analyzes the scene and tweaks the image to produce the best possible quality. (SBA mode is primarily for consumer-oriented, high-volume photofinishing operations.)

Kodak's PortfolioCD is a tool that can incorporate both images and sound, allowing a limited multimedia presentation. This capability permits the viewer to choose a topic to be viewed. PhotoCD television players can also be programmed to show the images in a custom order, and to rotate, resize, and flip them.

These PhotoCD technologies are popular tools, bridging and merging film and digital features in the same way that film scanners allow film-based images to be used in digital environments. Market demand for these bridge technologies will continue to inspire solutions that integrate film-based and digital formats.

SPECIAL EFFECTS AND RETOUCHING

Although many of these capabilities have been with us for years—as evidenced by the special effects imagery of innovator Pete Turner—we're now able to create special effects magic, plus perform a virtual plethora of other neat stuff, with our desktop machines and some increasingly affordable software.

Pete Turner (the acknowledged godfather of the photo special effects industry) has been creating sizzling, one-of-a-kind images for decades. His unique vision required very complex tools and procedures; for example, for a number of his commercial projects, he would use archived "elements" taken from his extensive library of images and combine them photo-mechanically in his studio, sometimes using gadgets and gizmos of his own creation to facilitate the process. Using multiple projectors firing images onto a huge screen in his studio, he'd create a meticulous collage that he then photographed and presented to clients for approval.

His clients would look at the presentation and say something like, "We like it, but can we have the mountains over there instead of here?" and he would then move the projectors and slides around, recom-

pose, reshoot, and resubmit it. He'd then manually combine images, sometimes dodging, burning, and fiddling with micro-surgical tools.

Now, thanks to Adobe Systems, you can buy the latest version of the Adobe Photoshop and perform Pete Turner's kind of magic with basic, simple computer tools. There's a somewhat steep learning curve, but there's also an increasingly broad selection of seminars and workshops that offer great training. Electronic imaging is clearly here to stay.

ADOBE PHOTOSHOP AND LIVE PICTURE

Adobe System's Photoshop program is the industry's leading photo design and production tool. As traditional photo processing incorporates more and more computer technology, Photoshop offers photographers the benefits of the darkroom with powerful image-processing and correction tools. Live Picture, a software program that's gaining in popularity, is a creativity and productivity tool that is a complement to Photoshop.

Computer-art photographer Laurence Gartel, who describes himself as an electronic photographer, not only uses Photoshop to facilitate traditional work such as his ads for Absolut Vodka, but has done what few commercial photographers have done before—designed a line of neckwear using his photographic images, which is sold at Nordstrom, Marshall Fields, and other department stores. He feels that "many photographers are wary of the digital world, but most who delve into it find that it opens countless new creative ideas and opportunities." Editorial photographer Shelly Katz says that while "digital cameras may become the photographic capture device of the '90s, Photoshop has already proven to be the photographic darkroom of today"; and acclaimed photographer Joel Meyerwitz calls the program "an exquisite tool for creating delicate balances of light and color."

Although there is other powerful and significant image processing software on the market, such as the widely accepted Live Picture (see below), Photoshop is unquestionably the standard. Adobe Systems is both innovative and acquisitive, absorbing competitor Aldus a few years ago. The company has a stated policy of encouraging third-party vendors to design plug-in add-on features for the core engine of Photoshop. They clearly want to move the program beyond just being an application into the realm of being a comprehensive operating system.

While Photoshop is still the choice of most professionals, programs like Live Picture continue to make inroads. Introduced in Paris in 1993, Live Picture was designed by Bruno Delean. "My goal was to make a product that was something like a [Quantel] Paintbox on a Mac," says the French designer and entrepreneur. Envisioning a future where desktop computers would grow more and more powerful and eventually chal-

Adobe Photoshop is the most widely used image manipulation program in the industry. It combines a full range of painting, editing, and image composition tools; sophisticated selection tools; and methods for adjusting gray levels and color in continuous-tone images. As an electronic darkroom, Photoshop lets you transform scanned photographs, slides, and original artwork in many ways, such as by cropping, rotating, and resizing an image, or by using filters that range in effect from blurriness to mosaics. As a post-production tool, Photoshop lets you edit images and produce high-quality color separations and halftones at lower costs than previously possible. Its printing options allow you to precisely adjust output to produce high-quality camera-ready artwork and film.

lenge power-laden workstations, he decided that "the only way to compete was to develop a complex technology that could give to the small computer the power of the high-end machine." He set out to invent a technology of "resolution independence," in which images could be described mathematically and manipulated with absolutely no reference to pixels.

After its debut, Live Picture caught the attention of the HSC's Kai Krause, who is perhaps best known for his highly acclaimed Photoshop plug-in Kai's Power Tools, which expands Photoshop's capabilities in an incredible way, making it easy to produce dazzling special effects.

For those with a substantial volume of work, Live Picture needs to be looked at critically; still, many of it's users feel that if you're going to be a player in the imaging marketplace, it's a necessity. One thing is certain, though: Live Picture works differently than, and is not a replacement for, Photoshop. There are many Photoshop functions that Live Picture doesn't even try to emulate. You may well want to have both platforms running, to accomplish different tasks.

DIGITAL CAMERAS

There is an ever-increasing array of great high-tech image capture devices, or digital cameras, out there—with more hitting the shelves daily. They're getting better, they're getting cheaper, and they're becoming significantly more abundant. Serendipitously, they're

also environmentally cleaner, using pixels instead of chemistry (like traditional cameras).

Survey information indicates that a relatively small percentage of photographers are working in digital formats, with everyone else shooting film and scanning. The high cost of re-equipping with digital equipment is proving to be somewhat of a barrier, but with prices coming down steadily, it's a coming wave that won't be stopped. In fact, both price and performance make up an important part of the digital photography equation. For example, yes, there is the high cost of digital equipment, but what about the environmental savings we'll amass by not using traditional chemical film materials? And, permanence is an issue in which digital imaging beats out chemistry and traditional film images, because pixels don't deteriorate over time.

Timing is also a key factor in another way, because digital cameras eliminate the need for time-consuming film processing. And, with digital file formats holding far more information than what's needed for monitor display, digital cameras will become more important as Internet use expands, because they will facilitate sending images via e-mail (since digital images are already in digital format and don't require scanning).

Even with all the digital hoopla these days, however, some photographers still feel that digital technology won't replace film. New York photographer Dan Baliotti explains:

> Digital imagery can only render a 4-1 light ration [which] does not allow the efficiency of scale to produce images of the same quality as film. The digital photographer must think and light their subject matter more like video, and use light in a flat sense, and rethink images in that context. No more film, no more chemistry, no more Polaroids, but lots and lots of bits.

Of course, there are many levels of digital cameras. While some are obviously aimed at amateurs on vacation, many systems offer very high quality results. Although digital cameras have been around for some time, only recently have they developed features, such as better resolution, that enable professionals to use them. We're seeing the emerging growth and maturing of digital capture devices both in 35mm and medium-format dedicated cameras, and in the hybrid market, with digital backs married to non-digital cameras such as Hasselblad, Mamiya RZ, and others. Some manufacturers have chosen to adapt their existing camera models to electronic imaging technologies, while others have created completely new digital cameras from the ground up.

Some digital camera terminology will sound familiar, such as *frames-per-second* and *CCD* (charge-coupled device), while some vernacular will be new to the uninitiated, such as Nikon's proprietary *reduction-optics technology,* which compresses the full 35mm lens image into the smaller 2/3" CCD format that's used digitally. Also, compatibility between different manufacturers is a basic issue. With digital cameras this can encompass existing lens systems and connectivity with Apple Powerbooks. This means, basically, that what you see through a 20mm lens on your traditional filmic Nikon will look the same as what you see through a 20mm lens on Nikon digital units.

Also part of this new lexicon that digital imaging brings to the commercial photography industry are things like pixels and interfaces. There are interesting new features, including automatic white balance (which eliminates the need for a color temperature meter) and the capability of some digital units to record the voice, allowing for spoken captions. With technology like this staring at us, we may be able to simply create images without having to consider the technical aspects of image-making. We may one day be able to forget about color balance, F-stops, and shutter speeds, and just take photographs.

As mentioned, current digital models are pricey, and with technology changing so rapidly, deciding whether to make an investment in a digital system is a difficult decision. Undoubtedly, prices will drop as more units are sold, technology will improve, and more people will be doing digital work. We may well look back at these early digital cameras as the Kodak Brownie cameras of the late-20th and early-21st centuries. Only time will tell.

COLOR BALANCE WITHOUT FILM

It's a challenge to achieve accurate color balance when you shoot digitally. In the same way that different film emulsions may display some inherent color variations, the charge-coupled devices (CCDs) that filmless cameras use can vary, colorwise, as well. CCDs aren't color neutral; each will have it's own color temperament. Although you can make corrections to color, to a certain extent, after you've made an image, with software such as Photoshop, some experts feel that unless you capture and store certain subtle colors in the actual digital file, it's difficult, if not impossible, to replicate them later on.

A recent *Photo District News* Electronic Studio evaluation led to the conclusion that color was better with daylight-balanced lighting than with tungsten lighting, but only marginally so. To achieve good color, some manufacturers produce specialized lighting systems that work well with digital cameras. Various companies use different technologies and approaches to provide ideal color balance. One such solution from Vision Industries makes use of 5000K fluorescent bulbs. Reportedly, these bulbs provide illumination that is well-diffused and evenly distributed, and unlike the household flourescents that challenge location photographers, these bulbs pulse an incredible 27,000 times per second, drawing up to 360 watts. Resulting

in even color distribution, these lamps are rated at 30,000 hours; with normal usage, you probably won't need to replace them for about 12 years.

PRINTING AS OUTPUT

Once, there were enlargers and then there were *enlargers*; now, there are printers and then there are *printers*. Printers have progressed quite a bit since Johannes Gutenberg first held printed output in his hands. The output we can now produce is phenomenal. For less than $1,000, you can generate photographic output (in various formats) with a desktop computer and printer. Of course, to produce output that you could turn in for an assignment, you'd have to spend considerably more (perhaps up to 20 times that) for a system, depending on your needs. Digitalist Gerald Bybee's images for the Profiles section of this book were output in his studio from a new Fujix printer, and the prints were unbelievably sharp and brilliant.

Desktop printers are an important factor in the digital imaging world. When computers first came into the studio, printers were clunky "dot-matrix" affairs used to print proposals, estimates, and invoices. What's available now is nothing short of amazing. You can now even design promotional pieces in-house on your computer and then output in-house to a color printer. When asked by clients for a portfolio, Gerald Bybee makes a selection of images from his computer database of work, outputs the prints, and sends them out to the client. It's instant and efficient, with everything done quickly and cost-effectively in-house.

Like the rest of technology, printers are changing for the better so rapidly that it's hard to keep track of what's out there. Still, there's a range of printer types available, and I'll cover a few of the most popular here. Whatever your needs and your budget, there's a solution for you, but you should do your homework before you invest in digital printing systems. If you have any desire to display and sell your digital printing efforts, you may want to look beyond a short-term solution that provides only throw-away proofs. And, as with all digital equipment, consider leasing it. Printer technology is changing too fast to warrant tying up all your money; if you lease, you can upgrade more easily.

THERMAL-DYE PRINTERS

These printers form color images by passing a color donor ribbon that's in contact with special paper over a high-tech thermal print head, causing image dyes to transfer from the dye ribbon to the paper. The cyan, magenta, yellow, and (in some printer models) black dyes that make up the final color image are each transferred in separate passes to the output mediums.

These prints are commonly called "dye-sublimation" (or dye-sub) units, referring to a process in which dyes in a heated donor material vaporize, or sublime, and then, after passing through a small air gap between the donor and print sheet, condense into the print image-receiving layer to form a color image.

Thermal-dye prints are not without problems, however. Poor light fading stability (poor permanence), high sensitivity to fingerprints, severe fading and image funkiness when prints come in contact with PVC plastic, and other fading or discoloration problems may occur when the image sides of prints come into contact with each other or when Post-It notes touch the image area. These prints can be useful if handled and stored properly, but when they start to fall apart, stand back and look out!

LOW-COST "RIP-LESS" THERMAL-DYE PRINTERS

A big part of the cost of most thermal-dye printers is the raster image processor (RIP) and RAM built into the unit. This cost can be eliminated by plugging in a host computer to do processing, but this yields reduced printer speed, and ties up the host computer during processing. With new high-end processors, this slowdown isn't as bad as it was, and this fact has brought a new class of low-cost RIP-less units to the market, starting at astoundingly low prices of well under $1,000.

SILVER HALIDE-BASED PRINTERS

These printers are compact units that produce high-quality continuous-tone prints using infrared laser diodes to espouse a sheet of false-sensitized silver halide donor paper. Prints are superb, especially when compared with thermal-dyes. Prints from this unit are so good that they're frequently used as final camera-ready copy for magazine ads and are increasingly scanned directly. They're very stable and appear to have excellent fading resistance.

GETTING UP TO SPEED IS EVERYTHING

Whether or not you elect to "get wired" and plunge into the wide world of digital photography with a hot, fully equipped, rammed-out computer of your own, in order to be competitive in today's challenging commercial photography market, you'll need to have knowledge of things digital. You'll need to know exactly and specifically what can be done with programs like Photoshop and Live Picture; the marketplace demands it. Buyers today have little time to deal with photographers who aren't totally familiar with all the tools of the trade. If you don't know about channels, layers, filters, and paths, you'll be watching all the other photographers get the clients and jobs that you want.

In the client world today, everything happens faster than it used to. Technology has drastically cut the

cycle time it takes for a project to go from start to finish sometimes from months to weeks. Kait Hilliard, design studio manager for Ketchum Communications in Los Angeles, says that "today's shortened deadlines are creating an environment in which there is less and less tolerance for the delays." Clients don't want to see rough tissue layouts anymore; instead they're demanding tight color comps (more finished visual proposals) much earlier in the process so that they can see what a project will look like before they invest in photography.

Art directors are making use of the technology available to them as never before. Team One, an advertising agency in Los Angeles, is using Apple's QuickTake digital cameras to shoot three-dimensional products with roughly the same lighting and angles that finished shots will have. Then, they send these digital shots to the photographer to use as reference for the actual shoot. Team One art directors bring laptops and QuickTake cameras to photo shoots, snapping the same images that the photographer is shooting and using them to design layouts, and get them approved by their clients, even before the final images arrive.

As technology changes at increasing speeds, it's imperative to change with it by getting (and staying) informed. And, along with changing technology, disciplines are also merging. In the past, photographers made photographs, designers designed, and printers printed. The lines delineating who's doing what are not so clear anymore; printers are designing, designers are printing, and photographers are trying to figure out where they fit in.

Every facet of our industry is being reinvented, not just photography itself. The landscape of this business is barely recognizable when compared to what it looked like only a few short years ago. Slide houses are becoming service bureaus, service bureaus are becoming graphic designer outfits, graphic designers are becoming multimedia producers, and multimedia producers are (on the road to) becoming rich. In the end, we may all be multimedia producers.

"It's a renaissance," reports New York photographer representative Howard Bernstein. And, anyone open to new possibilities can enjoy it. Consider the graphic designers and art directors who've leveraged themselves by learning about the new transformations occurring in their areas of the photography industry. Armed with new tools and techniques, they're now at the forefront of the technology wave, working on web design, multimedia, and other exciting projects that didn't even exist a few years ago. Witness also the photographers who've evolved along with the times; for example, world-renowned stock photo maven and authority Jim Pickerell, whose business has morphed into the production of multimedia, and Michel Tcherevkoff, who partnered with Canon to produce a best-selling CD-ROM.

Both these men were open to new technology and made use of opportunities, even if those opportunities seemed to be outside their territories. And, when you consider that media giants such as Time Warner, Disney, and the Discovery Channel are getting involved, you can begin to see the true size of the possibilities out there. It's time to expand your horizons if you want to be a player. It's time to get involved with the technologies that are irrevocably changing our business if you want to be in business five years from now.

Your best bet for staying informed is to plug into the pipeline of information that streams from the American Society of Media Photographers and from Advertising Photographers of America. Also, read every trade publication you can get your hands on, including *InformationWeek, Inter@Active Week,* and *New Media* magazines. Other strategies include taking seminars and talking to clients, printers, designers, art directors, and broadcast media professionals. It's imperative that you know what's going on in the technology area, what's coming down the pike, and how clients are making use of new technology.

Some photographers are already incorporating new technologies into their businesses in ways that they have never done before; for example, coupling digital printing with digital photography to yield filmless jobs. Interviewed in *Photo District News* magazine about a sizable catalogue project, photographer Bob Sterling said that digital photography and printing makes sense for his clients. "It will save the client a lot of money, and actually enable me to make more." This is because he doesn't have to charge the client for film, processing, or Polaroids, and by shooting digitally, saves significantly on scans and proofs. Astoundingly, that savings amounts to more than what he will charge them for photography, and this efficiency justifies his pocketing more for the shoot, which is only fair.

Digital capabilities have also spawned new business opportunities for Bruce Peterson, a Phoenix photographer who has redefined his commercial photography business to include handling graphic design work for clients. He reports that "a lot of the people we work for now depend on our ability to offer these [design] services in addition to photography."

California photographer Tom Sewall is also using technology to expand and diversify in new ways. With his partner, graphic designer Kim Pichon, he has formed NRG Studios, which services clients with smaller budgets. NRG offers a full package of high-quality photography, graphic design, prepress, and printing services at reasonable prices. After experiencing success in their start-up phase, NRG's goal is to attract bigger and better clients, including local advertising agencies, who've traditionally marketed their services directly to clients.

NRG's strategy is to sell complete design and printing packages after getting clients to sign on with the photography first. As Sewell explains:

> Smaller and medium-size businesses can't afford to go with a big advertising agency . . . but there's a definite need out there for good marketing materials, and that's the niche we're trying to fill.

Undoubtedly more serviceable niches will surface, as will commercial photographers with a clear vision of what the future holds and how they can capitalize on existing and emerging technologies to ensure their success in a rapidly changing world.

"It's a scary time for everybody," says San Francisco photographer John Lund, as quoted in a recent *Commercial Image* article. His photography studio prospered in the 1980s but hit a low spot when a major ad shop that furnished 60 percent of his income went belly up. Lund took the plunge and went digital, with a capital investment of nearly $200,000. Lund's film processing costs shrank from $2,000 to less than $50 a month, while his income soared.

Lund uses online services to deliver work. He sends clients image files via e-mail that they can review on their computers. They can make necessary changes and then e-mail the files back to him. Then, after completing those changes, Lund outputs the files on a Syquest disk and sends them to the clients for delivery via e-mail to an image setter. Lund also reports that he's adding a CD-ROM writer to his digital arsenal, which will provide an alternate delivery option. For all this technological know-how, however, Lund is not a technologist. "I sell myself as a photographer; that's important to me. Ansel Adams felt the art was in the darkroom. I have an electronic darkroom." Art director Brian Day, acknowledges Lund's metamorphosis:

> Lund used to be a good photographer in a city overrun with good photographers; then, he reinvented himself. Now he's a good photographer who's an expert at using desktop software to enhance ordinary photos and create wild photo-illustrations.

However, Lund cautions photographers that this is an area not to be taken lightly: "You cannot effectively dabble in this. It takes a tremendous amount of time to master."

Some photographers are often afraid of technology. However, many will say that you either learn about it or leave the business. Lund reports that the high costs of entering the digital domain have paid off for him, with about 80 percent of his clients coming back as repeat customers. He estimates that his total technology investment probably paid for itself within six months of becoming operational and that most of the assignments he includes in this payback wouldn't have hit his door if he didn't have digital capabilities.

New opportunities abound. Even though Photoshop has now been around for a few years, we're still just seeing the tip of the iceberg. Without question, electronic imaging capabilities are going to get faster, cheaper, and simpler to use. While there are certainly trends that will come and go, as there always have been in this business, digital technology itself is here to stay and will have a profound effect on the way we communicate and process information.

We all will have to find new and effective ways to meet competitive challenges in the age of digital communications. With all this whiz-bang stuff floating around, however, there are still a few basic requirements for success in the commercial photography business—service, integrity, and good work. The other day an art director whom I respect very much referred to a body of photography as "good old-fashioned, solid work." Whatever you wind up doing, wherever and however you wind up doing it, good, solid work is still going to be a requisite for success in this industry. And, a comprehensive understanding of new technologies and tools of the trade will enable you stay competitive and provide good, solid work for an ever-changing marketplace.

CHAPTER 4
GETTING WORK

For many are called, but few are chosen.

—MATTHEW 22:14

You've learned, you've labored, and now you've hung out your shingle and are ready for work—at last. Your path might have involved formal instruction at an institute of higher learning, or it may have been limited to on-the-job training as an assistant to an established commercial photographer. Or, perhaps you jumped ship from another profession; this business is full of recruits and converts from other lines of work. Whatever your path, you're now about to enter what famed photo-colorist Pete Turner calls "the wild world of photography" and experience the manifold joys of creating images for commerce. Here, you'll find excitement, fear, heartbreak, and, more than anything else, opportunity.

THE BASICS

If you learn the delicate art of liaising with clients and marketing your work effectively, you'll find success. The basic rule is this: To achieve massive results, you must take massive action. In today's marketplace, with more challenges than ever, only the truly serious and committed photographers win. Think of yourself as a farmer; when farmers plant seeds, they don't go to sleep expecting a harvest the next morning. It takes time, and the continued effort of watering and weeding, for the seeds to sprout roots and grow. The process of getting job assignments is no different; it takes time invested in marketing, promotion, and public relations for you to reap what you've sown. The task at hand isn't simply taking pictures; it's attracting people's interest and getting the telephone to ring. That's how it all gets started.

The success you have in getting work is directly proportional to the efforts you make in promoting yourself and letting the world know that your services are available. Your goal should be to have such an effect on clients that, after meeting you and seeing your work, they automatically think of and choose you whenever they need a photographer. Ideally, you should show clients such great photography and give them such great, hassle-free service that you "own" their business.

According to marketing executive Scott Schwerdt, "Successful people do those things that unsuccessful people don't." Keeping this in mind then, it's important to make the effort to consistently interact with clients. There is truly an abundance of opportunity out there, in spite of what you might think; what seems dismal to one photographer looks promising to another. In many cases, people who achieve huge success in this profession do so *not* because they're superhuman or because their work is totally incredible (in fact, their work may not be any better than yours), but because they use marketing consistently every day, day after day, week after week, month after month.

If your business is not meeting the goals you set for it, take a close look at your marketing tactics. If you've been around for a while, you may find that you're doing what you're doing purely by force of habit. It may be time to reevaluate your sales strategies and try something new. Remember that there will always be competition out there approaching your clients, chasing after your jobs, and earning the money that should have gone into your bank account. To survive, you must always be motivated and focused.

FINDING YOUR MARKET

Your first job as a commercial photographer is to decide exactly what kind of photographic work you want to do and who you'd like to work for. Then

you'll be able to gear your marketing and promotional efforts toward those clients. Once you determine who you're aiming at, you're on the right track. There's an entire world of photography buyers out there who, in spite of tighter budgets, are very actively contributing to a thriving marketplace and are responsible for spending millions of dollars daily to purchase photography. However, since this world of clients is so expansive, you must decide specifically with whom you'd like to collaborate.

To find your market, you'll have to do some research. This can be as simple as opening up the telephone book in your city (or the nearest large city) and calling various advertising agencies or graphic design firms to see what kind of work they do. Or, if you're interested in working for a Fortune 500 company, you could go to your local library to find the list of them in *Fortune* magazine's annual "500" issue. While you're there, ask the librarian to help you find a copy of the *Standard Directory of Advertisers*. Also known as the Red Book, it's published annually by the National Register and lists large corporations and their key employees, along with valuable information about their product lines.

Also consider subscribing to local business journals to learn more about various corporations. Or, call your local Chamber of Commerce to get a list of area businesses, and then pinpoint which of those organizations might need the kind of work you hope to do. "List houses" offer very targeted lists of specific com-

panies in specific areas—for example, industrial firms in northern Florida, southern Georgia, and eastern Alabama that do in excess of $20 million worth of business per year.

You could join your local art directors' or advertising club and other trade associations, such as the International Alliance of Business Communicators (see Resources), and get some issues of *Print: America's Graphic Design Magazine* and *Communication Arts* magazines to see which companies are winning awards and doing the kind of work you'd like to do.

If you live in or travel to a big city, keep a notepad handy. As you drive on highways, jot down the names of any large corporations whose offices you see from the road. Someone I know got a great assignment years ago by jotting down the name London Fog as he drove through downtown Baltimore. He figured that the company probably used photography and called. As luck would have it, they were in the process of dumping their old photographer, who had just made the unfortunate error of shooting white coats on a white backdrop without proper lighting. This is a perfect example of what can happen when you make the effort to position yourself in the right place at the right time.

There's no end to the creative ways in which you can find potential clients. And, your search for clients should never end. In fact, the best time to find new buyers is when you're the busiest. Unless you always have a network of clients who are considering using

BONUS OFFER

Get Your Feet Wet with Ira and Get a FREE Canon Aqua Snappy Camera!

How to Get a FREE Camera:
Just use Ira for your next assignment (minimum 1 full day) and you'll receive a free camera upon receipt of the paid invoice. Offer expires 60 days from the postmark on this mailing.

The Canon Aqua Snappy is a compact, 35mm, all-weather camera with flash, auto exposure and auto-winding that can be taken underwater, skiing and in the rain. Like the Aqua Snappy Ira has the spirit of adventure, likes harsh conditions, comes with a flash and guaranteed satisfaction! It's our way of thanking you for choosing us for your next assignment.

Why This Offer?
We want to introduce more people to Ira's superb photography!
Offer subject to withdrawal at any time. Limit one camera per customer.

Call Ira Today!
Say you want to get your feet wet!
(202) 337-4886

Rubber Duckie Not Included!

Unconventional promotional techniques, such as offering premiums to clients who hire you, can often drum up more business. In this offer, clients received a free camera.

you, you may find yourself out of work and out of money. This is not an instant business (Polaroid technology aside); it takes time for work to develop. As a rule of thumb, consider that you'll start hearing from potential clients roughly six months after they first see your work. Yes, there are exceptions, such as making an appointment to show your work at the exact moment that a company has decided to hire someone new, but you can't count on these situations to pay the rent. The hunt for work should be an ongoing process.

Once you've identified potential clients, it's essential to understand what they're looking for and to show them that you can fullfill their needs. This is what marketing is all about. According to Beverly Adler, senior art buyer at Ogilvy & Mather Direct, a well-known advertising agency in New York City, clients want photographers who have the right work *and* the right personality. "A dream photographer is somebody who, first of all, has a nice presentation but who, most importantly, is reliable and responsible once he or she gets that assignment."

In terms of your work, Adler says, "You want everything to be consistent. We'll see a great ad [in a sourcebook], call for the photographer's book, and find that the rest of the work doesn't look anything like the ad! There's this one image and everything else is totally different." (See box on page 55 for more advice from Beverly Adler.) The best way to get your foot in the door is simply to call up and make appointments. Then, when you meet with them, be sure to present information that's of value to *them*, be it a new technique or some other kind of benefit to your work. Don't just chatter endlessly and pointlessly about yourself; have respect for the client's time. Don't be afraid to ask questions, but make sure you listen to the answers. You'll learn quite a bit if you keep your ears open.

MARKETING YOURSELF TO CLIENTS

The dictionary defines *marketing* as the process of selling or buying a product or service. This involves determining prices, and planning and implementing promotional strategies. When marketing your photography, keeping consumers—buyers—in sharp focus is what it's all about. Consumer orientation is the foundation for modern marketing.

It's important to realize that you're not just selling your product here; you're also selling yourself. So, you must instill in your prospective clients a sense of confidence about your services. If you don't come across as professional, resourceful, reliable, expeditious, and pleasant to work with, you diminish your chances of landing and keeping clients, no matter what your photos look like. Clients need to feel that they can trust you with a job; if you don't perform, they will take the fall with their superiors and, if they've been around for a while, they've been burned before.

Seasoned photographer Michel Tcherevkoff has a distinct logo that he uses on all his promotional mailings and disk labels. This unique design element serves as a marketing tool that immediately identifies him to clients and also reveals something about his personal style and vision.

Selling a product is kind of like fishing; you may be absolutely 100 percent certain that there are fish in the water, you may have some bait, labor diligently, and still go home with no fish. The key is to find out exactly *which* bait attracts and catches the most fish. Photography buyers are looking for benefits; so, in a way, benefits are the "bait" that works best in this business. There may be 100 photographers after the assignment you want, but the photographer who gets the job is the one who provides the greatest number of benefits (whether actual or perceived). Keep your eyes and ears open, and learn to listen carefully; you may think you know what buyers are looking for in any given situation and be way off target.

Sometimes, the best way to determine what clients want is simply to ask them. Of course, if you're asking questions, you need to make sure they are the *right* questions. Inquire as to what the client is looking for in a photographer. You might ask, "What's most important to you in working with a photographer?" or "What have you disliked about previous photographers?" Another significant query is, "What kind of budget are you working with?" Try to find out if the client appreciates nice work *and* is aware of what it costs. If you're skillful, you can acquire a tone of relevant information just by asking.

In general, you'll find that you'll get about 80 percent of your work from 20 percent of the people to whom you market your services (it's the 80/20 rule), and you'll capture that 20 percent by working hard and being honest and fair. The classic rule in selling (and in any service business) is, of course, "The client is always right." This is important and holds even if clients state opinions or take positions that have no basis in fact. This can be quite frustrating at times, but the logic behind it is that you're in a service industry and want to grow your business by successfully working with your customers. It's often said that if you satisfy clients, you may never hear about it, but if you disappoint them and engender bad feelings, they'll go

WHAT BUYERS WANT

Photo: Katvan

INDUSTRY INSIGHTS FROM BEVERLY ADLER

Beverly Adler is a senior art buyer at Ogilvy & Mather Direct, an advertising agency in New York City. She offers a variety of guidelines and information for photographers approaching ad agencies.

It makes no difference whether I'm working with photographers or their sales representatives, as long as they're pleasant to deal with. I get tons of promotions in the mail, although not as many as I used to. Maybe fewer people are mailing or they're just directing their mailings better. I'm a big believer in mailings if they're done well and aren't too large. Ideally, they shouldn't be bigger than 8 x 10 inches. Postcards are also effective, depending on the image used and the quality of the printing. I think quarterly mailings (four times a year) work best. By mailing different things each time, you'll learn what gets the best response.

Portfolio images should be consistent in size. Never include 35mm transparencies or slides. They're too difficult to view. Ideally, have your work in either 5 x 7- or 8 x 10-inch transparency formats. The larger the better. I'd also rather see prints than tear sheets, but I prefer transparencies. If you include mediocre tear sheets because you want to show that you're published, you can seriously diminish interest in your work. Nobody really cares whether you're published. If people do, they'll ask. As far as prints versus chromes, it doesn't make a difference—as long as they're presented nicely.

Limit your book to 15 to 20 pieces. If you shoot more than one style, you can include 10 of each type, but if you have one style, keep it to 15. If you have 12 great pieces plus 3 so-so ones, just use the 12. If clients see work that is less than great, they'll think twice about hiring you. Sometimes, photographers want to show everything in one portfolio. They'll have a hodgepodge of everything they shoot because they don't want to miss out on any opportunities, but

this backfires. It just looks like they don't know what they want to do, and it isn't going to get them work. Even if all those different images are good, there has to be enough [consistency] to back it up.

I also recommend using "leave behinds" after showing your book. You can use your promo pieces for this. Don't, whatever you do, just leave a business card. No one is ever going to remember you by this. Always leave something with an image.

At this point, in my opinion, portfolios on disk or CD-ROM can't take the place of conventional books. You shouldn't leave them without an actual promo piece, too; art directors often take images with them to client meetings, and if the material is on disk, it's not as easy to view.

I get a lot of sourcebooks and keep them for our art directors to use as reference. We also look in stock photography sourcebooks. Stock has taken over much of our assignment work; if we can use it, we will because budgets are getting tighter. Obviously, we do assignment photography, but it's specified for the particular account, and it usually involves models, as well.

As far as some of the things that bother me, I hate when people call from the reception area and say, "I'm in the lobby, can you see me?" Don't call last minute and assume that I'll see you. Don't be overly pushy; it's annoying when people send me something, then call up a week later saying, "I'm so-and-so. Did you get my mailing?" I don't always remember, and if it wasn't very special, it's easy to forget. Don't put the buyer on the spot. Instead, do follow-up *mailings*. After an appointment, leave something behind; then, if you don't hear anything after a few months, do a follow-up mailing.

Also regarding follow-up, listen to the feedback you get. If somebody says, "I absolutely want you to call me—I definitely want to give you a job," you should go after this client. Use common sense. If you keep approaching people and don't get work from them, look elsewhere. Maybe give it a break for a year or two, and then go back to them. But, don't stop sending promo pieces. Just because you're not getting work, don't assume that you're *never* going to get work.

out of their way to tell others. However, if you do things right, you will prosper.

For best results, create a strategy, refine it, stick to it, and stand back. Marketing professionals speak of using a USP or *unique selling position*. This refers to

that special something that differentiates you from the rest of the market. It might be something like your style, service, enthusiasm, and so forth. It's the reason why the people who call you do call you over and over again.

You need to find your USP and build on it. For example, this might be the fact that you're the most expensive photographer in town—this might carry a certain *cachet* and work well for you. Or, you might be the only digital photographer in town. Or, you might become known for great service, great ideas, or even for arriving at assignments in a limousine. Anything that sets you apart from the competition, that makes you stand out from the crowd, will work to your advantage.

You may consider yourself to be in the business of producing images, but you're also in the business of providing a service. You must be more than just a photographer. Photography is your product, but if you want to keep working, you also need to think of yourself as a marketing organization. In this industry, you're not just "taking pictures." You're also marketing and selling a service; without marketing, you're not going to have any clients.

A GOOD REP IS HARD TO FIND

To promote your photography and drum up business, you can either market yourself or hire a commissioned sales representative (a rep), who spreads the word about you in the marketplace. Like all things in life, there are good aspects and bad aspects to working with a rep. On the good side, having a rep frees up your time, allowing you to concentrate on your work and artistry. It becomes the rep's job, then, to "bring home the bacon."

The downside of working with reps is that you'll be giving up part of your income to pay their commission, but this really is of no great consequence, because, even though you're giving up a percentage of your gross, if you have the right rep, your billings will grow steadily.

What is of great consequence, however, is that you're taking a chance in partnering with another person. You're attempting to bond successfully, and hopefully prosperously, with another human being, and this can be a difficult thing to do. The streets are littered with stories about reps who've come and gone, who didn't fit well with the talent they were attempting to represent. You'll definitely pay for good representation, and if you've found a talented representative, it'll be worth it.

Basically, going it alone vs. using a rep is like a one-man-band vs. an ensemble approach. Both can be valid. Legendary photographers have succeeded working solo and rep-less, but there are those who feel that if you want to become truly big, you need a rep. It's hard to do everything yourself and move forward. Many photographers even solicit work with different regional reps. Clients also express a range of views on the subject; some prefer to speak directly to photographers rather than communicate with the reps.

You'll have to weigh the pros and cons for yourself. Start by contacting the Society of Photographers Artists and Reps (SPAR) in New York (see Resources for address). They can answer a lot of questions and provide you with very good information.

CREATING A PORTFOLIO THAT SELLS

After you target some great art directors, designers, and clients with whom you'd really love to work and after you promote yourself tirelessly (through mailings, sourcebooks, etc.), the first question you'll (hopefully) hear is, "We'd like to see your book. Can you send it to us?" This is great; it means clients are thinking of using you.

You've caught their attention, but they'll want to see more of what you can do when they get your portfolio. Hopefully, your portfolio will reaffirm what they liked about your promotional piece; hopefully, your promotional piece wasn't your one cool image, leaving your portfolio looking like yesterday's news. Samples of your work are everything; if you don't have them, you won't get the job—no matter how good you are.

The most important selling tool in your arsenal is your portfolio. Promotion and marketing are nothing more than attention-getters. Once you capture the interest of a buyer, you have to prove yourself, and you do this with your book. What you show has a direct effect on what type of work you get. Don't expect to get portrait work if you're showing still lifes. Part of creating a successful portfolio is deciding what kind of work you want to go after.

As in life, when it comes to showing your work, first impressions are critical. According to recent studies, buyers may not remember you or your work, but they will remember the level of care taken with your presentation and packaging. *How* you present yourself can often be as important a factor as *what* you show.

Note that while buyers like to see commercial work, they also want to see some personal work to get a sense of who you are as an artist. If you don't show examples of your personal vision, buyers will assume that you have none.

In terms of formats, prints and oversized transparencies seemed to be preferred. Beverly Adler, art-buyer/guru from Ogilvy & Mather Direct, puts the kiss of death on 35mm slides. (See box on page 55). Why? Because it's hard to view them without special equipment and environments (loops, projectors, dark rooms).

This reasoning also accounts for the overwhelming "Nix!" to portfolios on disk. They're very cute but hard to put in front of clients who don't have the right computer equipment. Maybe this will change in the future as technology becomes more widespread, but for now big prints and transparencies are best.

Some people also feel it's critical to have multiple copies of your book on hand—perhaps a minimum of

10. This way, if you get multiple requests for a book simultaneously, you'll be equipped to handle them. If you only have two books you can only market to two people at a time. If you don't have enough books on hand, you will have to wait until someone returns a book. And, you may even find yourself in the position of actually bugging clients or buyers to return a book, instead of allowing them to keep the book until they're truly done viewing it.

It pays to have a file of portfolio samples that can be put together in flexible arrangements. Universal portfolio wisdom says to tailor a book to the specific needs of the buyer. You may receive requests for work

These portraits were shot on AGFA's new Scala black-and-white transparency film. Scala film could provide you with many benefits, which you can pass on to your clients and use as selling points when trying to capture their business. It yields transparencies, allowing clients to bypass both traditional contact sheets and prints. This saves your clients both time and money, and this can be a powerful marketing point, or benefit, for you to present to potential clients.

reflecting lifestyles, medicine, education, hotel work, still life, and anything else, and you should be able to address those different requests.

In general, don't let your portfolio presentation overpower your work. You're presenting the work, not the case it comes in. There are certainly a wide range of presentation styles, from laminated prints in hand-made leather boxes, to custom-made hand-bound books with wood covers and leather strap bindings.

There's no limit to what you can come up with, however, the most impressive work often comes in the simplest packages, not fancy leather binders. On the other hand, you have an opportunity here to score some points with clients and buyers by having an attractive presentation that's different from everyone else's. If everyone is using oversized binders with plastic pages, it might be time to consider doing something a bit different from the rest.

If you do show your work in a book with plastic pages, make sure you have a supply of new, unscathed pages to replace worn ones. Clients may see danger signals in a tattered presentation. They may wonder about what kind of quality and care you put into your work. Conversely, an attractive, tasteful, and different looking book will get attention and perhaps give you an edge over other portfolios.

Portfolio receipts, which can be simple forms printed with the photographer's information, are generally delivered with the portfolio, signed by the recipient when the book is delivered, and then returned to the photographer to track the entire transaction.

Regardless of your portfolio format, you should send some kind of delivery memo or tracking slip with it so that you have a record of which books are out to which buyers. When it's time to get your book back, some clients will automatically return things to you; others will require a friendly reminder. On average, clients hold a portfolio for about 3.5 days.

SENDING OUT YOUR BOOK UNSOLICITED
It's one thing to get a request for your portfolio. It's another to try to show your work, unsolicited, to buyers to let them know what your latest images look like. With tight schedules and drastically reduced staffs, it's harder than ever to see buyers and clients today, especially in larger markets such as New York, Chicago, and Los Angeles.

Many companies have a "drop off" policy, under which they'll allow you to send over a book and will look at it when they have time. Some of the busiest outfits will even say, "Send us a promotional piece in the mail, and if we like it, you can send over a book." In these cases, if you do send a book over, don't send it alone—include a *leave behind* piece that the client can keep on file.

When sending an unsolicited portfolio, be sure to include a very brief and to-the-point cover letter. State

SUCCESSFUL MARKETING APPROACHES

INDUSTRY INSIGHTS FROM HOWARD BERNSTEIN

Howard Bernstein, of New York's Bernstein & Andriulli, is one of the top reps in the business. Here, he talks about the industry and provides a few marketing suggestions.

Bernstein & Andriulli represents 10 photographers. For every hundred photographers I see, there might be one or two who I talk with further. I look for a very distinct point of view that is salable—something that's different or has a unique twist. What I look for most, though, is just terrific photography.

One way to find a rep is to speak to clients and find out who the good reps are. Another is to spend time researching. Look in sourcebooks to see who the reps are and who they're representing. Pick two or three photographers whose work you really like—whose careers have gone in the right direction—and see who represents them.

I think the business is incredible—it's just booming. Ogilvy & Mather Direct has five or six buyers who do nothing but buy art and photography all day long. Pick up magazines, and see how much actual photography is being done—it's tremendous.

Money is not the first issue in accepting assignments. The first issue is what the assignment is, plus who we're shooting with, and how it will help our book. If it's for a great designer who just doesn't have any money but has won a lot of awards, we'll jump on it. Editorial, fashion catalogues, department stores—I pursue everything. I target based on just doing good work.

In pricing, there are many different issues that come into play. It depends on who you're pricing against, how badly you want the job, how in demand you are. Many of my photographers are billing $7,500 to $10,000 a day.

When I got into the business, the food photographers made the big bucks. They got $5,000 or $6,000 per image. General Foods and other corporations have really changed this; they'll find four or five photographers who can shoot equally well and beat the price down to about $2,000. So, for a specialty, like food photography, it has gone bad, but on the other extreme, there are high fashion and portrait photographers getting upward of $25,000 a day for one image. There are probably about 25 or 30 photographers at this level.

As far as portfolios go, try to design something that's a little original and that you can change frequently, because you'll want to continually update your book. It should be neat, clean, and durable. I have everything from 8 x 10-inch chrome books to 18 x 24-inch lamination books. Most of the editorial books are tear sheet books, so they're 11 x 14 inches.

What you show depends on where you are in your career. If you've got some beautiful award-winning ads, show them. Also, I'd recommend showing personal work. And, it's not a mistake to show tear sheets. I think you probably give your clients a sense of security by showing these, but it's a mistake to *not* show personal work, too. Personal work gives people an understanding [of your vision] and a belief that you can probably do something better if given more freedom.

As far as the impact of technology, no matter how technical things get, we're always going to depend on somebody's creative "eye" and personal vision to create images. So, I don't think things are going to be any different. There's just going to be more technology. It's important to remember that art directors are wowed by images, not by technology.

A photographer can make it without a rep. There are good [independent] shooters working throughout the country, but that's not the same as taking your book to [an agent] who can really bring your work or money up a level. The best photographers in the business have always had agents. I don't see how you can shoot and represent yourself at the same time. If you really want to be creative, you need to spend your days creating. Picasso didn't spend his time worrying about galleries; he had people who did that for him. You can't do both.

I would say the biggest problem facing photographers today is competition. The competition drives prices down. When you look through the magazines and sourcebooks, you just see one great photographer after another. This makes it more difficult.

Success depends on what you want to do. There's nothing wrong with working in Cleveland; if you shot 200 days a year at $1,000 day for small clients and made $200,000 a year, I'd say that's a very handsome living if your overhead is low. Today, good work is everywhere.

Overall, it's really important to stay fresh. Continue to hone your craft; if you're not shooting for a client, you should be out there shooting for yourself. It's a matter of constantly pushing yourself and trying new things.

Al Satterwhite's portfolio receipt form lets clients know when he needs the book back and makes them aware of its value as well. It also tracks where his work is and how long it has been there.

what you've done recently, who you've worked with, what awards you've won, and even perhaps include a testimonial quote or two from a previous client. If done right, this can go a long way toward building credibility. Be sure to ask for the sale at the end of the letter; it's completely acceptable to say something like "I'm looking forward to working with you—call me!"

SELLING YOURSELF

Selling can be fun. Selling can be exhilarating. Selling can be hell. Some like to market their work. They get to meet with potential clients, talk of their glory, and stand back for praise (or sometimes, rejection). Others are not comfortable selling themselves and their work.

It's good to be in contact with prospective buyers yourself and let them meet you. You could, after all, wind up spending a lot of time working together. However, there are also a lot of good sales reps representing their photographers in a manner and with a consistency that's quite hard to achieve when you're both shooting and selling. It's difficult to be in two places at once—both behind and in front of the lens.

Reps can devote full-time energy to pursuing work, but for photographers, any time allotted to marketing is time taken away from making images. In the long run, this can prove impractical. Basically, especially in the beginning, someone needs to be out there getting your name around. If you can find the right rep, you may benefit from having someone else show your work while you concentrate on creating it.

Reps aside, it is possible to do your own selling. It takes a certain personality to enjoy both the creative and the marketing aspects of the business, and frankly, selling is not for the weak of heart. We're not all born salespeople, but we can all learn to sell effectively—especially if what we're selling is our own photography. Most people believe in their own work and ability. Selling commercial photography is simply telling present and future clients about your work. If you're doing it right—talking to the right people and showing the right stuff—your work should sell itself. In fact, on a higher level, you don't really have to *sell* the work, all you have to do is *show* the work.

There is a definite art and craft to marketing your work, and the process can be a lot of fun. Some buyers actually prefer meeting the photographer and knowing who they're dealing with, and this is especially true with corporate clients. Perhaps this is because it's critically important that buyers feel confident that the photographer can photograph the company's CEO without irritating him or her.

Sales involves catching people at the right time and having the right stuff at the right price. Getting assignments is a process, much like dating or courtship. It's all about looking good, getting the phone to ring, and then filling someone's needs. If you do this and earn a reputation as a problem solver, your phone will really start to ring.

This may come easily, or it may be challenging. However, if you persevere and are smart, clients will seek you out. You may even find that you actually enjoy the selling process. After a couple of "small victories," such as just happening to call clients when they're hiring (the legendary right place at the right time scenario), it starts becoming fun.

It isn't necessary to be a "hard-core" salesperson to be successful. All it takes is determination and a belief in what you're selling (your work). It's not about superhuman efforts, either. It's about daily, small, steady, forward motion. It's about building a pipeline of prospective clients so that eventually (in six months to a year, on average) you'll have work being produced, work about to start, work for which you're being considered, and work that your targeting (that you'd like to be a part of). Using daily marketing activities will result in the financial success you're after.

The challenges you'll face doing your own marketing include how to balance selling, shooting, and whatever else you do. It's an ongoing task. One thing is certain, though: When you're not shooting, you should be out selling if you want to keep getting work. This will set you ahead of your competition.

Marketing wisdom says that average buyers don't plunk their money down after only one or two exposures to your work. It may take up to 8 or 10 reinforcements. That's where perseverance comes in. You don't just make one call, mail one promotional piece, and get work. It's a cumulative process, and it takes time. The selling you do today will bring you work in about six months. Ultimately, consistent action brings consistent results. Try to talk to a couple of people every day for a few minutes about your work and your capabilities. Work the crowd constantly.

Of course, you have to make sure you're working the *right* crowd. Make sure you're talking to the right person—the person who makes the buying decisions. It's critical that the person you're talking to be the person with the responsibility (and authority) to hire the photographer. Otherwise, you're preaching to the choir. As long as you're investing the time and money to market, market to the right person.

WHAT HAPPENS AT THE INTERVIEW?

You've found a likely buyer. You've called and made an appointment to show your book. Perhaps you've even sent ahead some sort of mailer. Now, it's showtime. You never really know what's going to happen when you call on new prospects. You may get a totally neutral reaction, a bad reaction, or no reaction at all. By far, the best response is that they like your work very much and just happen to have a job for you.

The most likely situation is that clients will be cordial, ask questions about you, your work, and your fees, and say that they'll be calling you in the future. This isn't bad. If you keep in touch by sending new work and calling occasionally to tell them about neat jobs and new techniques, you may find yourself working with them in the future.

Sometimes, clients will sit there like dead wood and exhibit absolutely no reaction at all. However, this may not mean that they don't like your work. They may just be feeling the pressure and stress of their jobs, their personal life, or anything else. Don't take it personally.

When it comes to hawking your wares, you can only be responsible for your own actions—the calling, mailing, and following up. You can't be responsible for the results. However, you can be responsible for your reputation. To maintain a good, solid reputation, make sure that everyone thinks highly of you even if they haven't yet worked with you. Create the perception that you'd be absolutely wonderful to work with. The key to achieving this is quite basic—be nice to everyone you speak to, no matter how they treat you.

At some point, you may feel that you've called on everyone worth seeing. Comparing the number of clients to the number of photographers out there, though, it may be that you haven't called on all the right people yet. If you actively compete with 20 other photographers, and they're all still in business, you may be getting only 1/20 of the available work. The challenge is to determine who's hiring your 19 competitors. Look through design annuals, local art directors' clubs award books, *Print* magazine's "Regional Design

Annual," *Graphic Design: USA*'s award book, and other informational sources to find out who's hiring.

FOLLOWING UP

One essential component of successful marketing is follow-up. Calling and seeing people is just the first step; staying in touch with them is most important. This is the area in which most people drop the ball. Buyers usually remember the last portfolios they saw. When it comes to handing out an assignment, the last work in the door gets the prize. To overcome this, utilize consistent tracking and follow-up.

Good follow-up can singly set you apart from your competition. It can be as simple as brief phone calls to buyers (or their voice mail) to let them know that you're working on a neat project and thought of them or have a new technique to show them. Whatever information you impart, make sure it has value to them. Don't just call up and babble pointlessly. Clients don't have the time.

One key component of successful follow-up phone work (or any phone work) is showing enthusiasm. Motivation guru Anthony Robbins suggests actually smiling into the phone. Although listeners can't see you, they'll be able to hear the smile in your voice and delivery. Enthusiasm is sometimes hard to come by, as we all know. Expert callers build up a head of steam before getting on the phone; they do this by playing favorite music, listening to a motivational tape, or even just standing up and pacing around the room. All things being equal, buyers prefer working with someone who's enthusiastic over someone who's not.

Always keep track of your marketing and follow up efforts. Update your database of clients and prospects regularly and record such information as what you send them, what you say to them, what they tell you, and assorted fringe data, such as kids' and wives' names. Keeping your database accurate, current, and active is one of the most important tasks for any marketer. An effective way to do this is to use a fantastic computer program called ACT! (See page 40.) Or, you could use the old-fashioned file card box with index cards. Whatever works best for you.

USING THE RIGHT TOOLS

One of the first tools you might consider using to help track your efforts is a *daily accomplishment record*. A simple, well-kept record will enable you to look back at the past week, month, or year and see what you've accomplished and how far you've come. It is a commitment to taking consistent action on a daily basis.

In general, you shouldn't judge your marketing efforts by the results you achieve. While you are certainly responsible for focusing and putting out energy in a productive and effective manner, results aren't something for which you can be accountable. If no one needs photography this week, it isn't productive

to beat yourself up because no one called you for work. If this keeps occurring, however, then you should look at your daily accomplishment record and reassess who you've been calling, what you've been telling them, and what work you've been showing.

"SORRY, THEY NO LONGER WORK HERE"

Imagine the following: You've spent three years consistently showing someone your book, sending them samples, keeping in touch on the phone, and generally building a rapport. You've worked hard. It looks like payoff time is close by. And then, you call this contact one day only to be told, "Oh, she doesn't work here anymore."

It can be very frustrating. You make the effort and come up empty-handed. Unfortunately, this is part of the business. If you're lucky, some kind soul at that company will give you your contact's new telephone number. If not, your prospect vanishes. You can start from square one and begin marketing to your old contact's replacement, but if this new person has his or her own favorite photographers, you'll be yesterday's news.

Keep in mind, however, that no single person can make or break your business. Don't let any single person or unfortunate turn of events intimidate you or sap your enthusiasm.

REJECTION

No matter what you're selling, some people are just not going to be interested. Rejection is part of selling. In fact, it can be a positive thing; it lets you know who's not interested in your work so that you can move on to more fertile fields.

Fuller Brush Company, an old, venerable business that just about invented door-to-door selling, teaches it's sales people that "for every closed door, there's an open one." This is the correct mindset to have. You should also realize that when clients reject you for an assignment, they're not rejecting you—they're rejecting your work. It's not a personal rejection. These particular customers just can't use your photography for whatever reason.

NETWORKING

As a commercial photographer, you're dealing with a product and service that is, by and large, *not consumable*. This means that as soon as you complete an assignment, you've got to find another one to pay the next month's bills. A great way to get work is to keep in touch with others in the field, such as printers, paper suppliers, art directors, and others in the industry.

This is networking and it's one of the important tactics for getting work. By leveraging yourself via networking, you'll have others out there looking for work for you. If you benefit, they stand to benefit, too. It

makes sense; partners in serving clients and in getting work. Helping each other is what it's about.

For example, even though we're producing more and more things electronically, it's a good idea to make friends with printers. A lot of what we produce is still *printed*. Printers know exactly who the players are, and they know when the jobs come up. Make yourself valuable to them; look for opportunities to help with their promotion. This is called having a *strategic alliance* with an associate who stands to benefit from the same opportunities as you. You may discover that one of your clients needs a printer, while a printing salesperson may stumble upon a need for a photographer.

If done properly, networking can catch you some fine assignments. For this reason, it's important to get out to trade functions, such as local art director's club meetings and American Institute of Graphic Arts (AIGA) functions, and talk to people. Don't overlook social events either. Relationships that begin in an informal atmosphere can often be the most rewarding down the line.

In addition to printers, you might be able to find formal networking groups in your area. These are frequently sponsored by the Small Business Administration's Small Business Development Centers, which are set up on a regional basis. In fact, the SBA has many publications and services of considerable value to anyone in business. (See Resources for phone numbers.) Rubbing elbows with quality contacts may provide you with a good source of strategic alliances and ultimately have a positive effect on your cash flow.

BARTER WORK
Bartering is an ancient form of trade. The reason it's been around for so long is that it works. Traditionally, in a barter situation, you provide goods or services to someone in exchange for goods or services that you require from them. No money changes hands.

The classic barter situation for you as a photographer is a "trade-out" in which a designer or art director designs a promotional mailer or sourcebook ad for you, and then you compensate them in kind by offering them your photography work in trade. Printers also always seem to need promotional photographic items, while photographers can always use printing for their promotional needs. Some photographers even barter with accountants and office supply stores.

In the past few years, local, regional, and national barter networks have sprung up. These consist of "clubs" in which members receive "credits" (for services they perform) that they can then use to trade for a service they need. Look in your yellow pages under "Barter and Trade Exchanges." Note that the Internal Revenue Service considers services you acquire through bartering to be income; be sure to discuss any barter with your accountant so that you are in compliance with the IRS.

After responding to an ad in a business newspaper, I produced this image as part of a four-part YMCA pro bono campaign with TWBA Chiat/Day, a well-known West Coast ad shop. The campaign, originally produced for the Washington, D.C., market, won four Addy awards and was picked up for use in other cities.

PRO BONO WORK
Pro bono work is important for both new and established photographers. On a philosophical level, you make money in your community, and this is a way to give back to and help the community. That said, pro bono work offers you a couple of nice perks, as well.

First, you'll get the opportunity to work for people with whom you might not normally have a chance to do business. Second, the quality of the work will frequently be much higher than that of just "another job." This is because, generally speaking, in pro bono situations the photographer, designer, and other involved creative people work together to make the important decisions, thereby functioning (usually) at a much higher level.

Frequently, in pro bono arrangements, there are no clients and little interference. You won't hear typical client feedback like, "Gee, I like that, but don't you think it's a little too wacky?" Since you're doing this for free, you generally have considerably greater creative freedom. Typically, the client is much more open to pro bono creativity—after all, you're giving away your work.

A healthy way to look at pro bono work is to realize that it's advertising for you on quality projects, with quality people, and it often affords you the opportunity to produce good work that is widely distributed to a broad range of groups in your community—including prospective clients. Think of it as cheap advertising, not unpaid work. (Consult with your accountant to get the best tax advantage for any pro bono work you do.)

DEVELOPING YOUR OWN STYLE
There is a definite place for differing photographic visions or styles. The amount of success you achieve is

directly related to the strength of your style. If your work (and how you execute it) is different from what everyone else is doing, you may very well prosper. How you develop your own style is up to you.

For example, photographer David Gaz found his unique and distinctive style almost by chance. Early on in his career, he took some pictures that were slightly less wonderful than he had expected. He realized that he had to somehow come up with something strong for the assignment using those images, so he invented something new (although he won't reveal exactly what) and patented it. He not only succeeded with his client, but provided the basis for his current style.

In the search for commercial work, style is one of the key components for success. If you don't have a distinctive look, you'll be competing solely on price and convenience, along with the other hordes of people who do styleless, plain work.

Buyers have become accustomed to seeing newer and newer work that inspires ever-changing ways of doing things. As photographers learn to use today's awesome electronic tools, styles will come and go at an even faster pace. Buyers' hunger for different, attention-getting ways of communicating their commercial messages will continue to speed this evolution. No corner of the visual spectrum will be left unexplored in the search for a new vision or style. Perhaps, as photographer Hans Neleman says, "Originality is the best style."

EXPANDING YOUR MARKETING HORIZONS

One of the big questions I wanted to answer when setting out to write this book was, How do you go from being a big fish in a small pond to being a big fish in a big pond? In other words, How do you go from working locally out of your basement to being a photographer with a national presence?

One possible way is working hard to "own" your local market—using the assignment opportunities in your own backyard to build your book. To do this, work with the best local clients, do your best possible work, and get your name around. After you're getting the top local work, move on and target some of the national clients with whom you'd like to collaborate. At this point, you'll have the samples and experience to compete nationally with confidence.

Don't overlook any national clients in your own back yard; there may be national-quality shops and clients right in your local area. If you're able to start doing national work right in your own area, you're already on your way to reaching your goals.

Good research and targeted marketing will help you as you grow. Whatever your specialty—people, still life, cars, etc.—start looking for ads that catch your eye. Find out who the art directors are and how to get in touch with them by calling the clients (the companies whose products the ads promote). Or, go through awards annuals or great publications such as *Lurzers Archive*, published by American Showcase. (See Resources.)

ENSURING LONG-TERM SUCCESS

In commercial photography, you do a job, deliver it, bill it, and you're out of business—like an actor. The only security is recurring clients, and there's only a few ways to keep them coming back: good work, good service, good values, and good reliability. It's basic stuff; you take care of them, and they take care of you. (This works most of the time, however, sometimes you'll run into clients who treat you poorly.)

To have long-term sucess, do what you promise, and then exceed expectations. Deal with people honestly, and treat them with respect. Show interest in them as people, and they'll show interest in you. If you're good for your word, people will rely on you and tell their friends, which is the best promotion of all.

If you have any problems, be up front and deal with them fairly and effectively. Offer your clients intelligent solutions that fit the limitations of their budgets. Whenever you can, save your clients money—it will benefit you tenfold in the long run. Let your clients know that you care about them. And, be enthusiastic. Enthusiasm is one of the little things that can set you apart from your competition, even if others are better than you at a particular kind of work. Who would you rather work with? A dud or someone who's excited about doing the work?

If you're out of work, get to work. If you get rejected, don't take it personally—it's business. Realize that every "no" brings you a little closer to a "yes." As you roll through legions of potential clients, note the people with whom you have good chemistry. Look for someone who just loves you, loves your work, and loves to work with you.

And most importantly, make sure you're in this business because you love it; if you don't, find something that you do love. Make sure you know why you're in this business—be it for glory, money, or prestige—and make sure that a love of photography is one of your reasons, or you'll be doomed to failure. There are definitely simpler and less stressful ways to make money.

CHAPTER 5
MANAGING ASSIGNMENTS

In the middle of difficulty lies opportunity.

—ALBERT EINSTEIN

Achieving your goals requires commitment, focus, and fortitude. The road to achievement is paved with both on-ramps (opportunities) and potholes (challenges). You'll find, however, that many of the challenges you'll face are opportunities in disguise. If you're diligent and persistent, and have enough of what the marketplace wants, your phone will ring; you'll find yourself on the receiving end of a potential assignment. It's just like fishing; you'll have dangled your tempting bait out there in the clear, swift current, and then you will see the fish sniffing your lure.

Managing assignments can be challenging and rewarding. You'll discover that clients come in all shapes, sizes, and dispositions. Most are wonderful, and if you're lucky, you'll avoid the few rotten apples who give clients in general a bad name. Certainly, some jobs (like some clients) will be more difficult than others, but if you navigate well, create value for your clients, and find solutions to their problems, your commercial photography business will prosper.

GETTING THE JOB

The phone rings. It's an art director with whom you've been dying to work. You're up for a great job, and you have to send in your portfolio. This is the kind of assignment you'd kill for. This is the moment you've worked hard for. Now the real work begins: sending the right samples, presenting the right numbers, having the right chemistry, getting the job, and overcoming the challenges that lie before you.

You've got the job in sight, but you don't have it yet. It's not a done deal; you've got some challenges to overcome first. One big one is surpassing your competition. Several other photographers have likely also been called to show their work. You may be competing with colleagues from right around the corner, across the country, or even overseas.

Who gets the job depends on factors both visible and invisible. As a rule, a certain percentage of assignments for which you're called will never materialize for you. In general, you might get one assignment of every two for which you're called.

GATHERING INFORMATION FOR YOUR ESTIMATE

A critical component of getting a job is collecting solid, accurate information on which to base your pricing estimate. You can have great samples and great chemistry with potential clients, but if you base your estimate on inaccurate information, you're walking on thin ice, and the next person in line may get the job.

To get information, you have to ask good questions—the right questions. This is imperative if you're going to accurately visualize buyers' needs and visions and formulate an understanding of the function of the work for which you're being hired. Listed below is the information you'll need to be able to provide your client with an accurate estimate. This data will also enable you to create a realistic working agreement to get the job done.

- Job description—describes number and subjects of shots, and location. For example, 10 shots of models in sports apparel at Fountainbleu Hotel, Miami on 3/3/99.
- Film format—details film format, such as 35mm, medium format, 4 x 5, etc—and type.
- Location—delineates specifically where the work will be produced: in the studio or on location
- Client's information—phone, fax, address, etc.
- Media/placement—specifies in which media the work will appear
- Period of usage—specifies required period of usage time
- Size/type—spells out size of shots for final usage; also may describe final usage format (display prints, display transparencies, etc.)

Once you get all this information, you can create what I call a *job starter* to record it. Your job starter can be formal or informal, a printed form or a handwritten list, whatever works best for you. It doesn't matter what it looks like, as long as it facilitates the recording of all the information you need to create an estimate. (In this respect, it's similar to an order form.) It should allow you to break down the data and manipulate it into the bottom line figures that the client wants to see, and it will make producing an estimate much simpler.

This information in your job starter becomes the backbone, or framework, of your estimate. It includes how many shots and situations are required, what the locations are, and how much in the way of resources will be required to produce the work, along with the all-important questions of usage—in what media, over what time periods, and with what copyright licenses will this work be used?

Clients fondest wishes, of course, are to own all the rights to an image without choking on the associated costs of doing so. Some clients understand that the more usage rights you buy, the more you pay, but you'll find a lot of inexperienced buyers who don't understand this principle. You'll need to gently but firmly educate those clients. There are a number of good books and references that will help you with pricing your photography; see the Resources section for a listing.

After you've gathered the available hard data on the job, take a closer, more intuitive look at the assignment. It's of fundamental importance to gain an understanding of a job's parameters, but when figur-

Straight Shooter Studio, Inc.
123 Anystreet, Hometown, ZX 12345 • Telephone: 123-555-1212 • Fax: 123-555-2121

ESTIMATE

THIS ESTIMATE IS VALID FOR NINETY DAYS FROM THIS DATE OF ISSUE:_____ REFERENCE # _____

Client:

Assignment Description:

Usage Specifications:

Estimated Price:
 FEES_____ EXPENSES_____ TOTAL_____
 Note: For details of fee structure and expenses refer to attached schedule

Advance Payments:
 FEES_____ EXPENSES_____ TOTAL_____

Conditions of Transaction:
1. The copyright to all images created or supplied pursuant to this agreement remain the sole and exclusive property of the photographer. There is no assignment of copyright, agreement to do work for hire, or intention of joint copyright expressed or implied hereunder. The client is licensed the above usage specifications in accord with the conditions stated herein. **Proper copyright notice**, which reads: © 19__ Straight Shooter, must be displayed with the following placement:_____ . Notice is not required if placement is not specified. Omission of required notice results in loss to the licensor and will be billed at triple the invoiced fee.
2. All expense estimates are subject to normal trade variance of 10 percent.
3. Usage specifications above convert to copyright license only upon receipt of full payment
4. Usage beyond that defined above requires additional written license from the licensor.
5. Invoices are payable on receipt. Unpaid invoices are subject to a re-billing fee of _____.
6. Advance payments must be received at least 24 hrs. prior to assignment commencement.
7. The sale is subject to all terms and conditions on the reverse side hereof.
8. If client orders the performance of any services required to complete the above described assignment it constitutes an acceptance by conduct of this estimate in its entirety, whether signed by you or not.

_____ _____
SUBMITTED BY DATE

_____ _____
ACCEPTED BY DATE

This is a sample standard estimate form from the American Society of Media Photographers (ASMP). It provides space for the client's name, the job description, usage specifications, prices estimates, and advance payments, and also includes a list of standard transaction conditions, such as copyright issues and payment terms.

TERMS AND CONDITIONS FOR REVERSE SIDE OF
ASSIGNMENT ESTIMATE, CONFIRMATION, INVOICE.

[1] "Image(s)" means all viewable renditions furnished by Photographer hereunder, whether captured or stored in photographic, magnetic, optical or any other medium whatsoever.

[2] All Images and rights therein, including copyright, remain the sole and exclusive property of Photographer. Unless otherwise provided herein, any grant of rights is limited to one (1) year from the date hereof and to the territory of the United States.

[3] Client assumes insurer's liability (a) to indemnify Photographer for loss, damage, or misuse of any Images, and (b) to return all Images prepaid and fully insured, safe and undamaged, by bonded messenger, air freight, or registered mail, within thirty (30) days after the first use thereof as provided herein, but in all events (whether published or unpublished) within thirty (30) days after the date of final licensed use. Client assumes full liability for its principals, employees, agents, affiliates, successors and assigns (including without limitation independent contractors, messengers and freelance researchers) for any loss, damage, delay in returning, or misuse of the Images.

[4] Reimbursement by Client for loss or damage of each original photographic transparency or film negative shall be in the amount of One Thousand Five Hundred Dollars ($1,500), or such other amount set forth next to said item on the attached schedule. Reimbursement by Client for loss or damage of each other item shall be in the amount set forth next to said item on the attached schedule. Photographer and Client agree that said amount represents the fair and reasonable value of each item, and that Photographer would not sell all rights to such item for less than said amount. Client understands that each original photographic transparency and film negative is unique and does not have an exact duplicate, and may be impossible to replace or re-create.

[5] Photographer shall receive credit for Images as specified on the face hereof unless no placement is specified.

OPTION: [6A] Client will not make or permit any alterations, including but not limited to additions, or subtractions or adaptations in respect of the Images, alone or with any other material. **OR**

[6B] Client may not make or permit any alterations, including but not limited to additions, subtractions or adaptations in respect of the Images, alone or with any other material, except that cropping, and alterations of contrast, brightness and color balance, consistent with reproduction needs may be made. **OR**

[6C] Client may make or permit any alterations, including but not limited to additions, subtractions or adaptations in respect of the Images alone or with any other material, subject to the provisions as stated in [7] below.

[7] Client will indemnify and defend Photographer against all claims, liability, damages, costs, and expenses, including reasonable legal fees and expenses, arising out of any use of any Images for which no release was furnished by Photographer, or any Images which are altered by Client. Unless furnished, no release exists. Photographer's liability for all claims shall not exceed in any event the total amount paid under this invoice.

[8] Client assumes full risk of loss or damage to or arising from materials furnished by client hereunder and warrants that said materials are adequately insured against such loss, damage, or liability. Client shall indemnify Photographer against all claims, liability, damages and expenses incurred by Photographer in connection with any claim arising out of use of said material hereunder.

[9] Client may not assign or transfer this agreement or any rights granted hereunder. This agreement binds and inures to the benefit of Photographer, Client, Client's principals, employees, agents and affiliates, and their respective heirs, legal representatives, successors and assigns. Client and its principals, employees, agents and affiliates are jointly and severally liable for the performance of all payments and other obligations hereunder. No amendment or waiver of any terms is binding unless set forth in writing and signed by the parties. However, the invoice may reflect, and Client is bound by, oral authorizations for fees or expenses which could not be confirmed in writing because of insufficient time. This agreement incorporates by reference Article 2 of the Uniform Commercial Code, and the Copyright Act of 1976, as amended.

OPTION: [10A] Except as provided in (11) below any dispute regarding this agreement shall be arbitrated in [PHOTOGRAPHER'S CITY AND STATE] under rules of the American Arbitration Association and the laws of [STATE OF ARBITRATION]. Judgment on the arbitration award may be entered in any court having jurisdiction. Any dispute involving $____[LIMIT OF LOCAL SMALL CLAIMS COURT] or less may be submitted without arbitration to any court having jurisdiction thereof. Client shall pay all arbitration and court costs, Photographer's reasonable legal fees, and expenses, and legal interest on any award or judgment in the event of any award or judgment in favor of Photographer. **OR**

[10B] Except as provided in [11] below, any dispute regarding this agreement shall be adjudicated in [PHOTOGRAPHER'S CITY AND STATE] under the laws of [STATE]. Client shall pay all court costs, Photographer's reasonable legal fees, and expenses, and legal interest on any award or judgement, in the event of any award or judgment in favor of Photographer. **OR**

[10C] Except as provided in (11) below any dispute regarding this agreement shall be, at Photographer's sole discretion, either (1) arbitrated in (USE 10A LANGUAGE), or (2) adjudicated in (USE 10B LANGUAGE).

[11] Client hereby expressly consents to the jurisdiction of the Federal courts with respect to claims by Photographer under the Copyright Act of 1976, as amended.

[12] In the event a shoot extends beyond eight (8) consecutive hours, Photographer may charge for such excess time of assistants and freelance staff at the rate of one-and-one half their hourly rates.

[13] Reshoots: Client will be charged 100 percent fee and expenses for any reshoot required by Client. For any reshoot required because of an act of God or the fault of a third party, Photographer will charge no additional fee, and Client will pay all expenses. If Photographer charges for special contingency insurance and is paid in full for the shoot, Client will not be charged for any expenses covered by insurance. A list of exclusions from such insurance will be provided on request.

[14] Cancellations and postponements: Client is responsible for payment of all expenses incurred up to the time of cancellation, plus 50 percent of Photographer's fee. If notice of cancellation is given less than two (2) business days before the shoot date, Client will be charged 100 percent fee. Weather postponements: Unless otherwise agreed, Client will be charged 100 percent fee if postponement is due to weather conditions on location and 50 percent fee if postponement occurs before departure to location.

This sample form, also from the ASMP, shows the job terms and conditions that should appear on the reverse side of estimate, confirmation, and invoice forms.

ing prices it's also critical to look beneath the surface to understand all the forces—both obvious and hidden—at work.

Sometimes it's impossible to know everything about a project. Unless you have an opportunity to speak directly with the top person who's commissioning the work (the CEO or vice president of marketing, for example), you're going to be "flying blind" to a certain extent. You can only base your estimate on what you know, but it's the information you don't know that can really knock you off your post.

A hidden agenda can exert enormous force on any decision-making processes, both before and after you get a job. For example, this could be a reason you don't get an assignment after all the signs pointed to your being hired. Who knows what clients' real agendas are? It could be that they really wanted to use another photographer and called you in to provide an estimate just for appearances' sake. Maybe they needed to get three bids. Maybe they're using you as the "high-priced" photograher to make the bid from their preferred photographer look like a bargain. Unless you have that crystal ball, it's difficult to say.

Some photographers choose not to take part in the "ceremonial dance" of the estimating process. They feel, If you want me to do the work, let's sit down and work it out. They refuse to provide estimates until they know they're hired. They feel that if clients want to use them, they should just call and get their prices. In their opinion, these photographers are refusing to be used as part of clients' pricing exercises.

In the end, the choice is yours. If it's a project and client that interest you, go for it. Do everything you can to get the job. If you feel that the client is being less than honest with you, you'll have to make decisions based on your own, individual needs. For example, Will this job help you pay your rent this month? Will it build your portfolio? Is this an art director or client with whom you've been dying to work? Will the job bring in future work and money, providing a basic cash flow that allows you to go after the jobs you really want?

The best approach for getting more job information is to ask a lot of questions. For example, Are they getting prices from other photographers? Ask who those photographers are. You need to know if you're up against seasoned pros with high rates or new, inexperienced photographers charging considerably less for the same work. (You might decide, on hearing that the client's photography student cousin is in the running, that the client doesn't know *f*-stops from bus stops and opt to pass on the job.)

You might also ask, Is there a budget set up? What's the price range for the cost of the project? Is the job being awarded solely on the basis of price? If the client is uncertain about the full extent of the job, will there be an opportunity to re-estimate when more

is known about the shoot? All this information on job specs and competition is essential both for structuring your pricing and for putting together a winning portfolio that will stand out from the competition and land you the job.

SHOWING YOUR STUFF

Presentation is everything when it comes to getting the job, from the look of your mailing label right down to the look of your book. When it comes to portfolios, unless you're related to the art director, the first challenge is having the right pieces in your book. The second challenge is to raise the "comfort level" of potential clients so that they feel confident that you're enormously qualified for the job. There's a lot riding on the successful completion of a project—clients, ad agencies, and art directors all have reputations that could be made or lost on your performance.

With portfolios, it comes down to more than just having the right subject matter. To get the job, you have to meet and exceed client expectations to a greater extent than your competition. You may get lucky, and just happen to have the types of shots the buyer wants. Luck aside, however, your book has to stand on it's own merits; it must match the needs of the job and show vision and style. A portfolio is actually about two things: the work and the presentation. Both are key. One without the other might get you some attention, but together they can add up to the kind of results you want.

There is a wide range of portfolio presentation options available, both traditional and nontraditional. Electronic presentations on floppy disks, CD-ROMs, web sites, and even delivery via the Internet have all become both accessible and trendy. When it comes to effective portfolios, however, it's important to consider the needs of the client. Although electronic presentations are nifty and attention-getting, and should certainly be considered for promotions, when it comes to on-target presentations, most art directors and designers state one overriding need: the ability to have something in a tangible form that they can show to the client.

A significant number of clients, art directors, and designers are still without CD-ROM capability. Until this changes, print portfolios will be favored for one simple reason—ad agency designers and art directors need to be able to easily put something into the hands of their clients and buyers to review. This means either large transparencies (4 x 5 or, preferably, 8 x 10 inches) or print books. Many agencies won't even accept tiny 35mm slides; they're just too small.

Print books, or books of prints and tear sheets, provide something tangible to put into client hands. Print books come in many sizes, shapes, and varieties, but, generally speaking, the simpler the better. To an art

director, nothing is more impressive than a uncomplicated, gorgeous 16 x 20- or 20 x 24-inch print.

No matter what portfolio format you choose, when you send your book out to clients always make sure it's accompanied by a portfolio delivery form. This will enable you to prove that it was received and to track it down if anything goes awry. (See page 59 for a sample portfolio form.)

PACKAGING
Your presentation should be elegant, quiet, and understated and shouldn't fight for attention with your

SUCCESSFUL PORTFOLIOS AND MARKETING

INDUSTRY INSIGHTS FROM IAN SUMMERS

Ian Summers is an industry consultant who really knows the business, having worked as an art director and creative director at many ad agencies, Random House Publishers, and The Black Book. Here, he speaks about portfolios, the industry, and marketing.

A portfolio should show where you're going, not where you've been. You should represent your future. If your portfolio represents your future, then it is filled with personal work. As you get higher up the scale of innovation it's less important, and less expected of you, to have a portfolio filled with tear sheets. When I saw portfolios filled with tear sheets, I'd start looking at the concept, the type, and everything else, rather than the photography; I'd remember the ad and not necessarily the picture. If you must show ads, show them in a way that supports the photography, rather than having the ad intact and in a large format.

Be creative with your portfolio. Imagine this: You're an art director working on a children's fashion account. You're viewing portfolios. They're all very professional, but one really stands out. It's made out of Legos. You know right away that it's about children and that this photographer took the time to create something that reflected her work. If the images inside are of the same quality, then it's going to get you excited.

It's harder and harder for people to make a living. Stock photography has replaced assignment photography for many people. As a creative director, I would sell my client on the differences between assignment and stock. It's such a miniscule part of anyone's budget, and cutting budgets on images that are supposed to buy people's attention in a world of visual chaos is absurd. If your client's ad is based on stock, isn't specific, and is filled with compromises, people won't even notice it.

In general, photographers can make it without reps if they have sales energy and skills. A lot of people waste a tremendous amount of time. It's a matter of prioritizing, realizing which goals are never going to be accomplished, and being willing to give them up and set new goals. Photographers who are going to represent themselves should get sales training.

Directories, such as *The Black Book,* are passive mediums. They reach everybody once in a while—you just don't know who and when. You may get some calls, but if you rely only on a national or regional directory and then sit and wait for the phone to ring, you're not taking care of business.

Proactive marketing involves identifying the people who can give you what you want and getting their attention. You develop a relationship and build trust. I'm not going to hand over a $15,000 assignment to somebody I don't know. Even if you're in different cities or regions of the country, there's an opportunity to build a relationship on the telephone. That's proactive.

In my opinion, as a form of promotion, most direct mail is indirect mail. People say that you'll get a three-percent response to your mailing. They're not talking about jobs. They mean that if you happen to include a reply card, you'll get three percent of them back. The best you can hope for is that the recipients of your direct mail remember who you are when you call.

What if you targeted in a different way? What if you identified the 250 art directors who are right for you? What if, instead of spending $5.00 per mailing to reach 3,000 random people, you spent your $15,000 budget on reaching the 250 people who you know something about?

Art directors get 15 to 20 pieces of mail a day. With 250 working days a year, that yields 5,000 pieces of mail a year. Try to stand out in that and be remembered! It's hard. If you figure that there are 10,000 photographers doing this, you're talking about a big industry, and most of it is totally ineffective.

Overall, never compare yourself to the other photographers around you. Be who you are. That's the advice I'd give photographers.

images. Your work, not the package it comes in, should be the focus of attention. Great packaging is a bit hard to come by, but there are a number of good sources for custom-made and off-the-rack books and boxes, such as the superb presentation pieces available from Brewer-Cantelmo in New York (see Resources). Keep in mind that when you send over your book, you're presenting images, and you're also offering buyers a glimpse of how you'll handle their project.

Ultimately, custom-made boxes and binders with your name stamped in gold foil are a lot less meaningful than great images. Make sure that your book is professional-looking *and* your shots are terrific. Of course, nothing sends the message that you place low value on your work more than a trashy-looking portfolio. Invest in a good-looking presentation package. It's as important as having the right cameras, lenses, and film.

Some photographers are beginning to use customized portfolio packages, which can call special attention to their work. Some are inventing unconventional solutions to convey their unique visions to buyers, including metal boxes with windows that are artful in and of themselves. As with all things in life, you need to strike a balance here. You're selling yourself and your images, not boxes or books.

WORKING WITH CLIENTS

The truth is that clients need us for a set time, but as soon as the job is over, photographers are history. The trick is to work successfully with clients in productive collaboration, helping them fulfill their needs while at the same time looking out for yours.

There are some great clients out there who are wonderful to work with and who create nurturing environments in which it's easy to produce great work. These are the partners we all seek; they cultivate creativity through their support, understanding, and appreciation of your artistic contributions. However, there are also some less-than-wonderful clients around. You can certainly pay the rent working for these people, but it won't be as fulfilling as working with supportive clients. If you achieve a significant level of success, you'll have the option of not working for clients who don't appreciate your creative contributions.

DOING YOUR JOB

Your job, as a commercial photographer, is to deliver the goods. Period. Yes, sometimes your work is artful, but to clients you're ultimately a vendor providing a service. Successfully working with clients boils down to one thing: taking care of business. Always deliver what you promised on time, on target, and within budget. Fulfill your end of the deal. If you attend to all these details, you may develop repeat clients.

Loyalty in this business is an elusive matter. You can perform grandly on the job, provide the services clients only dream about, win awards, thrill the CEO, and still not get called back for future assignment consideration. Still, you will find some great clients who'll become lifelong friends and will call you for work year after year.

During the course of your career, you'll invariably run into challenges; you'll be faced with problems, obstacles, and stumbling blocks. Your goal is to smooth out the bumps. When problems come up during an assignment, don't get angry—get productive. Become a solution finder.

As part of the solution, you'll find yourself sought after and in demand. If you fail to resolve problems and only react in a hotheaded manner, you'll become *persona non grata*. This is a reputation you can't afford. News travels fast in this industry; the commercial photography community, though geographically diverse, is rather small. One bad impression can damage your reputation. It's just not worth it.

Problem-solving is a big part of your job. There'll be times when you'll hold one opinion and your clients will hold another. To handle situations like this, present your opinions and how you've arrived at them. If your clients are open-minded and genuinely interested in attaining the best results, they may change their minds. If they don't, at least you'll have professionally fulfilled your obligations by presenting all the options to your clients. This is truly the essence of what commercial photographers do; they provide experience, information, inspiration, and vision.

It's your job, of course, to put information in front of your clients at a shoot. However, you should always bear in mind the timeless dictum, *The client is always right*. Clients may be totally wrong. This can be frustrating in disputes over job specifications and changes. The best course of action is to plan for contingencies and anticipate problems. Thorough cover letters and change-order documents (which document changes to job specs and are signed by the client) will protect your interests when your understanding differs from that of your clients.

Generally speaking, when differences of opinion arise, your clients' interpretations of terms, conditions, and agreements will prevail unless you have documentation in writing to prove your position. Certainly, you can choose to be demanding, but in doing so, you risk alienating them. Most likely, they will never hire you again.

During your career, you'll find yourself in situations in which you accept an assignment, agree on specifications and prices, and then discover some part of the deal that you neglected to anticipate. Now you're locked into the contract, and you're not totally happy. The best thing you can do in a situation like this is bite the bullet. Smile, do a fantastic job, and remem-

ber what you've learned. This kind of education can be expensive and harrowing, but it's how we all learn.

For those especially big obstacles, calm down, wait a day, get a reality check from a colleague, and try to imagine yourself in your client's shoes. Try to understand what forces are bearing down on him or her and influencing the situation. Your client may be in a jam; and while, on the one hand, this isn't your problem, on the other, it can potentially be an opportunity for you to be the "white knight," saving the day by solving all problems. Look at problems as service opportunities. If you can come up with answers, you'll be exercising a creativity away from the camera that can only enhance your reputation.

With most clients, you'll have just one shot at success. A minor error in judgment can be disastrous. After all, what clients will take a chance on you—and take a chance with their reputations—knowing that you've goofed in the past? You've got to have a perfect reputation to stay in the race.

CUSTOMER SERVICE

Customer service refers to the level of care, consideration, and value you focus on each and every client. When you take care of your customers on a consistent basis, they become repeat customers because they trust you. Build this ethic into your commercial photography business and you'll have a solid foundation.

It's always important to keep an eye open for opportunities to improve your overall rating with

Part of good customer service entails always being reachable. In fact, it's critical that clients be able to contact you. You may find that some jobs are won by the photographers who were able to get back to potential clients first. If the first photographer called doesn't respond, clients will simply call the next person on their lists. A beeper or a cel phone offers clients constant access to you. This reachability doesn't cost you much, and it might end up being that extra something that sets you apart from your competition.

clients. Often, this comes down to doing the world's greatest job on a reasonable budget. Make your clients' lives easier—get it to them sooner, fix it when it's broken, make everything easy for them.

There are many customer service opportunities that arise both during and between assignments, and these are chances for you to make yourself invaluable to your clients. In benefiting your clients, you'll find that more business comes your way. Consider taking clients to lunch out of their office environment and listening to what they say in that setting. You'll uncover new opportunities. Offer to expand assignments to provide more value to your clients. For example, consider suggesting other shots that the client might like. This is a good habit to get into; you're adding value to the project, and you're showing clients that you're thinking about doing more for them.

Keep alert to any chances to bound forward in professional relationships, and make sure to ask satisfied and happy clients to give you referrals. Listed below are some solid facts to get you thinking about customer service and how it affects your bottom line:

- It takes six times more time and marketing effort to attract a new customer than it does to keep an old one.
- Dissatisfied customers will often tell 8 to 10 people about their negative experience with you.
- Seven to 10 disgruntled clients will do business with you again if you resolve their complaints in their favor. And, if you resolve the problem on the spot, 95 percent of unhappy clients will do business with you again.
- Of the customers who take their business elsewhere, 68 percent do so because of an attitude of indifference on the part of your company or a specific individual.

The bottom line is that customer satisfaction equals success. Learn what your customers need and want. Treat them fairly and with respect. And, above all, exceed their expectations. This is customer service. This is why people come back, again and again, and tell their friends how terrific it is to work with you. If you're not hearing from your clients with repeat business, you may have failed to establish enough of a rapport with them; or, you may not have exercised good (if any) follow up; or you may need more help with customer relations.

BIDS AND ESTIMATES

Once you've made the first cut, which means the clients have seen your work and liked it, you'll most likely be asked to submit some pricing estimates for one of several of reasons: 1) they have no idea what the job will cost and want to establish a "budget universe" so that they can incorporate your price into

their overall cost estimate or bid for the total project; 2) they're getting estimates from other photographers and honestly want to compare them all; 3) they truly want you to do the job and want to know what you'll charge them; or 4) they've chosen who they want to work with (and it's not you), and their client or boss insists that they procure two or three more estimates to show why their chosen photographer should get the work.

Pay close attention to the terms used here. Have clients asked for a *bid* or an *estimate?* While clients use these terms interchangeably, differences abound. The industry trade group Advertising Photographers of America (APA) recommends that their members use the term *estimate,* not *bid.* The logic here is that if you *bid* on a job, you imply that costs are fixed; a bid lists a specific dollar amount, which can be interpreted as a "not-to-exceed" figure, despite job specification changes.

An estimate, on the other hand, is a projection of the approximate cost of an assignment based on the initial information supplied by the client, art buyer, or project art director. While these assignment specifications are expected to be reasonably accurate, they're not totally binding; they are conditional on the accuracy of the client's initial description.

Since job conditions and requirements can often change during a project, APA recommends using a job *change form* (mentioned previously) to minimize any misunderstandings between you and your clients. Using a job change form records job specification changes and offers protection from clients who ask you to do and shoot more and then balk when they're asked to pay more.

When you provide an estimate it's important to let clients know that you're supplying numbers for the *current* specifications and information; be clear that if and when the specs change, your costs and fees may change as well. Unless the job parameters and subject matter are 100 percent finite and known (which is rarely the case), the numbers that you supply will be based on limited assumed information and can change. Your job is to let clients know this.

Sometimes clients tell you not to "go to a lot of trouble" with the estimate, that they're "just looking for a ballpark figure." Never quote prices on the spot; this is dangerous. You can't throw some numbers out off the top of your head and successfully cover your costs. Instead, say something like, "I'll need to call you back in [one hour, one day, etc.] to be able to give you an accurate idea of what this will cost." The word *accurate* is key here. You want to be accurate so that they can give their bosses or clients an accurate cost. Let them know this.

Note, too, that while a request for a ballbark figure sounds innocent and preliminary enough, there's some degree of risk that, to your clients, your "ballpark"

will represent your actual price. No matter what they tell you, this is the number that will stick in their minds and affect their impression of how you price your vision—even if shoot parameters change. If clients are also collecting prices from other photographers, ballpark numbers can sometimes even cost you the job.

In some situations, you may be successful at quoting a range of prices, such as $3,000 to $6,000, depending on the job specs. This might keep you in the running until more is known about the job and protect your interests while the job develops.

THE ESTIMATING THEORY

Like an accountant preparing a financial statement about the health of a given business, you can present your financial facts in different ways to meet different needs. (For example, in accounting, you can tell the bank how good business is and the IRS how bad business is.) Estimating commercial photography is a craft, involving the tailoring of good, honest, information to meet the needs and requirements of your situation.

The basic questions to ask yourself when preparing an estimate are these: Are you bidding against other photographers? Is there a need to have the best numbers? Is that how the job is going to be assigned? Or, do you actually have the job and does your client want to know the real cost of the work? You can honestly and ethically present numbers that read either way (as either the best or the most realistic).

To get to the lowest possible estimate, for example, you could list variable and flexible expenses (such as film, Polaroids, assistants' time, and overtime) at the lowest probable amounts, and then in your cover letter accompanying your estimate, list what it will cost additionally, if the job requires more of these resources. Write something like, "If more film/processing is required, it will be billed at listed rates." Regarding assistant overtime, list the assistant cost for the first eight hours, and then in your letter explain that beyond this, you'll bill overtime at time-and-a-half.

If, on the other hand, you know you have the job, you might elect to present an accurate, worst-case-scenario estimate and let your client know what the possible high-end cost range will be. Watch out here for stealth candidates for the job, of whom you are unaware, lurking in the wings; the classic is the nephew of the president of your client's company who happens to be a photographer and will do the job for one fifth of what you're asking.

In a realistic estimate you list all the resources you think you'll require and then, as with the lowball estimate, cover any possible changes in a letter. For example, list the five rolls of film that you think you'll need, and write, "If all the film/processing and Polaroid resources listed are not required by the job, the budget will decrease."

You can list stylist and model costs, which might be billed directly to the client, on the estimate or break them down separately in the letter. In this way, you provide the client with the required data but ensure that your estimate numbers are as low as possible; this still gives the client an accurate grasp of the actual project costs. For situations in which you're clearly bidding against other photographers and know price is a determining factor, this is a way to protect your bottom line numbers.

An additional flexible pricing area is travel expenses. Listing these costs on an estimate can add significantly to the bottom line. You might want to cover your photography expenses on your estimate and your travel expenses in a memo. Write something like, "Travel expenses will vary depending on when [plane tickets, etc.] are booked," or "When more information is known about exact travel dates and transportation needs/requirements, accurate cost information will be provided."

Note that when you submit an estimate, even one that spells out everything, most clients' eyes go right to the bottom line. Even if you send along an eloquent and informative cover letter with that estimate, detailing the ins and outs of every line item, you may find that clients don't read what you've written. This becomes clear when you present an invoice that includes the additional film they told you to shoot and they feign shock.

Since it's generally somewhat difficult to know what kind of competition you're dealing with for the job, a good approach is to craft a "best case" estimate, listing minimal (but honest) expenses, and present an accompanying cover letter in which you let the client know that you've included ample amounts of film and other resources in your estimate and that, if additional resources are required, you'll bill them at listed costs. Clarifying the extra costs for possible changes in a letter still provides all the requested information but removes some variables from your actual estimate, helping you in a competitive bidding situation.

Above all, be honest with your clients. While you can manipulate numbers to make your estimate more attractive, it's imperative that you give your clients full-disclosure costs, whether you list them in your estimate or in your cover letter.

PREPARING A REAL ESTIMATE
Pricing your creative services is one of the most challenging tasks you'll face. It's part craft, part skill, part art, and part science. The challenge is to take the guesswork out of it and turn it into more of a science—a series of strategic steps that brings you to the finish line ahead of your competition.

When pricing, you need to make a profit and cover your overhead. You also have an obligation to your profession to execute pricing that is in line with "trade practice"—in other words, to not underprice a job, either intentionally or unintentionally. Underpricing might solve your short-term needs by increasing your cash flow, but in the long run, underpricing can only hurt you and everyone else in the commercial photography industry.

One way to aid in determining the right price for you and your client is to simply ask, "What's your budget?" In some situations, clients have specific and limited amounts of money to spend, and knowing whether it's $500 or $5,000 is certainly good information to have. From time to time, you'll discover that the budget is actually larger than what you might have thought. Sometimes, clients may tell you that there's no budget yet and that they're waiting to see your estimate. A well-placed query along these lines before you price an assignment may be extremely helpful.

Here's a breakdown of line items to consider when estimating an assignment. Note that it's critical that you absolutely, positively work out all these fees and expenses prior to the commencement of work. Fail to do this and you may find yourself having to ask for more money after you start the job or even after you've completed it. If you do this, you place yourself (and the possibility of receiving any future assignments from that client) at risk. Clients hate surprises. Don't risk losing their goodwill or their future business. Standard fees include:

Creative Fee. This is what you'll charge to produce the assignment. Determining factors include the complexity of the project, media usage, and length of period of use. Any additional usage should be negotiated separately from this fee.

Pre-Production Fee. This covers your involvement in preparatory work before the shoot and doesn't include crew costs or production expenses. Some photographers charge for pre-production conferences and meetings and some don't. Personally, depending on who my client is, I won't charge for a meeting or two. To protect yourself against "meeting-intense" projects, you may want to let clients know in advance that you meet at no charge for a certain number of hours and that after that you bill 50 percent of your day rate on a per-hour basis, or whatever your terms are.

Travel Fee. This covers your travel time to and from an out-of-town location; it's usually negotiated as a percentage (usually 50 percent) of the creative fee on a per-day basis.

Weather Delay Fee. This covers delays in production caused by inclement weather and is also negotiated as a percentage (generally 50 percent) of the creative fee.

Post-Production Fee. This fee covers your creative involvement in additional work beyond the scope of

the original assignment and might include time spent on editing, special printing or processing procedures, and computer imaging.

In addition to the above fees, you also need to consider charges for the following production expenses:

Crew. This covers charges for any support personnel hired to complete an assignment, including assistants, production coordinators, and set builders, and generally encompasses overtime as well as pre- and post-production costs. (Always let your clients know how many hours make up an assistant's day, and give them a sense of when you start billing overtime.)

Stylist/Hair/Make-Up. This encompasses expenses for all personnel needed for styling the assignment (including hair, make-up, prop, wardrobe, and food stylists), plus any assistants and associated expenses. Some photographers elect to have these costs billed directly to the client.

Film Processing. This is all film supplies, processing, Polaroids, test rolls or sheets, delivery charges, and lab charges for special processing. Some photographers list unit per-roll and per-sheet costs; others just list total cost. It's a good idea to let clients know what your per-roll, per-pack, or per-sheet cost is so that they can see how much, in the way of film resources, you've allotted to the job. It's also smart to state in your cover letter that you will bill clients for any additional required film or decrease the film processing cost if less film is used. Without this disclaimer, some aggressive clients may assume that, no matter how much film is used, it's covered in your estimate.

Prints. This covers costs for producing test work and the required final prints, plus all lab charges for normal and rush services and any costs for special effects printing.

Insurance. This covers liability and property insurance, plus coverage for faulty film stock or camera malfunction. This charge can protect both you and your client against the expense of a reshoot due to technical problems. Additional insurance charges might include "certificates of insurance," which are sometimes required for location shooting; "carnet" fees, which cover export and re-import of camera equipment for out-of-the-country work; and special customs bonds. Allocating a little bit of the cost of your annual insurance coverage to each job is fair to clients and helps recapture some of your overhead costs. (Check with your insurance agent, or contact the Advertising Photographers of America or the American Society of Media Photographers for information on available insurance packages and providers.)

Location/Studio. These charges include location scouting, research time, a scouting assistant, location scouting film and permits, plus other related charges, such as travel expenses and security fees (which might include studio rental fees where applicable).

Props/Wardrobe. This includes charges for all inanimate objects, such as furniture, surfaces, decorative objects, food, clothing, and accessories, which you can either purchase or rent depending on the situation. Any purchased items technically belong to, and should be returned to, the client.

Rentals. This encompasses rental charges for special cameras, lighting, grip, and logistical equipment required by the assignment and includes items such as walkie-talkies, cherry pickers, scaffolding, vehicles, and the like.

Sets/Expendables. This involves charges for design and construction of sets and backdrops and can include costs for carpenters, painters, designers, researchers, hardware, lumber, and paint. It can also include charges for custom-painted backgrounds and surfaces specific to the assignment.

Expendables. These are items used during the course of a job that cannot be saved or used again, such as tape, foam board, and other supplies. Billing for expendables makes sense; these are items that cost money and that you use every time you shoot. Recouping this expenditure saves you money.

Shipping and Delivery. This covers costs for delivery of film and prints to your clients, plus charges for sending props, materials, casting sheets, and any pre-job information to the agency, client, or job site prior to the start of the assignment.

Talent Casting. These charges include all model fees incurred, plus casting costs, including casting fee, bonuses and residuals for additional use, and any film and Polaroids used for pre-production casting. Whenever possible, it's advised that all talent be billed directly to the client or talent agency. If clients ask that talent be billed to you so that they are only dealing with one bill (yours), it's common trade practice to include a production markup fee of roughly 20 percent of cost.

Travel/Lodging. This includes all air, rail, taxi, and car and van rental charges, plus excess baggage costs, hotel bills, meals, and associated job expenses.

Terms. Informs clients of your payment terms, including any monthly late fees you'll add to the bill (generally about 2 percent to invoices that are 30 days or more past due) and also of any discounts that you offer.

Production. Some studios charge a production fee—which is a group markup on expenses that are incurred during production—in lieu of marking up

individual items, much the way an ad agency marks up your invoice to their client.

Miscellaneous. Charges include gratuities, telephone calls, postage and any additional expense not covered elsewhere, which might include crew working meals.

Make sure, when you get the specifications for a job, that all of the photographers submitting estimates are being given the same information. Ask clients if all the photographers are receiving the exact same specs. (As jobs develop, specifications change.) This is important because it can affect your pricing. For example, if you have all the data—because you've asked the right questions—but the other photographers don't, your estimate may be higher than theirs and therefore less competitive.

Sometimes, if clients are getting costs from a number of photographers and your estimate is a bit higher than the rest, you can (depending on your relationship with a particular client) suggest that you might be able to "work with them" on the costs even though your fees might be a bit higher than "less experienced" photographers. If they really want you, clients may consider speaking with you after they receive all the bids and have a much firmer picture of what the job is actually going to cost them.

While the Federal Trade Commission heartily frowns on any trade group, such as APA or ASMP, from suggesting pricing (because this would be, officially speaking, restraint of trade), there are numerous informational pricing resources available, including books, audio tapes, and seminars (see Resources for a listing).

PRICING CONSIDERATIONS

Pricing has always been a challenge for commercial photographers. It's a give and take process—you give clients a price, they take off what they hope they can get away with. Although this is somewhat of an oversimplification, it's not too far from the truth.

On the buyer's side of the pricing issue, the core question is, How much of the project budget has been allocated for photography? On the photographer's side, pricing is affected by trade practice, experience, the competitive environment, and how desirable the job is, among other factors. It's possible for you to put together an intelligent and realistic pricing package only to discover that the client's expectations are somewhat different from yours. At this point, negotiations take place. If you're uniquely qualified to produce an assignment, clients will be somewhat more accommodating than if anyone in town could shoot the job. You may decide, after a concerted effort to reach a pricing agreement, that a client's budget is not enough, at which point you can simply withdraw yourself from consideration.

Remember the old joke, What does a 5,000 pound gorilla eat? Anything he wants! Well, clients are the 5,000 pound gorillas in pricing situations. They establish a need and price, and solicit price estimates. Their numbers are often inflexible and carved in stone. As a vendor, you're supposed to come up with estimates that match their expectations. While you can sometimes extract concessions, such as offering clients less usage for a lower price, it's often hard to get clients to adjust their budgets.

There are some guidelines, however, that you can use for determining prices. Look at your costs, your overhead, your goals, and the true value of your work. Ideally, your pricing is based on the quality of your work, the value both you and the client place on it, and the usage rights you'll license to the client.

With budgets getting tighter and clients using less and less assignment photography (and more stock), pricing has become more critical than ever. If you price too high, you may not get the job. If you price too low, you may hurt yourself (and every commercial photographer out there) by lowballing a job that should have carried a higher price tag.

Part of successful pricing is letting clients know why a job carries the price it does. When getting a price from you, some clients will say that they can't possibly pay that much and that you'll "have to do better," and then wait for a response. If you successfully explain that, due to the scope of the work, degree of difficulty, time required, rights being licensed, and other relevant factors, the price is reasonable and in line with trade practice, these clients may withdraw their objections and proceed amicably. If, on the other hand, you offer to try to come up with a lower price, clients will take advantage of the lower price.

Invariably, some clients always ask if you can do better, no matter what the price, to test the firmness of the estimate. To combat clients like this, always base your pricing on facts; then if you're asked to justify your pricing, you'll have the ammunition to do so.

To work out pricing, there are generally two types of expenses that you should consider. The first are fixed administrative and overhead costs, including rent, heat, phone, health insurance, and electricity, which are incurred regularly, whether you're working or not. The second are expenses incurred as a result of producing assignments, including the cost of film, processing, messengers, props, models, and delivery; these are costs that you wouldn't incur if you weren't doing any work. You must factor both types of expenses into the pricing equation.

COPYRIGHT: YOUR MOST IMPORTANT ASSET

To gain a full understanding of pricing requires an understanding of the issue of copyrights and their importance to photographers and clients. A copyright

is the exclusive legal right (granted to the creator) to reproduce, publish, or sell something; it usually applies to literary, musical, or artistic work. The copyrights on your photographs can be your most valuable and important assests. To get completely up to speed in the area of copyrights, read the ASMP's *Copyright Guide for Photographers*; it offers an in-depth look at how the copyright laws can affect your commercial

photography business. (See Resources for more information on ASMP.)

Simply put, under Federal law the copyright on an image belongs to you (the creator) from the moment you create that image. All work should be protected (from unauthorized use) with a copyright notice, such as "Copyright © 1999 [or whatever the date of first publication is] by Ira Wexler [insert your name]." This

WHAT FACTORS DETERMINE PRICING?

GUIDELINES FROM THE AMERICAN SOCIETY OF MEDIA PHOTOGRAPHERS

ASMP's excellent book *Assignment Photography* lays out an example of how to arrive at realistic pricing. It's based on a commercial photography business that has administrative and overhead costs, including depreciation, salaries, and other staff expenses, of $70,000. This amount represents the cost of keeping the studio open even if no assignments are produced.

With this data in hand, the next step is to approximate the number of assignments anticipated during the year. (This can be based on the past year's performance or current sales goals.) Let's say it's 40 assignments per year with a total of 70 days of work. Simply dividing the number of working days per year (70) into the operating expenses ($70,000) yields an average necessary per-day charge of at least $1,000 to cover administrative and overhead costs. This number represents the *basic fee*.

Added to this is the *creative fee,* to cover your services as a commercial photographer. This fee varies, based on the degree of difficulty for the given job and the amount of competition for the job. If a job is something that any number of photographers could do, you may have a lot of competition, which would drive the job price down; with more demanding and specialized work, on the other hand, you can bump up your creative fee.

Next, usage is factored in. The more clients use a photograph, the higher the usage fee. I recommend against transferring the copyright of your images to clients; this is like selling the family cow, and you may want some milk down the line. If clients need broad usage rights for an extended period of time, consider licensing "unlimited usage," or another specific, definitive usage option, for the period of time required. This would prevent clients from reselling your images to unknown third parties and might, depending on the specific usage deal, get you some stock photo resale rights. In general, whenever negotiating usage rights and costs, take a good look at

what the clients need and what you need. If you're having problems, call the ASMP to see if someone there can provide any guidance.

The final item to consider in pricing is a markup fee. Many photographers charge a percentage (of the cost of supplies and services), or markup, for supplies and services that are bought as part of assignments. For example, buying photographic supplies involves a significant outlay of cash, which you don't get back until the client pays your invoice (and this can take anywhere from 30 to 90 days). To compensate for the true and actual cost of this money, a markup is put on the film cost. A 20-percent markup is standard, while some photographers charge more (even doubling their cost as a pricing standard). Some studios also mark up other expense items, such as assistants, rental equipment, and deliveries.

Markups not only compensate for the cost of "loaning" money to clients but can also become small profit generators. Note that expenses such as cost of travel and lodging and on-the-job meals are generally not marked up. Most clients will look for receipts on these items and may challenge any such markups, however for the most part, clients do accept marked up film and processing charges.

Occasionally you'll run into a client that wants receipts for everything, but this is the exception. Frankly, if you lay out your money for film, shoot the film, process it, edit it, and then wait to get paid, you're entitled to a markup. In the film industry, it's standard procedure to charge a production markup as a percentage of all expenses and list it on the face of the invoice. This would be a hard sell in the commercial photography business, but markups on standard things, such as film and processing, are more readily expected and accepted.

There are no rules governing markups; photographers must make their own business decisions. Some prefer not to markup expenses, absorbing them into or adding them onto their creative fees. Others view markups as an important mechanism for recapturing legitimate business expenses.

should appear on all your work when you submit it to a client or potential client. Your copyright actually consists of a bundle of rights, which can be separated and licensed to clients for a varying range of fees.

When someone hires you to produce an image for them, you're not selling them the actual image per se; you're licensing reproduction rights to them to use the image in a specified manner, for a specified period of time, in a specified medium. Copyright licenses should be conveyed in written form. Copyright laws have been amended and updated in recent years to provide even more protection to the creator of the work. Despite these amendments, clients can circumvent congress' attempt to protect creators' rights to their works using two things: *work-for-hire* and *buyout* agreements.

WORK-FOR-HIRE AGREEMENTS

Work-for-hire agreements offer clients the one main loophole in the copyright law. Generally, work-for-hire provisions are meant to deal with photographers who were employees (like newspaper staff photographers) who were paid salaries and received employee benefits, such as health insurance.

For the independent contractor, work-for-hire agreements cover a narrow area, including supplementary work (like an addendum to a book); contributions to motion pictures, magazines, or textbooks; and a handful of other jobs for which photographers contribute to larger works already in existence, which are officially described as *collective* and *derivative* works.

While most clients openly and honestly address the legitimate needs of photographers who work for them, some will insist, "If you want to work for us, it's work-for-hire or nothing." In signing work-for-hire agreements, photographers, in effect, convey the copyright of their work to their clients; this includes the right to resell images without further compensation to the photographer who created the image.

While work-for-hire agreements may seem attractive, especially if you're trying to establish your business—they let you take the money and run—over the long term, these contracts have the potential to hurt both you and the industry as a whole. They deprive you of future income from your images and they deprive bonafide non-employee photographers of legitimate income while offering clients bounty that the Federal Copyright Act sought to protect against. If unscrupulous and overly agressive clients try to bully photographers out of our rights, it's incumbent upon all of us to resist. You may be covering the rent this month with work-for-hire money, but in the long run, you're hurting everyone in the business, starting with yourself.

BUYOUT AGREEMENTS

Clients can also circumvent copyright restrictions by demanding a "buyout" of rights as part of job specifications. What this means is that clients want to own all

the rights to the work. They want to ensure that they can use your work for whatever they want, without further payment to you and thereby precluding any future stock photo residual income you may realize.

If you're selling "all rights" to an image, you should be compensated for any lost future residual income by receiving more money for those rights. An industry rule of thumb is to increase your fee anywhere from three to five times. With today's tighter markets and budgets, it's common to see clients demanding all rights without offering any additional fees.

One thing you can do to combat this is just refuse to sell all rights. Another solution for dealing with demanding clients who want complete usage without paying for it, is to negotiate an agreement in which, since they're offering less, you sell them fewer usage rights. Suggest a *limited* buyout, which allows certain unlimited usage only for a certain period, in certain media and is priced accordingly at a lesser rate than buying all rights in perpetuity (a *total* buyout).

To limit buyouts, when you hear the word *buyout*, inform clients that owning all rights forever to a photo will cost them a great deal, since it prevents you from being able to gain residual income from that image. Explain that when they purchase all rights, they're really buying everything, including billboard rights in Siberia, for example. See if they really need such extensive rights.

Your clients should also consider the flexibility and endurance of the image; if the photo has people, cars, and buildings in it, will these elements look too dated to use in 5 or 10 years? Why pay for all rights if the image's value is going to diminish in a few years? With a limited usage agreement, you can help clients accomplish their goals and save them money. Another possibility is to offer clients exclusive usage for a given period of time after an assignment (say two years), after which you'll sell the images in question as stock.

Creative footwork like this can mean the difference between keeping and losing the job. Generally, if you look hard enough, there's a way to give clients what they need and still get what you need, too. Although your inclination may be to cave in and give clients what they want, don't. If they want more, they must give more; if they can work with less, they'll pay less.

THE COVER LETTER

A good cover letter covers your assets. It's imperative that you send one with every single estimate that leaves your shop. (Send a written estimate for every job, even ones for friends or relatives.) The cover letter goes over each item in the estimate and describes any job limitations of which your buyer should be aware. It's a way of letting buyers know what your numbers represent, what your parameters are, and what will happen to prices if job specs change. If something changes with a

job, you have the original specs in writing and are protected against future problems with clients suffering from selective amnesia.

The letter also lets buyers know what shots the estimate covers and the entire universe of costs related to successful production of the assignment. When writing your cover letter, always keep it simple; don't bury clients in arcane paperwork. Let them know what you need, but keep it short and sweet.

Provide breakdowns for items such as film costs and quantities included in the estimate, charges for additional film, licensing rights, and can cover such topics as prices for prints not listed on the estimate, billing policies for models, travel and lodging arrangements provided by the client, and any other details of a project. A good letter will explain what happens in every contingency so that, no matter what, clients will know every detail. It is, for example, the venue in which to discuss policies regarding weather days, cancellations, overtime, and who pays for meals, parking, scouting, and props.

If there are any surprises during production (any unforeseen factors that arise and affect the job cost), chances are you'll have a difficult time getting paid for them unless you've spelled out the rules beforehand. Clients hate surprises. Asking for funds not discussed prior to a job is risky. Even if you feel the extra costs were mandated by their requirements, in the end, in a tug-of-war over extra costs, you'll lose; clients will either refuse to pay or will pay but will never hire you again. If you don't inform clients about all assignment details, they'll quite naturally assume the most favorable terms and conditions for themselves. A comprehensive cover letter single-handedly prevents chaos and loss of good will on a job.

The cover letter is also the forum to discuss what happens if the job is cancelled or postponed. Generally, over 48 hours before a shoot, bill 100 percent of all the expenses incurred for the shoot; between 24 and 48 hours, bill 50 percent of your fee (the creative fee), 100 percent of the assistant fee, plus 100 percent of all expenses; cancellation within 24 hours of the shoot warrants billing 100 percent of the photographer's fee, 100 percent of the assistant's fee, plus 100 percent of all incurred expenses.

NEGOTIATIONS

Any business transaction comes down to making a deal. This sometimes involves a give and take called negotiation. According to ASMP's executive director Richard Weisgrau, "Negotiation is the process of balancing the interests of two or more parties in a way that is acceptable to all." On average, you'll spend only about 25 percent of your time producing work and most of the rest of it handling administrative and management matters, which often involves negotiating. Having solid negotiation skills minimizes the time needed to get things done, be it with clients, vendors, suppliers, or your own staff.

Negotiation expert Dr. Chester Karass feels that "in business, you don't get what you deserve, you get what you negotiate." Successful people don't take "no" for an answer; they get what they want by negotiating. Agreements, understandings, and relationships mean the difference between success and failure, with poor agreements routinely breaking down and yeilding dissatisfaction but good agreements helping attain goals and satisfy both parties.

Some people believe that there are times when it's best to stake out a position and go for a "win" at all costs. Following this strategy, whenever clients made you an offer, you would insist on something better; hold out for a better deal. If you successfully convey an air of confidence, they'll cave in; they may even increase their offer. Clients always seem to have some mystery pool of money somewhere when they need it.

Others suggest the following negotiating tactic: If you ask for $10,000 and a client offers only $8,000, agree to the lower number *subject to the approval of your partner or business manager*; wait a day or two, which allows your client to get used to feeling victorious. Then, call back apologizing and saying that your partner not only rejected the deal but named a higher figure, say $12,000. Clients will most likely be loathe to crawl back to their bosses and admit that the deal is off. After commiserating profusely with your client carefully offer to split the difference, bringing the price back up to $10,000.

Negotiation expert Roger Fisher, of the famed Harvard Negotiation Project and co-author of *Getting to Yes: Negotiating Agreement Without Giving In* (Penguin Books, 1983), holds that there's another way to negotiate—based on merits rather than haggling. He advocates that you "look for mutual gains wherever possible, and where your interests conflict, you should insist that the results be based on some fair standards independent of the will of either side." He suggests that you work through the elements listed below as systematically as possible before you begin negotiating with the other side.

Interests. Think about your interests in advance, both the obvious and the underlying.

Options. Instead of staking out just one position, brainstorm as many ways to reach an agreement as you can. If you don't get everything you want, you'll still be able to structure a creative agreement out of these ideas.

Alternatives. Develop other courses of action in case negotiations falter or an unacceptable offer is made. In every negotiation, map out your best alternative to the negotiated agreement in advance.

Legitimacy. Base your demands on external standards—market prices, for instance—both to convince others of your fairness and to protect yourself from being ripped off.

Communication. To speed up the negotiating process, plan what to say and what to listen for ahead of time.

Relationship. Ideally, you want to leave the negotiating table having built a strengthened relationship with your counterpart. Therefore, think of ways to facilitate rather than impede negotiations.

Commitment. Make promises that you can keep; think in advance about the specific promises you can realistically make.

It's always easier to keep an existing client than it is to acquire a new one, so you should make an effort to avoid photographer/client disagreements. Some of the skills necessary for keeping clients are to be able to maintain harmony and be flexible, and to be empathetic, fair, and a good listener. I strongly recommend setting goals and writing them down; determine the desired fee and advance payment, the number of days you'll work (or pictures you'll produce), the licensing rights available, and an acceptable payment schedule.

NEGOTIATING STYLES
In general, there are two styles of negotiating: hard and soft. Hard-sell types are tough, intimidating, demanding, and uncompromising. Soft-sell types, on the other hand, tend to be friendlier, more flexible, and understanding. Good negotiators incorporate a little of each style.

Watch out for intimidators who like to push you into a corner. To avoid feeling trapped, push right back. Give them what they're dishing out; sometimes it will stop them in their tracks. The following are some negotiating tactics from the American Society of Media Photographers:

- When dealing with noncommittal types, keep after them until they provide the answers you seek. •
When dealing with known liars, take good written notes and hang onto them.
- Despite the wide varieties of power, including that of money or office, keep in mind that you have the most powerful power of all—the power to say "no." In fact, *no* is the most powerful word in negotiation. (The second most powerful word is *yes*.)
- Keep red herring items—demands you can give up and live without—up your sleeve.
- Make sure that you're negotiating with the right person—the one who has the authority to make deals.
- Develop the art of listening.
- Using trial balloons is an excellent tactic. Instead of saying, "I want $5,000 for the job," say, "What would you say if I told you this job was going to cost $5,000?" Or, "How would you feel if I told you I needed all the expenses up front?"
- Just say no. If a client's offer is unacceptable, say so and offer your alternative. Don't say "Yes, but . . ." —it's too confusing.
- Take it or leave it offers are the simplest to deal with. If a job meets your needs, you take it; if it doesn't, you leave it. However, you should always test offers to make sure they're really take it or leave it; don't just automatically take them, because you just might be able to change the deal in your favor.

NEGOTIATING PRICES
The two issues you'll negotiate most often are usage and fees. To do so successfully requires an understanding of both the relationship of copyright to the value of your images and the clients' intended uses for your images. Since clients often want to buy more rights than they need, it's prudent to have different pricing options available to offer them in the negotiation process.

When it comes to usage, the right question to ask clients is, "How do you intend to use these photographs?" Explain to clients that you'll base your usage fee on their answer.

Then, the general process for calculating the price goes as follows: add your basic fee (a portion of administrative and overhead expenses divided by the number of shooting days per year) to your creative fee (which varies depending on degree of difficulty, skill, and equipment), and then combine this number with the usage fee (your charge for licensing rights) and any markups. This will give you your assignment fee.

When negotiating any fees, it's good to create a range of acceptable prices, including the lowest and the ideal amounts. Create this range by varying your licensing or markup fees. As a general rule, don't toy with your basic or creative fee. If clients express unhappiness at your stated needs, ask what they think is fair. If the amounts are miles apart, take a closer look—either you've miscalculated or the client is missing something.

Ask clients how they calculate their numbers, find out where the differences lie, and work to reach an agreement that fulfills your needs. If the discrepencies are great, let clients know that you're worth every dollar. If all else fails, however, find some legitimate way to come down a bit. If the price differences are not significant, you might consider ceding the difference as a goodwill gesture.

FORMS AND PAPERWORK
An important part of managing assignments is keeping track of everything. This is a business of details. The *who, what, when, where, why,* and *how* of each

assignment are all critical. If you don't keep track of all your job details, the results can be painful—fouled up jobs, unhappy clients, and the kind of public relations that no one needs. Fortunately, forms make keeping on top of business much easier.

Forms not only help maintain organization, but also provide record-keeping repositories for all the important information about each assignment. Forms help you interface with clients in a professional and businesslike manner by reinforcing your understandings with written descriptions of all job agreements. While the commercial photography industry certainly has an artful foundation, it is critically important to take care of *business* in order to succeed.

Your forms and paperwork also provide an ancillary benefit: They communicate the message to clients that you're professional, dedicated, serious, and organized. Clients will be attracted by your images, but their impression of you and your company will also be a determining factor in their decision whether or not to work with you. Your images represent your vision, but your paperwork speaks for what kind of businessperson you are. You need to show that you're a good, reliable vendor.

Your paperwork, which includes estimates, invoices, copyright licenses, delivery memos, cover letters, and faxes, should be the most user-friendly paperwork your clients have ever seen. Design the content of your forms and paperwork with the meanest person in the client's accounting department in mind. If it's painless for those folks, it'll sail through any clients' systems, you'll score points with your clients, and your checks will appear with the least amount of hassle.

The paper trail should begin when you get the first call about a job. Use the job starter form mentioned earlier. As a project progresses, you can use any of various types of paperwork, including portfolio delivery receipts, estimates with cover letters, invoices, and assignment delivery forms. Frankly, it doesn't really matter which forms you use as long as you have systems in place to keep track of things both for you and your clients.

PREPRINTED PAPERWORK

Preprinted standard forms provide relief in several ways. First, if you're using typical industry forms and terminology, clients will be more inclined to handle your paperwork. Second, forms help you stay organized; if you're ad-libbing in your paperwork, instead of using preprinted forms, you run the risk of leaving out something important. One slip on your part and you may lose a client and some income. Standard forms provide you with a checklist to go through.

Surprisingly, many photographers rely on oral agreements instead of written arrangements. They're the ones who haven't been burned badly yet! Critical point: get it in writing, before the shoot. Make the

client aware of your terms and conditions — all of them. Whatever they are. Get the clients' written approval (by having them sign off on your estimate and fax a copy back to you for your file), proving that they're aware of your terms and conditions. No exceptions. Business is business. Presenting your deal, terms, and conditions in writing makes your intentions known, even in the absence of a client signature, although it's best to get this. Keep file copies of all paperwork (at least until the job has been completed, and the invoice paid.) The bottom line is be professional and businesslike, and write it down.

The American Society of Media Photographers has compiled a great booklet of sample forms to which you can add your name, logo, and address. ASMP advises that "if you don't get it in writing, you may not get it at all," and this is absolutely correct! Accordingly, their booklet contains just about everything you need, including a comprehensive listing of specialist attorneys in 30 states plus Canada, England, and West Germany. In addition, the American Society of Media Photographers offers much of this material on disk ready for your word processor. (See Resources.) Their forms include:

- Adult [model] release (see page 21)
- Minor [model] release
- Property release (see page 20)
- Estimate
- Invoice
- Schedule of fees and expenses
- Assignment photography delivery memo
- Stock photography delivery memo
- Stock photography invoice

Another useful document is the change order form. It's essential for keeping track of costs and expenses as job specs change. It also lets clients see the additional costs they incur when they ask for changes. Change order forms come in many formats. Whichever style you choose, make sure it contains space for the basics: date, client name, your name, materials, a record of overtime, and expenses, along with a place for the client signature and signing date. When you send the invoice, include a copy of the change order form to back it up. (Clients sometimes "forget" the extras they request.)

After you review and customize these forms, I'd suggest letting your attorney review them. You may have an enormous amount of money (perhaps enough to ruin you) riding on their accuracy and efficacy. Make certain that your intentions and your forms are of one voice. During most of your career you'll be working with honest, ethical people, who keep their word. Every once in a while, however, you'll encounter a situation where your paperwork really saves the day. Beware of doing business on a handshake.

PURCHASE ORDERS

One of the most important forms in a paper trail is the purchase order, or P.O. You receive this from whoever hires you before you begin a shoot. Don't leave home without it. (If clients don't use a P.O., have them sign your estimate.) It confirms the deal you've negotiated and gives you a purchase order number to put on your invoices to make sure the nice folks in accounting get a check out to you. Sometimes there will be an accompanying job number, too.

Don't even take a lens cap off without a purchse order. Even if the client is your best friend, brother-in-law, or next-door neighbor. Too much can go wrong. In the worst situation, the client might even cancel the job after you've gone ahead in good faith and started the work. Don't leave yourself unprotected. It's extremely risky to do any work on a job if you don't have a P.O. If your clients don't use P.O.'s, have them sign your estimate.

GETTING PAID

After you've finished an assignment, pleased the client, and delivered the goods, the fun part is over. Now it's time to get your invoice paid and the money into your bank account.

The first thing to remember is to always send your bill with the job when you deliver it. It's the best way to get your invoice into the works. Waiting delays payment. Billing with the job ensures that your client sees your invoice immediately; what better time to get their attention?

When you write up your bill, keep everything simple and clear. In addition to including purchase order and job order numbers on your invoices, reference your estimate and its number, and any change orders and other paperwork that you generated, including your cover letter. (Write something like, Per estimate #12345 and cover letter dated 2/2/98.)

Straight Shooter Studio, Inc.
123 Anystreet, Hometown, ZX 12345 • Telephone: 123-555-1212 • Fax: 123-555-2121

ASSIGNMENT PHOTOGRAPHY DELIVERY MEMO

Date shipped: _____ Reference # _____ P.O. #_____

Client:

Assignment Description:

Usage Specifications:

Estimated Price:
FEES_____ EXPENSES_____ TOTAL_____
Note: for details of fee structure and expenses refer to attached schedule

Advance Payments:
FEES_____ EXPENSES_____ TOTAL_____

Conditions of Transaction:

1. The copyright to all images created or supplied pursuant to this agreement remain the sole and exclusive property of the photographer. There is no assignment of copyright, agreement to do work for hire, or intention of joint copyright expressed or implied hereunder. The client is licensed the above usage specifications in accord with the conditions stated herein. **Proper copyright notice**, which reads: © 19__ Straight Shooter, must be displayed with the following placement:_____ . Notice is not required if placement is not specified. Omission of required notice results in loss to the licensor and will be billed at triple the invoiced fee.
2. Usage specifications above convert to copyright license only upon receipt of full payment
3. Usage beyond that defined above requires additional written license from the licensor.
4. The sale is subject to all terms and conditions on the reverse side hereof.
5. If client orders the performance of any services required to complete the above described assignment it constitutes an acceptance by conduct of this estimate in its entirety.

Please review the attached schedule of images. Count shall be considered accurate and quality deemed satisfactory for reproduction if said copy is not immediately received by return mail with all exceptions duly noted. Your acceptance of this delivery constitutes your acceptance of all terms and conditions on both sides of this memo, whether signed by you or not.

_____ _____
ACKNOWLEDGED AND ACCEPTED DATE

This ASMP sample assignment photography delivery memo form will help you keep your business organzied. The terms and conditions that appear on the back of forms like these are just as important as the information on the front. For samples of complete terms and conditions, see the ASMP's Formalizing Agreements *booklet (see Resources).*

If job expenses exceeded the estimate, explain why; for example, "As you directed on the shoot, we shot additional variations which required extra assistant time, film, and Polaroids." It's best to document overages like this officialy with change order forms. If you don't cover something in paperwork, you (not your client) will wind up paying for it.

Once you've billed the job (and sent the invoice), you have a business asset—a receivable, which is the amount due you from your client. Great, you think, I've got receivables. However, keep in mind that while receivables look nice on paper, what you really want is *cash*. The objective is to get your money quickly. It's a fact of life that some clients pay promptly and others don't, but if your billing paperwork is effective, you should be able to get a check from your client in a reasonable amount of time.

If your paperwork isn't easy to handle, you won't be getting your money anytime soon. Presenting effective invoices is the key to keeping the cash flowing. This is critical stuff. Your terms and conditions should be printed on your invoice or on the back of it so that clients know what your policies are. You've got to present bulletproof paperwork; if things aren't in order, clear, and to the specifications of the client, it will take longer to get paid.

KEEP YOUR RECORDS STRAIGHT

During a project, it's very important to keep excellent records of all resources used, including your time, your crew's time, film, Polaroids, and backgrounds, along with all relevant receipts for billable expenses.

Record all this information immediately after the shoot; keep it in a separate billing file for that job, along with other relevant paperwork, such as purchase orders. If you fail to have adequate records of time and expenses, you'll lose money.

FOLLOW CLIENT BILLING PROCEDURES

One surefire way to hold up processing on your check, is to ignore client billing procedures. Carefully read the purchase order that you received prior to beginning the shoot; follow its directions to the letter. If something in the fine print doesn't meet with your approval, cross it off and initial it. Make sure you've got the right purchase order number and job number. If required, enclose a copy of the purchase order with your invoice. Include copies of any receipts (save the originals for your tax preparation) and change orders.

Also, see if the purchase order lists to whom you should send the bill. If it doesn't, you need to find this out. This is where you can reap the rewards of taking the initiative to speak to the client's accounting department, as discussed earlier, and finding out how they pay their bills. All this should ensure that your invoice will sail through accounting.

MAKE FRIENDS WITH ACCOUNTS PAYABLE

When it comes to getting paid, it's good to have a general knowledge of how most clients' accounts payable departments work. If you're cordial and courteous, you can get acquainted with the person who writes the checks. This is the person you want to become chummy with; he or she has the power to make sure you get your check quickly while other vendors wait for months.

I highly recommend that you introduce yourself as a new vendor to the person in accounts payable who writes your check. Be pleasant and businesslike—this person is your link to your money. Contacts in accounts payable are almost as important as contacts in the creative departments who hand out assignments. For fastest payment, most firms will suggest routing your invoice to the accounts payable department, and if you've called to introduce yourself, you can then send the bill to the attention of your "new friend" in accounting.

Most clients' companies have a convoluted paper and approval route that your paperwork must traverse before turning into a check. You need a complete understanding of the process. Often, the person you worked with must first sign off on your invoice. (This is an indication that they received and accepted your work and approved you for payment.) The sign-off process can take minutes or weeks. If your client is humane and professional, the process should be fast; if not, your bill might wind up in a pile on someone's desk and sit there for 60 days until you call, and they say, "Oops, sorry," or, "What invoice? We never got one."

SPEED UP PAYMENT WITH DISCOUNTS

Offering clients discounts in return for payment in a specified time period is one way to get paid faster. It's best to ask clients if they take advantage of discount offers. Some do, and some don't. A standard discount offer is "2/10/Net 30," which translates to offering a 2 percent discount on the total amount due, for payment in 10 days, with the entire invoice due in 30 days.

If you want to get paid faster, increase the discount. You just need to decide how much money you're willing to give up to get your check faster. For example, 5/5/Net30 might really get some attention. This is a five percent discount—a whopper—if *you receive* the check in five days. The challenge is to engineer a savings that clients can't refuse, while still getting fair payment for your work.

With budgets getting tighter, a 5/5/Net 30 discount can be very attractive. Some clients jump on offers like this; if they have the cash available, they can affect a considerable amount of savings over the course of a year. They figure they'll be paying anyway in 30 days, so why not pay 20 days earlier and save some money.

Note that some clients almost never pay late fees

for payments past due. You'll have to decide whether or not you want to charge this monthly percentage for late payment, which is just like the interest that banks, credit cards, and retailers routinely bill for overdue payments.

HURRY UP AND WAIT

If it's been more than 30 days and you haven't received payment, it's time to take action. It's a good idea to review all receivalbes at least once or twice a month; don't get so busy that you neglect to collect your money.

Once an invoice goes unpaid for more than 30 days, you're in the collections business. Here's what to do: Consistently and regularly send monthly statements, including any finance charges (they'll never pay them, but show them anyway), starting on the 31st day. At 45 days, it's okay to call the person in accounting who's writing your check and say that you're calling to make sure you're in the queue for payment.

Some clients will pay in 60 days, some at 45, and some at 90. That's a long time to wait. Why should you finance your client? If you routinely operate like

CORPORATE REPORTS INC.	(404) 233-2230 SIX LENOX POINTE ATLANTA, GEORGIA 30324

TO:

PURCHASE ORDER NO. 08409

DATE: _____ DATE REQUIRED: _____

OUR CLIENT: _____

JOB NUMBER: _____

SHIP TO:

INVOICE TO: (If other than Corporate Reports)

TERMS: | **SHIP VIA:** | **F.O.B.:**

BY: _____

TERMS AND CONDITIONS:
Our Purchase Order No., Client Name and Job No. (if applicable) **must** appear on all invoices, packages and correspondence. Invoices without our Purchase Order No. **will not** be approved for payment. All invoices must be rendered in a timely manner, and must include any applicable freight bills (including bills of lading), courier charges and any other charges incurred in the performance of this Purchase Order.

IMPORTANT:
All products and /or results of services covered hereunder will become, upon acceptance of this Purchase Order, the sole and exclusive property of Corporate Reports, Inc., including but not limited to all photography, transparencies, black & white glossy prints, contact sheets, color separations, proofs, film positives and negatives, and any items purchased by Vendor to be used in the manufacture of items or services performed for Corporate Reports, Inc. and invoiced under the terms of this Purchase Order. The only exceptions to these terms will be those items specifically designated as rental or lease items, or otherwise excluded from our sole ownership and perpetual use rights on the face hereof.
This Purchase Order will be considered accepted as written unless written notice to the contrary is received within (10) days from date of Purchase Order. We will pay for a maximum 3% overrun on print orders unless stated otherwise on this Order.

ORIGINAL— TO VENDOR · YELLOW—MASTER FILE · PINK—ACCOUNTING · GOLDENROD—JOB/VENDOR FILE

A client purchase order, like this one from Corporate Reports, Inc., is one of the most important forms in the business. The P.O. spells out specifically what the client is paying and what you've agreed to do. Read all client purchase orders carefully; they're generally written to benefit the client, not you. If you find anything that you don't agree with, cross it off, initial it, and return a copy to the client.

this, you may have an enormous amount of money outstanding; this costs you money.

Unfortunately, the bottom line is that you'll get paid when clients want you to get paid. Hopefully, that's sooner rather than later. If it's taking far too long, you do have some recourse. Assuming you've spoken to accounts payable already, you may want to ask the client's art director or designer who worked with you for help. This is a last resort option because you don't want to take up too much of a client's time. You also run the risk of irking clients (they may say, "Why are you calling me about this?").

Finally, if you just can't get a check no matter what you do. Pursue it through small claims court, a nasty legal letter, or just take your loss, learn from the experience, and move on.

WORK WITH RELIABLE CLIENTS
One way to find the dependable payers (and weed out the bad eggs) before a shoot is to get a Dun & Bradstreet rating on their business. Dun & Bradstreet is the premier credit rating service in the world. (See Resources.) A Dun & Bradstreet report will tell you everything you need to know to determine your client's credit record—things like who owns the company, how long it has been in business, what its assets are, and what its credit rating is. The highest rating is 5A-1, which is given only to one half of one percent of all companies rated.

To get a Dun & Bradstreet report, become friendly with someone who subscribes to the service and ask them to pull a credit worthiness report on a potential client for you. Generally, financial houses, banks, attorneys, retailers, car dealers, and other businesses subscribe. Or, you can contact Dun & Bradstreet for information on using their services. If you're able to find out what a new client's payment history is, you may save yourself some future grief.

FACTORING HOUSES PAY INSTANTLY
One way to get virtually instant cash from your invoices is to work with a factoring house, as discussed in chapter 2. What you're actually doing is selling your invoice at a discount to the factoring house.

Some photographers who use this method of cash generation, report that they don't always factor every invoice. It depends on their needs. Like a fish-eye lens that sits on the shelf most of the time, when it comes to factoring, it's nice to know that it's there if you need it. It's one more tool. A good factoring house to call is Creative Capital Corporation (see Resources).

FINAL TIPS FOR SUCCESSFUL ASSIGNMENTS
Two weeks after you turn in every job, call your clients to ask how it all worked out. Did the work serve its purpose? Was everyone pleased with it? Also take this opportunity to inquire as to what work they have now that you can do for them. Keep this great relationship going. Let clients know that you're concerned with more than just sending in the work and getting a check. Showing your client that you care raises you from the rank of vendor to that of collaborator. If you are part of the solution, not the problem, you'll leave half of your competition in the dust.

While we all have different visions, the things discussed in this chapter are all constants—recommended guidelines that you should always consider. To review:

- Provide written estimates for every job, prior to starting the job.
- Don't be afraid to say no to client offers.
- Ask for an advance; 50 percent up front is not unheard of.
- Find creative ways to solve problems in mutually beneficial ways.
- Keep good records during the shoot.
- When problems arise during assignments, put yourself in the client's shoes.
- Bill immediately.
- Send the invoice with the job.
- Make friends with the person who writes your check.
- Follow up with clients to get more work.
- Ask for samples from the job for your book.
- When the check comes, call your client to say thank you. (And ask what's coming up.)
- Always job exceed expectations.

STOCK PHOTOGRAPHY

Stock is no longer our second choice. It's our first choice.

—Tim Downs, creative director, WWL Advertising

Not too many years ago, few photographers shot images specifically for stock photography use. More often than not, stock consisted of assignment outtakes. Stock imagery was less desirable than commissioning original photography. There just wasn't that much, in the way of images, to choose from, and what did exist didn't always fit the needs of clients.

Today, however, stock is not only a highly viable alternative for art directors and designers—it's also a good source of income for photographers who are feeling the pinch of a sharply diminished assignment pool. Today, increasing numbers of photographers are abandoning assignment photography altogether to produce stock images exclusively.

According to the American Society of Media Photographers, a stock photograph is one that already exists and is available for licensing by the copyright owner or an authorized agent. Generally, an authorized agent is a stock photography agency, which gathers existing images from a number of photographers for its collection or files, although some photographers elect to market their own stock photography.

It's apparent, looking down the road into the not-so-distant future of the stock photography business, that photographers who choose agency representation will probably fare better than photographers who go it alone. With the coming dominance of electronic stock photography delivery and retrieval, keeping up with the global stock arena will be too much for a sole practitioner. Without question, it will be much more efficient, productive, and profitable for photographers to leave the marketing, researching, and billing activities to a professional stock agency.

While the mechanics of the stock photography business may be familiar to most experienced photographers, let's take a quick look at how it works. Stock photographs are really licensed, not sold to clients. The copyright holder (generally, the photographer who produced the work) places an image or series of images with a stock photo agent, who maintains a library or file of images that he or she markets to photo buyers at ad agencies, design firms, book and magazine publishers, and corporations, among others. Traditionally, successful stock agency marketing efforts have relied predominanatly on printed catalogues of images, which the agencies distibute free of charge to buyers.

WHY PHOTOGRAPHY BUYERS LIKE STOCK

Without question, the stock photography industry is maturing. If you could compare the stock business to the development of television, it might be accurate to say that the stock industry is now where television was in the 1960s. Even at this fledging stage, however, stock photography has had a significant effect on the assignment photography business.

Current research indicates that roughly 75 percent of assignments are gone forever, compared to the pool of available assignments as recently as 10 years ago, due to the wide acceptance of stock photography and CD-ROM photo collections; nearly 8 out of 10 photography buyers are choosing to use stock over original photography. According to recent survey findings published in industry magazine *Graphic Design: USA* there are eight reasons for this:

1. Stock offers relief from deadline pressure. As clients become more demanding, and deadlines more overwhelming, many see stock visuals as a fast way to visualize a concept and produce a finished piece.

2. Stock alleviates budget pressure; it is often a cost-effective photographic solution.
3. Often, it's not possible to achieve the photographic results clients want; stock photo libraries offer a wide range of options and substitutable images.
4. Stock archives are a unique source for nostalgic and historical images. They are therefore well suited to the recent nostalgia craze.
5. Many no longer see stock photography as a compromise, but as an increasingly high-quality source of original images and creative ideas.
6. In general, stock agencies provide more choices of images.
7. With standard, routine procedures for researching, licensing, and delivering images, some find it easier to deal with stock agencies than directly with photographers.
8. Digital technology is making it easier for people to search, import, experiment with, manipulate, and combine stock images.

The feelings of nostalgia and strength imparted by the three ladies in this image, by noted photographer Chuck Kuhn, are qualities that sell in stock photography. Images like these, could have a variety of end uses and, therefore, are very well suited to stock. Stock archives provide a unique source for the nostalgic and historic images that are so popular now.

Stock has definitely taken over a great deal of the assignment work. These days, most of what's left for assignment photographers are shots of specific people, places, or things that can't be found in stock. If a required image is anywhere near generic, art directors and designers will most likely look at stock first.

There are, however, some downsides to using stock. According to photographer Chuck Kuhn, clients must realize, if they add up the true cost of stock, including research time, and other hidden costs, that it pays to commission original photography. Another potentially negative aspect of stock photography is that the images clients pick may very well turn up in other companies' ads or brochures, perhaps even those of their competitors. Even worse, clients may find that the images they've rented also appear in not-so-appealing venues, such as condom ads.

When a buyer chooses stock, they forgo a certain degree of exclusivity. For many, however, this factor is outweighed by the convenience and monetary savings of using stock photography. For others, exclusivity is a more critical parameter; the issue of controlling an image is vitally important. These clients ask questions such as, When was the image used and by whom? And, when can it next be used? (Stock agencies keep track of information like this.)

Despite the drawbacks, stock works for two reasons: time and money. It all comes down to availability and affordability. Timewise, today's fast access to vast stock libraries—accessed via print catalogues, CD-ROM catalogues, and online retrieval systems—make it fast and simple to find an array of images. Moneywise, this yields significant savings that are extremely attractive to cost-conscious buyers.

Using stock remains more cost effective than commissioning original photography, and the advent of online delivery systems seems to indicate that some areas of the stock market will continue to experience declining costs. In today's marketplace, one in which most major corporations have drastically reduced staff and looked into every nook and every cranny of their business for ways to cut costs and reduce overhead, stock photography is often the only photography that can be used. Many companies simply can't afford to hire photographers.

STOCK'S IMPACT ON PHOTOGRAPHERS

According to industry professionals, stock is accounting for a much larger portion of photographers' incomes. A few years ago, stock only accounted for about 5 percent of average salaries; now, it's responsible for 40 percent. More and more photographers are relying on stock sales and production to supplement declining assignment earnings.

In the late '80s or early '90s, shooting stock was something of a gamble. There wasn't the same

While sales of photos of landmarks, such as the Washington monument, have consistently proven to be good investments for repeat stock sales, the market for stock photography has become more sophisticated and demanding, with agencies seeking images of subjects that once were exclusively the domain of assignment photography, such as multigenerational families doing everyday things, business situations, and sports.

demand for stock as there is now. Today, however, photographers shoot specifically for stock, and the stock houses often supply photographers with lists of the images that they have a need (and a demand) for. These "wish" lists help give photograpers some direction when shooting stock images. Knowing in advance that a need exists for certain types of imagery can be very helpful.

With the profusion in the '80s of stock catalogues, all the available images started to look the same, and stock became something of a cliché. Market demand for new and different imagery produced a rebirth of sorts in stock photography; there was a definite effort to broaden stock's repertoires.

With the enormous growth and acceptance of stock photography as the first choice of buyers, things have changed. With the burgeoning market for stock, and the sharp increase in the number of photographers producing stock, the quality of "canned" imagery has

changed. Generic shots, such as sunsets and scenics, have given way to heavily orchestrated and targeted image production by specialists. Clearly, the savvy photographer who creates unusual and on-target pictures will be more successful in the coming years than one who is still out shooting generic images.

Serious stock photographers like Steve Marks of Albuquerque (one of The Image Bank stock agency's main shooters) are now producing different kinds of images. In fact, he is presently enjoying strong worldwide sales of one image he designed—a shot of industrial gears with individual computer keyboard keys smattered throughout. The success of this image may be due to the fact that it offers a different way of visualizing the impact of technology on manufacturing.

Look is everything, especially in the stock business, as the flourishing Japanese stock agency Photonica happily discovered when it opened its American office a few years ago. Photonica images have a startling graphic and distinctly foreign feel, even though the agency added more than 100 American photographers to its roster. Phototonica's success is so awesome that, according to their New York office, they can't keep their catalogues in stock.

The path to the future is not as clear cut as it once was. We're on the verge of a new electronic frontier as the stock business continues to go through jarring and profound changes in the next decade. Photographer Craig Cutler, one of the new generation of super-successful commercial photographers, feels that there has been a big change in the direction of stock, with a lot of "alternative stock" wannabe agencies out there trying to feed on the same market that has made shops like Photonica so successful.

Cutler's flourishing assignment business keeps his New York City studio hopping, and he submits his personal work to his stock agent, GraphisStock. He explains how he works in relation to stock:

> I compile work from personal shooting trips I take, like a recent trip to Romania, and submit some of those images. I submit what I have, I don't go out and shoot work just for stock. I see stock right now as more of a way to show my work than a money-making thing for me; it's a way to get more work out there right now. However, I don't submit everything to the stock agency; some agencies are giving away your images for whatever they can get for them.

Photographer Craig Aurness says that one of the unfortunate problems with stock photography is that photographers have often tried to treat stock photo collections as a kind of retirement fund or annuity.

> The thinking is that, as they get older, photographers will be able to live off of the income their stock collections generate. They're forgetting that

graphics change rapidly, and the graphics market demands a new look.

Couple this with the introduction of new brightly-colored films, such as Fuji's Provia (and also the older Velvia), and photos made on Ektachrome and Kodachrome may have a diminished value.

Looks, styles, skylines, hairstyles, auto designs all change. And, photography is no different. The images that you hoped would generate your retirement income, may potentially decrease in value in years to come due to changes in technology and style.

PROS AND CONS OF SHOOTING FOR STOCK

The number of photographers who are opting out of the rigors and challenges of competing for fewer jobs in a dwindling assignment photography market and entering the realm of stock imagery is growing daily. Top shooters report that they've seen the market for assignment photography shrink so much that, in their seasoned opinions, it's almost not worth remaining in the arena.

Without question, anyone who is the least bit interested in making money in the stock photography industry has to understand the forces at work in this complex business. One of the best sources of information is Westlight stock photo agency's *International Report on Stock Photography*. It's a critical guide to an industry in flux and covers innumerable issues, from pricing to payment to things photographers should know prior to signing up with an agency. Get a copy immediately and read it; it will change the way you think about stock photography. (See Resources for ordering address.)

Another tool is Jim Pickerell's annually produced book, *Negotiating Stock Photography Prices*. Also a must have, it's chock-full of listings for just about every conceivable pricing situation that you'll encounter. (See Resources for ordering address.) Jim Pickerell also publishes *Taking Stock,* an informative newsletter for stock photographers that comes out six times a year.

Along with the decision to move into stock production, and away from the pursuit of assignments, comes a whole new set of rules, needs, and challenges. The one big difference between shooting assignments and producing stock is that assignment work yields payment in a relatively short period of time—within weeks (if your collection process operates at top speed) or (more commonly) months. Stock photography, on the other hand, involves a long-term earning process. This is because you must wait for images to sell, billing to take place, and payment to be made by buyers before you finally receive a *portion* of that income as a residual check. This can take years to build into replacement income. The lag between pro-duction and profit-making can be substantial, and sometimes challenging.

If you're shooting stock, you must be able to supply expense costs up front at production time (and wait, long-term, to recoup those expenditures). If you're traveling to exotic places to shoot, this can require significant capital. Once your payments start to roll in, though, it becomes easier to pay for production costs out of residual earnings.

Other differences between stock and assignment production involve things like deadlines and stress. Stock offers relief from both of these things. For example, it's absolutely wonderful to be free from the need to constantly seek new assignments, especially in a sharply diminished assignment environment that often causes more stress. It's a truly desirable industry asset, albeit one that takes time to adjust to.

Many photographers are able to make the transition from assignment to stock photography slowly, building up cash reserves and stock images while doing traditional photo jobs. Eventually, if you're capable, persistent, and savvy, you can establish a successful full-time stock-based business. Steve Marks, mentioned earlier, did. Over a decade ago, when he recognized that assigments were becoming more scarce, especially in the relative outback of New Mexico, he began to concentrate on producing targeted stock images. Today, his stock photographs sell worldwide, and he enjoys a very significant six-figure income from his work. Recognizing that the stock arena is becoming more and more crowded, he also recently began shooting stock *film* footage. He now enjoys the freedom to shoot what he wants, when he wants, and without having to cater to the whims and requirements of clients.

Stock film, although a relatively new venue, is growing considerably, thanks to the needs of filmmakers and commercial producers. Watch for significant growth here as the Internet becomes more widely accepted and used, and as computers become faster and better at accommodating the showing of video and film clips online.

As the assignment market continues to shrink, producing stock imagery makes great sense. Directing your business toward stock frees you from the linear rigors of continually looking for assignments, shooting for clients, delivering the shots, and then being out of work. With stock, you have the ability, to some extent, to make money while you sleep.

Producing stock instead of assignments has it's own concomitant set of challenges, however. You're swimming in a sea of competition as more photographers turn to stock. Success in stock requires effective stock marketing and promotion. And, for the multitude of photographers who opt for agency representation, entering the arena means that you'll be depending on others to get your work out and your checks in.

SELECTING A STOCK AGENCY

You can't be everywhere at once, and no matter how savvy you are, it's nearly impossible to reach all of the stock photography markets out there on your own, without the help of a good stock agency. Finding the right stock photography agency can be as challenging as finding the right mate.

As in relationships, it's critically important to make sure you know who you're getting involved with. Careful research is essential. Get the names of several photographers who are with the agency or agencies you're considering joining, and find out how things have gone for them at these shops. You may also want to call a trade group, such as ASMP or APA, to find out if any complaints have been lodged against the agency in question; you might even check with Dun & Bradstreet to find out about agency creditworthiness, assets, and personnel.

Some stock agencies, such as The Image Bank, have advisory boards made up of photographers that can often provide good information about how the agency works and whether there are any "challenges" of which you might want to be aware before you sign up. For example, important in any contract with an agency is some sort of exit option, because all things come to an end at some point. One issue is the return of your work after leaving an agency. (Consider asking for work to be returned in 30 days from the agent, 60 days from any subagents.) Another important thing is getting paid. (Try to get paid monthly, or at least in a timely fashion.)

Other points to consider include the right to look at the agency's financial records if you have concerns about getting paid; this should also extend to any sub-agents, especially if you give the agency the right to sign agreements with subs. Ideally, you should know who's using your images, for how long, where, at what size, for how many uses, and other pertinent data.

Ultimately, knowing what happens at the end of your relationship with a stock agency is just as important as having a full understanding of what happens at the beginning. Always be prepared for the best of times as well as the worst of times.

Years ago, it was possible to hook up with more than one agency. The stock industry was in its youth, and agencies everywhere were vitally interested in building their files. It was a time of gathering images, and agencies were inclined to be somewhat more liberal both in terms of contractual exclusivity and in the types and quality of images that they accepted for their files.

One of the all-time champs at securing multi-agency representation is Jim Pickerell, who at any given time has two dozen or more agencies selling his work around the world. While this strategy has worked well for him, many top agencies these days

Westlight is one of the leaders in the stock photo industry and made early and extensive use of emerging technology in its marketing efforts. Under the guidance of founder Craig Aurness, Westlight's efforts, such as this CD-ROM catalogue, have helped it grow and emerge as one of the preeminent marketeers of stock imagery.

require exclusive contracts, which means putting all of your stock eggs in one basket.

According to Westlight's agency director Craig Aurness, each agency has a very different character. Westlight, for example, is very digitally driven; coupled with in-house scanning capability. As Aurness explains:

> We have a team of about 15 people devoted to digital image projects. We're a very computer-driven company, preparing ourselves for the multimedia marketplace. We feel that you can work closely with a small group of productive photographers and produce what customers want. We have fewer photographers, and we focus on the production side of imagery, which means consciously going out and trying to get the images we need, rather than waiting for "seconds" (outtakes) from assignments.

Craig adds that some agencies depend on photographers whose primary source of income is assignment work; these agencies receive a lot of outtakes from assignments. Other agencies, such as Comstock in New York, are essentially production companies that look for "stock-driven" photographers.

GETTING IT IN WRITING

Traditionally, stock photo agencies have provided photographers with services such as marketing and sales of their images; storage, delivery, and recovery of photographs; and negotiation of fees for licensing the images to users. This fee is generally based on specific contract terms between photographer and agency. While most agencies are fair and reputable, contract terms vary from agency to agency. And, when it comes to contractual arrangements, it's important to realize that agencies present photographers with agreements that favor the agency.

Straight Shooter Studio, Inc.

123 Anystreet, Hometown, ZX 12345 • Telephone: 123-555-1212 • Fax: 123-555-2121

STOCK PHOTOGRAPHY DELIVERY MEMO

Date shipped: _____ Reference # _____ Return Images by_____

Client:

Description of Images:

Qty.	Orig.(O) Dupl.(D)	Format	Photograph Subject/ID No.	Value (if other than $1,500/item) In event of loss/damage

Total Count: _____

Title in the copyright to all images created or supplied pursuant to this agreement will remain the sole and exclusive property of the photographer. There is no assignment of copyright title, agreement to do work for hire, or intention of joint copyright expressed or implied hereunder. The client is licensed only by subsequent written license on an invoice. Proper copyright notice, which reads: © 19___ Straight Shooter, must be displayed with the following placement: _____. Notice is not required if placement is not specified. Omission of required notice results in loss to the licenser and will be billed at triple the invoiced fee.

Check count and acknowledge receipt by signing and returning one copy. Count shall be considered accurate and quality deemed satisfactory for reproduction if said copy is not immediately received by return mail with all exceptions duly noted. Photographs must be returned by registered mail, air courier or other bonded messenger which provides proof of return.

SUBJECT TO ALL TERMS AND CONDITIONS ABOVE AND ON REVERSE SIDE

_____ _____
ACKNOWLEDGED AND ACCEPTED DATE
(Please sign here)

Your acceptance of this delivery constitutes your acceptance of all terms and conditions on both sides of this memo, whether signed by you or not.

Any contract is nothing more (or less) than a starting point, a basis for negotiation and agreement. It's always good advice to look before you leap, or sign. Get a very clear understanding of the terms and conditions being offered to you and realize that everything is negotiable. You should be able to adapt the specifics of any contract to your needs. ASMP's *Stock Photography Handbook* is a good resource in this area, providing a wealth of contract information. Also, try to sign with an agency that belongs to the Picture Agency Council of America (PACA); this organization's members follow a well-developed code of ethics, and this can make your life simpler in times of challenge and dispute.

A good stock agreement is your basic protection during your relationship with an agency. Most contracts contain the same, basic wording, but most good agencies will consider being somewhat flexible when you present them with reasonable requests that diverge from the standard paperwork. Again, always take a close look at what you're being asked to sign, and consider having an attorney take a look at any contract before you sign it.

Be vigilant about your interests. The best time to speak up is before the ink dries on the contract. If you're not 100 percent clear about the terms, ask questions. If you don't like the answers, be as flexible as you can, but don't give up anything that is basic and important to you. If something doesn't sound good to you, try modifying it to suit your needs. Some agencies may take a hard line with their contracts, however most will be reasonable and listen openly to

your requests. If the agency you're considering is turning a somewhat deaf ear to your concerns, you may want to consider other representational options.

Contracts shouldn't automatically renew themselves; you should have the same rights to terminate as the agency. It's also critical that you know what an agency is deducting from your earnings, and you should have the right to set limits. Contracts should protect you in this regard. Agencies shouldn't be able to hold your images as collateral if you decide to leave. Furthermore, if a lawsuit ensues, you should be allowed to have your say. If an agency infringes on your rights, you have the right to proceed with the necessary action to ensure safe return of your images.

Other contract issues include who pays for duping and cataloguing costs, and whether or not there are volume or bulk sales discounts. It pays to sift through each section of your contract carefully; although contracts are only just words on paper, those words might cost you—or save you—hard-earned money at some point in the future. Diligent homework reaps great rewards.

As mentioned above, these days most agencies ask for or demand exclusivity when you sign with them. In return, you should weigh what the benefits are to you. Are you ensured of having more of your images in their catalogues? If you specialize, will the agency limit the number of other photographers they sign who share your specialty? Are there service charges or filing fees? Is the agency involved with online distribution and other electronic and digital options and services? (Pay attention to online distribution; this is the future of stock.) And, if so who pays for this stuff?

Make sure you're aware of any digitizing of your images; don't give agencies the right to automatically grant permission to do this. Once images are in digital form, distribution becomes very easy, and there's an increased possibility that some usage is going to go unnoticed, costing you money.

In any situation, if that little voice inside you is telling you that something's not right, consider looking elsewhere for representation. Doing good homework prior to signing a contract is certainly challenging, but even more challenging is deciding what to do after the fact (perhaps years down the line), when things are consideraby more difficult and potentially more costly.

CLIP DISKS

In addition to selling stock through agency representation, there are a number of other marketing avenues open to photographers with images to license. Some photographers elect to buy space in one of a number of sourcebooks that feature stock exclusively, such as *Direct Stock* (see Resources.) Another venue, which has been historically disdained by photographers is the clip disk market.

The reasons for this unpopularity are the low payouts to photographers combined with licensing giveaways that boggle the mind and fly in the face of traditionally accepted licensing practices. Photographers and related trade organizations (like ASMP) fought over these licensing standards for over half a century.

Payments are low because clip disks, by their very nature, offer a much smaller financial harvest to the photographer than stock sales via agencies. With agency representation, one quality image might sell numerous times over a long period, bringing the photographer a handsome, if residual-based, stream of income. Clip disks, on the other hand, generally house collections of images and the entire disk is often sold to an end user, who in purchasing the disk, is then licensed to do absolutely anything with the images on that disk in perpetuity. There is no residual income, only a small check each time a copy of the disk is sold.

This adds up to much less income. And now, the battle lines are getting blurry: some of the better known clip disk makers, such as PhotoDisc, are enhancing their disk sales with online delivery options, making one image available at a time, just like traditional stock photo agencies.

These days, most of the typical generic pictures that populated the files of stock agencies in the early days of the business are offered with limitless usage at bargain-basement prices by the clip disk industry. Ken Cosgrove, principal at Carter Cosgrove, a Washington D.C.-area advertising and design firm, recently spoke of one of his new clients, who was in the flower business:

> Ten years ago we would have hired a photographer and given him or her a budget to shoot for two or three days and produce a library of images to illustrate the work this client needed. Instead, we were able to purchase three CD-ROM clip disks containing hundreds of floral images for about $250. That adequately covered this client's photography needs for the next two or three years.

This is smart business for design agencies, but bad news for assignment photographers. Welcome to the future. Advertising agency art buyers report that clip disks are fast becoming a more significant source of photography. It's not uncommon for agencies to purchase large collections of clip disks from a variety of sources and have their (relatively inexpensive) staff members use software like Photoshop or Live Picture to assemble different elements from a variety of disks and create new images that fit the needs of their clients. Clients are still paying for photography, but it's no longer the photographer who reaps the rewards—it's the agency or clip disk publisher.

This is a legitimate process. The ad agencies are licensing pieces of photos and constructing new images. And, in case you think that clip disks just have

shots of sunsets and flowers, take a look at recent catalogues from any one of the major industry clip disk producers, such as The Image Club or PhotoDisc. The quality of the images, as well as the range and depth of subject matter, is startlingly strong and getting better with each new release.

Clearly, this cuts into the stock photo market and the traditional methods of marketing. Some photo collections on CD-ROMs offer more generic and less creative images for prices that are so low they boggle the mind! Consider Corel's Stock Photo Library for PC and Mac. According to company literature, they offer "20,000 of the best high-resolution photographs chosen from the millions submitted to Corel! Royalty free for use in everything from advertisements to presentations!" If you do the math, this works out to less than $.04 per image—for unlimited usage.

What photographer can make a living selling images for less than $.04 per image? This doesn't even pay for film costs! Yet amazingly, people are, according to Corel, vying for the right to supply images to them. In the same literature from Corel, down at the bottom in five-point type is a solicitation to photographers that says something like, $ATTENTION$ Professional Photographers—have your work published in the world's leading photo CD-ROM collection. This is very scary stuff.

Even more alarming, according to Jim Pickerell in his *Taking Stock* newsletter, are some of the terms and conditions that Corel requires of its contributing photographers, including assignment of all ownership and intellectual property rights to Corel, and indemnity—which, according to Jim's read of Corel's contract, means that if there's a person or a piece of property in any of the pictures, and the person or property owner decides to sue for any reason whatsoever, legitimate or not, the photographer agrees to pay all defense costs in the suit and is responsible for all judgments. Since photographers who sell to clip disks have absolutely no control over how the images are used, they're exposing themselves to tremendous risk.

Despite the fact that clip disks have long been seen as the bad boy of the photo-marketing world (and deservedly so considering the low remuneration available), the growth of both the number of clip disks out there and the overall quality of the imagery on them means that, for some photographers under some conditions, this might be a viable marketing arena. As image prices are driven downward by the marketplace and by online pioneers, some photographers may find clip disk sales more and more attractive.

In a recent solicitation to photographers, PhotoDisc, Inc. (which claims to have started the digital stock industry in the early '90s), alleged that there are distinct advantages to contributing images to clip disks. Unlike traditional stock agency marketing avenues, PhotoDisc says that it puts images directly in front of potential buyers. PhotoDisc also says that it bears all the costs associated with the acquisition, editing, scanning, production, distribution, and marketing of photographers' images. The Seattle-based company is on the cutting edge of technology when it comes to marketing, using CD-ROM disk products, an online venue (PhotoDisc Online), and their own web site on the Internet.

Compensation-wise, PhotoDisc photographers receive 20 percent of net receipts on disk sales (which is 50 to 60 percent of the retail price), and 20 percent of the retail price on single-image online sales. Disks retail for $150 to $300, with online images selling for $10 to $190 per image, depending on file size and rights granted. The company says that disks sell at an average rate of 150 units per month. With a disk that costs $150, photographers could earn $4,500 a month or $54,000 a year ($150 x 150 units x 20% = $4,500 per month x 12 = $54,000 per year). And this doesn't include single-image sales from PhotoDisc Online (which the company feels could potentially exceed disk-based sales).

At PhotoDisc, photographers retain all copyrights to their images. Contract lengths are seven years, during which time the company has exclusive rights to license and market photographers' images in digital form. Only model- and property-released images are accepted. According to Adam Flick, acquisitions coordinator at PhotoDisc, unlike traditional stock agencies, once PhotoDisc accepts and scans images, they place them online at once and market them directly to targeted customers. The pictures can therefore begin earning revenue immediately. At traditional agencies it can take one to two years before you start seeing sales. Clearly, this is a much better deal than the folks at Corel are offering.

Clip disks and the capabilities of image-manipulation software like Photoshop and Live Picture are having a profound effect on the market. Some industry professionals feel that even though conventional stock houses may have better quality, the quality, availability, and selection available on royalty-free clip disks are changing every day. While, as recently as one year ago, there was only a paltry selection of photos on CD, today the choices are so much better that there's a very good chance clients can find the shot that would have cost them $3,000 to $4,000 to have produced on a $200 clip disk (especially if they're willing to manipulate the images).

And, while traditional stock agencies may offer the best images, both in terms of content and technical quality (using actual transparencies as opposed to compressed digital files), delivery time, price, and image control and manipulation are often more important factors. Yet, with all the advantages of cheap images ready for the taking, clip disks are not for everyone. Marcus Liuzzi, creative director at

Crossroads Communications (a marketing communications firm in New Hampshire), prefers traditional stock agency catalogues to a shelf full of clip disks hands down. He feels that he might end up spending $1,000 on clip disks and still not find the image he wants because the photographic quality is not there.

STOCK AGENCIES ARE CHANGING

In recent years, many of the larger agencies have gobbled up the smaller ones. It's becoming a different industry for people like Vince Streano who, with his partner Carol Havens, markets his own stock photography. He has already felt the effects of this industry consolidation.

> We've always had the philosophy that we were never comfortable putting all our eggs in one basket, but three of our six or seven major agencies have now consolidated themselves into one agency, and we're almost forced, here in the United States, to go with one major agency, which we haven't been comfortable about doing in the past. Years ago, agencies would take almost anything you had just to fill their files. Nobody cared about exclusivity, because the agencies were only marketing in limited geographical areas; so photographers could sign with numerous agencies, and it worked out very well.

The advent of catalogues also changed the picture. With their stock catalogues, agencies were able to leap geographic bounds, and they started wanting to represent photographers on an exclusive basis to avoid seeing their photographers' images in other agency catalogues.

Now, unless your work is in the stock agency catalogues, it's no longer reaching a large enough market. You have to ensure that your work is promoted well. If agencies take a lot of your images and only put two or three of them in their catalogues, you'll be lost because 75 percent of all stock agency sales are now made directly from catalogues. Only 25 percent of sales come from agency general files. All the wonderful pictures sitting in files are almost never seen. Vince Streano explains:

> The bad thing that the catalogues have done is make art directors very lazy people. Instead of coming up with new concepts and new images, art directors now pick up the closest stock catalogue and start thumbing through it to see what the agencies have that will work; so virtually the only pictures that get promoted—and sold—are the ones in the catalogues.

Certainly some agencies are less dependent on catalogue sales, but overall, this is a significant factor to consider if you're in the commercial photography business and are interested in increasing your stock photo sales.

WESTLIGHT'S REPORT ON STOCK PHOTOGRAPHY

Someone who is part of the wave of change that is overtaking the stock photography industry and is helping to shape the future is Westlight stock agency's Craig Aurness. Anyone who wants to know what the future holds and intends to make money in the stock photography business must read the latest edition of Westlight's *International Report on Stock Photography* (see Resources). This incredibly comprehensive document offers a view of the future and a report on the state of the industry today.

Of particular interest is information about making the transition to new digital media. Aurness feels that the next decade may yield digital cameras offering resolution rivaling that of today's films.

As we become more and more entrenched in the wide world of desktop and multimedia publishing, it's important to understand the costs and difficulties involved in going digital. The market for digital imagery is enormous, but it's important to ask who will bear the initial cost of scanning and who will cover the annual cost of storing these images. Larger files become increasingly harder to manage, and sheer volume may discourage buyers from using one system or another.

Aurness feels that while the cost of putting images into files will go up, the cost of editing and delivering them will go down as clients begin to do the image research themselves. Clients will have instant access to enormous photo resources. They'll have comp images at the push of a button, with overnight delivery of image files or separations, and fewer people involved.

Since photographers cannot ignore the need to get into the digital market, they will have to begin locating digital services, which stock agencies may or may not offer. Photographers will need to carefully evaluate potential agency representation in several areas, including online catalogue capabilities (which offer control of image distribution via the agency's file servers) and CD-ROM catalogues (which can hold thousands of images but are at virtually unusable low resolution and are not intended for re-use as "finished products"). As Aurness explains:

> Photographers must position themselves in selling environments in which the volume will make up for decreased prices. . . . To survive, photographers must be sure both that their images will go digital and that they are assured of volume sales. Clearly, successful future image producers must embrace digital imagery, not fight it.

The issue of scanning is key in the digital world, and like all things in life, there is both good and poor quality. What really sells a photograph is its visual presentation, and in the digital arena, good visuals come down to good scanning. When choosing agencies for representation, consider whether they are

using PhotoCD scans or higher quality drum scans, and whether enhancements are being made to scanned imagery. Also, make sure that if an agency is making duplicates of your work, the dupes are of the highest possible quality. Are density and color balance being accurately conveyed throughout the scanning process? It's critical to consider all these things before choosing agency representation.

The confluence of digital media and traditional photography is making for some strange bedfellows, as some bewildered software programmers who combine images find that they are subject to copyright laws, too. More changes will come as whole new industries evolve that will use digital imagery but not transparencies. What does this mean to image producers? Some of the issues that will gain importance include photographers' abilities to shoot well-composed horizontal pictures because of the requirements of the horizontally oriented television and computer displays; shooting sequences of images that relate to one another, with multimedia and other uses in mind; and shooting mood-setting and sound-evoking images, such as those with ocean waves and lightning.

With widely distributed clip art imagery, clients will expect to get copyright images for less money than they'd pay for assignments, or even stock. Further, with online delivery available from international sources, you won't be competing with just a mere handful of other images; you'll be competing globally with worldwide photo libraries. Only the best of the best will make the sale.

Those with collections of still images may find their photographs increasing in value, while individual frames will decrease in value. So, agencies will look for volume sales to offset the lower profits they'll be making per image. In response, some clients may start buying images in bulk to get volume discounts. This will put increased pressure on agencies to streamline and reduce costs as they try to transfer some of the labor-intensive expenses of the image research and delivery processes to their buyers.

Clearly, as volume sales become the norm, photographers with larger, varied collections will fare better than photographers with limited collections. Agencies will try to work with fewer photographers to produce larger checks for them. Agency costs will become a more significant factor. Consider these Westlight figures: To place a single image in a physical file cabinet storage now costs approximately $5 to $10; to place the same image in a print catalogue with a reasonable distribution costs $800 to $1000. To store the same image digitally will run $25 to $75 depending on the format of the photo. This is significant savings, considering that if the scans are of sufficient quality, agencies will be able to deliver the same images over and over, further reducing the need to make transparency duplicates.

This cost shift will have a direct bearing on how many new images will be accepted for general files and for catalogues. Who will this affect? According to Aurness, production photographers, who will need at least five times the selling efficiency per image to break even; he adds, however, that these photographers will be able to afford to place more images in electronic catalogues, so their visibility may increase.

Making sure you're with the right agency is critical to attaining success in the future of stock photography. If you're not 100 percent certain that your agency is best for you, it's important to gain a solid understanding of what the relevant issues are. Get out and survey what's available to you. The agency business is changing and so are the agencies themselves. Getting in early, after doing your homework, and keeping up with developing issues may be your best protection. Take a look around you at which agencies are actively acquiring collections of images, especially unusual ones, and you'll discover who might be a future leader in the field.

Aurness advises, looking for agencies that have good-sized collections; unique images; limited file competition (not too many photographers); profitability; honor and concern for one another's future; team spirit among owners, staff, and photographers; and, critically, technical expertise in scanning, keywording, and all things digital.

ELECTRONIC MEDIA DELIVERY

Catalogue presentations of extensive stock files are now giving way to electronic media delivery of images to buyers, using both CD-ROMs and online capabilities, such as PNI (Picture Network, Inc.). These services have made very strong inroads into the market thanks to advantages like eliminating the need to work with a researcher or to wait to use traditional image delivery methods. Picture prices on these services have dropped to dramatic levels, which is causing alarm and concern among photographers, and as image delivery via the Internet comes more into play, prices will potentially continue to fall.

For some buyers, these services still have limitations, including the perception that there isn't enough variety among online images and that there's a lack of good people pictures both online and on clip disks. (However, royalty-free collections of images offered on CD-ROMs, which often contain hundreds of images, offer prices that often boggle the mind.) As Bev Don, vice president and manager of art buying at Wells, Rich, and Greene/BDDP (an advertising agency in New York), explains:

I tend to want pictures of people doing things, and the better images are coming from conventional agnecies. It's important to be there at the

beginning [of online digital stock service], but I have not found enough images there yet.

The acceptance and use of online delivery is growing significantly as more images become available. After speaking with industry experts, it's clear that the future of the industry lies here, with buyers executing image searches and receiving delivery of images over the Internet.

The burgeoning acceptance and increased demand that stock imagery is enjoying is only one of the forces propelling the industry forward. An even larger trend is the acceptance and demand for technology in the business world, which is binding the entire world together into one global marketplace. When electronic delivery of stock imagery becomes more sophisticated and makes full use of the Internet's capabilities, and when the majority of buyers acquire the hardware to receive online stock transmissions, the stock business will look quite different than it does today. When this industry matures more fully in the next 10 to 20 years, technology will be the glue that holds it all together, facilitating the exchange of images for dollars.

Even now, profound changes are taking place. Enterprises that in the past had little or nothing to do with photography or publishing are now bellying up to the techologically based future. Take a look at the stock photo industry's new giant, Microsoft's Bill Gates. With the deepest of pockets and a hunger for expertise and imagery, Gates' company, Corbis, is building perhaps the most visionary image archive around. For the past few years, the firm has been gobbling up electronic rights to the world's great art. Now, with the recent acquisitions of The Bettman Archive (which, incidentally, was the world's first stock agency) and innovative photographer Roger Ressmeyer's Starlight collection, Corbis has, in a few short years, become one of the most dominant players in the industry.

According to some sources, Corbis is bringing the traditional photography business into the digital world. Corbis' Mark Daniel, former marketing director at Comstock, believes that Corbis is a company that will dominate the marketplace as it moves from analog to digital distribution of images. Corbis' ultimate goal is to build an archive that illustrates the entire breadth of human experience using both existing collections and commissioned work that fills in any gaps. Quite a mission statement and quite a harbinger.

GETTING ONLINE

Online delivery means that images are provided directly to clients via modem instead of through traditional stock agency channels. The Internet will be playing a massive role in this area. An online library is queried by a buyer using keywords and other data parameters.

The search rummages through the online library and counts the number of images on file that meet the criteria described. Low resolution thumbnails are then offered to the client, who can then go offline to review the images without continuing to run up access charges.

Depending on the service accessed, a licensing fee may be negotiated, followed by a high resolution download of the images requested, with some sharing of the fee between the online service, any agencies involved, and the photographer who created the image.

As information networks proliferate—ranging from existing commercial outfits such as America Online, allied communications industries such as CNN, Time Warner, AT&T, and IBM, and Corbis—it becomes clear that the stakes are gargantuan. The expression "going national" is being supplanted by "going global." Quality, not volume, will become the critical parameter as the best images compete with one another in the new world of cyberstock.

Consider that most clients today work with a few agencies, favoring certain represented photographers. Now, global networking will allow clients to view images from hundreds of agencies and thousands of photographers. This means that buyers will be forced to search more narrowly, initially by keywording, then by image-to-image evaluation. The winning images will be those that have the best combination of precise keywording and visual excellence. If you want to survive and prosper, you'll need to consider the following: Avoid getting locked into one specific online network too soon. No one knows which one is the best yet. (Think of all the people who bet their farms on the Betamax video format.)

Most future global networks will be aimed at consumers. This might include students, home users, and other noncommercial customers. The "image community" is so fearful about the future that online services are trying to find and buy collections they can control, rather than trying to convince photographers about high-volume futures.

The graphics community may continue to remain interested in images of different, creative, strong quality. If this happens, those photographers with unique images that are unavailable from other sources will prosper. If you want to be a player, you'll need to be affiliated. No individual photographer has the volume, variety, or editing objectivity to be successful.

According to Craig Aurness of Westlight stock agency:

Online services have the potential to change the future of stock photography. Unfortunately, the future they will shape is not necessarily in the best interest of everyone participating in the services. [They will] increase the cost of doing business for agents and photographers, while at the same time reducing revenue.

The good news with online collections, however, is that clients will have access to a continually updated flow of new imagery. What happens is that with all of this imagery available on the desktop, clients are potentially able to access similar images from competing agency sources and bargain with agents seeking sales for better prices. In theory, higher volumes will make up for lowered prices, but the results are not yet in. The anticipated market that online services has the potential to create is out there already.

Aside from the photographers, stock agencies, and the clients, with online photography there's one more player—the transmission service. At the transmission end of the equation, there are development and technology costs to bear just to get up and running. Transmitters need quality images that will sell so that they have something to transmit, and they need to provide these images without pricing users out of the marketplace.

Photography buyers need to pinpoint images quickly, efficiently, and economically, and with online transmission they have the potential to do just that without having to go through stacks of print catalogues to find what they're looking for. Commercial photographers have a need to make a decent fee on stock sales, yet to have online services succeed, there will have to be a shift of some costs back to the stock agency or the photographer.

As business develops, watch for some parties to try to squeeze competitors out of the market. For example, photographers might work directly with transmission services and cut the agencies out of the equation, or transmission services might seek to acquire imagery in order to eliminate agencies. Free market forces will try to find a way to deliver images to the end consumer more efficiently and, therefore, more cost-effectively. Craig Aurness explains what will happen as a result:

> Most photographers will prefer to retain their stock agencies so that their images will reach a larger market and so that there are good reasons for electronic picture services to keep stock photography agencies as intermediaries between themselves and photographers.

Other factors that will have global effects are:

- Whereas stock agencies have historically given away millions of free catalogues to qualified buyers, online-based libraries will charge access fees to the end user.
- Where stock shops typically waive or refund both comp and research fees, online services won't.
- It will become extremely expensive to produce duplicates to support images without having well-managed and manageably sized agency files.

Some clients will still look for film-based images (as the end product), even though they're using digital technologies to locate those images. Also, while an annual fee is charged to both image providers and users, subscribers to online transmission services are paying for software ($50 to $500) plus a substantial per-hour fee for online access time, as well. The irony here is that what subscribers get for this money is the opportunity to do themselves what the stock agencies have been doing for them for free or for modest research fees.

The bottom line is that stock photography agencies need to reach the right clients worldwide in the most economical manner possible, and the cost of preparing images for online transmission may increase their upfront costs significantly beyond the traditional cost of bringing new images into the file. And, photographers will need, among other things, a structure that permits them to make a fair profit and ensures that the system is capable of protecting and upholding their copyrights.

Transmission services will most certainly have to recover their investments partially from end users and partially from stock agencies and photographers. Overall, anyone interested in participating in the marketing of images, whether they be photographers or stock photo agents, should be learning as much as possible about these factors, for they will most certainly affect future income.

Ultimately, the largest buyer of imagery will be the electronic community for electronic, not print, reproduction. Photographers are going to have to read and learn more to keep current with the trends that are driving the industry. As Craig Aurness explains:

> It's not just a matter of being a craftsman and making a good image—it's [making] a good image for *what* marketplace. In the future, volume will increase and prices will go down, which means that you have to have efficiency. You have to produce material that people want to purchase; they won't just want one frame, they'll want a cluster of sequences—[perhaps] eight frames and those eight frames will pay you back for [the costs of] producing the material.

THE FUTURE OF STOCK PHOTOGRAPHY

These "distant rumblings" are but mere forerunners of the new realities that are to come. Without question, the stock photo industry is on the cusp of dramatic and profound change. As the future continues to unfold, there will be a shift in the way that the stock business looks and operates, both for the agencies that sell images and the photographers who produce them. Many of these changes are already underway, and many of the horses are already at the starting gate. Today's pioneers are looking at an electronic frontier, and the territory they occupy is the global market-

place. For those with experience, chutzpah, and adequate capitalization, the opportunities are enormous.

Thanks to the onslaught of technology, we're already seeing cataclysmic changes in the stock photography industry. Changes such as more streamlined and efficient ways of viewing, receiving, and ordering. Part of this transformation is driven by agencies and designers who are relying more and more on new technologies, creating an incredible demand for computerized services. Which would you rather do? Page through endless printed catalogues or search for your image on CD-ROMs in a matter of minutes? Would you rather wait a day for FedEx to deliver the photos you order? Or have an online service pipe your images directly to you in minutes via computer?

Overwhelmingly, buyers see the future online. Some industry visionaries believe that all agencies will eventually deliver the majority of their images online, via the Internet. Photographers who want to succeed must be ready to embrace technology and to think about what they do and how they do it with an unusual, avant-garde mentality. The tools, techniques, and technologies that worked yesterday may not be viable in the future.

Photographers need to fully understand what's happening to stock photography. If you intend to make stock a significant part of your business and income, it's time to plug in, power up, and open your eyes. The stock photography industry of tomorrow may look nothing like it does today.

PROFILES

The messages here from our top 30 photographers are comprehensive and diverse, but often with one common theme: To succeed in this field takes focus, vision, commitment, talent, and a keen sense of business (or at least enough sense to hire someone with a keen sense of business). They also report that it takes people skills, listening skills, problem-solving skills, and an open mind.

To prosper in this business requires that you help your clients succeed. You must have an understanding of the problems, challenges, and needs of your clients. Only in solving their problems, meeting their challenges, and lessening their stress do you provide a complete and valuable service, and achieve your own success. Only through your vision and commitment, do you solve your problems.

As we approach the millennium, the tools of our trade look quite different than they did a quarter of a century ago. Many of us are using computers that are more powerful than the onboard computers that flew with the first space shuttle, and we're trying to find our place in the bright new world of cyberspace as the Internet and the World Wide Web bring us new and exciting ways to do business. There are choices available to us all: You can get wired with the latest and greatest technology, or you can work with one camera and a couple of beat up lenses. It doesn't matter; it's completely up to you and how you set up your commercial photography business.

The world is changing, and old or young, if you want to be successful, the message is clear: To succeed, fill the need—and do so by constantly reinventing yourself, constantly changing, constantly looking around the next corner. This is the real message of the research and interviews done for the book; change or perish. Nothing remains the same. Change is the name of the game—change in what the market demands from the buyers of our work, change in what those buyers demand to see in our work, and constant change in our work.

Another common characteristic among these photographers is that they all seem to be having fun. Certainly, no matter who you are or how much you get paid, every day can't be all fun. However, fun does seem to be an underpinning of success in this business. You've got to love it, you've got to enjoy it, and you've got to have fun doing it. If the photographers profiled here could speak to you in one voice, they'd no doubt say, If you're not having fun get out of the business and find something that is fun for you.

And, from each of these photographers we also learn something unique and very valuable. Here, you'll find wit and wisdom; you'll learn of the problems we've all had to face. Here, we have a clean and unfettered view of the lay of the land, as our photographers look back and also ahead to the coming century.

With today's technology, the learning curve is steep —steeper than ever. When we start in this business of commercial photography, we're often quite hungry for knowledge and information. We plunk down money to take courses and go to seminars, but ultimately, the lesson learned here is that nothing succeeds like good old experience and on-the-job training.

This career can be a lot of fun. It can be a lot of whatever you want it to be. My hope is that with this information at your side, you won't have to make the mistakes yourself. You can learn from other people's mistakes, too. These wonderful and successful photographers, who've overcome great challenges, paid their dues, and done what it takes, made the commitment to be a success. In fact, that's a common denominator—commitment. You can hear it in their words and see it in their images. If we can learn from them, that's better than cash in the bank.

CRAIG AURNESS

LOS ANGELES, CALIFORNIA

Craig Aurness has successfully combined the talents and interests of a photographer and an entrepreneur as the founding father of Westlight, a highly-respected California-based stock photography agency. Early on, he recognized the impact that digital imaging would have on the commercial photography industry and negotiated a joint venture with Eastman Kodak to develop their PhotoCD product.

Aurness' father's family was deeply involved in television (his uncle was Mission Impossible's *Peter Graves and his father portrayed* Gunsmoke's *legendary Marshall Matt Dillon), but he earned respect and assignments the hard way. After studying photography at Santa Monica College and comparative religion at Prescott College (in Arizona), he apprenticed with* Look *magazine photographer Earl Theisen, among others. In 1978, Aurness' work was published for the first time in* National Geographic, *and he went on to produce many picture stories for the magazine before retiring from the assignment arena to manage Westlight full time.*

Aurness' stock photography and digital-imaging reputation have made him an in-demand lecturer and the courses he has taught at the Santa Fe Photographic Workshops have been very popular with students. His achievements as a photographer, business owner, and director of Westlight (in addition to his pioneering work in digital imaging) have been the subject of numerous articles in the trade and general press, including Inc., Communication Arts, *and* MacWorld *magazines. He lives in California with his wife and two teenage children.*

I've been shooting for close to 25 years. [When I started] I didn't want to work in the studio industry. I wound up doing a workshop and eight months later I was working for *Sunset* magazine. I never went to a formal photography school, although I took several photo classes when I was going to college.

When I began, I had one objective—to work for *National Geographic* magazine. I analyzed 10 years of back issues of the magazine and tried to predict trends; then I went out and did a story, as if I was doing one for them. I showed them the work, and they said that if I came up with an appropriate idea, they would consider giving me the assignment. I spent several years working on ideas until I finally got one accepted.

I had the guidance of a man name Chuck O'Rear, who was and still is a *National Geographic* photographer. We did eight consecutive stories and accumulated thousands of "yellow boxes," which I wanted to use to build up a long term asset. So, stock photography was a natural course.

I started Westlight stock agency with Chuck O'Rear and Bill Ross when we realized that we had an accumulation of images but didn't really have an outlet for them. Every chance I get I go out and produce imagery that we need as a company. To me, that's personal work. My artistic interests and my professional interests are both the same. I haven't done assignment photography for more than 10 years; I have 70 employees and am responsible for about 300 people [at Westlight], and I feel that my job is here first. When I shoot, it's really on behalf of the company.

I've taught several workshops and that's about the only thing I've done outside of *National Geographic* and Westlight. Assignments never interested me. I'm very self driven, and to me, working at *National Geographic* was only a partial compromise. I do things because they interest me, not because somebody assigns them to me.

Style is important in both stock and assignment work. My shooting style and subject matter always tended to be very people/culture oriented. Right now there are so many photographers producing imagery for stock that if you don't have a style and a specialty, it will be very hard for you to achieve success. You have to have a niche now and focus on it.

The dominant source of income for certain stock agencies is their cata-

Make sure that photography can still be exciting, and do it for the love of it. Get excited about your work.

logue. At other agencies that's not at all true. At Westlight only about half of our sales come from catalogues; the other half comes from our files. Quite a few of our photographers get the majority of their income from the file.

What's started happening is that with the computer and easy desktop image manipulation, photographs are going to become components of new pictures that the clients construct. Clients are going to take control once again of the creative process, but they're going to be using materials from us. There are a lot of people putting together pieces of photos to create new images, and it's legitimate—it's not a dishonest process. They're licensing pieces of an image and constructing something new.

Basically, the way in which information is being delivered to the mind is changing from the printed page to the electronic form, and at Westlight we're trying to position ourselves in the electronic format as quickly as possible to improve our efficiency. This transition will probably result in a substantial increase in volume, a lot more images sold per piece of information communicated. So, instead of a 32-image article in *National Geographic,* there'll be a 300-image multimedia presentation communicated either online or via CD-ROM. And the overall cost for those 300 images may not be higher than the 32 images, but that's what the market is going to command and demand.

Westlight has about 100 photographers. Quite a few of Westlight's photographers still do lots of assignment work, but a good number are 100 percent into stock. Westlight focuses on the production side of imagery; the photographers consciously go out and try to get the needed imagery, rather than wait for outtakes from an assignment. Westlight's distinction is that it's very digitally driven, complete with a Kodak PhotoCD workstation. There is a team of about 15 people who are devoted to digital image projects. We have over 60 computers in the building so all of our staff members are online throughout the process, from customer transactions to photographer activity.

One of the tragedies of the stock business is that photographers have tried to treat stock photo agencies as IRAs, hoping that as they get older, they can live off their stock photo revenue. They're forgetting the speed at which graphics change and how rapidly the market demands a new look. So the

"IRA" isn't there anymore, and they're frustrated because they think that the stock agency has failed in its job.

Photographers must realize that this is a living, breathing industry, and while there are some categories in which you can have some longevity, there are also a lot of changes. One technological change is the introduction of bright color films, such as the Fuji's Velvia; suddenly all the scenic material that was shot on Kodachrome or Ektachrome diminishes in value. So the value of that huge stock file you hoped to retire on is now much less. You can get good money for your work, but you're not investing in real estate that goes up in value each year. Collections of images, particularly ones containing people, age rapidly.

As far as the future of the stock business goes, I think that the largest buyer of imagery will be the electronic community, with electronic, not print, reproduction. If you're going to live in the stock of the future, you're going to make your money from electronic transactions. This means that you have to be electronically smart.

Also, volume will increase and prices will go down, which means you have to be efficient. You have to produce material that people want to purchase—clusters of sequences. Clients don't just want one frame, they want eight frames. Photographers say they can't survive if their images are sold at low prices. Well, they're going to have to; they don't have options. The markets change.

Most photographers, in my perception, are doing several things wrong. One thing is that they don't seem to be reading enough and keeping current with the trends. They aren't spending much time studying the media of the future. They need to spend more time looking at emerging and developing technologies beyond Photoshop if they expect to survive.

Photographers who do best at stock today are ones with smaller egos and those who are more practical business-people. The low-key, highly professional people who can listen to editors are the ones making the money. Most stock photographers who are successful in stock right now will tell you that it takes a couple of years to start making money, and you either need to have some other form of income or some protective environment.

You have to make sure that photography can still be exciting and do it for the love of it, because the staying power required to get established in stock is pretty serious. Make sure you still love the feel of the camera. If you have that magic still left in you, there's no such thing as burnout.

TIM BIEBER
CHICAGO, ILLINOIS

Tim Bieber got started with photography as a hobby in grade school and high school, where he worked at the weekly newspaper. From there, he got a full-time job as an editorial photographer at a small newspaper in Northern Michigan but quit after six months to start freelancing. Now a commercial film director and cameraman, he was a still-image commercial photographer for 20 years.

His clients have included The Los Angeles Times, *Evian, Marlboro, Seagrams, Royal Viking Cruiseline, Westinghouse, Olympus Cameras, Prudential, McDonald's, United Airlines, GTE, Philip Morris, Citibank Diners Club, Allstate Insurance, Suzuki, General Motors, Phillips Petroleum, Volkswagen, Illinois Tourism Board, Cathay Pacific, Westin Resorts, and many others.*

When I started in this business, I did a lot of newspaper work and then more annual reports and corporate work, then more advertising. The last 10 to 15 years has been all advertising. During the past three years I started doing film, and this past year has been all film. I work with three film reps plus Michael Ash, my print photography rep.

By the late 1970s, a great deal of my work was corporate. The more corporate work I did, the more I realized that I wanted to do more advertising. It was partly the money, and partly the fact that the corporate work at that time seemed to be really repetitive—fly to 10 different cities, shoot in 10 different factories, take a picture of the guy who owned the place, and eat at McDonald's. I don't know if it's changed much today, but that's where it seemed to be going for me. I like to travel, but I got to the point where I thought that if I had to shoot one more factory machine, I'd probably drop dead. What I got out of it, though, was that I learned how to think quickly and make dull things look interesting. But creatively speaking, it was more rewarding for me to do advertising, to start with nothing and create the whole thing and make it interesting.

In my portfolio, I've basically always just shown pictures that I like, whether I shot them for myself or for jobs. Sooner or later, people —the good people anyway —hire you for *how* you see things, not for *what* specifically you're seeing. I've always shot pictures for myself, which I think you have to do or you'd be dead. If you just count on the work you get from assignments for your portfolio, good luck. I think that anyone who doesn't shoot stuff for themselves isn't going to go very far careerwise.

From the beginning, I realized that you need a rep to promote you. It's pretty hard to walk into someone's office and say, "Give me this job, these will be the best pictures you've ever seen." That's the rep's job, and it's easy for them to say things like that. It's hard to talk about yourself that way. In general, you also make more money with an agent, even though you do pay them a fee. A good agent always gets you more money, smooths out the hassles, weeds out the people you don't want to work for, and is much more in tune with the marketplace than you are. You have to dedicate your life to your work if you want to be any good at it; being a successful commercial photographer is a full-time job.

I have a strong commitment to promotion and marketing. I advertise everywhere I can afford to and do direct mail. I really believe in advertising. When I was doing print work, I advertised in *The Black Book* and the *Workbook*. I don't have any written goals or plans, per se, but my goal has always been just to do better work and more of it—to try to be at the top of the business. In the still photography arena there are 10 or 15 people who are at the top; they get all the nice jobs. I don't think the business is that much different from when I started. Technically, there are no better cameras or anything to use. You still need to know where to stand and how to aim the camera. The hard part about most commercial photography is not so much the shooting, but getting the jobs.

The success I've achieved, is due in large part to my promotional efforts and the fact that I've dedicated my life to my work. You have to do it full time. When given a choice between doing something to improve my photography (or further my career) and doing something purely recreational, I'd always choose the former. There was never any question about it. You have to love it, and I do. I love taking pictures; it's still magic for me.

> *You have to love it. I love taking pictures; it's still magic for me.*

My company is Mr. Big Productions. Mr. Big was the character who Boris and Natasha [from the '60s TV cartoon, *Rocky and Bullwinkle*] worked for, but you never saw him. I kind of think we all work for our own Mr. Big. I bought my first computer in 1980 and basically just use it for the formal business aspects of the job. I have the Photoshop software program and I put pictures on the CD-ROM to archive them. But, that's not part of the business for me—it's more like fooling around. It's neat. I enjoy it. I understand it and like how it works, but for me, if I'm going to shoot a job, I would much rather shoot it right, the traditional way. Knowing the light, knowing where to stand, doing everything I can so that I don't have to doctor the image later in Photoshop. For me, it's sort of a purist thing. It's nice to be able to touch up little things, especially for advertising, but my idea of a good time is to load a bunch of T-Max in my Leica and just go shoot pictures.

My portfolios have always been in book form. One full of pictures—big 11 x 17-inch prints of images that I like—and a second book of finished ads in the same format. I have more success getting work with the book of individual pictures because people

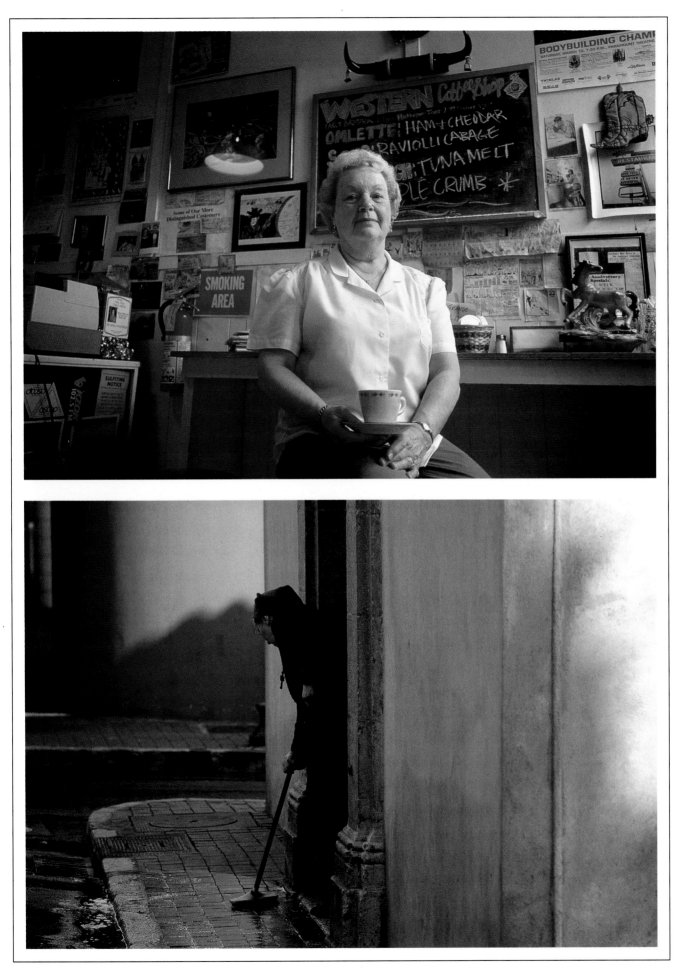

relate more to the images when they see something they like. If you show a book of ads, the discussion focuses on the headline or typeface, or how it was printed. The pictures are part of the ad, but there are a lot of other factors that distract from them. You just want people to see your photos.

I'm seeing more people using stock today. I sell stock through the Image Bank, but it's basically just my out-takes. Computers are also coming into play, and clip disks are everywhere. It seems like the market for assignment photography is a little bit crimped these days. A lot of people are struggling and looking for a gimmick. You can fudge a lot of things, but you still have to be in the right place and get the right light and the right feeling. You can fool around with a computer, but there's something honest about a great picture, and the easiest way to get that is to be good at what you do. You can't become good at photography by reading about it, or mucking around with your computer, or watching somebody else do it. The only way you can learn photography is to do it yourself every day. You need to shoot pictures, have them developed, and take a look at them to see what things look like. It's the only way to learn.

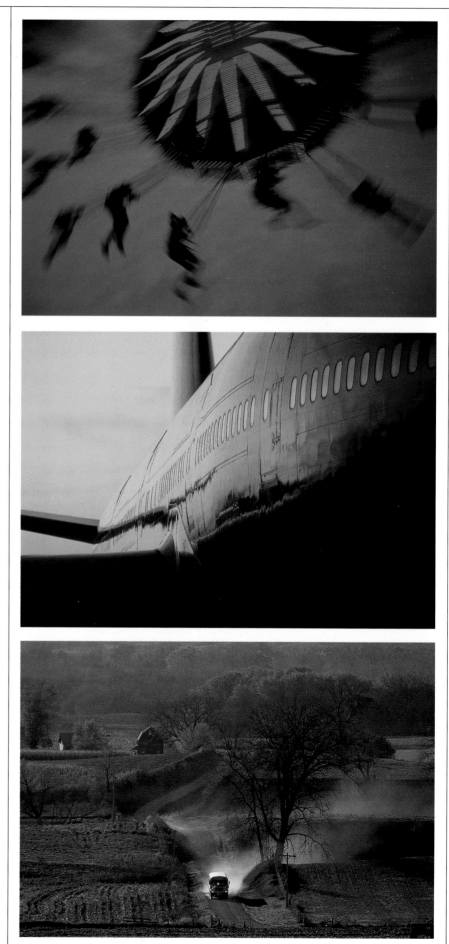

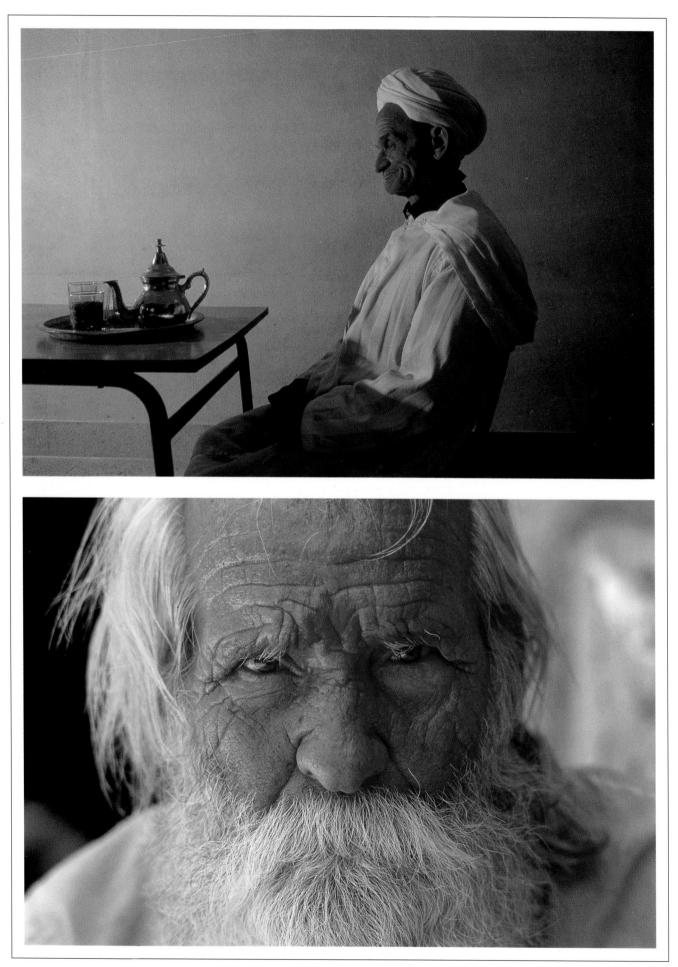

BARRY BLACKMAN
NEW YORK, NEW YORK

Barry Blackman enjoyed a successful career as a magazine art director for McGraw-Hill and an executive art director for West & Brady Advertising before he opened his own photo studio in 1970. In 1986 he made the leap into the world of digital image manipulation with his first Silicon Graphics workstation running Barco Creator software.

His first book, Special Effects for Art Directors, Designers and Photographers, *was very well received, and the images here are from his second book,* Creating Digital Illusions: The Blackman Portfolio *(Van Nostrand Reinhold, 1996). He is a popular and accomplished speaker and has addressed professional conferences in North America and Europe.*

He has received major awards for his work, and his clients include AT&T, Sony, American Express, IBM, Newsweek, Johnson & Johnson, Sports Illustrated, Molson, Seagrams, Time Warner, National Geographic, Bantam Books, and Polaroid.

When I graduated from college, I became an art director. I was an art director up here in New York, and then I was hired as a creative director down in Washington, D.C. At that time, Washington was a very unsophisticated town. Most of the photographers were photojournalists who were fooling around as advertising photographers, so it was a good opportunity for me to throw my hat in the ring and become a photographer.

When I first started, special effects were done in the camera, and most photography was done against black backgrounds. Washington was a really good place to start because you had to do everything; it wasn't like New York where everybody specialized. You had to do photojournalism, advertising, annual reports, table top, people, and fashion all at the same time. This gave you a pretty wide range of experience.

I never worked as an assistant; I learned on the job. I just made mistakes, and when images didn't come out the way I expected, I went to the photo labs or stores and spoke to other photographers to find out what I had done wrong, and I learned. On my first job, I used high speed Ektachrome 35mm film—the Ektachrome of the early '70s—and when it came back it had a grain the size of golf balls! When the clients saw it they said, "We love the technique, but could you use a finer grain film next time?" And I said, "Oh. If you wanted a fine grain film you should have said so." Then I went out and found out what a fine grain film was. This shows you where I started.

I've always included special effects, or photo illustration as they call it now, in my portfolio. There were very few agencies that had a demand for special effects, but they all remembered my special effects work, and that really helped me get my foot in the door.

Working with computers was just the next logical extension of what I was doing. When I moved up to New York, the movie *Star Wars* had just come out, and I figured this was the future. I got a Barco system, and I'm still using Barco today. Of all the systems on the market today, the Barco is still the most flexible.

Photoshop is also incredible. It's a source to be reckoned with. With it you can take any photograph and posterize it, solarize it, and use a flow or ripple tool. The same thing is happening here that happened when photographers first discovered the star filter; every image had a starburst in it. What this did was make the art buyer more selective. So right now, everyone is using Photoshop, but the market will become so saturated that the public and the art buyers will become much more sensitive to when it should and shouldn't be used.

The computer enables me to literally do anything that an art director can draw. An art director can come in with a concept, and we can finish it off. It was all done here. Working on the computer *and* with the camera, gives me an advantage because I know what is best done with the camera and what is best done with the computer.

Clearly, everyone will wind up with some sort of computer capability on their desktops. Even if they only use it for minor retouching. Retouchers are really the dinosaurs of today.

Since I've been in New York (it's 16 years now), I've gone through at least four reps. Like anything else, there are good reps, bad reps, and average reps. You kiss a lot of frogs before you find a prince. I've found that the most effective marketing tools for me are sourcebooks, such as *The Black Book,* because when art directors look for ideas they go through the sourcebooks. This year, for the first time, I tried a CD-ROM sourcebook. I went with the *Black Book CD.* However, the feedback I've been getting is that many agencies don't know how to work with CD sourcebooks yet. They're very busy, and they don't have the patience. But, it's the wave of the future, and eventually, they'll all be CD-ROM literate.

Become computer literate and study hard.

I don't think that there's anything that we as photographers can do to change or override the prevailing business environment, in which the "bean-counters" are more in control than the creative types. It's the age-old contest between craftspeople and mass production. If the industry doesn't appreciate craftsmanship, there isn't too much we can do about it. If price is going to rule over quality, again, there's not much we can do about it. You can only cut your prices so much, and then after a while it's not worth it anymore.

My advice is to become computer literate and study hard. [But, keep in mind that] you can always learn the techniques, but you've got to develop the eye. Old timers who are afraid of computers and don't want to learn a whole new technology or way of working, and who are just hoping that they can last until they retire from doing what they've been doing, had better learn computers, too. Everything is becoming so rapidly computer oriented.

BURGESS BLEVINS

BALTIMORE, MARYLAND

When he isn't shooting ads for national clients, Burgess Blevins finds time to climb the Bitterroot Mountains in Idaho, where he is a licensed outdoor guide. Blevins cut his teeth on photography as the "in-house guy" at Barton & Gillette, one of the most prestigious design houses in the country in the 1980s. Moving past the corporate work at Barton & Gillette, he opened his own studio and has been doing impressive work ever since. He is a graduate of the Maryland Institute of Art and has specialized in location photo-illustration for 27 years.

He has been honored by such organizations as the Advertising Club of New York and Magazine Photographers of America and by Communication Arts *magazine, and has received Clio and Kelly Awards for his work. His cleints include American Express, AT&T, Anheuser Bush, DuPont, Lockheed Martin,* National Geographic, *Panasonic, Philip Morris, Quaker Oats, and others. His work has been widely honored by* Communication Arts *magazine, along with The Advertising Club of New York and others and he has received both Clios and Kelly awards for his work. When not in Idaho, Blevins can be found on his farm on Maryland's eastern shore.*

I started as photo art director at Barton & Gillette Company [a large graphic design house] in Baltimore right out of school. I studied photography at the Baltimore Institute of Art. I'm primarily an advertising/location/illustration photographer. I don't do as much personal work as I used to.

I was lucky. When I started, Barton & Gillette had a great national reputation as a design house. I was able to start out being national. I stayed there from '64 to '69. It was a great learning experience. I started out shooting in a suit and tie, and ended up with jeans and long hair, so you see where it goes. It was fabulous. I was just out of art school. I can see where assisting somebody for years and years makes sense, but for me this situation was a great training ground.

I was getting great awards from the work I was doing at B & G, so I started freelancing. I started with my prices high for the region at that time; nobody had heard of a photographer charging $1,000 a day. But, my approach has been that if you're doing great work, people will buy it. I felt that my work was worth a certain amount of money, and I still feel that way. If your reputation demands that you get paid, you'll get paid.

This is a career I chose to be a part of, and unfortunately, it has changed. For instance, the whole computer thing. [Still, there will always be] the few of us who take greatpictures and will never be out of work because the computer simply can't do what we do. You can take three great shots and digitize and manipulate them into one great shot, and it'll be great; and, that has to be done on a computer. But you still can't make what I get.

I think my work has a "sense of smell" about it—a realness. It's not that polished advertising look. Sometimes this works for me and sometimes it hurts me; it doesn't get me a lot of car ads. But, one of these days I'll end up with one primarily because stuff I do does look dirty—it looks like the mud's real. I go out of my way to make sure it looks that way. I use makeup and everything that everybody else uses, but the person in my shots will really sweat.

My portfolio is traditional. When I signed with my new rep, we redesigned my book. It's all C prints. It's very exciting, very fresh, very expensive. It's actually in "book" form with a binding. I get great results from it. I just keep changing the images. The book now goes over my total career, because

there are a lot of images I did when I started out that are as fresh today as when I did them. I'll probably eventually consider doing a CD-ROM portfolio, although I've always felt that if I were an art director, I'd want to hold the work of the photographer I was considering in my hands.

I use computers. I created my own studio management program. But, I don't have any desire to be a retoucher. I may eventually just play around with Photoshop. I have no desire to learn it at this stage. It's just something I'm not into. It's too much of a thrill to still do it in camera. Let the people who love Photoshop do it.

I'm optimistic about the future of the business. I think there's going to always be a need for a handful of great photographers, and the computer will not replace us. One of the biggest industry problems is the disappearance of the smaller ad agencies. They get gobbled up by the few remaining big shops, everything ends up being in the hand of "bean counters," and the desire for great work disappears. During the next five years the big corporations that have let so many people go will find that nobody out there is

I'm an absolute stickler for quality. I just cannot tolerate mediocre work.

able to buy their product. They're going to realize that they have to return to doing great advertising.

I think the Internet is something we all need to get up to speed on. The problem is that if you've got an image and it goes on the Internet worldwide, it can always be downloaded and used. You've got to find a way to protect your copyright. The Internet has the possibility to be deadly, but it may also become so saturated that it's totally useless, too. You'd have to pay me a blooming fortune for me to even consider putting one of my images on the Internet. Once it gets worldwide, how are you going to control it?

I think success in this business is an awareness. If you're going to be a successful commercial photographer, you knew it when you were five years old. By that I mean you knew you were going to be doing something in the arts. I think the people who are in trouble are the ones who suddenly said, "Well, hey—I want to be a photographer."

There are those who are born seeing light and those who you can try to teach to see light. But the ones who are born seeing light will always see something different than those who had to learn to see it. You can only teach the basics; you can't teach people how to feel, and that's the difference.

BARBARA BORDNICK

NEW YORK, NEW YORK

Internationally renowned portrait and fashion photographer Barbara Bordnick began her career in Copenhagen and Paris, before returning to New York. Well known for her fashion work, Bordnick has created a broad range of images for an international clientele and produced a body of wonderful editorial assignments capturing subjects as diverse as Olympic figure skaters and Broadway performers. Captivated by the digital world, she is now working digitally on some projects, and has just completed a wonderful series of lush portraits, entitled "America's Great Women of Jazz," for the Polaroid Corporation, using their legendary 24-inch instant camera.

Her images are in the permanent collections of the International Center of Photography, the Gilman Collection, and the Polaroid Collection, and over the past 27 years she has received numerous honors and awards for both her print and film work, including more than one Clio, The International Film Festival Gold Medal, the Nikon Award, and the Art Director's Club Award.

A strong advocate of photographers' rights, Bordnick recently served three terms as president of Advertising Photographers of New York (APNY) and, from 1977 to 1978, was the first woman president of the American Society of Media Photographers. Her work has been featured in numerous group and one-woman shows and has appeared in such nationally known magazines as Time, Newsweek, Forbes, Fortune, LIFE, Harper's Bazaar, Connoisseur, French Vogue, Graphis, *and* Communication Arts. *She has also appeared on* Good Morning America *and the PBS* American Masters Series *program on Richard Avedon.*

I didn't get started in photography until quite late; I never really studied it. I was a student of fashion design and fine arts at Pratt Institute. However, I was fascinated by photography and finally took a course in my senior year.

When we lived in Copenhagen, where my husband worked, I started looking at magazines, writing down names of photographers and calling them, hoping that they'd speak English and hire me as an assistant. A couple of photographers sent me to a photo magazine; the editor there looked at my pictures and bought them. So I was published. When I saw the double-page spread with "Barbara Bordnick" printed across it, I thought, "This is fabulous. I'm going to be a photographer! This is easy!" And that's how I decided to become a photographer.

Of course, it was anything but easy, but that one positive experience kept me going for a very long time. We ultimately moved back to New York City where no one would hire a woman as an assistant. Eventually, I set up my own studio and began my career.

My specialty for the majority of my career has been fashion, but I do all kinds of people work. I love doing portraits. I think it's the most terrifying, but the most interesting, of all photography. I like photography that takes me places where I learn something. While it's very visually stimulating and has a lot of freedom to it, there's a limit to what you can learn from fashion photography. Still, I would never give it up because it feeds my other work in many ways. And I think I've always been hired because I was a fashion photographer, no matter what it was that people wanted me to do. There's a certain sensibility to my work because of my fashion background.

I have a very old-fashioned book of tear sheets and prints that I use for presentation and one portfolio that I present only in person. It houses a collection of photographs that I'm doing as a personal project. I want to put my work on a CD-ROM as soon as I can.

As far as reps are concerned, I don't have one at the moment, although I am currently looking for one because I think it's very necessary in this market. I'm not very good at self-promotion, and I've been very fortunate to work on projects that promoted me over the years. While I always took pages in the sourcebooks, I never got any work from them directly. They were simply a way of keeping my name out there. Fashion photographers don't get work

You'd better have a strong idea of who you are and what you want to do. It's the only way you'll survive.

from sourcebooks, they get work from previous editorial work.

For stock I'm with GraphiStock. I'm very bad about producing images for them. I know that it would be a good alternate income, but I have other interests besides photography that take my time. I also prefer to handle resale of my fashion work myself, since I remain in control that way. The important thing is to always retain ownership of one's work. Never give up the rights to your photographs.

As for advertising work, I was noticed purely because of my editorial exposure in the right magazines. That's how my advertising clients found me. I think it's the same today except that there are so many more photographers, and the magazines are tied to contracts with a few photographers, so it's harder to break in.

I don't do nearly as much personal work as I should, but I do do more now than I've ever done. I had an exhibition of a series of nudes of Alvin Ailey dancers that I shot digitally and output to Iris prints. I liked shooting digitally. It's a fascinating process. Eliminating the chemical darkroom is a very environmentally sound and attractive possibility, although I don't know that we'll ever fully do that.

Digital work is going to be in everyone's future one way or another. No question about it. Even if it's only to scan images into a program that you can print out from or simply for storage. I was not interested in image manipulation at all when I did my Ailey nudes, but I can see myself as a 70-year-old woman with all my old pictures, sitting at my computer instead of in the darkroom, playing around and creating new images. That might be the perfect solution for getting older.

One of the things that frightens me about computers is the delusion that if people see something on the screen, they're seeing it. I just went to an exhibit at the Metropolitan Museum of Art and I bought the beautiful exhibit catalogue. While I bought it for educational and reference purposes, it's still such a letdown, because my whole body and mind remembered the experience of seeing the originals. I got a tingling feeling seeing the originals—it was absolutely visceral. That doesn't happen from a printed reproduction, much less from a screen. I fear that people surfing the Internet are deluding themselves into thinking that they're being exposed to the art of the world, when they by no means are.

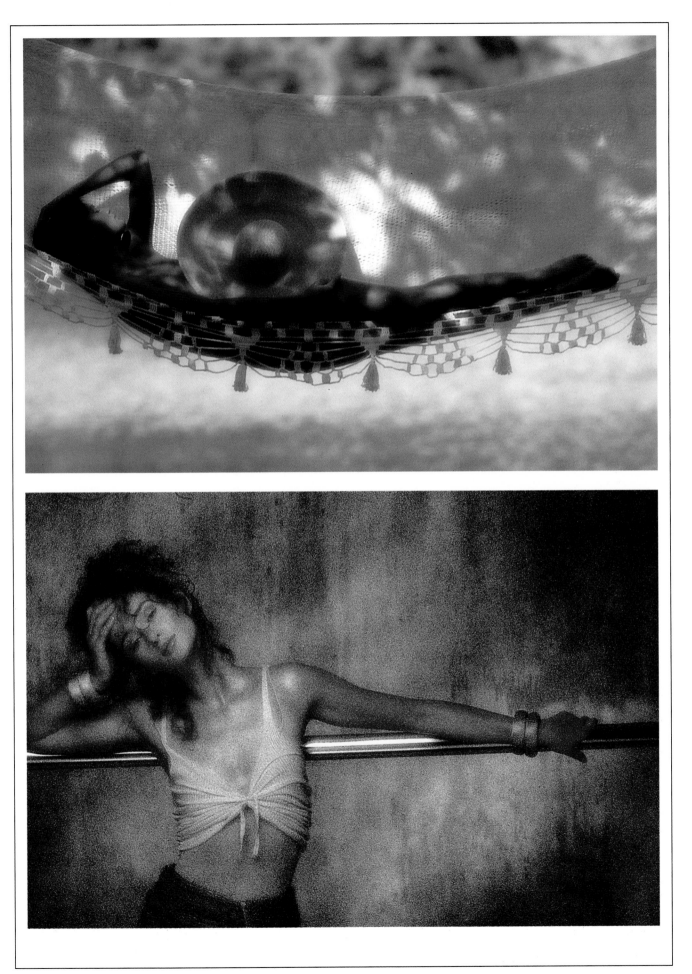

Then there's also the amount of information available. Informed people are far more equipped. But information seems to have achieved its own intrinsic value. I don't see it that way. Information has no value in and of itself. It's the use made of it, the application of it, the value of it in relation to one's person, one's life, one's project.

I don't know what the business will look like in 5 or 10 years. The most distressing thing I find now is the lack of respect for the photographer and the creative person. Popular America has always seen the creative person as a threat, an outsider. And, the people who hire photographers have no sense of the history of photography. Consequently they have no sense of the place of photographers in the present.

I think the people who are most "successful" are workaholics. Their work becomes and defines their life.

While I think my work defines and is my life in a lot of ways, I've never been driven by it. Creating marketing plans and written goals is much too "professional" for me. I hate the American obsession with knowing ahead of time what's going to happen. It's the absolute destruction of creativity. There's so much chance involved with creativity. You have to be able to make mistakes, or you won't do anything of any genius or real quality. It can't happen if you have to plan and know everything that's going to happen in every minute detail, which is what American business is all about and why mediocrity is so rampant in this country.

The real difference between one artist and another is his or her point of view. It's the only thing we have that is absolutely, unquestionably, intrinsically ours. You have to figure out what your point of view is. Besides talent, your point of view is absolutely everything, as far as being an artist. It's based on your life, your upbringing, your history, and your culture, and no two people have had the same life experience. Consequently, nobody is exactly the same. Therein lies the strength (or weakness) of your own creativity.

You can never imitate somebody's style. It always looks like an imitation, because it lacks the soul of the original. The more you discover about yourself and how you feel about things, the closer you'll come to your own creativity. It's all in how you perceive life.

My advice to people entering the commercial photography business is that you'd better have a really strong idea of who you are and what you want to do and say, because it's the only way you'll survive. That's the only way you'll have staying power.

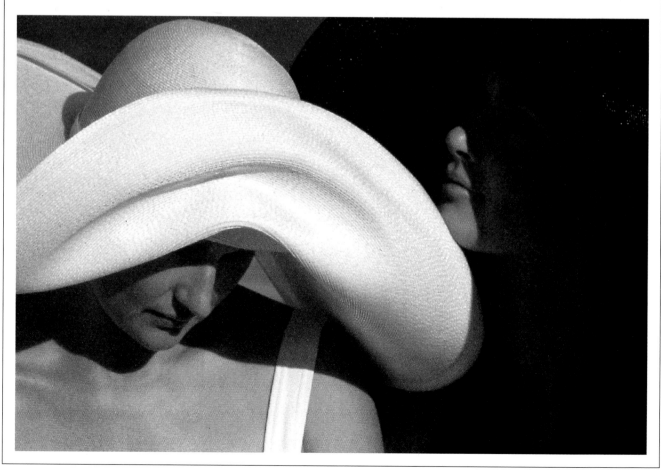

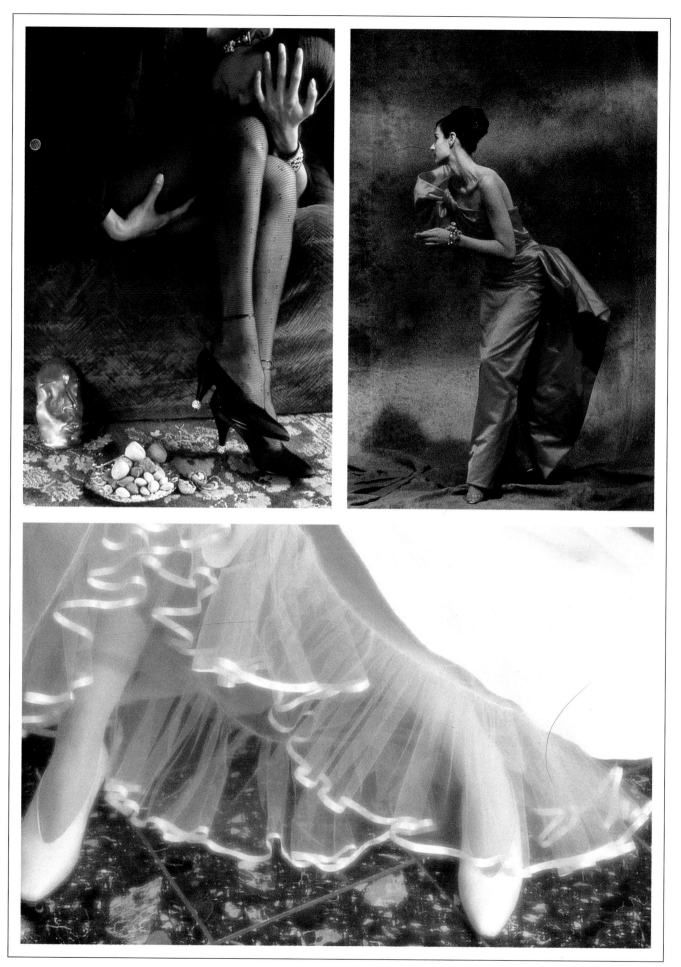

GERALD BYBEE

SAN FRANCISCO, CALIFORNIA

Gerald Bybee is a San Francisco-based photographer who specializes in digitally manipulated images. His work has been featured in Communication Arts, Graphis, Electronic Imaging, Imaging News, *and* Online Design. *He has won multiple gold and best-of-show awards in the Art Director's Club and Ad Club sponsored San Francisco shows.*

His client list includes Adobe, AT&T, AutoDesk, 3Com, Intel, IBM, Silicon Graphics, Hewlett Packard, Novell, Polaroid, Fuji, Levi's, Wells Fargo, Visa, Nickelodeon, Sutter Home, Gallo, Jim Beam, and Knott's Berry Farm. Due to the success of his work, he is now able to focus more attention on his ranch in western Sonoma County, where he's at work establishing another state-of-the-art digital studio.

I've been shooting for over 20 years now. I've only begun to specialize in the last few years. Five years ago I started getting involved in digital imaging. I had some friends who were involved with testing and marketing early computer illustration and paint programs for Macintosh. I watched what they were doing and could see it coming for photography.

Last year, my retouching and digital fees matched my assignment fees. I bill for imaging the same way I bill for photography—by the project. At first, it was a little harder for clients to understand our estimates, because when we included the digital part of a project, the bottom line looked so high compared to a separate, simple photography budget. Most account executives and art buyers weren't used to seeing estimates for digital *and* traditional photographic work lumped together from one supplier. They'd say, Why are we paying this guy so much money?

I'd respond that the digital part should come out of the post-production budget, not the photography budget and suggest they check their production budgets. Once clients realized they'd been paying all along for this kind of work, it was easier to sell the budgets.

I got into the business because it was a good way to make a living, not just because of the art. Photography looked very interesting to me from a creative and artistic sense; however, when I understood the commercial side of it, I realized I could make a good living and provide for my family. I never did the "starving artist" thing. Only in the past few years, since I started working in a digital environment, have I felt more artistic freedom and room to experiment. At that point, the business was established and successful.

In terms of portfolios, I originally used a print book, then went to laminated transparencies and tear sheets. I recently switched to digital prints produced in-house on a Fujix Pictography printer, which lets me update my portfolios quickly.

I've never had a stock agent, although I sell a lot of stock directly. I'm definitely getting more requests for stock images, particularly those I create or assign for promotion. The idea this year was to do a book with 100 new digital images and then market and license them.

I'll also market images on the Web. The challenge here is that there's increased potential for copyright infractions—although people have always had the ability to copy images. Maybe it's a bit easier across the Web, but you still have legal recourse. If you publish an image in a sourcebook or as a poster, it can be rescanned and rescreened for publication. If you publish at low resolution on the Web, the images are really only useful for limited applications, such as other electronic uses or very low resolution printing. While it's easy to understand some of the paranoia about putting images on the Web, I don't really see a major shift in the paradigm. The good thing is that the Web should make imagery more accessible to a wider range of buyers and marketplaces.

Overall, things have changed a great deal in the industry, but they've also remained the same. The bottom line is still the image itself, and how it moves people. How images are created is really important only to the technician. There seems to be a lot of competition out there, but I've heard that ever since I started in the business. When I began, established photographers were complaining that there were too many of us newcomers; now, 20 years later, I hear the same thing.

The biggest change I've seen over the years is communication within the industry. Anyone who wants to be a photographer today has ready access to a lot of information on how to do it, from techniques to business tips. When I started, it all seemed like a big mystery. There were just a few demigod shooters, who had all the magic answers and knew all the technical tricks. So, the only way to learn was to sweep their floors, go through their garbage, and figure out how they did it.

Photographers like Phil Marco, Irving Penn and Richard Avedon created the art of lighting with expensive custom-made strobe equipment and big banks of softlights. Nobody else had this technology. Now, you can buy whatever you need at any photo store. All of this technology—which is a big part of photography—is rentable in most major cities, and that's a major change. And this is becoming true of digital tools, as well.

Everybody seems to think there's some magical solution to it all, but there are so many ways to make a living in photography that it continually astounds me. There are so many markets and companies buying images, and there are so many images being published. If you're interested in imaging, just find a niche that grabs you and go do it.

> *There are so many ways to make a living in photography. If you're interested, just go do it.*

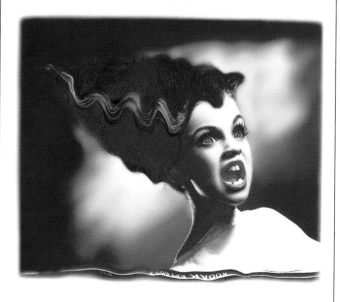

CRAIG CUTLER
NEW YORK, NEW YORK

When Craig Cutler decided he didn't like working as a nuclear piping detailer, he went back to school and began the journey that's led him to become one of the hottest young photographers on the horizon. An internship with photographer David Langley convinced him that this was where he wanted to build a business.

Starting out shooting newspaper ads for the New York department stores, Cutler quickly moved into the editorial market, which flowed into advertising. In 1987, he opened his own studio, where he continues to actively pursue personal work, which he feels is the key to success in the commercial photography industry.

Cutler's work doesn't fit neatly into any category. His background in architecture, graphic design, and advertising has enabled him to be just as comfortable photographing shoes as he is shooting buildings. His clients include Tiffany, Lexus, Canon, Kodak, IBM, Sony, and Bombay Gin, plus GQ, Metropolitan Home, *and* Outside *magazines. His work has been featured in* Communication Arts, American Photography, Graphis Photo *and* Graphis Advertising.

I've been shooting for 13 years now. My specialty is that I don't have a specialty. Ever since I started I promised myself that I wouldn't limit myself to any one direction. I get very antsy. I started just doing magazines. From there I moved to more personal work, and from there into other things. Then I did an assignment for Stuben that put me on the map.

I do a lot of personal work. I find myself liking personal projects or goals, and it pays off in one to three years, because that work gets picked up in stock or people see it and want something in that vein. For example, for the last two years I've been making portraits of diners across America, and I'll do a book proposal on that project. Art directors ask me where I find the time to do all my personal work, but you have to *make* the time. I set aside days or weeks to do personal projects.

I think the biggest mistake photographers make is not trying other things quickly, once they get on a roll. This will be the death of you artistically. I've seen so many people die with a certain technique or style—they get caught in it. As soon as you have success in one direction, you have to change into something else.

I have a sales rep, but I'm not one of those guys who has marketing plans set in stone. Subconsciously, I know what I think and what I should do, but I don't go out and look at the results on paper. I might do a sourcebook, and I did direct mail. And, I enter a lot of competitions. But I don't sit down and say, I have to put 24 percent here and 10 percent there, and so on. At one time I had three assistants and an intern, plus one producer and a rep. Now, I'm restructuring and am down to one full-time assistant, one intern, and a full-time printer. I made this shift because half of my work is in the post-production area.

My philosophy is that I use "outside" specialty people and let them do what they do best. I let my printer make prints and this gives me more time to take pictures. And, I go to an outside source when I want to do some serious retouching. It's just more cost effective. I don't know how you can spend your day shooting and then spend the next four days retouching on Photoshop and still be productive. People get stuck on Photoshop and take forever to do anything—it doesn't make sense to me.

In terms of using consultants for career guidance and marketing—if you're lost, I think you've got more problems than you think. I value other people's opinions, and I absorb my assistants' opinions. I think it's a team effort, but I just don't agree on this whole "consulting" thing; one person's opinion is just one person's opinion. There are a lot of people doing [the consulting thing], and I just have a hard time with it. I think things have to come more from your gut; you have to have your own subconscious direction, or you won't succeed—it's just too brutal a business out there.

I have a commercial portfolio of my advertising work, which is mostly 5 x 7 inches. I have about 12 of these portfolios. Print or transparency. Every one or two months, I restock those portfolios with at least about 20 new images. I also just finished a print-location portfolio; these are two-book sets. That's a whole different direction. And then, I have some personal portfolios.

I also have a web page, which is interesting. I'm taking it cautiously. Polaroid has images of mine—if you look up www.Polaroid.com, you'll find half of a show of my work that I did in Italy for The Polaroid Gallery. And on PhotoServe (which I think is set up in Europe) they have some of my work now. I've gotten some responses from these sites. It's a very young market, and I think eventually it's going to come into play more, but there's still so much weeding out to do. There's so much garbage to get through.

You should always be striving—always be moving on to the next thing.

I'm with a stock agency. I just compile my work. If I go on a trip (I try to make two trips a year for personal work), I take some of the images I take and submit them to stock. I've been with my agency for two years, and it has started paying off. I'm surprised; I see stock right now as more of a way to show my work than a money making thing. I'm hoping that will change in the future.

You've got to be very careful when picking a stock agency—a lot of agents will give your images away for whatever they can get for them. It's a scary thing. I don't submit everything to my agency, and I don't give them personal work because I feel it's personally worth more to me. Almost all of my stock is miscellaneous stuff from the past few years. I don't think stock is ever going to completely take over [assignments].

My philosophy five year ago was, Take any job that comes your way. But, I've changed. I'm more selective with what I want to do now. I've always said I'll get out of this business when I'm not having fun anymore, because it's just too much work.

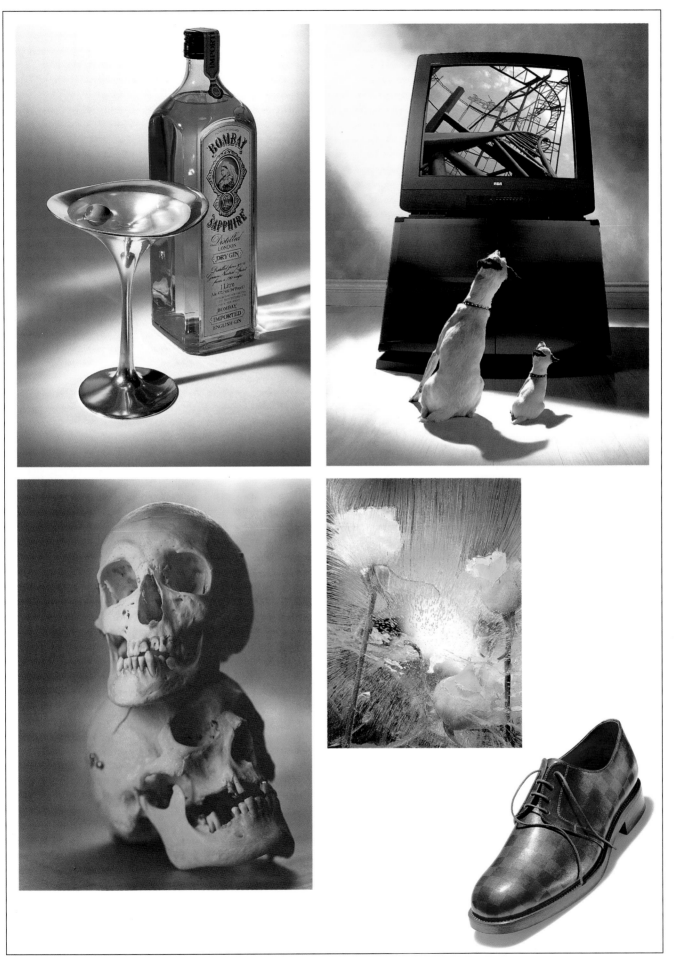

BRETT FROOMER

LOS ANGELES, CALIFORNIA;
NEW YORK, NEW YORK

As a teenager, Froomer's interest in art led him to photography, and while earning his degree in economics at UCLA, he worked as an assistant to many of California's most successful photographers. After college, he traveled around the world for six months, from Hong Kong to Istanbul to Paris, making photographs. He was the youngest photographer to sign with The Image Bank stock agency, and his assignments have taken him to such diverse locations as Colombia, Hawaii, Scotland, Sardinia, Vancouver, and Nova Scotia.

An award-winning photographer, he is best known for capturing the essence of light and atmosphere through the use of still and motion picture cameras. Clients such as Jaguar, Lexus, Mercedes, and Honda hire him to bring excitement and adventure to their advertising, while Condé Nast's Traveler, Men's Journal, *Jergens, Mobil, Microsoft, American Express, Hertz, Nikon, and Kodak also all seek out his talent. Born and raised in Los Angeles, Froomer is now bicoastal, splitting his time between homes and studios on both coasts.*

I started assisting when I was 16 and I continued through college. I started to shoot right after college at age 22. Now I'm 38 years old. I've been in New York for the past 10 years. The first person I ever worked for, for four years in high school, was Sid Avery; he taught me everything I really needed to know. Then I worked for Larry Dale Gordon for two years, and then I went out on my own. So those two people really set me off on my own course.

To succeed in this business takes commitment to the profession—a passion for your work, where nothing can stand in its way. I really didn't feel that I needed to go to photography school, because either you have the eye or the instinct, or you don't. My education was both with [the people I worked for] and then on my own. I learned on a need-to-know basis. I learned by doing. My specialty is variety. However, most of my work involves problem solving on location, whether it's editorial or advertising.

I do a tremendous amount of personal work, which I use for promotions. Personal work is a very big subject for me, because in order to do great advertising you have to be very happy personally. And if you have only a steady diet of advertising, I don't see how you can be personally happy. To be very effective in advertising, you need to *not* shoot advertising every day. Otherwise, you become a machine, and that's not where your value is. Your value is in the personal touch you put in your images that makes them yours.

Promotion for photographers is a necessity, and I refused to run ads with a picture, name, phone number. The only place I do that is in the sourcebooks, where that's the standard format. I also advertise in *Archive* occasionally, and sometimes I send posters out.

My overriding philosophy is that I'm not interested in photography as a business; I'm interested in it as a journey, and a very important component of that journey is who I work with. So, I'm not interested in just doing a job. I'm interested in my development as an aesthetic person, not in making money.

If photographers are just interested in making a lot of money, they could probably do it for the short run but they could never make it for the long run, because in order to be successful and endure, they've got to be fresh and new and exciting. You can't be that way if you're shooting production jobs—advertising shoots whose tear sheets will do your portfolio no justice at all.

Ads of soft drink cans walking down the middle of Fifth Avenue that are going to be electronically retouched to look like they're dancing, will not benefit my portfolio. They will look like advertising, and the trend right now is for photographers who are not "advertising" photographers. That is, the market wants photographers who have a sense of personal image, personal style in their work. That soft drink can is pretty much straight advertising, and that won't get you anywhere today.

There's a new heartbeat in advertising. As a photographer you can either look at the industry and criticize it, or throw your hat in the ring and be a player. I'm a player. Everything changes and to be in that evolutionary process requires energy, talent, excitement, enthusiasm, and an ability to evolve personally. The people at photography seminars and gatherings who sit around and complain about the good old days are really saying, We just don't have enough to muster the energy to go another round.

Complaints about budgets are cop-outs, in my opinion. Yes, things are tight; you have to account for your money today. Back in the '80s and earlier you didn't have to account for it. But it's a business now, and it wasn't back then. So either you do it or you don't. Back in 1983, they certainly weren't *paying* the kind of fees that we're getting today. Nobody seems to complain about the fees.

I started out representing myself. It was an incredible experience; you develop a tremendous amount of respect for reps. It's a great thing to do if you're just beginning. If you're established and have never done it, I don't know if I would suggest it; it's very humbling, to say the least. My current rep is Howard Bernstein of Bernstein & Andriulli.

In terms of repping yourself, if you have a handful of clients that you hand select (and your overhead reflects that philosophy), then I would say yes, you probably could make that work. However, if you want large volume, I would say it's going to be very difficult to answer the phones, send out portfolios, and manage all that. (I have eight portfolios, and most of the time that's not enough.) It depends on what you want out of your career, but you can be successful without a rep.

I view the relationship between a photographer and a rep as a marriage. It infuriates me when photographers say, My rep isn't doing anything for me

> *I'm not interested in photography as a business. I'm interested in photography as a journey.*

and isn't getting me any jobs. The most that reps can do for you in the marketplace is bring you to market. They can't tip the job your way. The photographer's job is to equip the rep with as much ammunition as possible, so that the rep can get you in the right door. You take over from there.

That means your portfolio has to be on fire, and the only person who can take care of that is you. Giving a mediocre portfolio to an agent is not going to get you mediocre work; it probably won't get you any work, even if your rep is in the right advertising circles. Your work is everything. The rep just gets you there and presents you properly.

While your rep is out there selling your work, you should be out trying to make a new version of yourself. You don't create a portfolio and then let it sail for the next two years. It's a living, breathing entity that represents you and that needs to be updated as quickly possibly. My goal in my portfolio is to get an old piece out in order to put a new piece in. I show Iris prints. I'm not into any of the electronics for portfolios at this point, because I still view my work as art and therefore I want that to be reflected in the format.

I feel that *style* is another word for *personality*, and I think this is very important in every aspect of your career. [On a job], not only is your work scrutinized but everything else taken into consideration as well, from what kind of studio you run to what kind of person you are. All of those things are your tools to use in the very important "will-you-be-invited-back-next-year?" game. You have to use those tools.

I have stock with The Image Bank, but it's not a prime concern. It's not as motivating as it use to be because I have an employee who handles all my stock. I'm not personally involved with it anymore because it's too time consuming; my concerns need to be with the next picture, not with stock. Still, stock is outstanding, and I swear by it. It got me started. I'd say that photographers can make it without stock, depending on their overhead.

The more I advance in my career and the more I journey down the road to development visually, the more difficult it is in terms of getting better projects—it's tougher at the top. And it's not just a local market anymore. The business has gone global. My advice to newcomers is, regardless of what the old guys say, don't listen. Follow your heart. Top clients will use you if you have the work in your book. There's no such thing as an equity ladder whereby you have to be famous to shoot a big ad. Any art director will use talent, regardless of age, regardless of fame.

MICHAEL FURMAN

PHILADELPHIA,
PENNSYLVANIA

A neighbor's darkroom and intense interest in photography captivated Michael Furman at an early age. A growing interest in high school led to studies at the Rochester Institute of Technology and his first studio after graduation in 1974. Specializing primarily in large-format studio shots of cars, he has built an international reputation for elegant, well-lit work, which has led to a successful career working with automotive clients and top ad agencies.

An interest in the expanding digital world and it's potential to facilitate his vision led Furman to help found one of Philadelphia's hottest digital service bureaus. Frequently using multiple digital platforms to tweak the best out of software, hardware, and image combinations, he still falls back on the basics of simple, quiet elegance with great color and lighting to produce the exceptional work he's done for clients such as Mercedes-Benz, BMW, AGFA, Bell Atlantic, and Elan Skis.

He has been actively involved in national photography organizations, such as the American Society of Media Photographers for which he served as president of the Philadelphia chapter. His work has been featured in Communication Arts, GraphisPhoto, Photo/Design, *and* Print *magazines.*

When I was 11, one of my neighbors had a darkroom in his basement; he and his father got me involved in photography. That was more than 30 years ago. I opened my own studio in 1974. I started working out of my parents' basement, and when I got a little bit of money together, I got an apartment and worked out of there. In 1977, I moved down to where I am now.

There are a couple of different issues involved with specialties. One is subject. What subject matter are you good with? In my case, it's cars in a studio. Another is creativity. What is your creative specialty? Mine is creating very simple and elegant communication—very direct, very sincere. I hope that when I take a picture I've captured the essence of the subject matter. Hopefully people will see my images and relate to them or be touched very deeply by them.

To market yourself, the best thing you can do is do the best work possible. The vast majority of the work that you do is either for repeat customers or for people coming by recommendation. So, the best promotion is doing your best work so that those people will come back and refer others to you. You have to say to yourself, My reputation rides on every assignment that I do so I've got to do the best I can.

The next step is to understand that clients don't just show up at your door. They have to be motivated to call you. If they don't know that you exist, then you have to target them. Once you find your potential clients, go after them, contact them, show them your work, and make sure that your work does in fact relate to their needs. For example, if I wanted to photograph fashion I wouldn't show a fashion account my car portfolio. Clients want to see something from you that shows them that you're capable of doing the work they need.

The first volume of money that I spend in promotion is what I spend on my jobs to make sure that I do them as well as I possibly can (to get return clients and referrals). I might spend extra money doing things better than the client ever budgeted for because I feel it's important.

I've used outside reps in the past, but generally I handle the work myself with two people on staff. Their main full-time job is finding work. My main portfolio is laminated prints; some reprints and some original color prints. I have a second portfolio for our digital imaging company and that is mostly 8

x 10-inch digital transparencies. That portfolio seems to work best as transparencies [as opposed to being on CD-ROM] because a lot of people want to see what the actual work looks like.

I'm considering putting my portfolio on CD-ROM. I think it's a great idea; anything that gets the portfolio out quickly in a high-quality form is very important. You'd be surprised how often clients call for work that's similar to something I just did the previous week. In my traditional format, it takes quite a while to get an image into the portfolio. If I do it on a CD-ROM I'd have something out there within a couple of days.

You have to create a portfolio that will enable you to get work. You can have all the capability in the world, but if clients don't see it in your portfolio, they're not going to call you in. You also have to continually show new work, otherwise you're not showing where you want to go, you're showing where you've been. You've got to show the kind of work you want to get. And, many times, the kind of work you want to get is not the work you've done yet. It's important to show clients what you *can* do, or what they could do if they worked with you. It's critical to educate your clients not only about yourself but about where they can go.

As far as technology, some people use electronic imaging to do things they never could have done before—that they wouldn't do in the real world (and that looks like they couldn't have done it in the real world). Other people, like myself, want to do what we would have done but weren't capable of doing. For example, I had to put a car in a situation where it wouldn't fit. If I had put the car in that situation, there would have been so many reflections in it, I would have had to retouch the car until I was blue in the face. So I shot the car separately from its background and then set it into the situation with the computer. When I was done, you would have sworn the car was shot there.

I'll often use many different systems—the Mac for PhotoShop, the Barco Creator platform for heavy duty work that would have taken too long on the Mac, and also Live Picture. Having PhotoShop is critical just to be able to talk to people, and you can coordinate well with Quark and drop documents in.

I think photography is going to continue as long as there are people out there with visual things to say—there will be a place for them. But, the busi-

I hope that when I take a picture I've captured the essence of the subject matter.

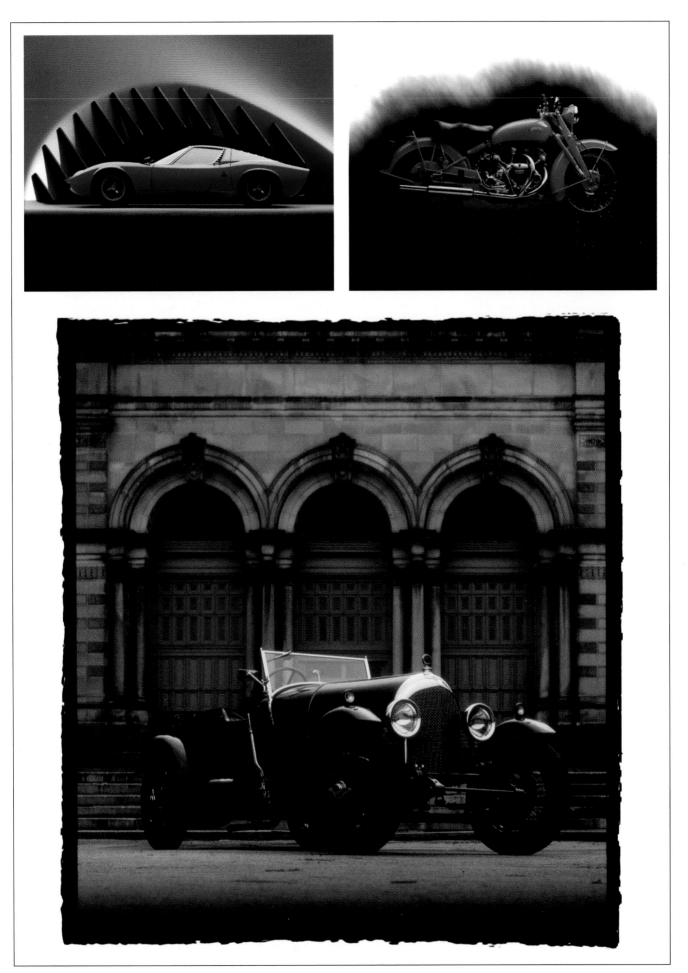

ness is heading in a more electronic vein, and that's what I've prepared myself for. The only negative to the coming technology wave is that it's going to cost money. On the plus side, we're going to gain extraordinary control over our images. You'll be able to alter images at a level that you could never do in the darkroom.

Photography is also heading in a direction where photographers are much more involved with the overall process. We're not just photographers anymore, we're visual communicators—visual resources for our clients. It's exciting for people of our age, who have a strong visual background and know that we want, to get into the electronic field. What's going on today is that a lot of the kids coming out of school are overlooking the visual skills and are going right to the computer skills. They have the technical ability to operate the delivery system, but they don't have the visual knowledge to create the content.

Anybody can learn to work a computer, but not everyone has the visual skills that I already have. If people of

my age can commit to learning some of the new technology, they can apply so much more experience and knowledge [to the medium]. I'm not afraid of the new people coming up because most of the new people coming up don't care about the content. When you get to the point where you live for the content and you live for the thought of the communication, then you're a photographer.

As a photographer, I know how exciting it is when you previsualize your photograph and then have the final photograph look as you intended. That same excitement can also occur if you approach potential clients and they finally call with an assignment. It's fantastic and it doesn't get any better. If you've lost at the end of the day, you have to put it into the right perspective. You have to try to say, I didn't get this one but I have to go after another one. You have to be very careful, because if clients sense that rejection gets you down, they'll feel very uncomfortable walking back through your door.

My advice for people who've been shooting for a very long time and are

burned out is to stop and assess your situation. You have to decide whether it is, in fact, what you want to do, and if it is, you rejuvenate yourself by making a commitment to it and figuring out what's getting you down about it and what would get you going again. The people who've been around a long time and are really good, have the energy and curiosity of children. And every one of them, if you didn't pay them a nickel, would still be doing what they do.

I think it's hard for young people getting started today, because it's harder to find where photography's going and to define where you as a young person want to go in photography. For me, photography takes place in your head. I don't need a camera to take pictures. I'm taking pictures when I'm asleep. I'm taking pictures when I'm awake. What a wonderful vocation—being paid to see. From my point of view, I couldn't think of anything else to do. I don't think it's necessarily a noble profession—we're not curing cancer—and if the world didn't have it, I don't think it would really care one way or the other, but I would sure miss it.

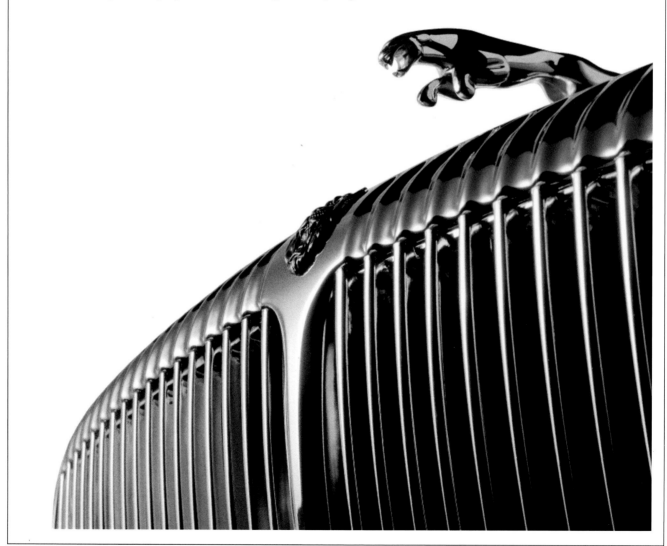

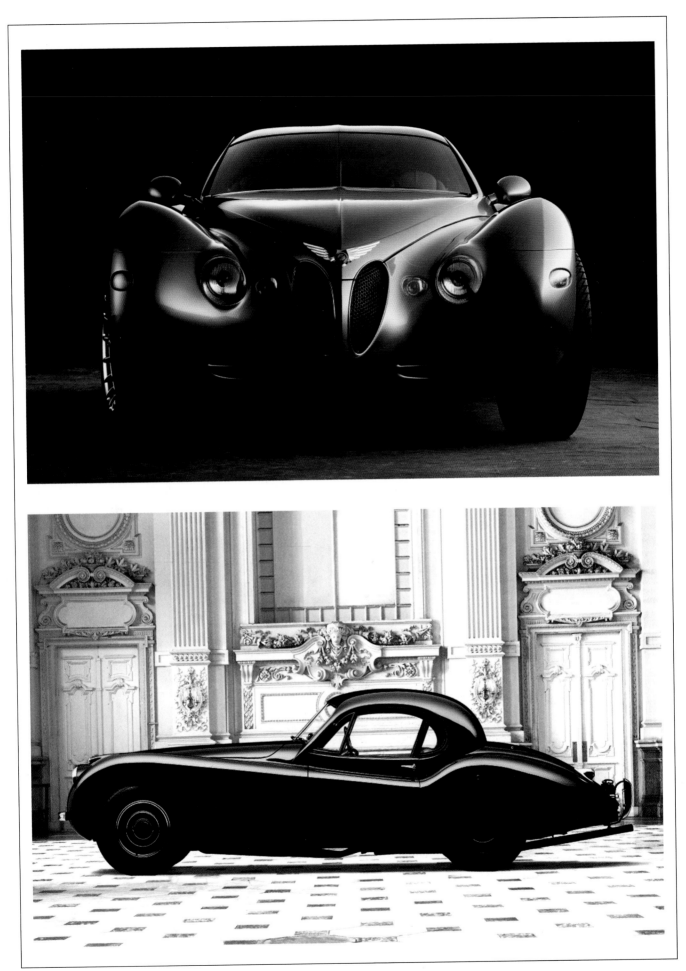

DAVID GAZ

SAN FRANCISCO, CALIFORNIA;
PARIS, FRANCE

David Gaz grew up in New Jersey. He attended the Art Center in Los Angeles on a Pentagram scholarship, graduating in 1989. Almost immediately after graduating, he moved to Paris where he developed and patented his unique photographic process in which he uses layers of film that he lights in washes of saturated color.

After establishing himself in Europe, Gaz moved back to the United States and set up a studio in San Francisco. His work has been featured in Communications Arts *and* Photo District News, *and he has had a diverse range of commercial clients in the high-tech, fashion, and music industries, including Levi's, Sony, Warner Brothers, EMI Records, Polygram, RCA, and Xerox. He has exhibited in both Europe and the United States and his work is part of the permanent collection of the Bibliotheque Nationale in Paris.*

I was living in San Francisco and had just graduated from school. A friend of mine who is French was telling me how great Paris was. He lied and told me that everybody spoke English in Paris and that it would be very easy to live there. I sold everything I had, moved to Paris, and found out that nobody spoke English. After learning a little bit of French, I wound up staying.

My specialty is color. I shoot still lifes, people, scientific subject matter, album covers, but the one linking factor is the color and maybe my technique. I have a very particular, specific technique, and most people hire me for that. It's based on colors—saturated, very vivid colors. I like to work a lot with concepts and ideas. The technique is just a way of delivering those ideas and concepts.

More and more I'm using agents to sell, commercialize, and promote my work. I didn't really track down my reps. We just met through the course of working, or through people talking about my work. I have a rep in London, a rep here in Paris, and a rep in Washington, D.C. (Arlene Soodek), which takes care of England, France, and America.

Right now, I'd say the large volume of my work is mostly European. There's a bit of a difference when you're working for a European client rather than an American client. In America, with fairly good sized budgets, you get a lot of commercial constraint. They're very marketing oriented there, and they take fewer risks. In Europe, clients are willing to take more risks. So I can experiment more with my European work.

I do quite a bit of promotion. I put ads in *The Black Book* here in Paris, send out postcards and mailings, and things like that. I have a promotion strategy in that I have a very specific way I want to market my work, more like heading toward the things I would like to do, but I don't know, necessarily, if you would consider that a "marketing strategy." Maybe it's a personal strategy. I'd like to base my career advancement on enjoying my work and being able to do the work that pleases me the most.

I'm not terribly organized in terms of a marketing plan. I just try to spend as much money as I possibly can on promotion. It's very important. I think a lot of what promotion does is to reassure people that I'm a successful photographer, that I can get the job done for them. Promotion is a way of letting clients know who you work with and that your work is successful for other people.

I'm not a big computer buff at the moment. My portfolio isn't on floppy disks or CD-ROMs. It's mostly transparencies, because I think it's the most dazzling way to show the work, color-wise and lightwise. I use smaller format transparencies, probably for commercial reasons—I can duplicate many more of them for the same amount of money. Also, I like shooting in a smaller format camera, and I think if I were to show larger format transparencies, people would expect me to give them larger format transparencies for jobs.

My technique evolved probably as an accident. Basically, I had to show some work to a client. I looked at the film, and it was something I couldn't use. I started playing around with the pieces of film, trying to get something that I could present to my client because I didn't have time to reshoot the job. I started placing pieces of the film together and found that doing this made the colors look great. That was probably the breakthrough in the way I do my work now. I achieve the results of my current technique mostly by lighting. I use very standard processing.

I do sandwich a lot of the film. But, it's mostly lighting in conjunction with contrast in colors.

You have to hustle. You have to show your work as much as possible.

I'm a little bit nervous because of computers. I think they're going to have a very large impact on photography. Techniques will change. Prices will change. The way people do business will change. In all of the other similar and related fields prices have gone down. I think that may happen with photography. I think it's too bad; people should pay for ideas, not technique.

I'm conscious of the need to put money away and look at my images as maybe a form of savings in themselves. Basically, at this point in my career, I'm concentrating on promoting my business, making things go faster, getting more work, having my day rate go up, and things like that. I'm not so much concentrating on my retirement. That will probably come later. I tend not to sell the copyrights on my images. I like to keep the rights myself, because I see an equity in that later. I can resell those images much later at a certain value.

Maybe this is somewhat of a retirement plan. The more images I create and the better they are, the more value they'll have later on. In general, the more work you do, the more successful you'll be; it's not a money thing—it's just that the more you work, the better you'll be.

MARK HANAUER

HOLLYWOOD, CALIFORNIA

As a junior in high school, Mark Hanauer knew exactly what he wanted to do after graduation. After some classes and a stint assisting, with portfolio in hand, he found himself a job working as a staff photographer at A&M Records. After two years there, he decided that he wanted broader horizons than the music business could provide and started showing his book to potential clients on both coasts. He also started doing magazine work, as well.

Hanauer's photography has appeared frequently on ads and spreads in the pages of many national publications, such as Entertainment Weekly, Vanity Fair, GQ, *and* Newsweek. *With a current specialty in sports advertising, he has recently been producing work for Nike, Converse, and ESPN. He has also produced a lot of imagery for the motion picture industry and is a sought-after lecturer.*

I studied photograpy for two and a half years in high school, and I took a course in junior college. I never made a good print in the class, but I learned more there about photography in terms of technique, how to deal with film, exposure, and processing than I did in any class. I also took an advertising class when I was pretty young, which helped me a lot. That's the extent of my formal training.

I used to rep myself, and with few exceptions, I really liked the people I encountered when I did. I would get a great response or have a meaningful conversation like I had once with John Loengard [of *Life* magazine fame] when he happened to look at my book. He said, "You seem to solve other people's problems very well; what about your own?" This really made me think about things—about creating more of my own vision. It's something I think back to. It meant a lot to me.

I'm not teaching any more, unfortunately, because I could not make the two careers work together. But, I do enjoy teaching. I enjoy bringing people together and helping them find what they initially got involved in photography for—for the sense of pleasure they get from it and the sense of fun. When I speak to someone who wants to get into photography, I really try to stress having fun with it. Why else be a photographer? Unless you're doing it just to make money. You can do one or the other; or, you can do both. To me, however, the most important thing about it is having fun, otherwise you shouldn't be a photographer.

In terms of format, my book is currently pretty traditional. I'm in the process of redoing and changing it. It's now a mixture of transparencies and tear sheets, and it's kind of a conglomeration of different periods of my work. I'm working to re-establish who I am as a photographer and bring it up to date.

Onyx, the agency that represents me now, seems to have marketing plans, and the reps don't necessarily let me in on them. Hopefully it works. But we do talk about issues like what markets I want to be in, what kind of work I want to get into that I'm not now doing, and who should see the work. I don't have any kind of formal marketing plan. I'm not very businesslike. I show my work, I get work. Onyx also helps by placing promotional ads in publications such as *Photo District News*. There's a designer at Onyx who does beautiful work, and we collaborate on those things.

I also worked with [consultant] Ian Summers; this gave me the opportunity to sit down with someone and try to understand who I am and where I need to go. Ian is a very good mirror that reflects back who you are. It's often hard to understand who you are, and so it's good to have someone who can help analyze this and help you find direction. Ian was very good at doing this for me.

It's almost like a zen thing; it's not so much a matter of when you push the button on your camera, but what's behind the finger pushing the button. I think I discovered my "path" along the way, and I think it makes the most sense in that the path we choose in some ways reflects what we want to see about ourselves or what we do see about ourselves.

I take pictures for myself on occasion. It's a source of renewal. It makes me realize what I'm interested in in the world; it helps me to *see* what I choose to look at through the camera, what I choose to photograph. Afterwards, when I edit this work down, I'm able to really see what is important to me. I find it very helpful.

In terms of where the industry is heading, I have no idea. Things will change. For example, the use of film will become isolated, for the most part, with the exception of a few people that still prefer to use it. Imaging will go digital— we're pretty close to that right now. It's really usable, although in some regards film is still doing a better job. Overall, it's a transition that's in progress. But people will still have to come up with images, create them.

Just because you have a computer doesn't mean you'll know how to use it. And just because you have a digital camera doesn't mean you're going to be able to create good digital imagery. It's the same thing. Photographers still will have to be visionary. In that sense, photography will not have changed at all really in the last 100 years or so. The technology will be no less or more difficult that it always has been.

In terms of advice, everyone is different. For example, I chose not to go to school because I didn't like that kind of environment. Sometimes I regret not having a degree from school. Everyone does it differently. Everyone has to find their own way. For me a formal school environment wasn't the way, but for a lot of people it is. The best thing I can say is to just be honest with yourself about who you are and what you want to do.

> *Just be honest with yourself about who you are and what you want to do.*

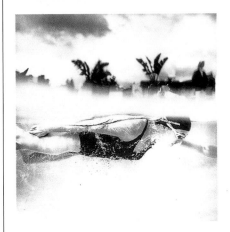

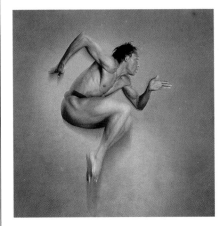

GREGORY HEISLER

NEW YORK, NEW YORK

Gregory Heisler's unique blend of technical mastery coupled with a thoughtful responsiveness has allowed him to interpret an unusually broad range of subjects. He is perhaps best known for his trademark editorial covers and his work for Time, LIFE Magazine, Sports Illustrated, Fortune, GQ, *and the* New York Times.

In 1990, the city of New York broke with tradition by selecting Heisler's photographic portrait of Mayor Edward I. Koch—rather than an oil painting—as the official portrait. In 1991, Time *magazine chose Heisler to create the first commisioned photographic "Man of the Year" cover in the publication's history (of president George Bush). He subsequently photographed Ted Turner for the 1992* Time *"Man of the Year" cover and also captured "The Peacemakers: Yitzak Rabin, Nelson Mandela, F. W. de Klerk, and Yasser Arafat" for the magazine in 1994.*

He has photographed award-winning advertisements for Kodak, Kohler, Cannondale, Reebok, United Technologies, and Dewar's (their classic "Profiles" series) and has produced annual reports and brochures for clients ranging from The American Ballet Theater to American Express. He has been profiled in magazine articles in Esquire, LIFE, *and* Communication Arts *and has received many awards for his work, including the World Image Award (1991), the Leica Medal of Excellence (1988), and the ASMP Corporate Photographer of the Year award (1986).*

Heisler is a sought-after lecturer and teacher at dozens of international seminars, workshops, schools, and associations, including New York's International Center of Photography and New School for Social Research, and National Geographic in Washington, D.C.

I got started by coming to New York to assist Arnold Newman. I wrote him a letter saying that I admired him above all mortal men, and he sent a reply, which was very nice of him, saying basically that he wasn't interested. Then I flew out to New York to see him. It turned out that he actually had been looking for somebody; he just didn't want to give false hope to somebody coming from out of town, and I ended up staying and working with him.

I guess portraiture would be the main thing I work on. Portraits for magazines, advertising, and privately commissioned portraits. I used to do a lot of corporate work for a long time, but I was a bad businessman. My business was in shambles. I was thrilled to be doing the assignments, and if I had my choice of typing up bills or going out and shooting, I'd go out and shoot. By the time I got around to paying my bills, it could be anywhere from two to six months later, and by then who even knew where the receipts were? I was right on the verge of disaster. My wife, Prudence, saw this and rolled up her sleeves and straightened everything out.

Last year, I was on a contract with *GQ* magazine, and that facilitated my simplifying my studio staff because all of a sudden I didn't have to generate bills every week since I was on a contract. The need to have somebody in the studio generating papers and dealing with receipts vanished. For a period, I actually didn't have a studio manager. Now I again have one, but he doesn't really do as much of the paperwork. I have a bookkeeper who comes in once a week to cut all the checks and pay the bills.

Instead of just taking the best picture, people now shoot for coverage; they have many different set ups and changes of clothes. I think this moved a lot of people into doing corporate work, which also provided an opportunity to shoot without an art director. You'd get general direction, but basically you worked independently, and so it was still similar to shooting editorially. And, the production was always very good because you were working with corporate designers, who are generally very respectful of photography.

I got tired of corporate work and felt like so much of my energy was spent making something that was horrible look okay. I felt that in advertising maybe I could at least start off okay and make something that looked amazing. And also, instead of having to be a one-man band, I could actually work in a collaborative way, pulling together the talents of many people.

That was the allure of it, but it's terribly competitive. The nature of corporate work is clean. You're dealing with business people; you go out and take the picture, you send a bill, you get a check. In advertising, there are meetings, client meetings, estimates, and re-estimates. You need 50 portfolios; you send the book out, you bid and then re-bid, you go to meetings, you go shoot the thing, and then afterward there are problems with this and that, and more meetings.

For an advertising picture, maybe instead of $2,500 you get $5,000, except that the $5,000 gig hangs around for two weeks. Either that or you need a very big studio staff so that you're doing $5,000 gigs every day and making enough money to let everyone else deal with all those other things.

I've worked with a couple of reps over the years, which for me has not been satisfying. I just felt like it wasn't working for me. I felt like I was doing the lion's share of the work. I didn't feel like the same kind of effort, creativity, and ingenuity was being put out there on a sales and marketing level

> *You have to do whatever it is that will get you excited about the work.*

that I was putting out on a photo level. They had their people who they worked with, and if my stuff fit in, great; if not, too bad.

It would be as if you had a really great rep who was really innovative, and you just shot your stuff by formula every time. The guy kills himself bringing work in, and you just use the same lighting stuff—you just bang it out—over and over.

Also, I was really good with people. When we'd go to meetings with clients, I was usually the one who'd wear a suit and tie. People usually thought I was the rep. I always got on well with people and was happy to work on problems. I always tried to be a very good listener—that's really important. I found that reps were frequently not as good at it as I was. Although I felt that I didn't need a rep, that's not the norm in the business. But, my business has been the busiest in the past three or four years without a rep.

In terms of promotion, I haven't done a sourcebook ad for the past three or four years. The best promotion is to have your work shown editorially, along with word of mouth. People think that promotion is appearing in *The Workbook* and other directories. Sourcebooks have become a whole industry unto themselves. You could spend $50,000 a year putting your ads in various books, and I resent that.

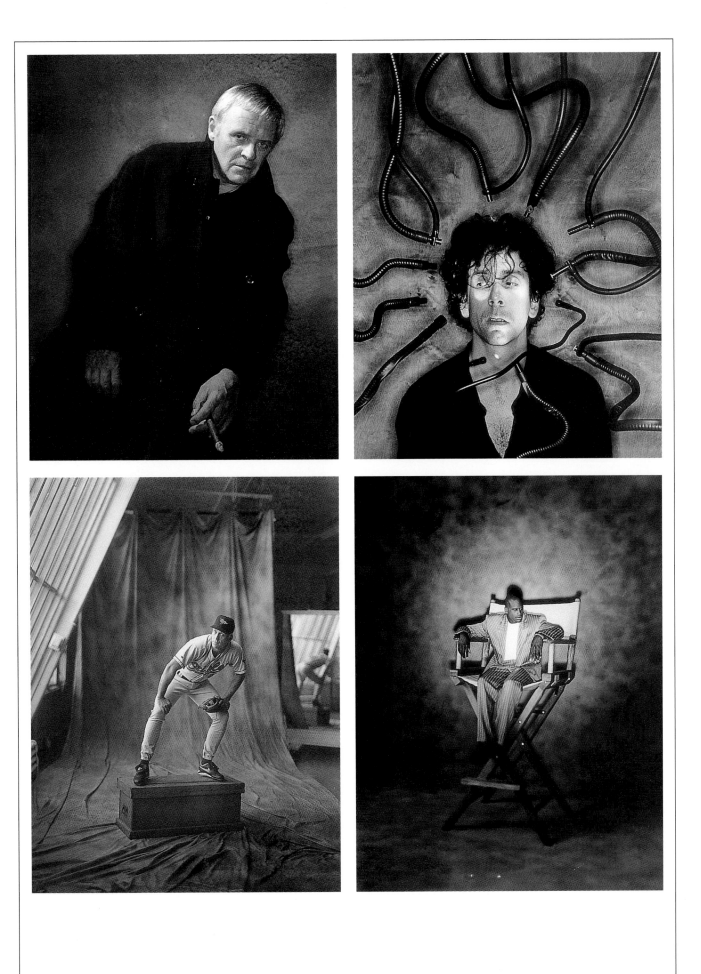

When people see work editorially, on the other hand, they feel like they're "discovering" you, and that's a good thing.

Also, word of mouth is a big thing. One of the reps I worked with, Michael Ash, told me that you have to really get your foot in the door at an ad agency. You need to get the buyers there to trust you and think that you're the best thing in the world. Once you do that, your name will get passed around within the agency. Ultimately, it's the best promotion you can have—in-house word of mouth. The biggest and best jobs I've gotten have been through word of mouth, not because they saw a *Black Book* ad or a picture in *LIFE* magazine.

I never thought of my career as a "career"; I never planned it out. I've only just recently started to think in broader terms like that. I was always just keen on whatever job I was working on at the moment. And my sense is that you just do the best job that you can and put everything into that job. And then the next one comes, and you do your best on that, and so on. It snowballs. I could have been more focused. I definitely spread my energies out a lot, but I don't know that I would have benefited from a more focused approach.

When I get called to send out a portfolio, I very rarely send out transparencies—that would be more for corporate work. My books mainly go out now with 11 x 14-inch laser prints of either magazine (editorial) tear sheets or advertising tear sheets. It's completely a tear sheet book. The loss of quality with laser prints is actually quite marginal. It's not like I'm showing my work to a museum, in which case I would want to show them original prints. The point of this is to show what I've done and give people a quick feeling about it, as opposed to showing a C-print book, which I used to have and which cost an absolute fortune to produce.

Also, it's easier and faster with laser prints; you go to the corner laser printing place that has a Canon laser copier, come back an hour later with the laser prints, and put together a new portfolio (or add or update) right away.

I show different things for different reasons. In my corporate work I would never show printed material. I found the designers tended to really be thrown by seeing other designers' work. It distracts from the photography. For corporate, unlike advertising, people want to make sure that you can light things properly, shoot a situation, and give them camera-ready artwork that they can give to the printer without further embellishment. In advertising, however, they do tons of post-production color correcting and retouching, and there are budgets for that.

Everything is different about the business from when I first started. It was horribly competitive then, and now it's beyond that it's so competitive. What's sad is that the unbelievable popularity of the work of photographers like Annie Liebowitz and Herb Ritts, for example, has created hundreds of photographers all over the country who just do variations on their styles; that's 99 percent of what goes in magazines. And that's too bad because there are a million ways to take pictures. This whole idea of photographer as celebrity—of photographer in the spotlight—is just weird.

My sense is that I'll just stay really interested in photography. I love taking pictures more than I ever have. If I stay enthusiastic, maybe pictures and the business will follow. I'm always trying out new stuff, always thinking of other ways to be taking pictures and other people to take them for. But, I'm not a marketing person; that's not my thing. I don't want to find out what the latest trend is. In fact, if I found out what the latest trend was, I'd run screaming in the other direction.

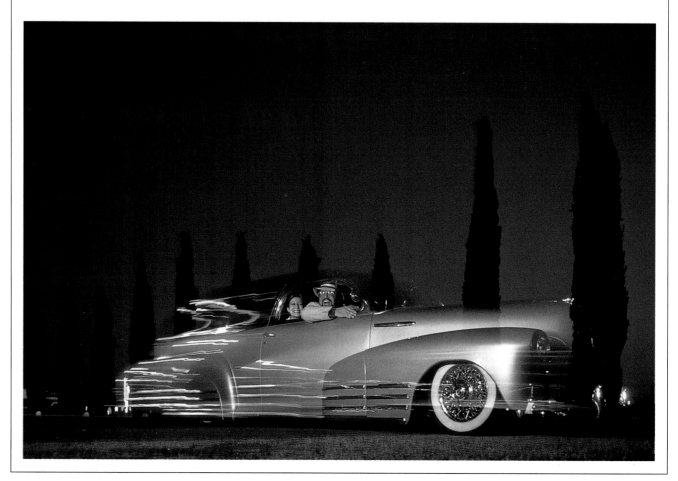

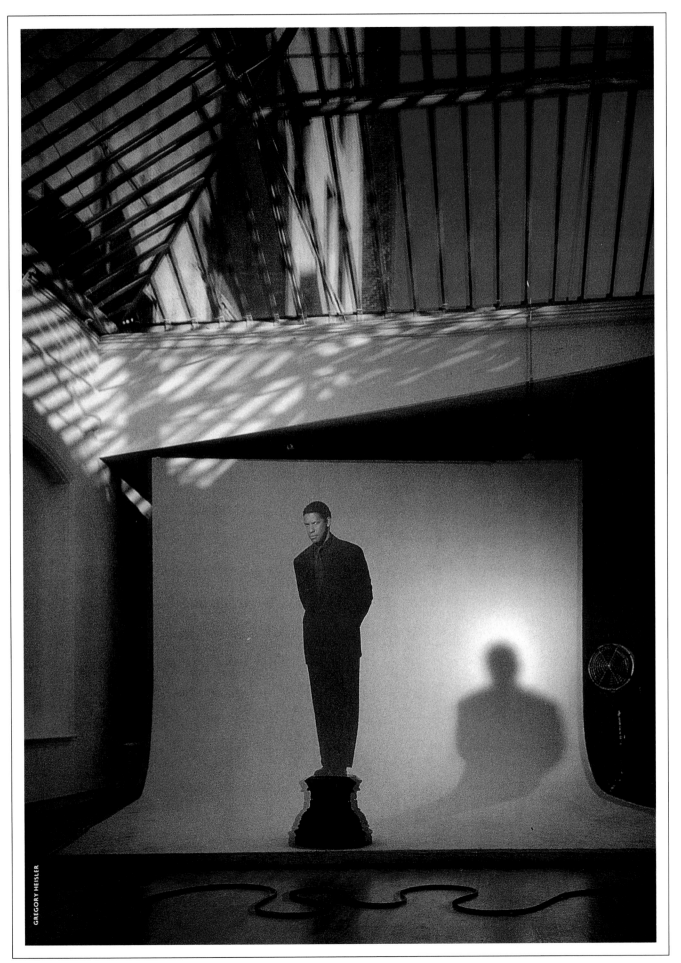

AARON JONES
SEATTLE, WASHINGTON

In 1979, at age 36, Aaron Jones sold his woodworking business in Green Leaf, Oregon, to pursue a career in photojournalism, but a turn of events directed him into advertising photography; with no commercial experience, Jones was hired by Seattle's Cole & Weber agency to shoot ads for the Boeing 747.

He set up his first studio in Portland to service his growing client list, which included Nike, Speedo, Soloflex, Westin Hotels, and Weyerhaeuser. In 1985, he moved to San Francisco, and in 1989, he relocated his studio to a huge 5,000 square foot facility in Santa Fe, New Mexico.

Currently operating out of an 8,000 square foot production facility near Seattle, he works with a large staff on film, video, and television projects. His recent print clients include Sony, Suzuki Motorcycles, Ralston-Purina, Kahlua, Microsoft, Compaq, Volvo, Royal Viking Cruise Line, UPS, AT&T, Lexus, 3M, Chevrolet, Lawry's, Drambuie, and Remy Martin. In addition, he has directed television commercials for Coca-Cola, PBS, Dow Chemical, Southwestern Bell, Chevrolet, Nissan, and others.

The inventor of the HoseMaster light painting system, which is widely marketed throughout the world, Jones is noted for his special lighting techniques and painterly style, which he applies to still lifes, portraits, and now to film and video, as well. His work has appeared in Communication Arts, Archive, Print, Graphis, Zoom, Adweek, Ad Age, Photo District News, *and numerous international publications. He teaches regularly at workshops and seminars around the world, and regularly holds three-day workshops at his Santa Fe studio.*

I started shooting 16 years ago in Seattle. An ad for the Boeing 747 was the first shot I did where I was hired to do something. It was one of those strokes of luck that would be pretty difficult to duplicate today, because in 1979 people weren't pounding on the doors of ad agencies. Today there's so much awareness of the advertising business. It's an incredibly crowded field now—a lot of very talented people.

It has become much more experimental than when I started; everything was very straightforward back then. Now I'm almost 100 percent involved in film, translating the look that I developed in print. But I still get calls from people who want me to do print. I just did an ad for General Motors, and I did some other campaigns this year, but my real focus is on motion pictures and on translating that look of painted and sculpted light into film.

Anytime you do technical stuff and you go from still images to film it's 1,000 times harder, but it works beautifully. It takes a huge investment, though. I work with a couple of other people who are involved in motion control, and we've developed a really great system that's 100 percent accurate. George Lucas hasn't come down to buy me out yet, but he has, in fact, just ordered a system from the guy that developed mine for me.

I'm also working on a ceiling-mounted system that will "fly" the camera. Right now I use a 35mm "motion control" camera, and it's on the end of a ten-foot broom that rides on a doily so you can do a lot of stuff with it. I think my studio has got a great niche in film. We certainly got a great reaction to our new reel. Right now we're working mainly on television commercials, and we're talking to people that make trailers with films.

I know we're not in the heart of the entertainment world up here, but we're going to try working from here. Actually, we're negotiating to do some things with Microsoft, because they're jumping into entertainment. We don't know whether we should tie in with DreamWorks SKG [Steven Speilberg's new studio]—whether that will negate any of the other major things we're working on [with Hollywood studios]. But, right now, my real emphasis is on TV commercials.

The business, in still photography work especially, is more fickle than ever. The future is online and the magic word is *content*. I've always been somewhat of an inventor, and builder,

and painter. With HoseMaster, I think I was just bored with studio photography in general. I wanted light to be more flexible. That's really how HoseMaster came about.

I was talking to a friend of mine who is a photographer in Grand Rapids. Every year, he said, a class of about 25 photography students would come to his studio for a walk-through. But this year there were only two students that came through. Why only two? Everybody is in the new digital classes. Nobody is interested in [traditional] studio photography; they don't think there's a future in it. I think digital will kill still photography. They're going to hire art directors and pay them very little money, and then they're going to mess with images in the computer and make something interesting.

It used to be that the photographer had a skill to offer. But a designer or art director is not going to hire a photographer who would be doing basically what they could be doing at a much lower cost. The great years in photography were up through the end of the '80s. But, on the other hand, it could come back. Someone could sell a look that's classic—an Irving Penn look or something. But they'd never make the money today.

You've got to realize your opportunity when it's there in front of you.

Art school students aren't familiar with the people who were heavies in the business a few years ago. Very successful photographers can find the whole thing crashing down on them; they can walk into agencies today and not be recognized by 24-year-old art directors right out of school. A lot of people make the mistake of thinking that, since they're at the top and they get all the attention, it's always going to be that way. It's not; things can change overnight. You can't assume that success is just going to carry you through. There are plenty of geniuses out there and plenty of talented people. It's absolutely fickle, and there's no sort of business loyalty.

Then there's this other thing about age. I was talking to an award-winning photographer I know who's 55. He said, "I don't dare go into an agency to show my work because they look at me and say to themselves, 'I don't think I want to work with this old duffer'." I've seen this happen to so many guys. I'm lucky because I hung onto the money, invested it, and decided to go in a new direction with film.

In terms of reps, I have a good one in New York. But again, it's primarily on the film side. I also have a very good rep in Chicago, who has really

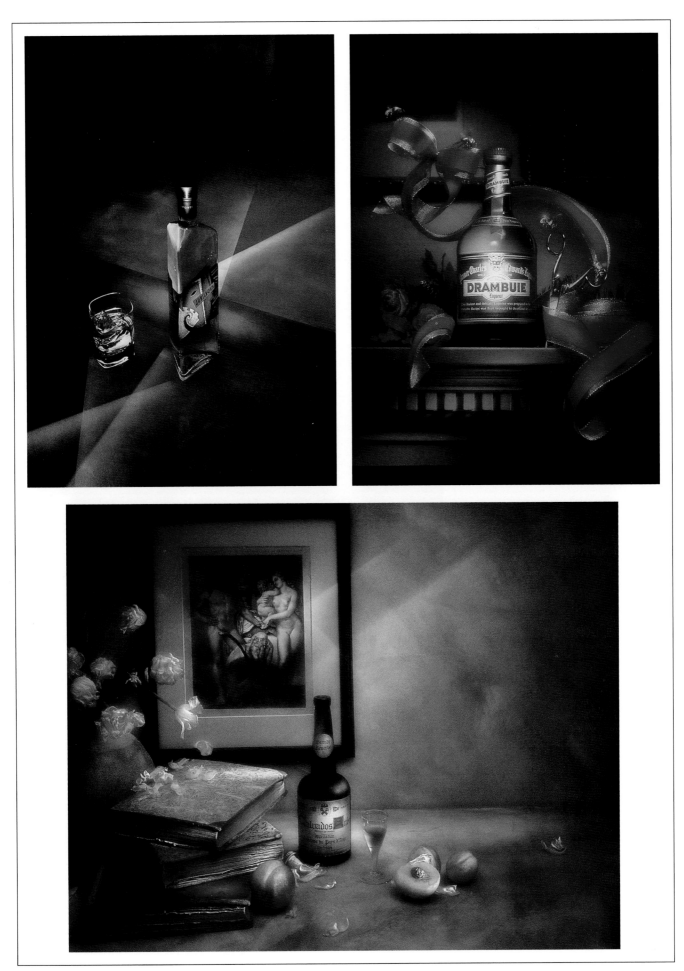

brought in a lot of work, and another very good one in L.A. With film, you've got to have a rep. You've got to know what's happening in the business—who's doing what.

I do a lot of direct mail and have an ongoing major campaign with full-page color ads every week in film trade publications. And then the reps start going out with the new reel, so it opens doors. Without doing that, it's just like with still work—you just can't get in. It's a different market, too. You have to really market to producers, to agency producers and creative directors.

Very few make that leap into film successfully today, because again, the business has really shrunk, but the number of people trying to get into film is considerable. I've seen a lot of people lose their shirts; they get a couple of film jobs directing, and they think, I'm moving to Hollywood and just joining up with a production company. And they don't get any work.

When you're trying to go from working in a local or regional market to being at the top, you've got to realize your opportunity when it's there in front of you. You've got to be willing to take that leap of faith that you can do it and do it well. You'll have to work your butt off. And you've got to really promote yourself.

I can say it's getting harder to be successful in the industry. The business isn't there. You've just got to keep coming up with new stuff—new looks. The one thing I find is that style is everything in terms of marketability. It's a look. If you've got the *in* look right now, you might get hired for the job. The reason [my light painting style] worked for me was that I knew no one else could really do what I was doing. I owned the technique. Other manufacturers have tried to knock off the HoseMaster, but I have a patent.

Photographers require common sense business acumen and artistic talent. A lot of people don't have this combination of skills. I'm lucky in that respect. And, I'm constantly watching what's happening and thinking about which direction I should go in next. For me, that was film. It's sad to me to see what's happened to photographers in general, because so many people are really talented and would love to work in the field, but I just don't see where or how they're going to support themselves. I'm excited about what my studio is doing, but I know what's happening in the rest of the still photography world, and it's too bad. I don't want to discourage young people, but at the same time, somebody has to hold up reality so people don't waste their time.

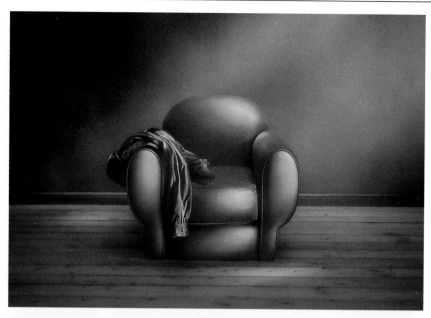

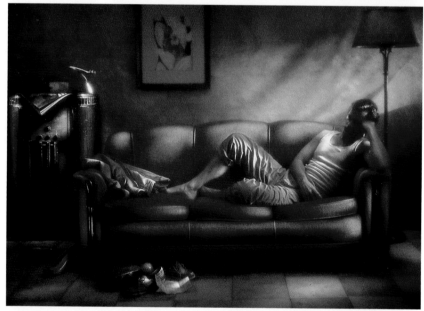

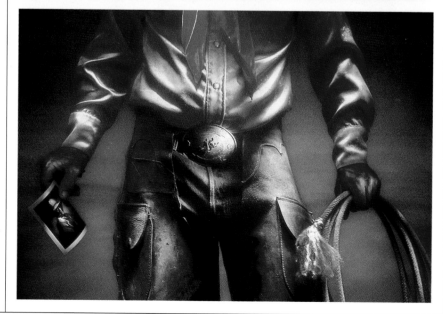

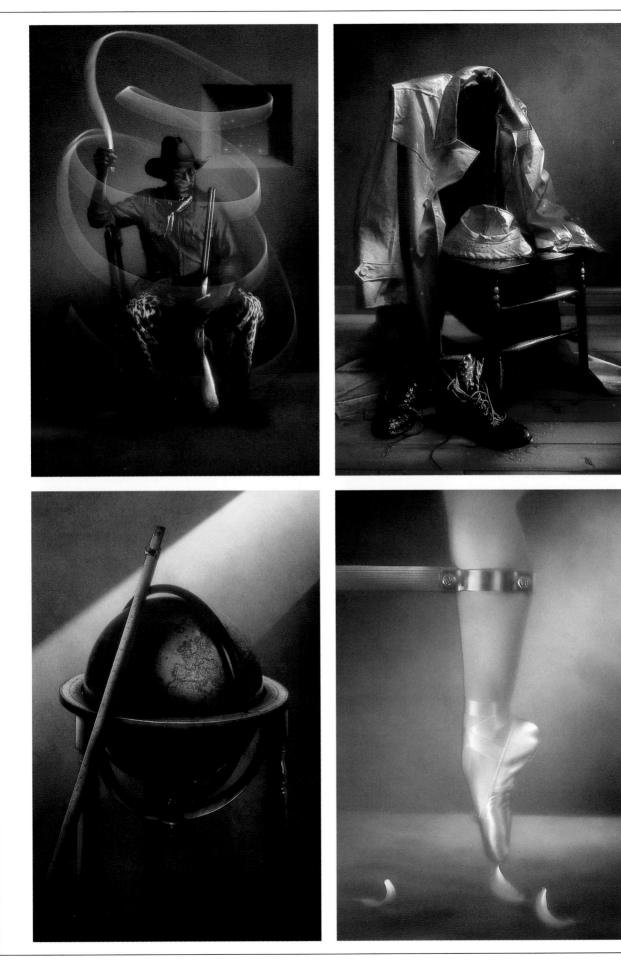

LOU JONES
BOSTON, MASSACHUSETTS

Lou Jones is one of Boston's top commercial and art photographers, specializing in photo-illustration and location photography. Raised in Washington, D.C., Jones graduated from Rensselaer Polytechnic Institute with a degree in physics. While in college, a roommate put a camera in his hands—an act that would eventually change his life. In 1971, after helping to start a computer company, Jones started a commercial photography career that has taken him to guerrilla territory in San Salvador, seven Olympics, and the boardrooms of the Pacific Rim. His work for clients such as Nike, Federal Express, KLM, Met Life, AETNA, Fortune magazine, and National Geographic has won him awards and also taken him to Europe, Africa, Japan, and 44 of the 50 states.

A big believer in the importance of personal work, for the past five years he has been working on a project documenting men and women on death rows in the United States. Active in the industry, he is a past president of the New England chapter of American Society for Magazine Photographers and a longtime member of their National Board of Directors. He is on the Board of Directors of the Photographic Resource Center in Boston and was one of the founding members of the Advertising Photographers of America.

Jones' images have been exhibited throughout the country in venues such as the Corcoran Gallery in Washington, D.C., the Polaroid Gallery, the San Francisco Museum of Modern Art, the Cooper Hewitt Museum in New York City, the Museum of Afro-American History in Boston, and Boston City Hall among others.

Deciding to become a photographer just came to me one day. I had taken a lot of photography classes in college, and I really loved it. I didn't even know how to develop a roll of film—I'd only been in a darkroom once or twice—I'd always taken my film down to the local lab. I never assisted for anyone; I didn't even know which end of a developing tank to open.

I'm not a scenic photographer or anything like that. For me, a photograph usually has something to do with the presence of man. I started out doing editorial and photojournalistic work in 35mm. I had apprenticed with one photographer who showed me how to use large format cameras, and from him I learned how to use 4 x 5 and 8 x 10 equipment to do still life.

I do a lot of personal work—almost too much actually. We've got a couple of large, very expensive personal projects that we've been doing for quite a while now. By "we" I mean the people who've worked for me over the past 20 years. They're the ones who allow me to go and explore new things, who put me on airplanes, make sure that there's film in the refrigerator and that the bills get paid.

I've tried reps in the past, and it rarely worked out. I had the most success selling my own goods; in the last five or six years I've had a full-time staff person who works out of the studio and does all of my marketing. She gets new work, new assignments. She also markets my fine artwork, gets me gallery shows, sells to gallery collections. I'm working on one big project right now and she's gotten a book contract for that.

I've been working the gallery aspect of the business for the past 10 years or so. It moves glacierly. It's as much of a business as commercial photography, but it's a completely different venue, with it's own set of rules and players. The artists—the pure artists—look at people who accept money for their art as philistines. But I feel that money equalizes things; if someone says, "I want to use you," or, "I don't want to use you," that's much more democratic than a lot of the intrigue that goes on in the art world. You have to learn all of the aspects—who has the galleries, how you get in to see those people, how you sell your work, how do you get work sold as limited editions, who's running the museums. It's very difficult, and there's not a lot of money in it. But the money is not what you do [the gallery scene] for. You do it because you think you're saying something a little bit different than other people, because you have a vision.

I also market in *Black Book* and in *Klik*. We did a big study years ago that showed us that the only directories actually getting business are these two, so we've whittled it down and now only market there. We called an enormous list of clients and potential clients and asked what kind of work they did, how big their operations were, who their clients were, how they hired photographers, whether they used photographers out of their area, and if they used sourcebooks, which ones they looked at. Other sourcebooks may be very good, but in fact, when asked nobody could name anything other than *Black Book* and *Klik*. No matter what kind of promises sourcebooks make, if nobody's looking at them, I'm wasting my money.

We also do very small mailings, not mass mailings, sending out perhaps 10, 20, 25 pieces at a time to targeted people, and then we follow up. We never do mailings without following up.

The world is full of talented photographers who don't know how to get their work out in front of people. In this respect, I find the pure artistic geniuses to be very often inadequate. The real workaday photographers sometimes gain prominence over the geniuses for this reason—they may be better marketers than the geniuses. It's a combination of talent and an indomitable spirit.

I'm not here to make money, I'm here to make great pictures.

For me, [attaining some success] had to do with the fact that I love taking pictures. I adore the process. I think it's almost like legitimate stealing—I get paid to go out and look at amazing things. My love of photography carried me through the rough times in the beginning, when I wasn't making any money and couldn't feed myself, could barely pay the rent. I just pressed on. The next epiphany is what I'm after.

In a seminar on stock photography, out of a room of 32 or 33 photographers, I was the only one who said I wasn't there to make money from stock photography. I'm not here to make money; I'm here to make great pictures. I'm more interested in people using lots of my pictures and seeing them everywhere than I am in getting paid for them. That's been the progression for my life. The kinds of projects I'm involved with are extremely expensive, very difficult to do, and will probably never make me any money back, but there's a point to what I'm doing, and I'm hoping that people will pay attention eventually.

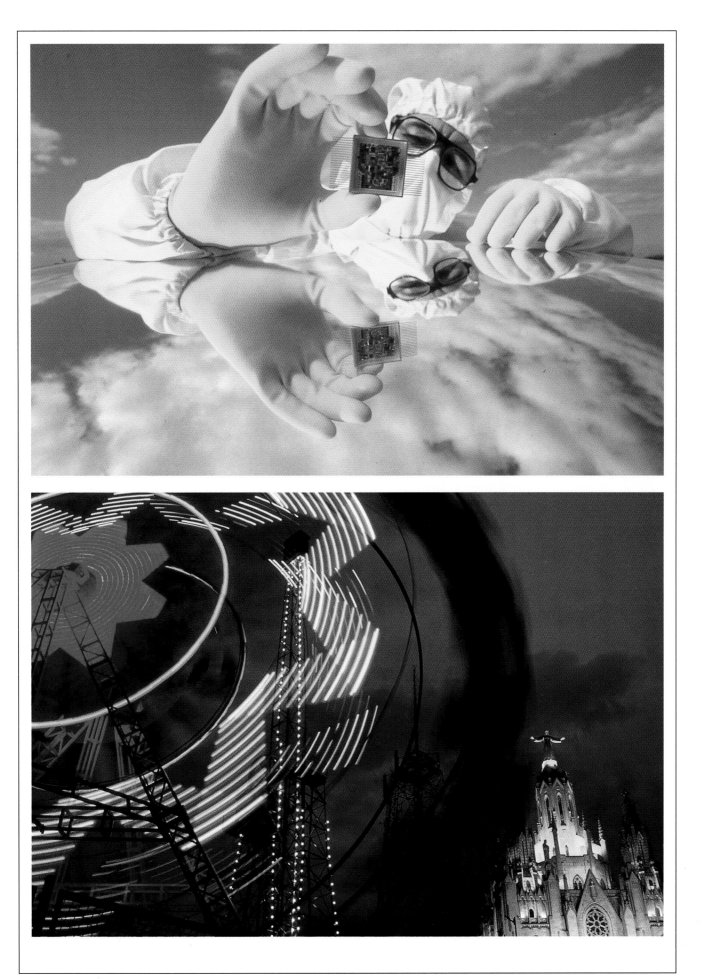

Marketing became a very important thing to me years ago. I do it all the time. I call it reinforcement. I've always thought long term. I'm going to be here whether you call me or not, but I'm going to be here. I've got a lot of potential clients I haven't approached yet. For people who saw my portfolio five years ago and thought "I can't afford Lou Jones," or, "He's not quite good enough," eventually some of them will come around to thinking, "He's been around now, let me give him a try."

I think the business is shrinking drastically. I'm trying to do more advertising and more work overseas. The Internet may be a participant in my being able to nurture clients further and further away. That's how I anticipate expanding my business. In Europe, they rely a lot more on networking. There's more loyalty and repeat business, and there's still a lot more business done on a handshake. You become part of a little team; you go back and work again and again for the same people. We're looking to do more of that.

As to the reason why there are so few black photographers, I think you could also ask, Why aren't there more white women photographers in this business? The majority of the reason is that—as with all other parts of the marketing and advertising world—it's a white male organization.

Back in the middle ages, there were large rich families. One of the sons would become head of the household and take over the father's business, one would become a priest, and one would become an artist. And he became an artist because he could afford to. With black people, that's traditionally the way that art has happened in America—one son could afford to become an artist—but black photographers primarily come from an environment that generally doesn't provide a support system. And photography, especially commercial photography, is an extraordinarily expensive profession to get into. For me, being able to sustain these professional rigors means that I'm an anomaly, and I have my detractors (to put it nicely).

In the art and commercial worlds there are people who ask, "Why aren't you taking more pictures of black folks?" or, "Why aren't you working for more black clients." Because black clients can't afford me, that's why. Not because I don't want to. I got a call from the head of one of the largest black charitable organizations in the country. She said, "I want you to do my pictures. I want to spend a lot of money and get a really nice photograph." I told her it would cost her $900, and she flipped out. I told her that I had already cut a third off my price because I knew she wouldn't be able to pay, and that this was just barely covering expenses but that I wanted to take her picture. But she still couldn't afford it. Black folks just don't always have the kinds of budgets that reflect what I need to charge to stay in business; I'd be in trouble if they were my only clients—if they were the only people who would allow me to get into the room.

I'll be 53 years old on my next birthday, and still to this day, when I go into an ad agency in Boston, bringing my little portfolio for an appointment with a creative director, the first thing the person at the front desk says is, "Drop the package off here, we'll give you a signature." That's what I get, 9 times out of 10.

When I started in this business, there was this company that processed film. They begged me for years to become one of their clients. I asked to set up an account so that I could charge my film processing rather then having to walk in there with 20 bucks every time. The guy behind the counter said he "didn't know" and called up a friend of mine, asking how old I was, how long I'd been in business, and saying, "I heard a rumor that he's black." I didn't get an account. Boston is one of the most racist large cities in the United States.

I became a board member of the ASMP for one reason only. I got into a cab one day, and the driver told me a story. He'd been a photographer here in Boston for years, with a studio in a large factory building that had been filled with artists and studios. Then one day the studio building burned down. The fire burned all his cameras, negatives, prints, and everything he owned. He had had no insurance and that's why he was out driving a cab. And I thought, He can't get insurance, doesn't have daddy to pay for it, and can't go to a bank because he's black.

Photography is not expanding as a business. It's impossible to make a life's work of photography today. If you think of all the people who were photographers once and aren't today, you're talking about some major statistics there. Commercial photography is art in commerce, to be very truthful. Do what you want to do. Take the pictures you want. But if you want to take pictures of flowers, for example, don't just walk out there and take pictures of flowers all the time. To sustain your business, think about who's going to buy pictures of flowers.

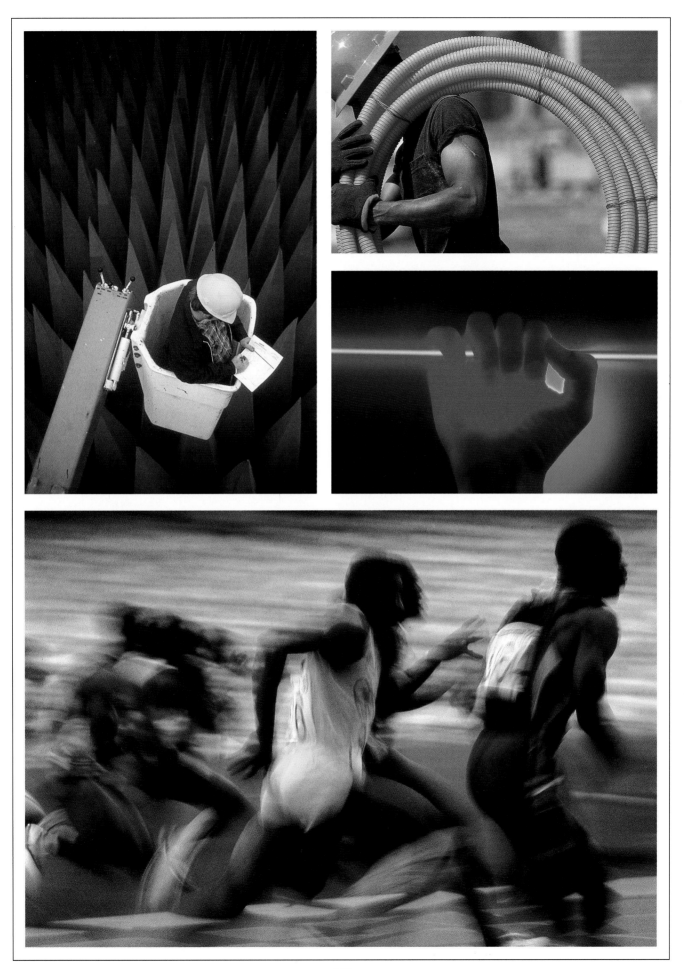

CHUCK KUHN

BAINBRIDGE ISLAND, WASHINGTON

An honors graduate of the Art Center College of Design (in Los Angeles) and Willamette University with a B.A. in English literature, Chuck Kuhn is an award-winning location and lifestyle photographer who has been in business for nearly 25 years. Known for his moving portraits of the life and landscapes of the American West, especially those of the American Indian and the cowboy, he recently broadened his scope, developing a new body of work depicting the people in the small towns of rural America. Once recognized only for his work with huge productions, Kuhn now avoids slick imagery, instead focusing on being unpretentious and straightforward in his photography.

Kuhn's client list reads like a who's who of corporate America, including Marlboro, Nike, Miller Beer, IBM, Budweiser, Coca-Cola, Hewlett Packard, Nintendo, Isuzu, Pepsi, Saturn, General Motors, Maytag, Oldsmobile, American Airlines, and Allstate Insurance. He has been honored 16 times in Communication Arts *and was recently the subject of an article in* Photo District News.

My specialty is real people and real places. The West is a part of that, and small towns are part of that, vehicles are part of that (be it trucks or pickups), and the advertising and editorial markets are part of that.

As far as the marketing goes, I do a range of things. I run ads in the sourcebooks; presently I'm in the *Black Book, Workbook,* and *Single Image.* Sometimes I run ads in *Archive.* I also use direct mail and occasionally work with reps. About 15 years ago, I came with the slogan "Kuhn in the West" as a marketing concept. I happen to live in the West, and at that time, a portion of the work that I wanted was on the East Coast. I figured that it would provide quick linkage between my name and my location. It has worked very well. It was a way for me to get my name noticed by people on the East Coast or in the Mid-west.

A lot of buyers of photography like to put people into categories. Sometimes it may have to do with the literal-mindedness of clients; for example they need someone to take a picture of a cabbage, and unless you have a cabbage in your portfolio, they think you can't take a picture of a cabbage, which is totally insane. When you do your promotion and your work for your portfolio, it's important to consider how much you want (and don't want) to be categorized.

I don't do "style" to do style. I think that's a lose-lose situation. I try to do "content" and hope that the way I shoot or the way I see the world becomes the "style."

My portfolio has gone through many changes over time. In the very beginning, it was laminated prints. Then it was a mini-book of tiny pictures all laminated together that folded out, accordian-style. Then I went to chromes. At present, it's a print book. Basically, I show 30 to 50 images. I've also tried putting some of my work on CD-ROM.

At the beginning of every year, I start off the year with my "let's suppose" business plan, which includes a marketing plan detailing the amount of work I'd like to do and the clients that I'd like to reach. Basically, it has to do with making more money, spending less and saving more, and getting more clients and more jobs. But, like life, things are always changing, and I redo my goals on an ongoing basis.

In terms of business planning, one of the main things to do immediately is have a retirement plan and religiously put money into it. Your retirement plan needs to be an essential part of your business plan. It's a necessary expense, just like advertising, rent, and your studio telephone. You have to find a way to ensure that paying yourself first just becomes a natural part of your expenses.

We use computers for studio management. Frequently, the agencies who I do advertising photography for will sub out any retouching or manipulation of images that they're using for the final ad. I personally don't use Photoshop. I don't see the value of my doing it. If I shoot for someone from Milwaukee, that person doesn't want to have the Photoshop work done all the way in Seattle. In some instances, clients are going to make changes and want to come in to see the work progress, so it could potentially be a nightmare trying to ship the imagery back and forth.

My advice to newcomers and burned out old-timers is to stop and step outside your individual situation and look at why you initially got into this business and then go and photograph what you want to photograph with no preconception as to whether it's going to be successful or not. Do it solely for the experience and joy of doing the photographing.

> *Just go and photograph what you enjoy solely for the experience and joy of doing the photographing.*

I've been doing just exactly this for the last few years. Out of these personal shoots, I try to market those images that have to do with the essence of what I'm about. Working like this, regardless of economics, my photo "spirit" is always hopefully upbeat, because I'm doing things that I enjoy. The basic human emotions, whether photographed for your own personal use or done for commercial work, are universal emotions that all people have, regardless of where they are. If you can capture those things, you can capture them anywhere; the only thing you change is the background.

In many ways, when someone hires me, they mentally buy into what I'm about; if they don't understand and don't hire me, it's their loss. This photographer is living life. When I go and photograph people, I'm with people. If I go and photograph Phoenix, I'm with Phoenix. If I go and photograph product, I'm with product. I'm not in an office. That understanding of human emotion is not of an office, it's out in the world. People (and art directors) shouldn't be in offices—they should be on location all the time, because that's where the ideas are; ideas aren't in an office on 42nd street in New York City.

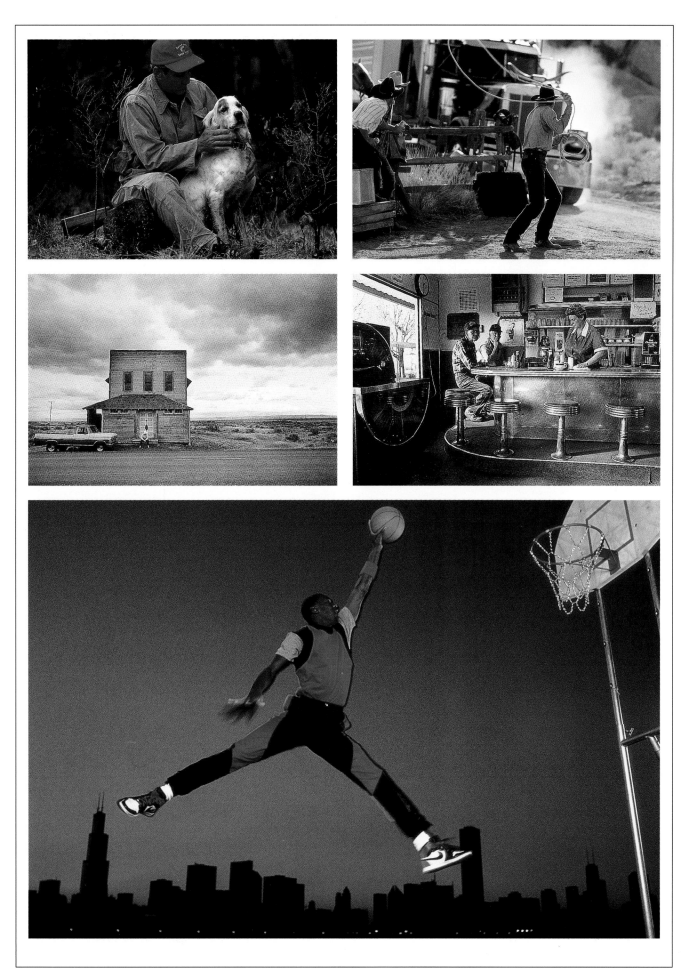

DAVID LANGLEY
NEW YORK, NEW YORK

David Langley has had a diverse life experience. After high school he attended Cornell School of Agriculture. While at Cornell he had a job driving surveyors around and when the owner of that company announced that he wanted to make a progress film of one of the construction sites, Langley was picked for the job. He lied and said that he knew how to run a movie camera and then went down to the local library and borrowed a book on how to make movies. After two years at Cornell, he was drafted into the army.

Around this time he bought a Rolleiflex at the army PX for $70. After getting out of the Army and working at a postcard printing company, he decided to pursue photography. After a brief stint at a photography school in New York City, a job as a wedding photographer, and a position as an assistant at a fashion catalogue studio, he opened his own studio with a partner before finally going solo with his business. Over the course of his career, his work has taken him all over the world, including to Chile, Argentina, and Sweden.

A strong believer in mentoring and giving back, Langley has taught at a number of places, including The School of Visual Arts in New York City, and believes that from this he learned just as much as, if not more than, his students did.

As a kid, I had a friend Jonathan, whose father was the copy editor of *LIFE* magazine from the day it began publication. They had a spare room and in it they had every *LIFE* ever published. That was my introduction to pictures. I remember very clearly hating all the ads that I saw in the magazine and loving all the terrific black-and-white photography. I always felt that the pictures in the ads looked so phony and contrived.

Originally, I was desperate to be a street photographer. As it turned out, I really was a poor one, and I had to face this fact. Sometimes I'd walk through the city for two days straight and not expose one piece of film. One of the things that I came to grips with was that I had to have a reason to take a picture. I couldn't find any reason to stick a camera in somebody's nose on the street; I found it rude.

I had a portfolio of great concept ads. I always believed in just showing ads. I loved solving problems and doing very difficult assignments. A gold medal winner out of [a prestigous ad agency] is hard to put a price tag on; it might be worth a $100,000 of business in terms of promotional value. But still, I never did photography for the money. I always enjoyed it tremendously. I love it when somebody says, I don't think this can be done but lets give it a shot.

I never wanted to be a retoucher; I have no interest in manipulation. They're wonderful tools, and great things can be done; however, there's no software that has a taste button. If I see another purple rhinoceros in the sky, I'll throw up. They do these things only because they can be done. There's no rhythm or reason to do it. There's no concept behind it.

The last four years have really driven a stake through the hearts of established photographers—the ones who refuse to make changes and move on. It has a great deal to do with the picture buyers and the changes that are taking place in ad agencies. Most of the agencies have become account driven; accountants have taken over the agencies and basically look at the bottom line. The bean counters decided that all the older guys, who had the experience, were way overpaid. They just looked at the figures. I know hundreds of seasoned, experienced well-trained, dedicated, advertising art directors who don't have jobs. They're just gone, replaced by 22-year-old kids just out of art school.

If you look through national ads for major clients nowadays, you'll see that a lot of them have no concept. It fascinates me; there's virtually no idea, aside from the "design aspect" with maybe five or six typefaces. The clients are completely wasting their money.

The personality of the photographer has a tremendous amount to do with the ultimate image. Annie Leibowitz, for example, is crazy, social, and a real personality. She's a powerful lady. She knows what she wants, and she doesn't let anything get in her way. I find her to be incredibly honest and direct. She rented my studio on 50th street a couple of times, and she's a damn good shooter. It's not just that famous people were in front of her camera; it's her ideas, and it's a function of her personality and her looseness to get these people to do things. How do you get Whoopi Goldberg to sit in a bathtub full of milk? You've got to be pretty damn persuasive.

For a young person starting out in today's market, success has more to do with being off the wall and breaking the rules. I love the process, I love advertising, I love terrific ideas, I love working with bright-eyed, bushy-tailed people, whether they're 20 or 60 years old. There's no substitute for a creative mind. It's great when somebody pushes you a little bit farther than you ever thought you could go. A good art director can manipulate and mold and get the best out of the talent that you have to offer.

> *I love the process, I love advertising, I love terrific ideas.*

I'd tell people who want to be photographers to get a good, solid technical background and know all the tools. The technical side of photography is quite simple at this point and the materials and equipment are excellent. After that, I'd tell them to go to libraries, go to the books on great photographers—Henri Cartier Bresson, Irving Penn. Just devour all that work and then shut off the photography thing and think about what you're interested in in your lives—find the avenue to that through the medium of photography.

If you've been around for a while, and the phone isn't ringing, you can get upset or you can find out why it isn't ringing. It's terribly important that you look at yourself and say, "I'm responsible for where I am—for whatever I do or don't do to get to this position." I love the business; I've had spectacular experiences, fabulous life experiences and a lot of them didn't have to do with the actual production of the photographs but with the experiences of rubbing elbows with fascinating people. It's wonderful and it's been a fantastic way to make a living.

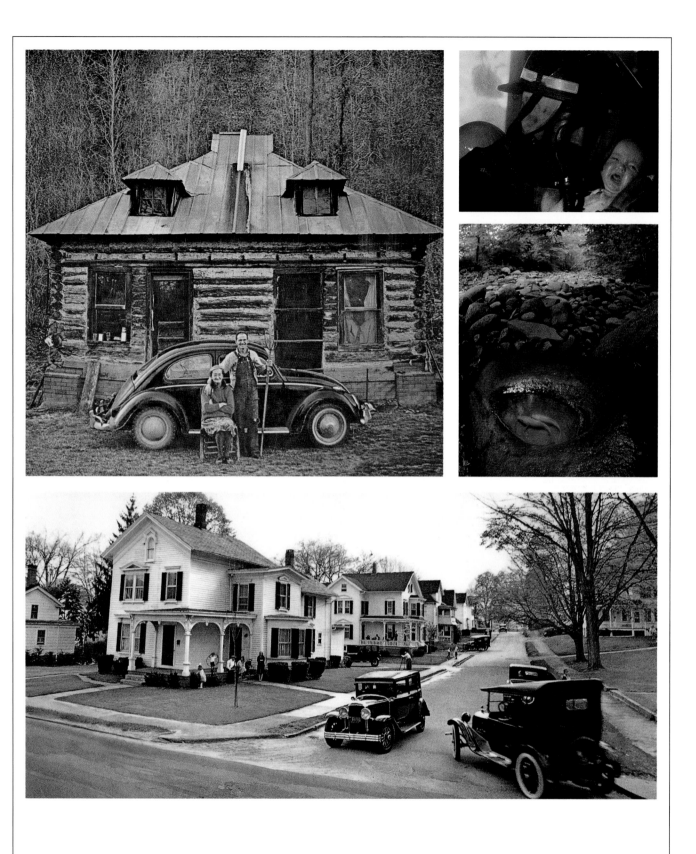

LARRY LEE

HOLLYWOOD, CALIFORNIA

Larry Lee is happiest traipsing down a busy street in a foreign country looking for that next shot to add to his large stock photo library. A consummate businessperson, Lee has fine-tuned the art of packaging to help his studio's bottom line. He's a master at bundling assignments from various clients to build a much larger assignment that permits him to put together photographic odysseys that have taken him around the globe. After a stint in the army, where he was trained to work on motion pictures, he assisted for a few years, and then decided to test the waters by opening his own shop. He's never looked back.

With a primary specialty in imagery for the petroleum, energy, and environmental markets, Lee has become known as a sort of "ninja" in the business—working alone, quietly slipping in, getting the shots he needs, and then fading into the background. His clients include the largest oil and gas companies in the world, and his work is represented by more than 30 stock photography marketing agencies around the globe.

I worked for several photography companies as an assistant before I finally began to really learn the business and went off on my own. Right from the beginning, it worked out pretty well. It's fun when you start your own business. No one paces you—you just improvise. I've been on my own ever since, and it has been ideal.

The industrial part of my business more or less just developed. But I had done a little of everything as an assistant. You have to be able to do all types of photography, but you still have to specialize so that you build your reputation and, marketing-wise, have a direction.

I think there's quite a bit of competition for what I do, although it's not as visible as the competition in other specialties. This is most obvious when you look at the sourcebooks. Nine-tenths of the people in those books are advertising types. You have very few industrial shooters. There are a lot of guys doing a little bit of what I do—but there aren't as many people who do exactly what I do and as much as I do.

I very rarely have to bid for my projects. It's not like advertising. If you're shooting a beer bottle, there are lots of people who can do that. But when you're talking about an industrial situation, my experience sets me apart from other photographers. In fact, it's a bad concept to get bids; the cost of the job is not what you're buying—you're buying the photographer's knowledge and understanding of the situation. Having shot a hundred oil wells gives me a better chance at getting a good shot than the guy who never shot one before. Hiring that guy because he charges $100 less than me is stupid.

My marketing strategy has worked well for me. The marketing potential is vast because of the projects I do. Every time a job comes up, there will be a couple of clients involved and a couple of related businesses involved, so I have the potential of marketing to people other than my primary client every time I do a job.

I have a client base in the industrial and construction industries. They're international-type companies, and I call them up or send out letters saying, "I'm going to Europe (or wherever)—do you need something shot?" Either they'll need me to shoot something that's there or sometimes, even if they don't need anything, they'll say, "If you're going to Europe, let's go ahead and just cover some of our facilities."

In the past, it was common for companies to send you around the world for just one assignment. Now, clients always look for a deal, so if you keep your travel expenses to a bare minimum—because you've combined various assignments into one trip—it's a bargain for them and it's great business for you. Recently, I've also expanded into producing more stock on trips.

I've traditionally used computers for financial matters, for storing my customer database, and for mass mailings, but I've recently become very involved with using Photoshop to manipulate and enhance my stock images; you can do so much with a computer. Now when I shoot, I don't worry about the sky not being terrific, or a phone pole being in the middle of an otherwise great shot. I can fix these things after the shoot. I'm experiencing a renaissance working with my images on the computer.

I've always been a firm believer in sourcebooks. They did very well for me for a couple of reasons. First, there are very few industrial photographers advertising in them. Plus, I amassed a tremendous stack of reprints from my ads—over a five-year period of being in two or three books every year—basically a portfolio. I'd mail out samples of my work and people would buy those images, or see my capability, or see that I traveled, or see where I was going to be geographically if they needed somebody to shoot in that area.

There's a place for everyone in today's photography market.

As far as change, it's a lot harder to get assignments. You just have to keep your overhead to a minimum, which is easy for me because I work out of my home. I like a home office. The idea of being able to run upstairs and spend an hour or two doing work—as opposed to driving to the office or studio and sitting there late at night and then driving home and never seeing the kids—works for me. There are a lot of family functions that I really enjoy doing, and that's very important to me. I wouldn't have it any other way.

In the past, things were very different in this business because photographers weren't really experienced. Most training was "on the job." Now, the new photographers are really sharp. They have a tremendous photographic knowledge and a much better business sense. So in the future, you're going to have to be very sharp, both creatively and in terms of business. The competition is going to increase; the marginal people aren't going to make it, and that may be better for the industry. There's room for almost anybody, whatever your personality. There's a place for everyone in today's photography market.

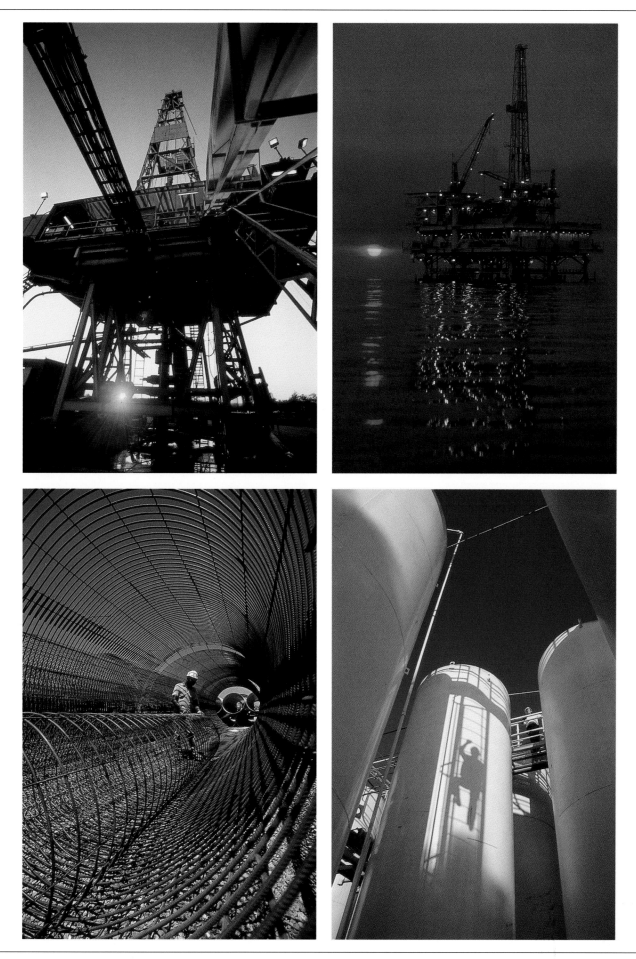

FRED MAROON

WASHINGTON, D.C.

Fred Maroon is an internationally renowned photographer whose work is in the permanent collections of The Museum of Modern Art, The Metropolitan Museum of Art, the International Center of Photography, and the Library of Congress. He is the recipient of Gold Medal awards from the Art Director's Clubs of Washington and New York and of four first prizes in the White House News Photographers' Association annual competitions.

He has exhibited widely at both national and international venues, including the Corcoran Gallery, the National Gallery of Art, and the Smithsonian Institution. He has been a regular contributor to major national and international magazines for more than 40 years and is an active lecturer in the United States and abroad. He was a visiting professor at the Newhouse School of Public Communications at Syracuse University, where he was awarded the Newhouse Citation for significant contributions in the field of visual communication.

A graduate of the Catholic University of America (with a degree in architecture), Maroon received an honorary doctorate from his alma mater and also did graduate studies at the École Supérieure des Beaux-Arts in Paris. He is the author of 11 books, the most recent of which is a collection of photographs entitled The Supreme Court of the United States *(Thomasson-Grant Publishers, 1995).*

Photography has been my hobby since I was 12 years old. When I was in college studying architecture, I was elected editor of the yearbook. The month before graduation, I got a letter from *LIFE* magazine asking if I was interested in working for them. I couldn't turn down that opportunity. That was the beginning of my professional career as a photographer.

I don't specialize; my specialty is photography. This is because as a freelancer working out of Washington, you didn't say no when somebody called you up for an assignment. In the '60s, magazines sent me all over the world doing travel, fashion, food, portraiture. I got assignments that included two or three specialties, which was very good training for me. And, you attracted other people who were looking for the kind of work that your display in a magazine (with your byline) showed you could do. It was your portfolio. You couldn't beat that. Each magazine had circulations in the millions.

With the magazines, we got a guaranteed pay rate. It started off as $100, which was the ASMP minimum dayrate in the '60s. Then it grew as the decades went on to $300 or $350 a day. If I do editorial today and I ask for $600 a day, I don't have any problems. But I don't get that many calls for editorial, so I couldn't make a living from it. As I raised my rates, I got more work, showing that the respect clients had for you was measured by how much you charged. I thought underpricing yourself was how you got a job, but I found out the contrary could be true. If you have a big fee then people figure you must be worth it, you must be good.

In the '50s, in order to handle the amount of assignment work I was getting, I felt it was better to get an agent, instead of doing it myself. My rep got that much more work, so despite the fact that he took 25 percent of the money that I got, there was still a lot more money for us to divide. He was able to generate top fees for me. I've never advertised in sourcebooks. When they came out, I had my agent, and I already had more work than I wanted to do.

Very early on I started to buy stocks and then I bought real estate. I had the building in which I lived and worked and another property, and they both appreciated considerably. Real estate is one thing that is very good to get yourself involved in very early on, in an ownership position. My accountant told me many year ago to diversify as much as I could—to have real estate, stocks, treasury bills, and treasury bonds.

I haven't worked with Photoshop to any great extent. I did fool around with some of my images on PhotoNet, putting them out by electronic means to tie in with current events in some way. It was not at all successful, as far as I can see. I made a few sales but not enough to live off of, and it worried me that my imagery was exposed to a huge audience, waiting to be plagiarized. I'm very reluctant to get involved in it. Somebody's going to make money, and it won't be the photographers, because we'll have lost all our control.

The thing that makes stock photography work for a photographer is to have a certain exclusivity in certain areas. Then at least you're not competing with tons of other guys doing the same stuff. My Egypt collection sells now; my navy pictures still sell. My U.S. Capital images are something that people want, because there hasn't been a lot of photography done of that.

Stock can be profitable, but I don't know how long it's going to last, because now there's another transition going on with electronic imagery, with CD-ROMs. I think it won't be long before photographers are giving their work away. There are some outfits that are very aggressive in getting photographers to sign off on everything.

> *You should always challenge yourself with something that's beyond what you've done before.*

You should live by being honest with yourself and with your clients, and develop relationships in which you always give your clients and yourself 100 percent on an assignment, whether it's an important shoot or an unimportant shoot.

I've always said that unless you're technically proficient, you'll never become artistically proficient. Take a great Renaissance fresco painter, like Michelangelo. He had to watch what kind of paints and mediums he mixed, and how he applied them, so that they wouldn't flake off the wall. You need to be just as good a technician as a photographer. As good as you are technically, that's how good you'll be creatively.

The beautiful thing about photography is that you can shoot until they put you in the grave. It's great that I can be able to do my hobby, because it's still my hobby and I'm still an amateur. The word *amateur* comes from the Latin *amator,* or lover, and *amare,* to love. It's not a derogatory statement at all to say you're an amateur; you do it because you love it.

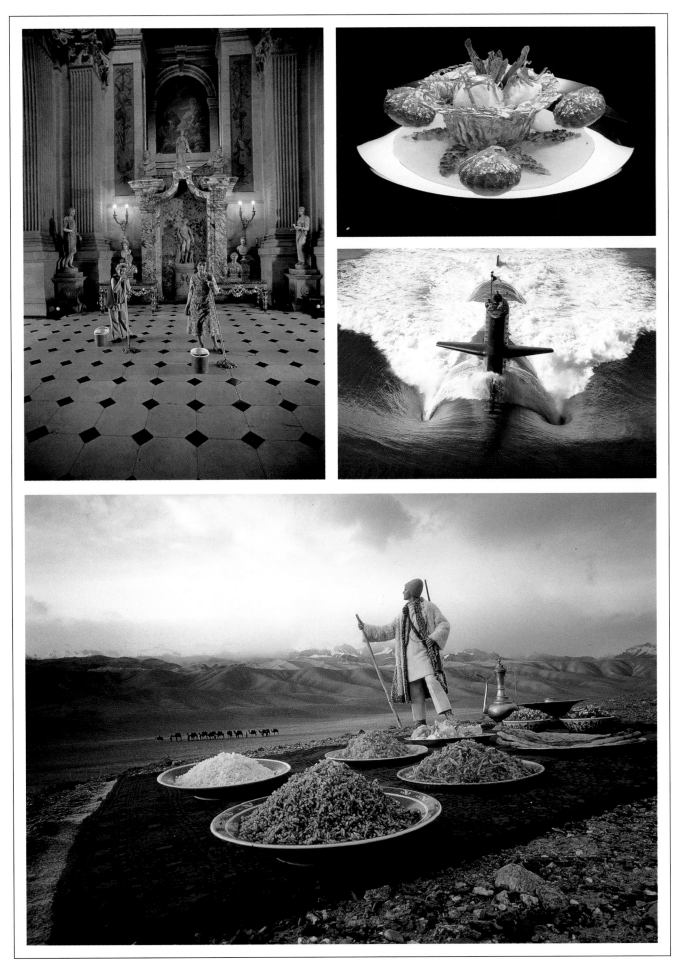

149

ARTHUR MEYERSON

HOUSTON, TEXAS

A college course requirement brought Arthur Meyerson into the world of commercial photography. A firm believer in goals, this native Texan spent the early part of his career producing work for the editorial market, which led to his great success in the corporate and advertising arenas.

He is included in "The World's Top Ten Annual Report Photographers" listing compiled by Communication World *and has been named* Adweek's *Southwest Photographer of the Year on three separate occasions. Recently,* American Photo *magazine named him one of the top 30 advertising photographers. His photographs have been exhibited internationally and have been featured in publications such as* Communication Arts *here in the states, and* Zoom *in France and* Novum *in Germany.*

Meyerson maintains a strong conviction for the industry and for teaching others. A frequent industry speaker, he regularly leads seminars and workshops to help give back to the profession and has produced award-winning work for clients such as Coca-Cola, Nike, Apple, National Geographic *magazine, the NFL, Compaq, Russell Athletic, United Airlines, American Express, Konica, Puma, NationsBank, Levi's, and Motorola. He is the recipient of gold medals from the New York Art Director's Club, the Art Director's Club of Houston, and* Photo/Design *magazine, and received the prestigious Stephen Kelly Award for his work on the Nike advertising campaign.*

My fascination with photography started as a kid, looking at *LIFE* magazine and *National Geographic.* My mother gave me a hard time, saying, "Why don't you read those magazines instead of just looking at the pictures?"

I set a goal for myself early on. I followed the work of talented art directors and designers, and set my sights on working with those people and with their good clients. One of the ways I got started was doing some non-profit [pro bono] work for clients like the YMCA or the Boy Scouts. Since it was non-profit work, I had complete creative control, as long as I met the needs of the project. This gave me the opportunity to work with (and network with) some very good art directors and designers (who were also working pro bono).

Since it's very difficult to maintain a studio and staff doing editorial work, I don't do as much of it as I used to; however, editorial work was helpful in my getting started. It was a great way to get my work out there and seen. I also did directory ads, posters, direct mail pieces, and speaking engagements at art directors' groups and ASMP meetings.

I've never had a rep. I think part of that is me—I've been doing this so long on my own that it becomes a question of my willingness to entrust it all to somebody else. It's not so much a matter of the the commission as it is of believing that I've got somebody out there really batting for me. I'd recommend using a rep to a lot of people, however. Because they're such terrible businesspeople, many talented people need reps. You can be really talented and still be dying of hunger. You need business sense and creative sense. The person who combines those two things will be successful.

My portfolio goes out in several forms. I try to tailor the book to what the clients are looking for, unless they want a broader, general portfolio. In terms of format, I have everything from 35mm slide trays to print samples [tear sheets] to enlarged dupes to, most recently, a CD-ROM. I don't think that most clients have the capability or desire to use CD-ROM yet, but once they do, it might make things simpler and easier in terms of getting the work out there.

Like most photographers, I'm still concerned about having my work ripped off if it's presented in electronic form, but that can happen on print samples, too. There's no guarding

against it either way; you copyright the images and put notices on them. There's always going to be dishonest people out there; hopefully, the majority of people you deal with are honest.

My philosophy about promotion is something I call the three C's—consistency, continuity, and commitment. You just can't advertise once and expect to get results. You have to dedicate yourself to it. And you have to presented your work in a way that highlights it. It's important that the presentation not only be good but that it have some consistency. It becomes a building process, and after a period of time, hopefully, clients begin to look at your work or, better yet, recognize it right away.

Advertising agencies are more apt to use sourcebooks. Most graphic designers doing corporate work don't make much use of these directories, except if they're in a real tough situation. On the other hand, art directors, art buyers, and creative directors scan the directories more often to see who's out there. Of course, the word-of-mouth referral factor always helps, too.

Award shows and competitions are also very important, promotion-wise. If you're in a local community and there's an art director's club competition, make yourself a part of that. The Communication Arts Photo Annual, Photo Design, and Graphis photo annuals are extremely important on the national and international level. To get into those shows is always impressive. They

You need business sense and creative sense. The person who combines those two things will be successful.

are a good barometer, because they put you up there against your peers and highlight your work. However, you should never take the awards seriously; you're crazy if you do. It's just another way of promoting yourself and getting your name out there.

Stock photography is extremely important to me and to my studio. Although I'm with The Image Bank, I'm primarily an assignment photographer. I shoot for assignments, and when I get a chance, I shoot for myself. If something I have happens to have stock potential, great. There have been times when things were slow and stock was the thing that kept us going. Also, I'm adamant about not selling all rights; I believe in stock, and I believe that as a photographer you can only shoot so many jobs in a lifetime. Stock's our means of retirement in a sense, and quite frankly it's been very beneficial to have.

To newcomers to the business, I'd say try to get a job assisting someone

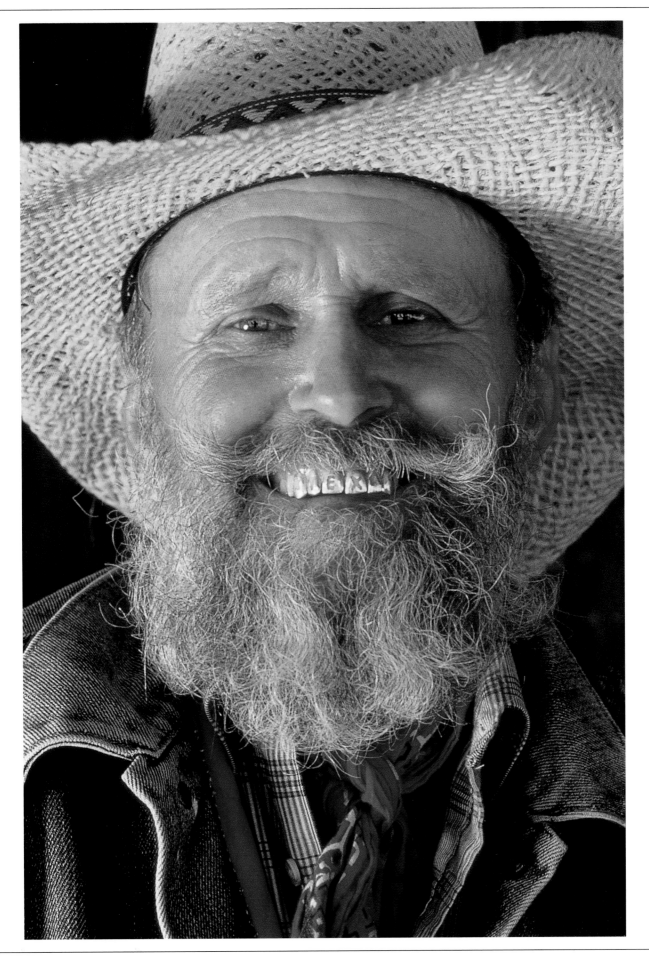

whose work you really admire. It's very tough to find that kind of position, but it's so important—you learn so many things that you don't get in school. One of the things that photographers need to do is share information. Also, be patient and persistent while trying to find your own visual style, and it's absolutely critical to learn to edit your work, to be your own worst critic.

For burned-out photographers, I'd say never stop shooting for yourself. Try to remember why you got into photography in the first place. Maybe take a workshop. One of the best things that ever happened to me was back in the '80s when I needed to make a change in the direction of my work and took a photo workshop in Japan with Ernst Haas. It was one of those "change your life" kind of experiences. The things I learned from just being around him, I carry with me to this day.

In terms of changes in the business, the biggest thing would be the technological changes. There's also a tremendous amount of competition. When you add to that the problems of price undercutting and people giving rights away, it makes taking a good photograph and having a good photograph respected much more difficult. It's tougher to get to a point where you can get the kind of projects you want, beyond just making a living. There's a tremendous amount of pressure to "take it or leave it." I don't know if this mentality came from clients or agencies, but it's forcing photographers to do things they wouldn't normally do, such as giving more rights away than they would or charging much less than they would or should.

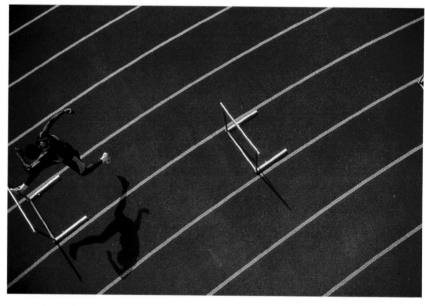

In terms of giving all rights away, I've fought that for a long time. It's just bad business and bad for the profession. You need to learn to negotiate, but not to the point where you're sacrificing things that are critical to your business. This involves being able to say, "No, I don't do that, but what if we approach it this way?" Give clients an option. It's a give and take process. The last thing you want is to be out on a shoot, take an incredible shot, and then think, "Oh no! I just sold all rights on this." If you start out saying "no" in the beginning, it's much easier to say "no" the second time. One of my favorite quotes from Ernst Haas was, "I made my reputation by saying no." It's very important that you learn to negotiate upfront or, if you're uncomfortable with that, get a rep who can do it for you. Successful commercial photography is a blend of art and commerce.

DUANE MICHALS

NEW YORK, NEW YORK

Duane Michals was born in McKees-port, Pennsylvania, in 1932. In 1958, he borrowed a camera and went to Russia as a tourist. As a result of this trip, he became a commercial and fine art photographer. Known for his moving and often surreal peoplescapes, he is also a successful advertising shooter.

Recently appointed an officer in the Legion of Arts and Letters by the French Government, Michals' work has been featured in countless magazines and exhibitions. A definitive monograph on his work, The Essential Duane Michals, *was recently published in London by Thames and Hudson, and one of his latest books,* Salute, Walt Whitman, *was published in 1996 by Twin Palms Publishers. He is a frequent lecturer at workshops and seminars, and freely shares his vision and philosophy at many nationally-known events, including the Smithsonian's "Masters of Photography" series.*

I never assisted; I knew nothing about photography when I started, thank God. If I had known anything, I would never have had the courage to become a photographer. I was making a hundred and a quarter a week, which was a decent salary in 1960, and I thought that was terrific. I never wanted to be a business. I never wanted to be a studio. I never wanted to have six assistants. I just wanted to make enough money to live comfortably and do what I wanted to do.

I've never not done my own work. A lot of photographers want to be artists or whatever, but all their energy goes into their business. They figure one day they'll go out and do their own work, but they never do. It's very important to do your own work. Otherwise, it's just another job.

I've been working 35 years now. I had an agent once for two months. It made me nuts. I never had an agent again. It makes me feel like I'm working for somebody else.

I never market my work, never advertise, never go see anybody. I do sometimes when business is slow and I get nervous, but I get phone calls most of the time. It has a life of its own, in other words. The classic route is that you do editorial, then you get seen, then you get the better jobs. I discovered advertising about 15 years ago, and that was marvelous because you make so much more money and you work just as hard, maybe, probably harder.

Most of my work is advertising now, but I've done absolutely everything. I've never specialized. I essentially do portraits. I've learned everything on the job, which is the best way to learn. I use freelance assistants. I work about two days a week on average, and I don't have any staff, so I have no overhead.

I thrive on variety. I loathe the idea of going to a studio everyday doing food setups or beauty pages in *Vogue*. If you have only happy people in your book and they want sad people, they won't call you. They can't make the stretch.

I like solving problems, so I have fun when somebody [hires me], but I have no idea how I'm perceived. I know that I'm not unknown, but I don't know how I'm perceived as compared to others. I just work all the time. I have more fun than anybody I know. But also, I serve my own work. I'm doing two books for next year. What makes it fun is solving [people's] problems and then, on the other hand, working to solve my own problems.

You should go back and forth between the two. I never consider what I do to be work.

That's the secret of success—to find an activity you love doing and then get somebody to pay you to do it. Occasionally, my personal work will come over into my commercial work, but not always. With 90 percent of the work I do viewers never know that I've done it. Clients give me an idea of what they want, and I give it to them. My ego doesn't get into any of that crap. I never badmouth a client, either. I've never put down anybody who's kind enough to hire me. I think it's an act of faith on their part.

I'm a blessed person. I say that modestly, but it's true. I'm better now than I've ever been. I feel like, at 63, my imagination has never been better and my work has never been more interesting. I'm always in a state of excitement. I feed off my own energy. I'm always up for something.

My portfolio is all samples. It's rather large and very attractive, but it's all samples, all jobs. When clients see tear sheets, they see that you can function with an art director, that you can publish. It shows how the photograph looks when it's used. Anybody can do a book of interesting prints—that's a waste of time.

> *Photography's always going to be tough. If you want it easy, go sell shoes.*

The last thing I want to be is old and poor in this country. I've feathered my nest. I've always put away money. The problem is that a lot of people never think in advance. They suddenly find themselves in their early fifties and they say, "Oh my God, what do I have to show 10 years from now?"

I think all this digital stuff is important; it's the future, but I don't do it. I think it's just another tool. But I know that's what all the kids and students do. This work with silver prints and the stuff we're doing now will, in another 25 years, be just like the Daguerreotype.

I think that any good graphic designer can become a good photographer, because you have an innate sense of the appropriateness of things. You'll have a sense of the way your photograph should look. A lot of students don't know how to put a photograph together. They have absolutely no sense of what makes an interesting picture.

I just read *The Tibetan Book of the Dead*. I think Buddhists know what's going on. I think there's a continuum. I've meditated and worked out for years. Yes, I'm very cautious—conscious of health. Take two photos and call me in the morning.

SCOTT MORGAN

SANTA FE, NEW MEXICO

Scott Morgan is one of the most sought-after young photographers and TV commercial directors working today. Recently relocated to Santa Fe, after years of working in Los Angeles, he has successfully persuaded clients from across the country to still use him. His strong conceptual imagery has won him major accounts with Nike, Levi's, Reebok, IBM, Pepsi, Coca-Cola, Shiseido, Lotus, Time Warner, Sega, Joop! Jeans, Apple Computer, and American Express.

With the help of a background in fine arts, Morgan brings an infusion of magic and personal vision to his photography. After studying sculpture and painting, he began assisting fashion photographers in Europe and New York. He returned to California in the mid-'80s and won every major award for annual report photography, including those from the Art Director's Clubs of Los Angeles and of New York, the AIGA, and Graphis. *His work has been featured in* Communication Arts *and many other publications, and his film work has been recognized internationally, recently garnering a prestigious Clio award.*

I studied painting when I was in school, so I approached photography in a very different way. I didn't study photography, and that gives me freedom within the medium. I try to talk clients into doing things that are new, that haven't been done before. That's what the market wants—someone who can do work on a consistent quality level that looks different for every project. That's my niche.

I'm a painter. I came from a fine art, hold-the-print-in-your-hand, admire-the-craft-and-quality-of-it background, and that will never be out of me. Film is a very plastic medium; to see it you have to sit down and put a tape in a VCR. But a print—you can have a print on your wall for years and get different things out of it every time you see it. I'll never stop being a still photographer. I am an artist. This is my medium.

I do tons of personal work. Most of the work that becomes commercial work comes out of personal work. I also keep very extensive journals with lots of ideas. I write them down or I put in Polaroids or I do collages or I do drawings. I put down quotes that I like. I cut up pieces of paper and put them in. I do something in it every day, on some small scale.

Often, the journal is my only real creative outlet. I could be shooting a big advertising job, but it may not be fulfilling for me creatively. It's fulfilling business-wise, but creatively it's not. You don't just want to be able to be creative when people pay you; being an artist, and being in this business, is a life, not a job. Part of that is to keep the flow and the excitement of being a creator always going. Sometimes I'll be stuck for an idea, and I'll go through my journals.

To excel in this business, you have to be able to solve other types of problems besides photographic ones. People don't hire me to solve the photographic problems; they assume that a photographer on my level can solve any technical problem. They hire me for my ability to solve aesthetic problems. They don't have the actual idea, the structure of the image. My job is to come up with the image.

I feel that electronic mediums are just mediums. They're not the be all and end all of the future. People are still making platinum prints—one of the first photographic processes. Art directors are not interested in things that look like they've been generated on computers.

Also, the market is basically cyclical. As people master Photoshop and do very complicated, beautiful, intricate things with it, art directors are going to want stark black-and-white photographs. And when everybody becomes very adept at printing stark black-and-white photographs, they'll want color. That's the nature of the human condition.

As delivery systems, CD-ROMs and floppy disks are great, and they're here to stay. But they're only one way of doing it. People are always looking for the different way. As soon as everybody has CD-ROM portfolios, I guarantee you if you come in with a brown paper bag filled with prints, people are going to go crazy over how original that is. I know how art directors' and designers' minds work; I was an art director for a short period of time.

If everybody is going in one direction, if you want to stand out, it's very good to go in the other direction. That's how I run my business. If everything is very clean, sharp, color material, it's good to do out of focus, blurry, dreamy, black-and-white because it stands out. And eventually art directors will catch on, because their job is to make their clients' products stand out.

I've had a rep for two years; before that, I didn't. I've tried advertising in all the sourcebooks. The thing that works best is the *Workbook*. But, the best marketing tool is to win awards. Awards in publications like *Communication Arts* make a huge difference. If you win awards, you're featured in the annual award issues—tons of free publicity! Free publicity is better than publicity that is paid for; people look at it in a very different way, and they accept it.

Photography is just one part of my life. I don't shoot on weekends, I don't shoot all night.

My marketing plan is always changing, because I'm always wanting to go to another level. I always want to be doing the best jobs, the most interesting jobs, the most aesthetic jobs. I'm constantly working to establish my way of seeing things, redefining my aesthetic. I have a way that I see the world—with a sense of wonder and a mystical quality—and I try to make images in that way. It doesn't always come across, but generally, if you look at the entire body of my work, it has those qualities.

I'm not on that very top level, but I would say that it's not uncommon for clients to pay $25,000 to $35,000 a day. Some of the big photographers are getting $100,000 a day. But you have to put it in perspective; if someone gets $100,000 dollars a day—let's say Herb Ritts—the client gets all the rights for every shot made that day. And the

photographer might shoot 10 to 20 different set-ups and go through 200 rolls of film. And every one of those can become packages, billboards, ads. So $100,000 is cheap. A hundred thousand dollars for a day plus expenses is cheap for clients if they get 10 good images that they can use for anything they want.

Photographers need to find their own vision, and then follow it. That's more important than Photoshop or digital technology or whatever. It's is a fact that the highest paid photographers in the world, the best photographers in our business, shoot black-and-white. Name a fashion photographer who uses any digital imagery (aside from retouching). The people that have the vision do it the simplest way and get paid the most money.

There's different ways to look at the business. Some photographers take every job they're offered—two or three jobs in one day. I chose a long time ago to make the business of photography just one *part* of my life. I don't shoot on weekends, I don't shoot all night, I don't take jobs that I don't think that I'm appropriate for. I do things that are either creative or involve a lot of money or are going to lead to more work or offer stock potential. If a job doesn't meet any of those criteria, I don't do it. I turn down work all the time. The reason I'm successful is because I follow my own intuitive understanding about what work I should do and what would lead to more work.

The point is that it's a life, not a job. When the phone isn't ringing, I shoot for myself. And you know what happens? The phone rings. Every time. Because when I'm doing what's right for me, it makes me creative, and that's what people pay me for. Early on I realized I have to do what fulfills me, or I'm not going to make it.

I don't look at myself as a photographer per se, although I am. I'm an artist, and this is a medium that I use. I also do collage, I also draw, and I also paint if I need to. It's just a medium. I love the medium of photography. I love its fastness, its quickness, its texture. I love seeing a print come up in a developer. I like holding the prints. I love all those qualities. But, at the same time, I'm not at all attached to photography as *the* medium.

I've always looked at my life as a totality. This isn't my job; I'm an artist. This is what I do. I shoot advertising, I shoot film, I shoot personal projects, I work on books, I teach, I draw, I do collages, I write poetry, I do writing, all those things. It's all about keeping the creative flow going.

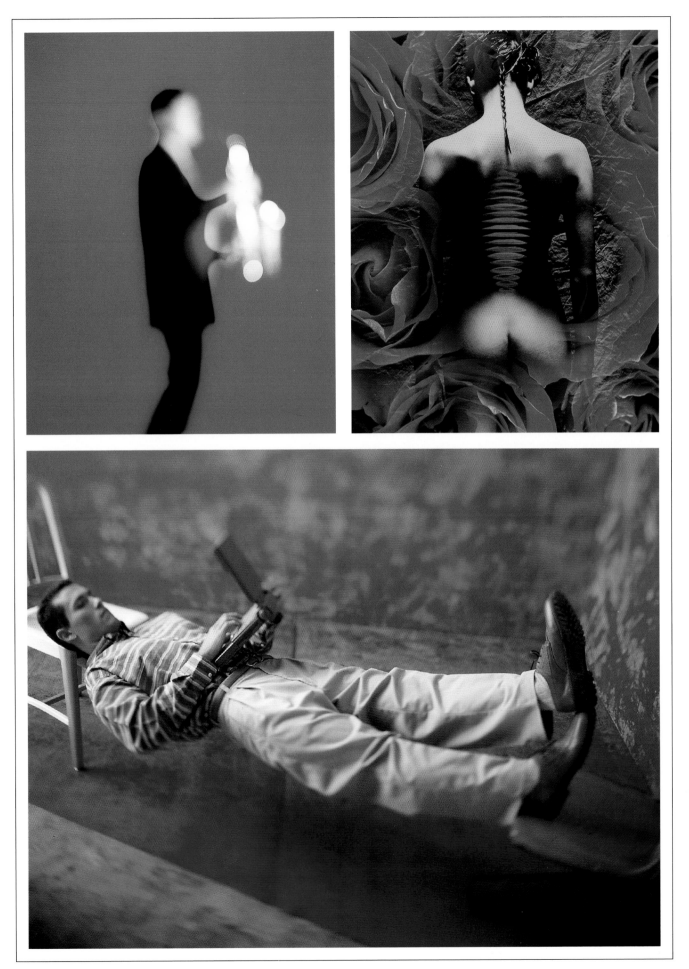

HANS NELEMAN

NEW YORK, NEW YORK

Winning a photo contest in England propelled young Hans Neleman into the wide world of commercial photography. During his first 10 years in New York, the native Dutchman established himself as one of the leading young advertising and art photographers. His unique style has its roots in his background as a painter and sculptor; his work is influenced by classic Dutch fin-de-siècle paintings and connects as freely with mythological themes as with modern ones. His work has appeared in Rolling Stone *and* Esquire *magazines, and with clients such as American Express, AT&T, British Airways, CBS, Chivas Regal, DeBeers, Fuji, General Motors, Hershey's, Kodak, Lufthansa, MCI, MTV, Nikon, Reebok, Sony, Xerox, and Yves Saint Laurent, Neleman has assured his success as a still photographer.*

The recipient of numerous awards, Neleman finds himeslf at a crossroads in his career and sees his next big challenge as film. He has directed several television commercials and music videos and recently signed with Epoch Films in New York City.

It was always my intention to try and blend both fine art and commercial photography as much as possible. I especially like the challenge and the resistance of commercial photography to fine art, and so I took the road that required the most fighting.

I started out doing basically a little bit of everything. I've basically jumped onto every opportunity there was for an assignment. At ICP [International Center for Photography], I took all the courses about all the great photographers—Arnold Newman, Duane Michaels, Robert Mapplethorpe.

I started showing both portraits and still lifes in the same portfolio, which finally got so full that I had to separate them. In terms of personal work, I am continuing on my own little road as far as it takes me, and fortunately it keeps getting positive responses. It's something that you have to do. I keep listening to my inner voice and intuitive artistic direction, and go with it. I'm looking for bigger, newer, and different stimulations from things such as music videos and commercials. I also have a couple of galleries where I actually find an outlet for some of the stuff that I do.

I signed with Howard Bernstein from Bernstein & Andriulli recently. And Epoch Films handles all my film work. I used to handle everything myself, which I really enjoyed doing. I found it better to separate both the film and the still photography, and have them distributed by separate entities; so far that's worked extremely well.

I'm totally loyal to still photography, especially because it's still my main love. But, on the other hand, I see so many new, interesting things that I haven't tried yet and that I'm learning about; I'm interested in the continuous learning aspect.

While I was going to school, I worked for anybody that I could. Actually, I would do the same as a lot of people do now—talk to the photographers and work for free. That was in England. Other than that, I did my internship with William Wegman. I kept assisting to a minimum because I seem to have skipped that whole bit, by starting to actually shoot while I was in school.

I think that style is what it's all about. Style is what you're trying to let shine through your work, as long as it's honest or as long as it comes from you. To follow a style or a trend, or to copy something that happens to be in at the moment is something I always fight against. It's better to just go with your instinct and follow your own path and have people choose to follow your

> *Do what you love. Don't ever stop working. . . . Keep listening to your inner voice.*

direction or take your lead or see what you're doing and apply it to their work. I think something has to set your work apart if we're talking for constructive or educational purposes.

I believe in promotion, and for a while, I promoted quite heavily. I believe that making an "initial statement" is to be [seen in] as many places as possible. Once you have more of a recognition factor behind your name, advertising as much isn't as warranted, but I do still put together [promotional] booklets. Articles in magazines always help, as do awards. I always recommend to my students, and to anybody who's starting out, to be a winner in some form. It tends to put you in a category in which you're perceived as better than others, and that's your first stepping stone to the next plateau.

I teach an occasional semester, as adjunct faculty, at New York University. I share a little bit because I don't really believe it's "teaching." I share with the students for whom I can shed some light on the paths that they're taking, mostly in art or in photography. If they don't know really what they're up against, and they get the wrong information in school, like some people do, they have no reality perception at all, and it's very confusing when they leave. They've been so protected and shielded from what's really out there. So I like to, in a sense, burst a bubble for them a little bit and tell them what happens when they go out there. I'm just guiding them a little bit if it's possible. It's kind of giving back to the industry.

I've been approached a few times to do digitally manipulated work, and I think that soon I might actually start taking some of the offers. For me, it's easier to use it in film because in film the computer is already an integral part of the process. Editing and film manipulation are done on computer, whereas in still photography it's in an infant stage. Plus, the work I've seen has really put me off a little bit. I think there's a way to use it well, and it should be used. I feel sometimes the computer offers too many options and too many possibilities, and the initial message or the initial concept gets lost in the shuffle, but for me it's about making an ultimate statement. The message, or why we're doing it, is more important than what means it's done by. I still like the actual hands-on aspect with the camera; that's really the most direct way to photograph.

I served for a little while on the board of APA [Advertising Photo-

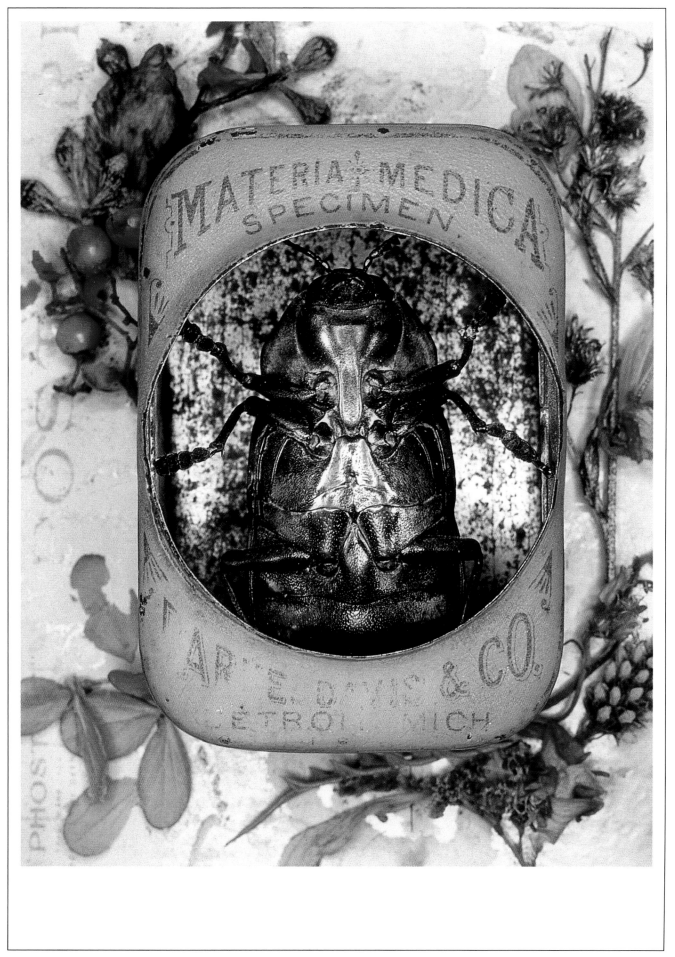

graphers of America], and I feel a lot of times when there's too many people involved in the decision-making, it kind of dilutes the purpose of everything. However, the evenings they organize are very educational. That's where I got my beginning tips from, just listening to other people. ICP is another good example [of something else that works]. It's an incredible institution where people teach, and open up, and where you can absorb so much. I encourage making use of these things more so than consultants.

In the commercial photography business, only the toughest survive. That holds whether you're old or young. Your dedication must shine through, and people will see that in the work. Unfortunately, it's a less and less profitable industry. People struggle more and more, and in part it's due to our own lack of organization and lack of sticking together. The models are making 10 times that the photographers are. (It used to be completely the other way around.) Why is this? Because they're organized and have their act together. A lot of people in photography end up having to compete against each other.

My advice to people is to do what you love. There's no greater reward than that, and if you can actually support yourself, that's great. If you like my art, it's because I love doing it; making a living at it has been an incredible extra. And, don't ever stop working. Keep pushing the envelope, and the boundaries and see where you end up.

I think I've done what most people did through the centuries; they left their country in search of other things and came across the sea to live in America. Amsterdam has a certain beauty that you don't find anywhere else in the world, that's for sure. It's nice, but when you walk through the sunlit streets of Soho in New York City you feel a buzz of sorts—that this is the actual center of the world.

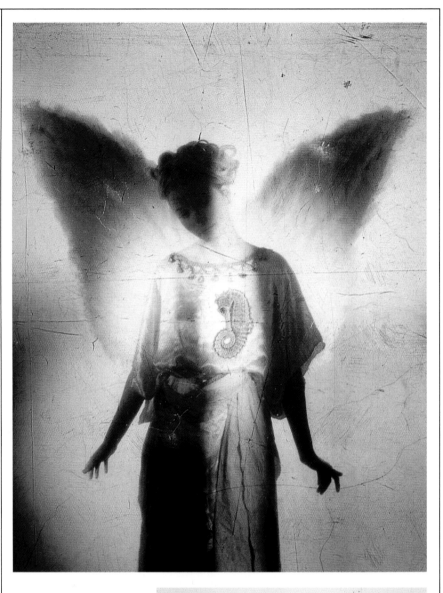

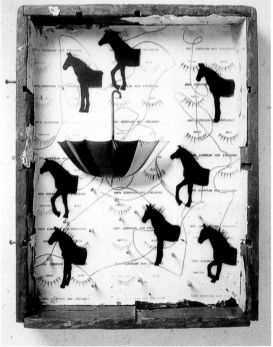

162

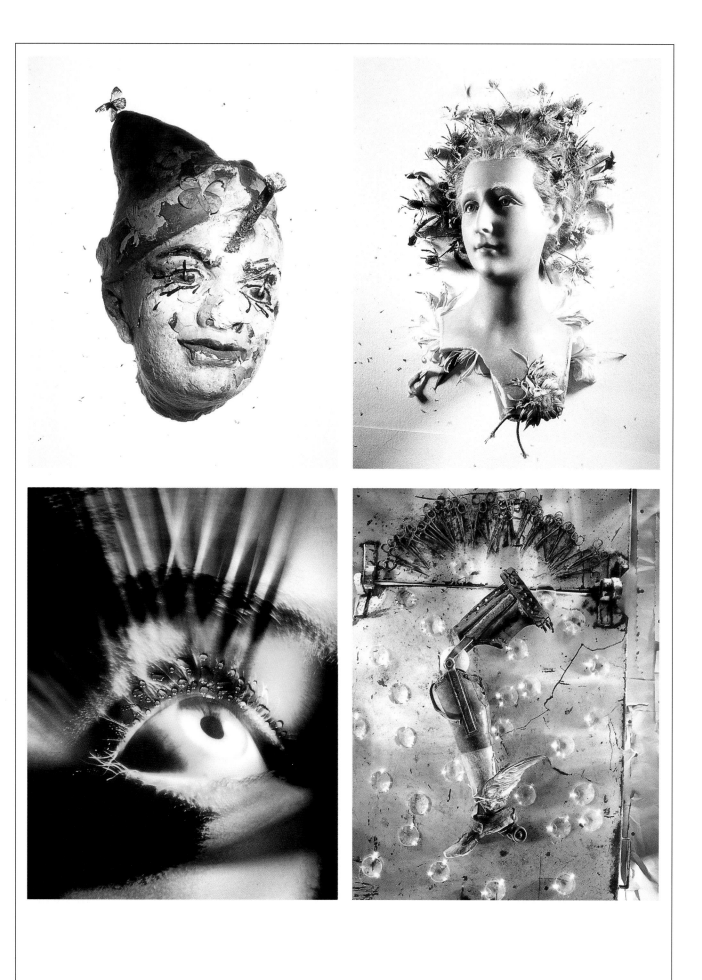

TIM OLIVE
ATLANTA, GEORGIA

For Tim Olive, photography is about ideas, thoughts, and feelings. It must be working. For the past 28 years, this Atlanta-based photographer has produced outstanding work for clients such as DuPont, IBM, Coca-Cola, Pepsi, American Express, Kodak, and Royal Caribbean Cruise Lines.

Olive grew up in the Philippines and was 18 when he was hired by director John Derek and was given his first assignment—shooting stills of Derek's then wife, actress Ursula Andress. He returned to the United States to attend college, receiving a B.F.A. from Samford University and an M.F.A. in Photography from Ohio University. He has been nationally active for many years on photographers advocacy issues, and his work has been featured in Communication Arts *magazine and numerous other publications. He has won many top awards for his work, as well as recognition as one of* Advertising's Ten Best of the Decade, 1980-1990.

All the way through college, I shot pictures to earn money. When I was in high school, I shot pictures to earn money. So when I got out of school that's what I did to earn money. I never worked for another photographer.

I shoot pictures of feelings. Because of my fine art background, I love what happens in a photograph, and so basically I'm interested in how you can capture feelings in a photograph—mostly still lives. My work is very strongly concept oriented and has to do with conveying a message. If the feeling is there then you've conveyed the message. That's the power of photography to me.

I advertised in *The Black Book,* but it wasn't until I started doing direct mail that I began to see really good results. Of course, money was a lot easier then than it is now. I was so successful with it that I actually held back mailers because I didn't want to have to turn down work. The next thing I did was to advertise in *Archive* magazine, because I felt it would produce more direct results than the sourcebooks. Over the years I discovered that if you do a good ad and the right people see it, you'll get work no matter what it's in.

I've never had great experiences with reps for two reasons. For one, I think Atlanta is not a "rep town," and secondly, reps haven't brought me the best work that I can do. They bring you work that you can do but not work that'll go into your portfolio. At least that was my experience.

Also, most relationships with reps put the photographer at a disadvantage, because the photogrpaher has to carry the burden of overhead (when he's not busy), which the rep is not contributing to, and yet the rep gets commissions right off the top when the photographer is busy.

My portfolio is always prints. I'm not going into CD-ROM or anything like that. I think that's an interesting way of presenting a book, but photography deals with pictures and a monitor screen is not a picture to me. I don't think the CD-ROM will ever completely replace the printed page. A printed page is a printed page; there's no cost to look at it. With the CD-ROM, you have the cost of the equipment to look at it.

I have a one-year, a three-year, and a five-year plan. You cannot achieve anything of significance in life unless you have a goal. That's one of the greatest lessons I've learned. If your goal is nothing, you'll hit it every time.

Until you set a six-month goal in every area of your life, work at it, and then realize that at six months you've accomplished that goal, you don't understand that the power was simply in sitting down and setting a goal. That was the power because you cleared your mind, you evaluated, you prioritized, and you did a good job of thinking it out. It's about setting your course. It's in the past two years that I've made the most progress, because of goal setting. I wish I had done that earlier.

It's like my biggest problem was always in not dreaming big enough. I didn't understand the process of setting goals. I realized that I needed to set bigger goals for myself, and that was a challenge. When I turned 42 or 43, I realized that what I had given up the first half of my life was worth far more than what I had achieved. It's not just business success. You can be the world's greatest photographer and die, and people won't miss you. There are other things in life.

We give more to our profession when we have more to give personally. You can't have more to give if you don't set your profession aside and deal with yourself, work on yourself, build yourself, and set personal goals, personal direction.

Another thing I wish a lot of people had is a respect for elders. That's the principle of finding a mentor, or someone else who's been before you, and sitting down with them and trying to understand the pitfalls. They're like a road map; they've been there. They know the problems. Independent artistic types tend to think that they don't need guidance, and we isolate ourselves from everybody. I think you can't really achieve anything significantly worthy in a lifetime without the help and cooperation of somebody else. You can't do it all on your own. No man is an island.

I'd say that consultants are very good. There's nothing like meeting head to head with the truth. There's a lot of ego in what we do, and that's one of the problems of what we do. It's also one of the driving forces of what we do, but left unchecked, it can hurt you. When I wanted to move from doing local to national work, I met with [consultant] Henrietta Blackman and asked her to honestly review my portfolio. Initially, her critique was an incredible slam to my ego, but I have the greatest respect for Henrietta and owe her hundreds of times more than what she ever charged me for her ser-

> *You cannot achieve anything of significance without a goal. If your goal is nothing, you'll hit it every time.*

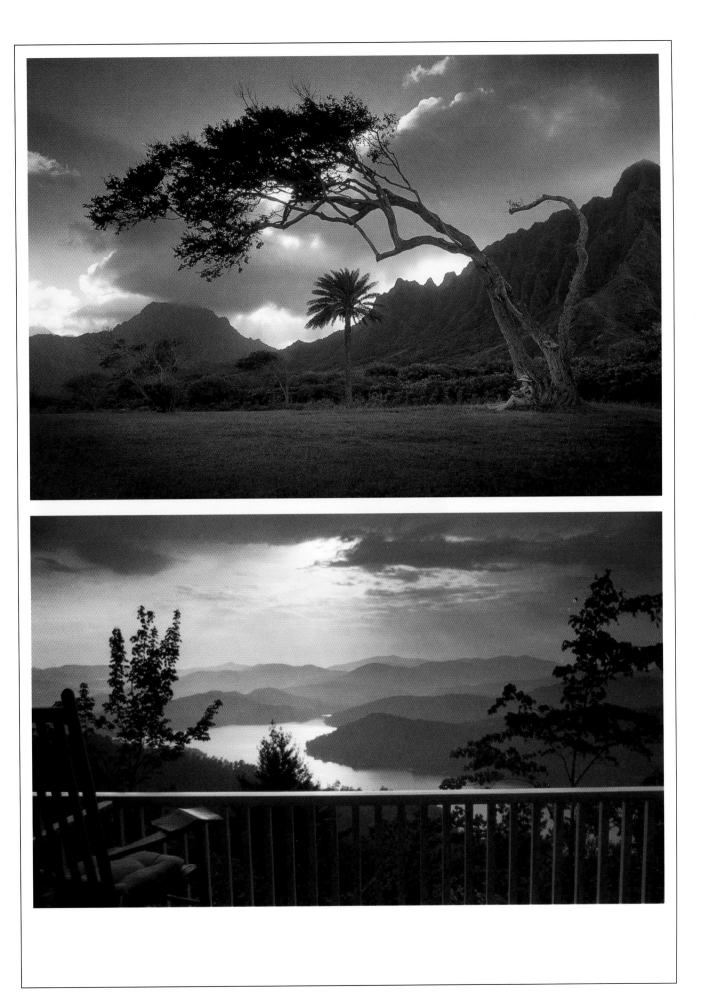

vices. I went back subsequently and saw her two other times. She really hit it right on the head.

If I need to use a computer, I have a local company who provides all the services I need. I go in and hand in the settings; they scan it and 30 minutes later, it's on a computer that I can get to. I can do my work, get up, and walk out. They finish it up for me. I'm doing everything digitally there. At this point, I'm interested in creating the image. I don't want to be necessarily involved with the "plumbing" aspect of digital imaging. I really don't even know that much about using Photoshop. I just don't have time to keep up with what it can do for me. It would be as if a film director was also the film editor. A film editor is a totally separate thing.

If I were going to advise somebody to prepare for this business, I'd say to be sure to get a good art background. What you tend to see more than anything else is technique above vision. Technique can be learned. Vision cannot. You have to develop your vision. A lot of people are technique driven, and they don't realize it. Things like HoseMaster, digital work done on computers, those are all techniques. Technique is prevalent now because of what's happened to television and movies. Things like the scene in *Forrest Gump* in which Gump is shaking hands with the president. There are so many techniques like that, which can be done for wonderful results, but if the results aren't there, and you don't have the vision in your head or understand what's going on visually, having technique isn't going to help. It has to do with understanding both who you are and why you're doing what you're doing. The vision thing evolves over a long period of time.

People want to see something different, but still it gets back to what happens between those four corners of that page. You've got to convey something, and it has to have what I call the four elements of a good photograph: good subject matter, good lighting, technical expertise (plus design and composition), and good balance. If you don't have those elements, no matter what you're doing, if you fall down on one of those things, then the others fall down, too. You can have the best light in the world, but if you're shooting the picture without all of these elements, it's not going to make a difference. It'll just be a lighting exercise, not a great photograph.

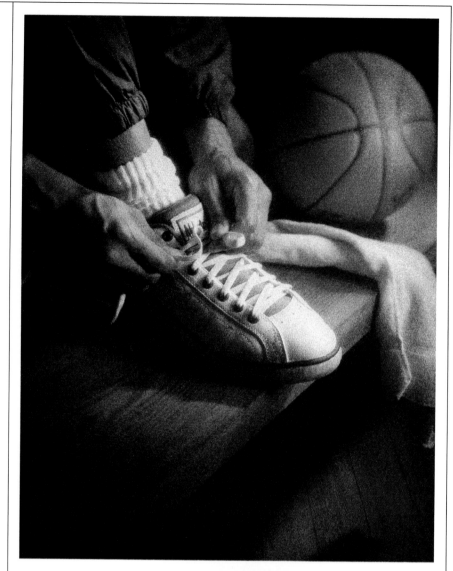

166

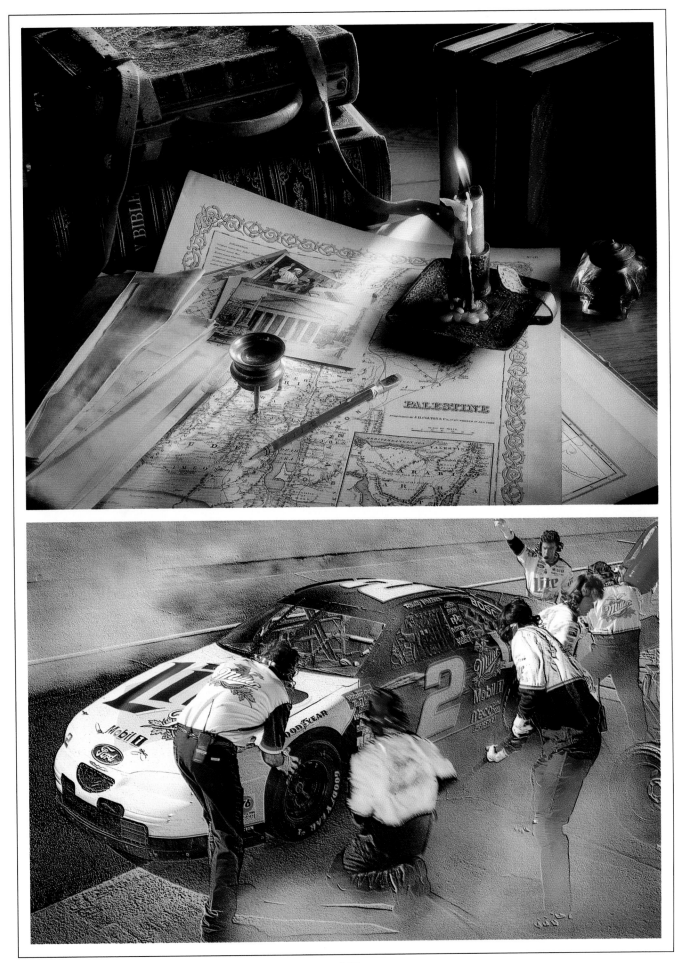

JIM PICKERELL
ROCKVILLE, MARYLAND

Jim Pickerell started as a full-time photographer in Vietman with a cover for LIFE *magazine. A prolific stock photographer, he is represented by about 28 agencies around the world, and stock makes up the bulk of his work and income. He feels that one of the reasons for his success with stock is that he got into that area of photography at its very beginning, rather than waiting until the industry was mature and the growth had disappeared.*

Dedicated to his profession, Pickerell has given numerous seminars, including some on the stock arena and its benefits. With his daughter, he also runs a small stock agency called Digital Stock Connection

I've been into stock ever since I first started shooting. I was always aware of stock, always putting pictures in the file, usually outtakes from editorial assignments. Over the years, that income started to build. In the late '70s, I began to see that there was a possibility of making some serious money shooting stock, and that there seemed to be an increasing demand for certain subjects. I started shooting stock specifically, doing shoots specifically for stock. It turned out that my timing was pretty good. It was right at the stage when the demand for corporate stock started to really escalate.

When I was getting started, stock was mostly used by textbooks and by magazines who had such low budgets that they couldn't afford to pay for an assignment photographer. Stock was looked down upon as being cheap stuff of no value. There was some use of stock in greeting cards, but the advertising and brochures markets would never consider stock; they'd always feel that they could only get the photo they needed by assigning a photographer to shoot the specific shot.

Throughout the '80s, clients began discovering stock. There was constant growth in the market for stock. By the end of the '80s virtually everyone looking for pictures was checking to see if what they wanted was available in stock. If they couldn't find what they wanted in stock, then they'd consider assignment. So, a total reversal took place.

Now, we're in the middle of another revolution that is going to bring about another dramatic change for stock—the digital revolution. And it manifests itself in a number of different ways. One is "clip" photography (photo CD-ROMs). With the clip photography market, it's now possible for amateur photographers to participate in the stock photo market, when before they couldn't overcome the problem of getting their images seen. Most amateurs couldn't get their images into stock agencies, but now companies like Corel are finding these amateurs, paying them a flat fee for the rights to certain images, and then marketing those images. And, the marketing companies—not the photographers—will end up making the bulk of the profit off of these images.

During the '80s, it wasn't uncommon for stock agencies to have 30 to 40 percent annual growth per year. But overall, the stock industry has stopped growing in the last couple of years. More and more, clip disks are eroding it, particularly for travel images, scen-

ics, backgrounds, and wild life. Some of the players in the clip photo market asked photographers to send in 110 images and they'd probably buy 100 of them for $100 apiece once they'd settled on a particular subject. Now, they've got so many disks out there that they can be much more picky.

Things are changing. It's going to be possible to show many more images in digital catalogues than print catalogues. You can now put 7 to 10 images in a digital catalogue for the price of putting 1 image in a print catalogue, on floppy disk, or on a network. Right now, online stock isn't working, but eventually all stock will go online.

While the networks may be the long range future of image distribution, CD-ROMs are going to have a very long and useful value as an interim service. We're seeing very impressive sales from disks [at Digital Stock Connection]. Several years ago, we came out with 25 pages in *Stock Workbook* with a total of about 275 images from 20 different photographers. The book was distributed to 30,000 art buyers in the United States. A month later the *Stock Workbook* disk (on which we had 615 images) was distributed to only 5,000 art buyers in the U.S., and we made roughly twice as many sales from the disk as from the printed book. All of the top buyers have CD-ROMs and are looking at disks.

Digital search makes it much faster to find images than flipping through pages in a print catalogue. For many people, time is their most important commodity; when they look for pictures, they want to find something that will work fast, and disks help them do just that. They're going to disks first, and if they find what they want on them, they don't even open the print catalogues. For the past few years, I haven't put any of my images in printed catalogues. I've been using all my advertising dollars to put images on disks.

In the future, instead of producing very high volumes of stock images, photographers will edit and try to fill holes—be very selective in what they show. They won't put their whole image files into the digital environment. They'll put out imagery that will meet 90 percentof the demand. On those rare occasions when somebody needs an image that is different or more in depth, those people will then call a photographer and get those images directly.

I'm with a lot of agencies, although the direction in which the business is moving is to photographers putting

> *Producing stock in the old way is too risky.*

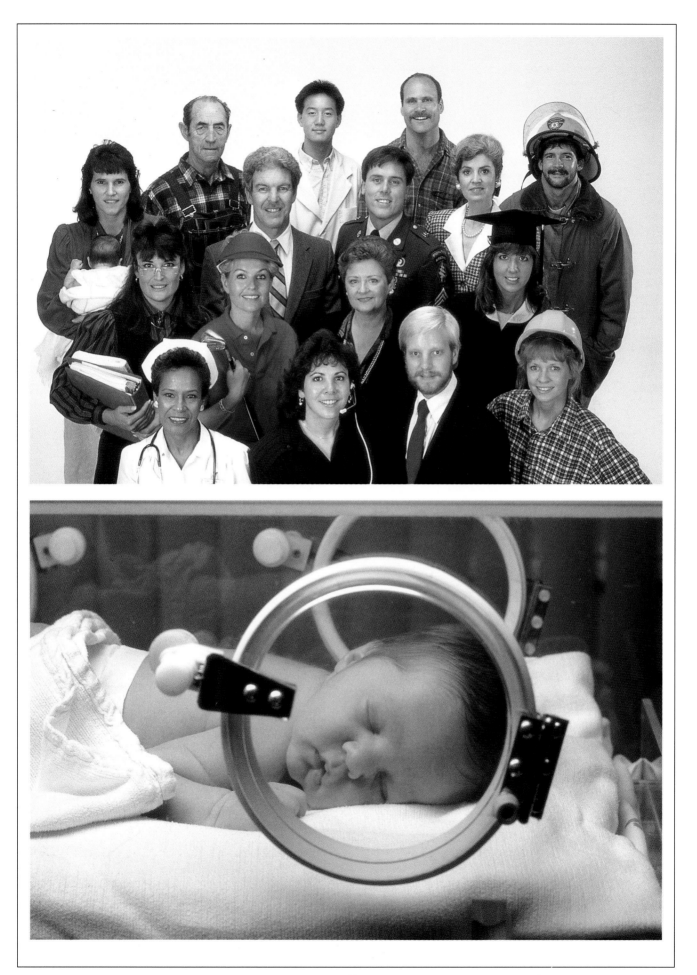

their images into digital catalogues and getting wider representation and distribution. It'll be available to anyone anywhere in the world. Photographers will need fewer agencies to represent them and will be able to maintain more control.

As you get a tremendous oversupply of certain kinds of images, the value of those images is going to decrease. We're going to see a resurgence of editorial photography. Multimedia is going to need a much more editorial approach and much more in-depth coverage than most photographers have been doing over the last couple of decades. But it's clear that multimedia will have a life. There's a demand for information and entertainment. Still photographers may get more sales in the information area than in the entertainment area, though, because the needs of entertainment producers (of games and things like that) may wind up being met by the motion picture industry.

There's going to be a huge demand for information. We recently produced a CD-ROM of press release portraits of every member of Congress. We're marketing it as image sizes—file sizes that people can use for publishing. This format allows people to drop these photos into their publications, as opposed to just being a catalogue of yearbook pictures that people will look at, but that won't give them any use beyond that.

We've done a lot of direct mail to lobbying organizations and to associations. We're also marketing to small newspapers, television stations, the Democratic National Committee, the Republican National Committee, national and state committees of Congress. We believe that the disk has some potential use for kids in school, and we try to reach that market, which is much more diverse. We've taken out ads appearing for three months in software catalogues that go to a million CD-ROM users. We've also produced a number of portfolio disks. At this point, probably the medium that's working best for portfolios is floppy-disk based.

It's becoming harder to determine what you can shoot to have sufficient enough long-term value and allow you to make a profit, given the additional market competition. In the '80s, you could shoot a lot of different things and all of it would sell a little bit, because there wasn't much else out there. That time is past. Now, if you come out with a new image or idea, you can almost be assured that next year, 9 or 10 people will have produced images that explore the theme you've pioneered. New ideas aren't going to have a very long life span.

It takes a lot of hard work to be successful. Besides looking at all the financial ramifications and researching what's hot in stock, photographers need to view their stock photo business in two ways. First, they must ask themselves, "How can I maximize the sales of the images I've already produced?" and second, "What do I go out and produce in the way of new stock?" Other factors to consider include clip disks and reproduction rights in the digital domain.

I think photography as we have known it is gone, but that's not necessarily bad. It's possible that the outcome may bring about a different type of demand for imagery and a different way of supplying it. Much of the market in the future will be for digital usage. People will find it harder to make a living from traditional stock. There'll be a reduced number of print users. People will discover that the digital market is much more effective than the print market, and they'll shift the way they spend their budgets.

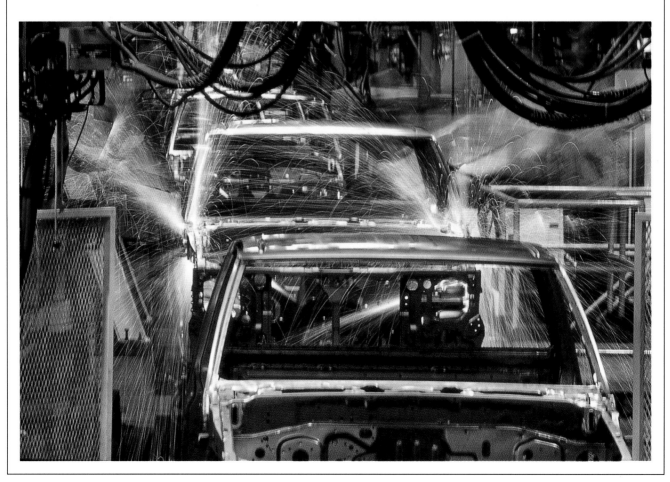

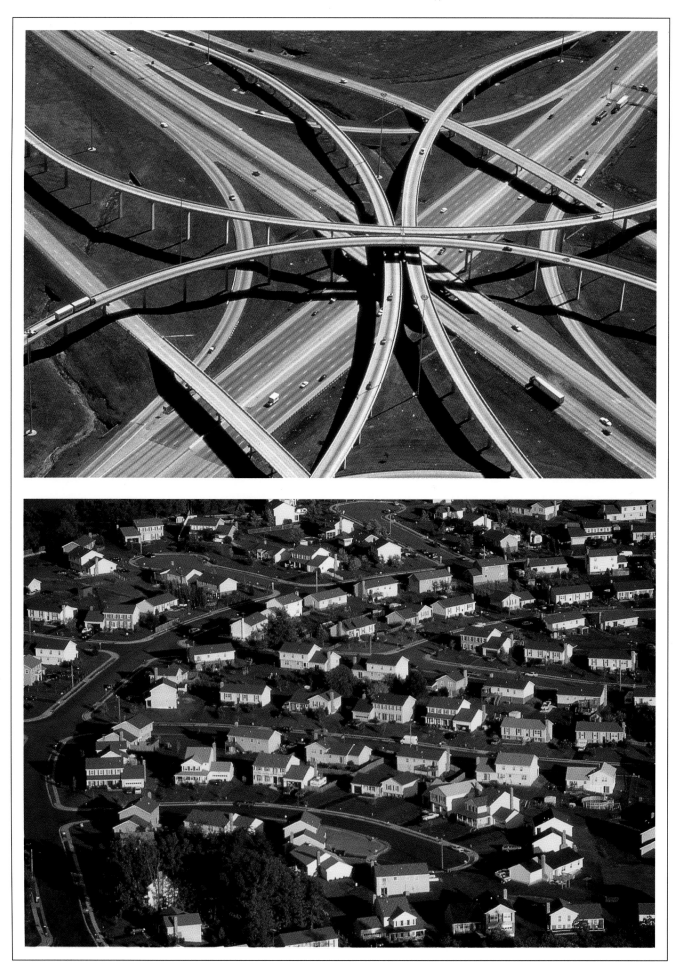

WILLIAM RIVELLI

NEW YORK, NEW YORK

Photo © Wilhelm Scholz

After graduating from Brown University with a degree in philosophy, William Rivelli began his professional career assisting one of LIFE magazine's best known staff photographers, Ralph Steiner. As one of the top corporate photographers in the United States, Rivelli has crisscrossed the globe for some of the world's biggest companies.

His work has been included in many prestigious shows around the country at venues such as Nikon House, Photo Expo, and the International Museum of Photography, and in numerous Art Director's Club shows in New York, New Jersey, Boston, and Toronto. Most recently, he had a one-person show of this theatrical photographs at the Graduate Center of the City University of New York. He has received over 30 significant awards and his work has been featured in Graphis, Communication Arts, and other well-known industry publications.

Rivelli has lectured widely at various conventions and workshops across the United States and in Canada, and teaches classes in professional photography disciplines at the School of Visual Arts in New York. He is a former board memeber of ASMP and an indefatigable worker for the betterment of relations between photographers and the photo-buying public.

I got work by calling up art directors and going in and showing them my portfolio. Through different designers and public relations people that I met, I got a chance to do some things. A lot of it was "grip and grin" PR photography and then just evolved. What I always really enjoyed was industrial work. Working on industrial things got me more into doing portraits and pictures of people at work.

If you're working in business and are photographing people, you certainly need to use psychology. It's a difficult thing to express in words. When you're in the situation, you have an idea of what you want the person to do, and you lead them that way somehow.

Today, you've got to know how to use a computer. If you're a photographer with a small operation, you can get a lot more done, even just in basic office procedures. About four years ago, I decided that I should learn something about digital imaging. I started learning PhotoShop. It's been great. I haven't really used it much in my work yet, but I want to. My photography is basically straight photography. I thought that all I really wanted to do was retouching. And I did that at the beginning. It was wonderful, but as I worked with it more I found that what I really wanted to do was something different from photography.

I felt that if I want a photograph I'd rather take a photograph. I enjoy working with cameras and working with photographic materials. Whereas with the computer, what I'd like to do is perhaps take a black-and-white image, scan it, and then colorize it and maybe posterize it, or change the color dramatically and come up with something that looks more like a drawing.

What's great about teaching it is that you have students who are much younger, who have much less knowledge, who don't really know what they can't do, so they'll try crazy things.

You have to think of a computer as you would a zoom lens. You can't say, "Well I don't need a zoom lens. It's not for me. I don't believe in them. I only use single focal length lenses." That's foolish. You have to be aware of what a zoom lens can do and use it when appropriate. And it's the same with the computer. There are times when doing imaging with the computer is really appropriate and the best way to go.

There'll probably be a backlash toward traditional media, which is fine; there'll be a lot of computerization in the commercial world, and in the fine art world maybe there'll be more of a return to traditional darkroom techniques. This is happening already. People are into platinum printing and are using the bigger and bigger cameras (the 8 x 10s and 16 x 20s). This kind of makes a distinction between fine art and commercial.

I market primarily through direct mail using my own mailing list. In the past, I've taken out ads in all the various sourcebooks, but they've probably never really paid off. It's throwing money away. It never really resulted in anything except a tremendous amount of phone calls from assistants, who'd be calling all the time saying, "Oh, I saw your ad in the *Black Book*. I'd love to work for you. Can I come and show you my work?" When I stopped advertising in the sourcebooks, the assistants stopped calling. Very few jobs came out of it for me, although I'm sure that the ads kept my name around. Still, the best you ever hear from photographers about sourcebooks is, "Well, I broke even; I got a job that paid for my ad." That's not good enough.

In my larger mailings, I've done a lot where I might send out 250 small 4 x 5-inch prints glued on to a 5 x 7-inch card with a little note in the card, like a little greeting card or a postcard. For my bigger mailings I go to a printer and have 2,500 copies of a certain image printed and mail that out. When I was really doing it a lot, I was sending out mailings maybe once every six weeks. But then things would get busy, and I might not do it for two or three months. There've been times when I might only have gotten two mailings out in a year. It's good to do it frequently—once every two or three months is probably enough.

I've learned that you have to show your portfolio to people first hand, to see what they respond to. It's too easy as a photographer to fall in love with a picture that doesn't communicate. I make photographs of things that connect with me. But, sometimes they don't connect with others. That's why it's good to put them in a portfolio and show them around to get some feedback.

What I'd like people to remember and think about me is that I can take very ordinary subject matter and find something in it that's unique and worth celebrating. To me, that's one of the things that photography is all about—putting a frame around something, showing it to people, and making them really see it for the first time.

> *Think of a computer as you would a zoom lens. You have to be aware of what a zoom lens can do and use it when appropriate.*

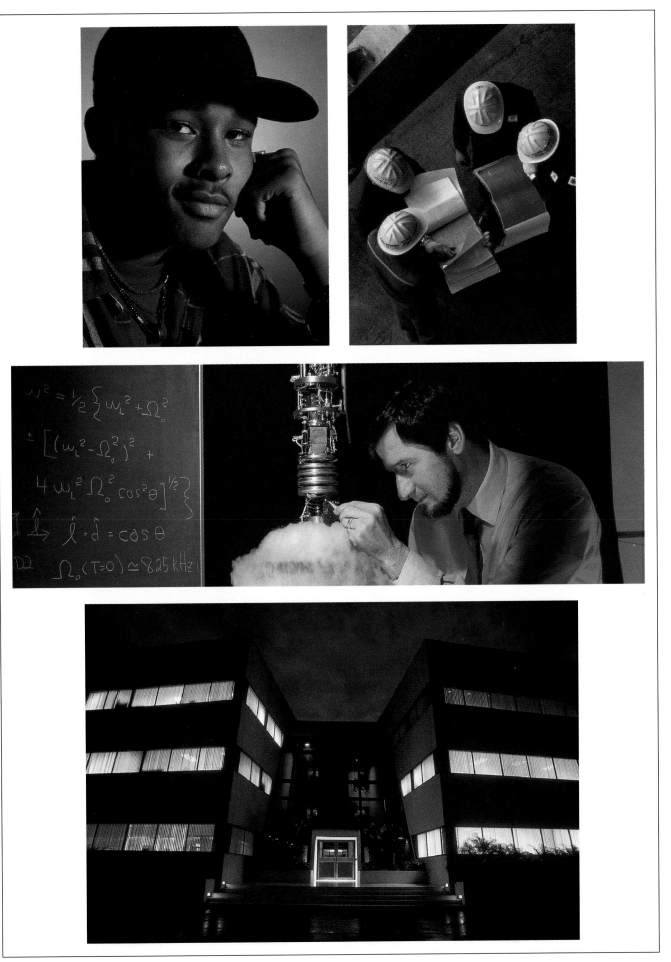

The equation on the blackboard reads:

$$\omega^2 = \frac{1}{2} \left\{ \omega_L^2 + \Omega_0^2 \right.$$
$$\pm \left[(\omega_L^2 - \Omega_0^2)^2 + 4\omega_L^2 \Omega_0^2 \cos^2\theta \right]^{1/2} \left. \right\}$$
$$\hat{\ell} \cdot \hat{d} = \cos\theta$$
$$\Omega_0(T=0) \simeq 8.25 \text{ kHz}$$

AL AND JOY SATTERWHITE

CONCORD, VIRGINIA

Al Satterwhite's professional photographic career began when he was in high school, working part-time for the St. Petersburg Times. *During college, he branched out into working with UPI, covering major news stories in Florida throughout the 1960s. After a stint as personal photographer to the Governor of Florida, he spent the next 10 years doing freelance magazine work for almost every major magazine, including* LIFE, Newsweek, People, Playboy, Sports Illustrated, Time, *and* Travel & Leisure.

In partnership with his wife, Joy, Al has worked on important advertising projects for major clients, including American Express, Coca-Cola, DuPont, Kodak, Polaroid, Oldsmobile, Sony and Universal Studios, winning numerous national and international awards in the process. Together, they have also written two books, the most recent of which is Lights! Camera! Advertising!: How to Plan and Shoot Major Advertising Campaigns *(Amphoto Books, 1992).*

In 1991, the Satterwhites moved from New York City to a sprawling 25 acre farm in Concord, Virgina, where their scope has widened to include film production and feature work. Al has completed work on several features, while Joy has branched out to run a major digital production house.

I never assisted. I went from editorial work, to part-time work during college, to full-time work. I spent 10 or 15 years shooting for a lot of magazines, and then I got to the point where I wanted to make some money instead of constantly traveling and not making money. When I started, fees were $250 a day. Then they went to $350 a day.

Joy basically took over the business because I was in pretty bad straits; we were having an economic downturn at that time, in 1982, and I was going nowhere fast. Joy took the reins and started repping, managing, and promoting—doing everything—and we started getting jobs that I really wanted to do.

We're doing a lot of digital, in fact Joy's gone all digital. The first project we did where we gave our client a digital file, as opposed to film, was a job for Riuniti wines in New York. The theme was a couple in a little motorboat with a Christmas tree, going across this lake with a little mountain in the background. There were other images, too, and we could never have done it live.

When you're doing the [computer] work, instead of sending it out, you're responsible, which means you can be more creative because you're there and can make a judgement call every time you have to. Joy could make instant corrections. She'd output a proof of her work on her printer, FedEx it to the client, and talk to them about it, asking them what they thought and what adjustments they wanted. Then she'd just open up the file on the Mac and make the changes.

With a computer, you can make all those corrections; you control it all. You bill for it, and you offer a total finished product. You're actually saving money, you're saving time, and you're being more creative and making more money. And you're more in control.

In terms of marketing, Joy says we should change the name of our company to "Seat of Your Pants Productions." She does a lot of the marketing by the seat of her pants, because, as she says, marketing is very instinctual. You have to be aware of what's going on, and you have to be aware of trends and shifts. When everything seems to be going a certain way, the best position to be in is to be the first ones doing it that way; if you're the last one, then there's a glut and nobody's paying attention anymore.

As an example of "instinctual marketing," a few years before the 1996 Summer Olympics in Atlanta, Joy had a feeling that sports activity shots were going to be hot. She felt that we should start gearing our book for sports. Joy knew that we'd make our money back in stock sales eventually—she doesn't do anything for just one reason, this way she has a way of recouping her money. We made a lot of money off of this in stock sales, and it happened to get us a lot of attention.

My advice for people new to the business would be try to work with people you like. You like their work, you can relate to their passion. If I had to start over, I'd take psychology and business in school. The hell with photography. I learned photography from doing it. But if you have training in a field like psychology, it helps because you really need to figure out what's going on in people's heads. And, if you took business courses, you'd understand how to run a business. The rest is easy.

My advice to old timers is that everybody doesn't have to get a computer and sit behind a screen, but it probably wouldn't hurt to understand how computers work, or where they fit in the scheme of things, so that if you're not going to use one, you can at least be literate in the process—because, inevitably, somebody'll be using your images on a computer.

Additional advice for newcomers is don't sell out. Just because you're new doesn't mean you have to work cheaply. I started at the bottom, and then when I saw an opportunity I moved up. If the competition is asking $2,000 or $3,000, you shouldn't say, "Well, if I bid $1,000 I'll get it," because all you're doing is hurting the market and it will come back to haunt you. If you go in at $1,000, a lot of times those people will never hire you again for anything above $1,000. If clients are considering you for the job that means you're thought to be on a par with these other photographers. You should price yourself according to job structure. It shouldn't be a low price that gets you jobs; it should be what you have to offer, and you earn at least in the ballpark of that job's typical pricing structure.

Moving to Virginia cut our overhead by $50,000 a year. As a corporation in New York, we'd had expensive overhead; you have to pay for extras that you don't have to pay for in other states. Rent tax, subway tax, all kinds of things, and it just never ended. With faxes, computers, telephones, and FedEx, we figured we could set up shop anywhere. It's perfect.

> *It's a numbers game. It's not just how many people you pitch to; it's how many times you pitch to them.*

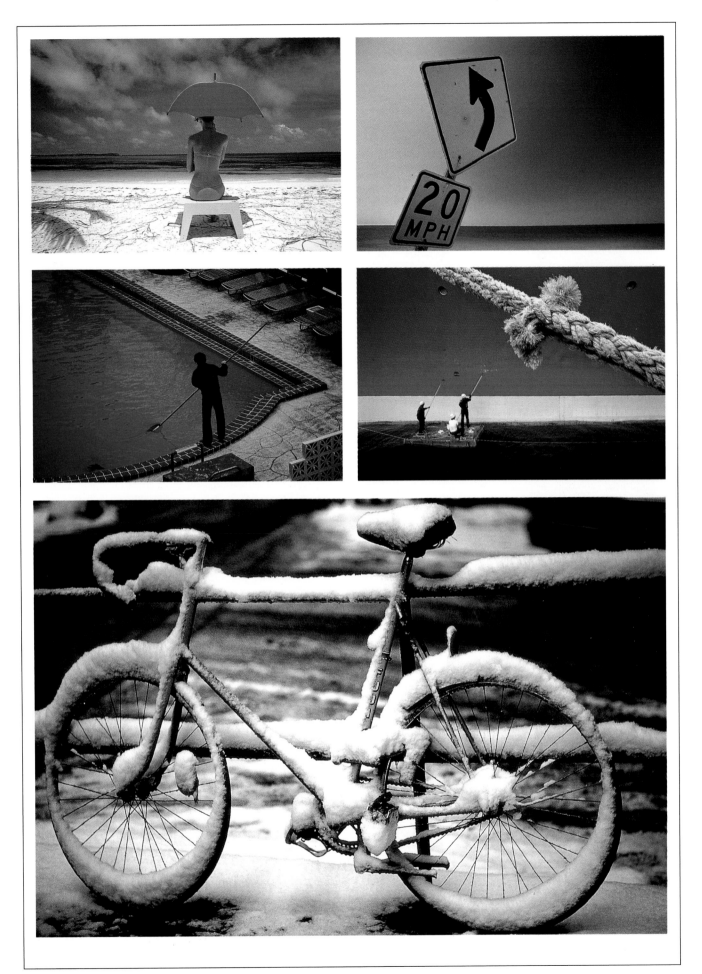

ELLE SCHUSTER

DALLAS, TEXAS

Elle Schuster was born in Pittsburgh and spent her childhood in Pennsylvania, Ohio, Australia, and New York, finally settling in Dallas in 1963. Her career began in 1972 when she received a 35mm camera as a gift. She began shooting sporting events for fun, and it soon became a business. In 1974, she opened her first studio.

Since then, she has built a strong reputation for surreal images and special effects, and her clients include Neiman-Marcus, American Airlines, Frito-Lay, Xerox, Mead Paper, and many others. Her editorial work has appeared on the covers of Time, Psychology Today, Omin, U.S. News and World Report, *and numerous trade publications.*

Schuster is also a fine artist, making three-dimensional photo-sculpture, and has had several exhibits throughout the country. Being self-taught, she has drawn inspiration from many fine art fields other than photography, such as painting, architecture, stage productions, and music. She feels that her greatest influence has been the writings of Ayn Rand, who stresses the Romantic nature of art—that it is spiritual food that should represent the ideal.

An active lecturer at photography seminars, universities, and trade organizations, Schuster also gives back to the community by frequently contributing her art pro bono to arts organizations and charities.

I learned everything by reading books. I borrowed $13,000 from my father and bought a used 4 x 5 camera and a used strobe with an attached umbrella. I saw that the photo studios in Dallas that were big and were making a lot of money were mostly catalogue houses. They all had large staffs and lots of equipment. I said to myself that I didn't want to become an administrator. I wanted to be a photographer. I didn't want to get that big and have that kind of overhead, so I realized that I'd have to develop a style that would be so distinctive that I'd be able to charge more money but not have the burden of huge overhead. That, coupled with getting a special effects assignment (and my admiration for the surrealist painters), pushed me toward the surreal style that I've developed over the last 23 years.

I would advise people starting out to have a good accountant. I got some really bad financial advice that has cost me enormously, and I'm still paying. It's so important to have good financial advice and to stay current with the IRS, because they'll kill you. They don't care. They'll take everything you have and still want more.

Another important thing I learned early on is to try to make every job my personal work—not to separate them. People would say, "I have my commercial work and my personal work," or, "I have a certain standard of ethics that I use with my friends and another standard that I use in business," and I thought, That's a lot of hooey. You don't have integrity. You're not integrated as a person unless you have the same standards for everything. If you'll cheat anyone, you'll cheat anyone, including your loved ones if you're pushed hard enough.

I put my heart and soul in every job that I do. It should be art—should be physical, intellectual, and spiritual. Physicality is the technical quality, compositional harmony, and color harmony. The intellectual aspect is what you learn from it. The spiritual is the mood or the feeling it imparts. Real art has to hit all of these things on a very high level, and if you try to put all of these things in your commercial work, you will succeed. I've tried to find a way to incorporate my own personal style and my own art into my work as much as possible.

I've had six reps. I don't think I'm going to have another one, because I don't think it's worth giving 25 percent of your net for that service. An accountant once said to me, "You don't pay

You have to constantly be exploring and growing as an artist or you get left in the dust.

yourself 25 percent; your rep is earning more money than you." I do a lot of advertising in sourcebooks. I found that to be very effective because it gives you national exposure; most of my client base is outside of Dallas, because I made the investment in those national ads. I also do direct mail which I find to be almost as effective as ads, especially with editorial people because they don't get as much in the mail as the advertising and design studio people do.

Another way I promote myself is to enter the annuals. If you can get a photo in a California photo annual, your phone will ring. It's just amazing how that "free" PR can payoff. I also do a lot of pro bono work for charities and arts organizations. You make very good connections, plus you can get very beautiful samples out of it.

I use to schlep my portfolio myself. Then I had reps, and now I feel like I can't do it. It would be such a comedown; it would be psychologically damaging for me. It would give the perception that I must not be very successful if I'm out there showing the work myself. I'll mail clients a portfolio or send them something, but I don't try to go out and make calls.

I do editorial. If I have a cover on a magazine, sometimes three or four people will call for a commercial assignment based on having seen it. You're well paid for doing the cover. Inside the issue, you're lucky to get $800 or $1,000, or maybe $1,200. I always ask that they add the expenses in there and then can get another $500 or $600 out of them. I take what they offer as the fee, and then I ask for expenses on top.

If you have a very distinctive style, people will remember your promos. If they like them, they're going to hire you. But the other side of the sword is that when you've developed a style that's so unusual, as is mine, you don't get called for any "normal" jobs, or anything but high-dollar jobs and very tricky special effects. That's the niche that I've been placed in, and I put myself there, but it limits you. So, consequently, in the middle and late '80s, when advertising budgets got really tight, my business suffered. I couldn't get a normal job to save my life. Thank God, I had a lot of stock in The Image Bank, which brings in really good income.

Photographers can make it without shooting stock surely. A catalogue shooter certainly doesn't need to do stock. I think for a little higher level person, who has a more distinctive

style and does advertising and that sort of thing, it certainly helps; it's a nice security cushion. You have a slow month, and that stock check still comes. I was told that my work was too bizarre, too weird, it would never sell. Well, by the late '80s, the kind of stuff I do was the hottest selling stock there was, and I'm still doing very well. I could live on my stock income.

The nature of stock has changed. With these photo CD disks where the client can buy unlimited use of 100 images for $50 or something, the low end has completely disappeared from stock photography. Nobody in his right mind is going to pay $300 to $500 for basic, generic images when they can get them on a disk for essentially $.15 an image. It's disgusting. I would never sell any of my work to any of those disks, ever. I can't imagine who does. They're idiots.

I'm a sole proprietor, and I don't have any employees. I've tried having staff assistants, but one week you're real busy and the next, you're not. So, I hire freelancers and bill the client; it doesn't cost me that way. I handle my studio space this same way. I work out of my house when I can, and when I need a bigger space, I rent a studio for the day (or whatever) and bill the client. I don't pay for the overhead. It's been very effective for me.

I only use computers for Photoshop and for my art. I don't have a word processor, or studio management program. I have a Rolodex sitting on my desk. My clients are on 3 x 5-inch index cards; I'm not organized on the computer from my business side. I'm not doing 20 or 30 jobs a month, I'm doing 2 to 7. There's not a lot of paperwork, so I never felt the need to get all of that on a computer. I never even learned how to type, because I didn't want to get stuck being a secretary.

The business is certainly harder now. There's a lot more competition. My marketing strategy is that you constantly have to be coming up with new, fresh, exciting looks. You cannot rest on your laurels. You cannot just keep doing the same kind of thing, the same style; you have to constantly be exploring and growing as an artist or you get left in the dust. Everybody else will copy your style, but they'll do it cheaper than you—I guarantee you. You've got to keep running ahead of the pack.

STAN SHOLIK

LOS ANGELES, CALIFORNIA

Stan Sholik was born in Boston and raised in Connecticut. He moved to southern California after graduating from Carnegie Mellon University with a B.S. in Physics and an M.A. in English. He worked in the aerospace industry for four years before leaving to open a commercial photography studio in Costa Mesa, California, in 1973.

Self-taught in photography, he quickly found success with the rapidly growing high-tech industries in Orange County. He specializes in product photography for the medical devices and computer hardware and software industries, and his work involves a high percentage of macro/close-up photography and special effects, including multiple-exposure, in-camera photo-compositions. In 1993, he added a digital imaging computer workstation to extend his special effects capabilities, and in 1995 he began offering high resolution digital image capture to his clients.

He has been a member of the American Society of Media Photographers since 1980 and is currently serving on the Board of Directors of the ASMP Southern California Chapter. He has won continuous recognition for his commercial photography, including awards from the Art Director's Club of New York.

The bulk of what I do is macro photography. I got involved with that because I always enjoyed close-up work. I was always taking pictures of flowers and things, even as an amateur. When I saw that there might be a market for that, I started by doing some portfolio pieces, cold cut macro work, and just took off from there. I have several specialties within the area of macro work. That sort of developed into some in-camera photo-composition work. I do a lot of motion simulation things, too.

Back in the early '80s, I got my first computer mainly to run Studio Manager software, which is great. Tim Olive, who wrote Studio Manager, keeps updating the program and adding new things to it. With it, I've virtually been able to eliminate a couple of assistants that I had. I'm down to one assistant and computers. My business runs just as efficiently this way.

I'm also using computers now for image processing. I have a Dicomed system, which allows me to do image manipulation on large format transparency. A PC with Photoshop is fun to play with, but it's not something that you could use in any sort of production environment and still work on large size images.

My idea in the digital area is to still be a photographer. In other words, be a photographer who does a job and delivers it as large format transparencies back to the client. I'm not a big believer in shooting and then having a service bureau perfect the image. Clients are more comfortable getting a large format transparency from me, like they always have, and the Dicomed system allows me to do that.

I'm also getting assignments now that involve retouching of photo-composition. It used to be that I wasn't getting jobs like this. I'd do my work here and take the job someplace else to get that work done. Now clients come to me saying, "How do you recommend you do it?" And, I'll say, "These three things I can shoot in the camera, these other things I'll have to shoot separately, and then I'll sort of compose it and give you a transparency."

I have as much fun generating an image on the computer as I do in the camera. You go about the same problem solving, the same sort of excitement and frustration, but I really get a lot of pleasure out of computer work. I just love that whole part of the creative process, so the technology end of it doesn't scare me. I can go either way—I can get behind the camera or sit in

front of the computer—and I'd be just as happy.

Clients are accustomed to paying for the cost of computer retouching. What I'm doing is something special that they can't do on their own. What I'm doing with the Dicomed is a level above what they would be willing to undertake. So, there's really no question about the fees that I charge for this work.

I've investigated working with a lot of electronic distribution means for my portfolio, and I'm not really satisfied with any of them. So my book is still a book. I have a book that I take around to show people, and I have a mini portfolio that I send out to people if they're kind of interested. What interests me the most right now is an electronic bulletin board type of portfolio where you would upload images and clients could dial a phone number with their modem and look at images online. Then they'd call the photographer for a traditional portfolio showing. I like this concept better than all the other electronic media. I talk to people that have contributed their portfolios on disks and most people are very dissatisfied with that type of electronic distribution.

Without a niche, you're just interchangeable with anybody down the street. You become a commodity.

When a client calls and wants me to bid on a project, the question I ask is how the decision [of which photographer to use] is going to be made—will it be made based on price, or on some combination of other factors. If the client is honest enough to say it's being made on price, I'll try to find out who else I'm bidding against. If the other bidders are people who aren't legitimate for me to be bidding against, I just say I'm not interested. I know what it costs me to be in business and what my prices are for doing certain things. I just say that my price is based on those factors.

Very few photographers in the country do macro work, and I don't know anyone who does it like I do, so if clients have a product that needs the particular type of photography that I do, they basically call up and say, "We need this shot, and everyone we've talked to said you're the guy to do it. How much is it going to cost?" To me that's the position you want to be in, which is why you specialize. By specializing, I'm able to be different from everybody else. In this way, I don't have to deal with bidding. You just have to figure out what your niche is. Without a niche, you're just interchangeable with anybody down the street. You become a commodity.

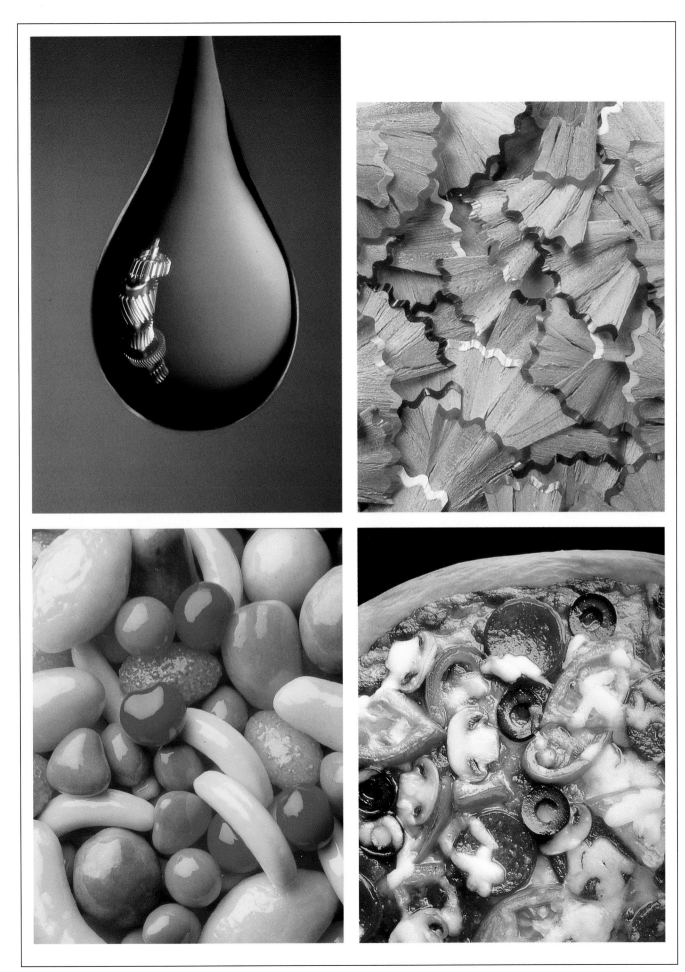

VINCENT STREANO

ANACORTES, WASHINGTON

During his junior and senior years at San Jose State University, Vince Streano also worked full-time as a staff photographer with the San Jose Mercury. *On graduating with a B.A. in Journalism, he took a full-time position as a staff photographer with the* Los Angeles Times *and, over the course of his five and a half years there, won numerous state and national awards for his photography.*

In 1973, Streano left the Times *to begin his freelance photography career. During his first eight years freelancing, he concentrated on the editorial market and completed assignments for many major national magazines, including* People, Time, Newsweek, National Geographic, *and* Sports Illustrated. *In 1980, he shifted his marketing focus to corporate assignment work for such well-known companies as Greyhound, Nissan, Yamaha, and many others.*

In 1989, Vince and his partner Carol Havens moved their business from Southern California to a small town in the Pacific Northwest and decided to shift focus once again, concentrating on producing stock photography. They have their own stock agency, Streano/Havens, which markets their images directly, and they also market images with other stock agencies throughout the world.

Streano has devoted a great deal of his time and energy to helping improve the commercial photography industry through his involvement with ASMP, first as president of the Southern California chapter, then as an elected member of their National Board of Directors, and finally as national president of the society.

When I started freelancing, I was basically a photojournalist at heart and still am. Around 1980, I basically realized that photojournalism wasn't making me a lot of money. It's very difficult to be a photojournalist if you don't live on the East Coast, which is where most of the assignments originate from. So I started branching out and doing some corporate/industrial work, and then ultimately did some advertising assignment work, too.

Then in '89, I kind of burnt out on corporate/industrial work and advertising, and decided I wanted to develop my stock income more. All the time I was freelancing, I had also had a stock business. We (my partner Carol Havens and I) decided to see if we could make a living doing primarily stock photography rather than primarily assignment photography, and I've been doing that ever since. And, if I hear of an interesting assignment that I think I would enjoy, I also consider that.

We don't put out any ads in *The Black Book,* which I used to advertise in every year. I don't send out any promotions for assignment work. My marketing and promotion efforts are in stock photography. We approach stock a little bit differently than most people do. We don't earn a lot of bucks in it but we do what we want to do, and we travel where we want to travel, and we're happy. We make enough money to pay the bills, and as far as I'm concerned, that's where it's at.

I started doing stock as an outlet for my creativity, because assignment work is so structured. I do whatever interests me; I just go off and I shoot. I don't create pictures, I find them, which is very different from what a lot of photographers who make big bucks in stock do. They produce pictures; they hire models and go out on sets and create the entire thing. I, on the other hand, might travel two or three days in a row and not find anything, and then on the fourth day I go nuts and shoot 30 rolls of film because I'm in a good situation.

For instance, on this last trip that we took to Italy, we were in a wonderful village in Tuscany walking down this narrow street, and this little eight- or nine-year-old boy was walking toward us with this mob of people. He was so Italian it was unbelievable. He was wearing a bright red and green beanie cap and was dressed in a very Italian manner, carrying this large melon for his mother—they'd just been

to the store. I asked her if I could photograph the little boy, and she was obviously very proud of her little boy. I don't speak Italian, and she didn't speak English, but she got the point and I was able to photograph him. I took some beautiful portraits of him. These are the kinds of images that I love finding and shooting.

We're marketing our work through six or seven stock agencies. We also market ourselves directly. We're never comfortable having all our eggs in one basket. Many times we've thought about not marketing ourselves, because it's a pain in the butt. You've got to have somebody here when you're gone, and you've got to do the marketing—and that costs money. Still, the prices we get for our work are, on average, three times what any of our stock agencies get for us, or more. My average sale, that I make myself, is over $1,000.

I worked together with Craig Cradoc on FotoQuote [pricing software]. It's a joint effort. I did all the pricing information as well as all the coaching information in the program, and Craig licenses it from me. I get a small royalty everytime one of the programs sells. My whole philosophy on pricing stock photography is that in addition to placing exact usages, you also have to take into consideration the uniqueness of the image in the marketplace. Almost every major agency in the country has the program, as well as a whole lot of the smaller agencies, not only all over the United States but all over the world. It's a phenomenally easy to use program.

Carol and I promote our stock agency (Streano/Havens) a number of different ways. We've traditionally taken out ads in the *Stock Workbook,* and that has worked very well for us. This year, we took out a page in *Direct Stock,* and we also put some images on Jim Pickerell's catalogue CD-ROM disks. That hasn't hit yet, so we're waiting to see how well that does for us. This year we're advertising more images than ever before, and we're keeping our fingers crossed that it works.

The photography business is incredibly different from when we started. When we got into the business 15 years ago, it was very easy to get in with stock agencies. They would take almost anything you had, just to fill their files. You could sign with three or four agencies; nobody cared about exclusivity, because they were only marketing in little geographical areas. Now, agencies have started putting out these cata-

There are a lot of great photographers who are starving to death because they don't know how to market and promote themselves.

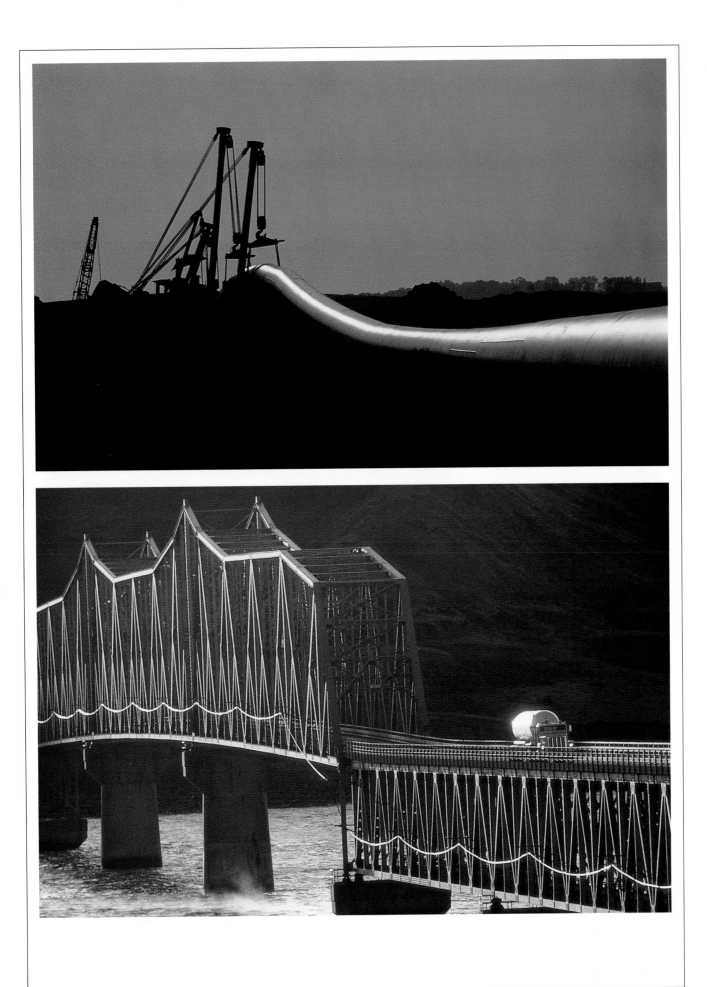

logues, and the catalogues started going beyond the boundaries of the agencies' traditional marketing areas. Agencies wanted more exclusivity, and they wanted to tie you up in a bigger geographical area.

Now agencies sign you up on an exclusive basis, because they don't want you selling your stuff with other agencies; they don't want to see your pictures in other agency catalogues. That's the number one problem that the catalogues have created. The second problem is the fact that it's no longer good enough just to be with a stock agency—your stuff must be in their catalogue. You must make sure your stuff is promoted as well. If you sign with a stock agency and they take a lot of images, but you only get two or three of them in the catalogue, you're lost because 75 percent of all stock agency sales now are made directly from catalogues. Only 25 percent of the sales now come from the general files.

The catalogues have made art directors very lazy people. Instead of sitting at their desks and trying to come up with a new concept for an image, they now pick up the nearest stock catalogue and start thumbing through it until they find the image that they want to buy. Then they call up the agency and buy the image. Instead of calling the agency and looking at a lot of pictures, they're only looking at those few images in the catalogue.

The other thing is that these changes have created sort of an "inbreeding" situation, with buyers continuing to buy the same sorts of images, buying only the pictures that they see in the catalogues, and photographers shooting the same pictures that sell over and over. This doesn't present a healthy atmosphere for creating new images. And the agencies are telling their photographers, "This is the type of stuff we need." They give photographers very strict guidelines on what to shoot, and as a result, photographers are losing their creativity.

I guess I'm painting a bleak picture of the stock industry, which I think in some respects it is. But the stock industry is a very healthy industry. It's having a very good year. You have to be very careful if you're a photographer who only produces stock. Otherwise, you basically become a slave of the stock agency's needs and demands. You're shooting what they tell you to shoot. And, if you're going to do that, you might as well be an assignment photographer and get paid to do it. I still have faith in the stock industry. I think it's going to continue to do well.

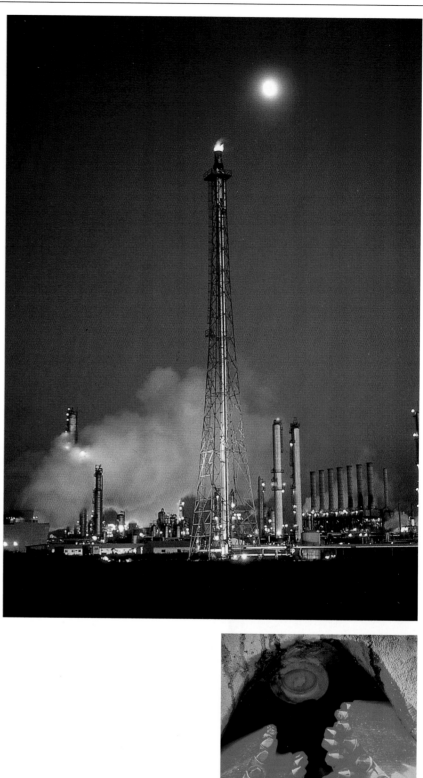

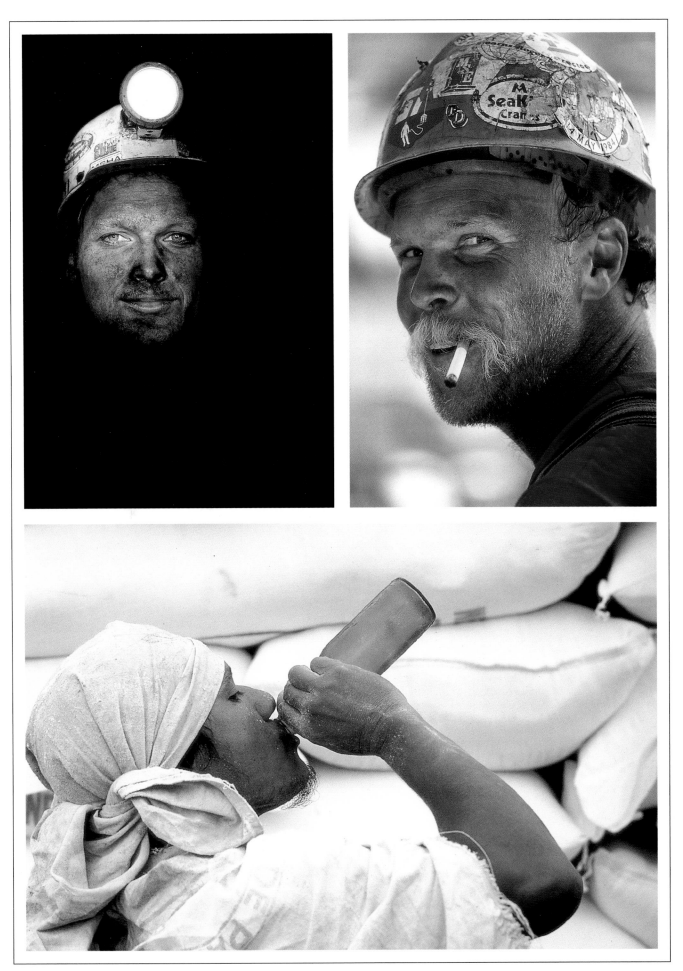

MICHEL TCHEREVKOFF

NEW YORK, NEW YORK

Born in Paris to Russian parents, Michel Tcherevkoff professes that he never planned to be a photographer. After graduating from law school, Tcherevkoff came to the Unites States where a series of unrelated events drew him to the world of photography. He has been producing award-winning work ever since.

Today, he is recognized as one of the world's preeminent conceptual photographers, internationally known for his unique ability to create visual metaphors for clients such as FedEx, Bell Labs, GE, Prescriptives Cosmetics, AT&T, General Motors, Panasonic, Kodak, and Canon (which sponsored and released his interactive CD-ROM I-Sight, *which holds a gallery of 50 images, 125 videos, and an original score to guide you through Tcherevkoff's mind and imaginative wanderings).*

He has received over 100 awards for his creative advertising and editorial imagery and has exhibited internationally, including in one-person shows in Brazil and Portugal. In 1986, a monograph of his work, entitled Tcherevkoff: The Image Maker, *was published by Watson-Guptill Publications.*

Involved with creating intricate photographs in-camera, or in the darkroom, long before the advent of computer imaging, Tcherevkoff feels that "today's imaging technology has generated a new era of creative freedom for photographers. There's never been a more exciting time to be a photographer. I think of this as a renaissance for our industry."

Totally by accident, I got a job with a guy named Pete Turner. Pete was really the first to approach photography as a graphic colorist using color, shape, form, and other elements to produce photographs. He is the one who planted the seeds that eventually grew into what I do today.

After 20 years in the business, I still don't know how to describe what I do. It's image-making, and I say image-making because I use the camera more as a tool. I don't point the camera and record what I see. I basically construct an image or a story and then put it into a film form. I rely very heavily on my ideas to come up with a story.

My work is basically mostly personal in the way I approach a job. When a client says, "Do something for me," it's for me, but it's also for commerce. I don't say, "This is my portfolio of very personal work, and this is my commercial portfolio." They are both together. When I come up with something that is "personal," it's always available to fit into what people want. Basically, a lot of people buy my personal work.

With the new economic crunch in our industry in late '80s and early '90s, things have changed. The recession was one contributing factor; the second is the advent of technology in the digital arena. In the past, I was basically alone in doing the kind of work that I did, I had to develop personal techniques as ways of doing things. Everything that I did 5 or 10 years ago technically can now be done easily on the computer, so my work was in need of an evolution. It was a natural thing that happened. It would have happened anyway even without the advent of technology.

Due to the evolution in my work and the new marketplace realities, I've changed my marketing strategies. Before, I did almost nothing or very little—a couple of pages in a variety of sourcebooks and very light promotion here and there. Now, I'm doing a little more. For example, instead of having an agency out there getting work for me and collecting the standard 25 percent commission, I'm now having someone in the studio dedicated to getting work strictly for me. I can tailor my market strategy more closely, and go after a particular account or market or type of work. Before, whatever work came in, came in.

I feel that what clients are buying is a little piece of my soul, but it still has to be presented and organized very professionally. Accordingly, I present my portfolios in a variety of ways, and

Don't give them what they want, give them what you have, and then the market will find you.

if there's a trend, to present work via prints instead of transparencies for example, I'm not going to say, "I'll never do that." That would be stupid of me. I'd adapt to the market. If a lot of art directors said that they'd like to see portfolios in print format, I'd make portfolios in print format—or in any other format that would be the trendy or acceptable way of the day. That's normal marketing strategy. Specifically going against the grain is stupid.

Right now I show a lot of 4 x 5-inch transparencies mounted in very light, solid material. I send about 25 or 30 transparencies per request. I'm also making print portfolios, but they would be more for the charismatic and beauty industries, which favor flat, printed work, rather than transparencies.

Then there's the very novel interactive CD-ROM format. This is another marketing strategy, because that's the way the world will eventually go. Some of the world is already there. It has multiple appeals; not only you can view images, but at the same time you can see and hear people talking to you; you could hear me explaining why or how I do an image and get more information. Clients are not just looking at a portfolio. They're finding out who the person is behind the image.

The response so far to my interactive CD-ROM, *I-Sight* (produced in 1995), has been amazing. Now, if clients request a portfolio, I ask them what they'd like to see and in what format they'd like to see it. However, interestingly enough, although the technology is here and available, the adaptation time of that technology is not here yet. People talk about electronics and CD-ROMs, but only a very small amount of people actually make use of them.

As far as producing images, though, everything is done electronically now. It's not easier, it's not faster, and it's not cheaper. But what it gives you are creative options that you didn't have before. Once you have this capability, you can do so much more than you did before. This is why it becomes more expensive, more time-consuming, and more difficult.

In terms of electronic imaging, I'm working in a variety of ways. I'm working first with the SGI Indigo machine; that's my workhorse, very high-end. And then I also have Live Picture and Photoshop, plus many other software programs. Using different software is exactly like using the different tools you have around the studio, such as lenses. The computer is

nothing more than an additional tool. You use it when you need it, not because it's there, and that's really a very key point. Because it's so new and exciting, people have a tendency to overuse it.

In general, there are very few women in the business and most of them are in fashion. One of the reasons is that male photographers have, or used to have, a tendency to be very chauvinistic (even if it's only subconsciously). They wouldn't hire women assistants, and that diminished the pool of availability for women. One of the stupid remarks that I heard many times from men was, "Women can't carry heavy equipment." So they didn't hire women.

It's very difficult to get to know and become successful at your business, if you don't work with anybody, because you don't learn. Therefore, you don't progress. And if you don't progress—unless you have an exceptional talent—you can't get into the business. I know several women who just got discouraged by not being able to get jobs as assistants, so they became stylists, or hair and makeup people. But it's changing. Rapidly! And that's good.

There are also very few black photographers. The only black photographer I know is Lou Jones. He's working in both the commercial and editorial arenas, and he gets grants, so he can do personal projects. He's very versatile, and he's a good businessman. He's had to work real hard to get where he is, and he did well with it.

Overall, I find this buiness very rewarding. I think it's a very, very good time to be a photographer. The challenges are bigger than they've ever been. It separates the wheat from the chaff, and that's very good for the industry; it forces people to dig down deep in their souls to come up with better work. If there are only a few good ones, everything becomes too complacent, and it's not good enough. You need new blood, and that's very important. That new blood doesn't necessarily have to be a new person; it could be the same person, just cleansing out the old and bringing in the new.

What potential buyers are looking for from photographers is a personal point of view. So, don't give them what they want, give them what you have, and then the market will find you. I didn't plan on doing what I did. I did it because I liked it, and because I liked it, I believed in it and it turned out to be salable and good. I turned out to be a very happy photographer instead of a miserable lawyer. It's very important. You've got to be happy about what you do. Do something that's fun. Something that you believe in.

RESOURCES

CLIP DISKS

PhotoDisc, Inc.
2013 Fourth Avenue
Seattle, WA 98121
(206) 441-9355
fax: (206) 441-9379
CD-ROM stock photographs.

COMPUTER RESOURCES AND SOFTWARE

America Online
For questions about connecting:
(800) 827-3338
For trial disks: (800) 827-6364

FotoQuote
Cradoc Corporation
1574 Gulf Road, Suite 1552
Point Roberts, WA 98281
(206) 842-4030
fax: (206) 842-1381
An easy-to-use, utterly essential guide to stock photography pricing and negotiating policies; available in buyers and sellers versions. If you have one piece of software on your computer, this should be it.

PhotoByte
Vertex Software, Inc.
31 Wolfback Ridge Road
Sausalito, CA 94123
(800) 837-8399
Studio management software.

CREDIT RATING SERVICES

Dun & Bradstreet Information Services
Customer Services Center
(800) 234-3867
Check your phone book for local offices.

TRW Business Information Services
(800) 520-1221
There are offices in major cities.

DIGITAL IMAGING AND PROCESSING SERVICES

Chrome Photographic Services
3247 Q Street, NW
Washington, DC 20007
(202) 333-3270
Museum-quality scanning, digital imaging, printing, and processing.

FACTORING SERVICE

Creative Capital Corporation
461 From Road
Paramus, NJ 07652
(201) 967-8520
Ask for introductory kit.

MARKETING CONSULTANTS

Maria Piscopo/Santa Ana, CA
(714) 556-8133

Elaine Sorel/New York, NY
(212) 873-4417

Ian Summers/Stockton, NJ
(609) 397-8601

Elyse Weissberg/New York, NY
(212) 227-7227

ORGANIZATIONS

U.S. Small Business Administration
Answer Desk:
(800) 8-ASK-SBA
fax: (202) 205-7064
For hearing impaired:
(202) 205-7333
For information on publications and managing-by-objectives:
SBA Publications
P. O. Box 30
Denver, CO 80201-0030
To find your local SBA office look in your telephone directory under "U.S. Government," or call the Small Business Answer Desk. Request a free copy of The Small Business Directory, *a listing of business development publications.*

PORTFOLIO SUPPLIES

Brewer-Cantelmo Co., Inc.
116 East 27th Street
New York, N.Y. 10016
(212) 685-1200

PUBLICATIONS

Adobe Press Staff
Advanced Adobe Photoshop for Windows
(from the Seminar in a Book Series)
Hayden Macneil Publishing, Inc.
6264 Hix Road
Westland, MI 48185
(313) 729-5550
This is an incredible interactive training workbook that comes with a full-featured CD-ROM entitled Classroom In a Book: Imaging Essentials, *which offers professional studio techniques for Photoshop and other Adobe Systems products, including Illustrator, Dimensions, and Premiere.*

American Association of
Advertising Agencies
Guide to Buying Advertising Art & Photography
666 Third Avenue
New York, NY 10017-4056
(212) 682-2500
fax: (212) 682-8391

American Showcase
Lurzers Archive
915 Broadway, New York, NY 10011
(212) 673-6600

The American Society of Media
Photographers, Inc.
Assignment Photography Monograph
Formalizing Agreements and
 supplementary disk
Photographers Guide to Negotiating
 Rights and Value in Traditional
 and Electronic Media
Stock Photography Handbook
14 Washington Road, Suite 502
Princeton Junction, NJ 08550-1033
(609) 799-8300
fax: (609) 799-2233
 Contact ASMP for additional
 publications information and
 membership information.

Roger Dawson
Roger Dawson's Secrets
of Power Negotiating
The Career Press Inc
Box 687, Three Tice Road
Franklin Lakes, NJ 07417
(201) 848-0310
fax: (201) 848-1727

Adele Droblas-Greenberg
and Seth Greenberg
Fundamental Photoshop: A Complete
Introduction, 2nd ed.
Osborne/McGraw-Hill
2600 Tenth Street
Berkeley, CA 94710
(510) 549-6600
 This book makes using Photoshop
 a lot easier.

Ernst & Young Staff
The Ernst & Young Business Plan Guide
John Wiley & Sons, Inc.
605 Third Avenue
New York, NY 10158
(800) CALL WILEY
 For more information on business plans.

Roger Fisher and William Ury
Getting to YES: Negotiating Agreement
Without Giving In
Penguin USA
375 Hudson Street, New York, NY 10014
(212) 366-2000
fax: (212) 366-2666

Michal Heron and David MacTavish
Pricing Photography: The Complete Guide
to Assignment and Stock Prices
Allworth Press
10 East 23rd Street, Suite 400
New York, NY 10010
(212) 777-8395
fax: (212) 777-8261
 An extremely helpful compendium that
 gives great insight into the challenges of
 pricing.

Jim Pickerell
Taking Stock (newsletter)
Negotiating Stock Photo Prices (book)
Self-published.
110 Frederick Avenue, Suite A
Rockville, MD 20850
(301) 251-0720
fax: (301) 309-0941
 The newsletter is published six times a
 year; the book is published annually,
 and buyers and sellers versions are
 available.

Linda Pinson and Jerry Jinnett
Anatomy of a Business Plan
Dearborn Financial Publishing, Inc.
155 N. Wacker Drive
Chicago, IL 60606-1719
(312) 836-4400

Stanley R. Rich and David E. Gumpert
Business Plans that Win: Lessons from the
MIT Enterprise Forum
HarperCollins Publishers
10 East 53rd Street
New York, NY 10022
(212) 207-7000
 Provides information on creating
 successful business plans.

Westlight
International Report on Stock Photography
2223 Carmelina Avenue
Los Angeles, CA 90064
toll free (800) 872-7872
in CA: (310) 820-7077
fax: (310) 820-2687
 A review of stock photo business
 methods worldwide, including a review
 of digital imaging.

SALES REPRESENTATIVES

Howard Bernstein
Bernstein & Andriulli
60 East 42nd Street
New York, NY 10017
(212) 682-1490

Society of Photographers Artists
and Reps, Inc.
24 West 30th Street
New York, NY 10001
(212) 779-7464

STOCK AGENCIES

Image Bank International
111 Fifth Avenue
New York, NY 10011
(212) 529-6793

Westlight
2223 South Carmelina Avenue
Los Angeles, CA 90064
(310) 820-7077
fax: (310) 820-2687

STOCK PHOTO SOURCEBOOK

Direct Stock
10 East 21st Street
New York, NY 10010
(212) 979-6560

TRADE ASSOCIATIONS

American Association
of Advertising Agencies
666 Third Avenue
New York, NY 10017-4056
(212) 682-2500
fax: (212) 682-8391

The American Society of Media
Photographers, Inc.
14 Washington Road, Suite 502
Princeton Junction, NJ 08550-1033
(609) 799-8300
fax: (609) 799-2233

American Institute of Graphic Arts/
NY Chapter
545 West 45th Street
New York, NY 10036
(212) 246-7060

International Alliance of Business
Communicators
One Hallidie Place #606
San Francisco, CA 94102
(415) 433-3400
 To learn about companies that might
 require photography.

TRANSPARENCY DUPLICATION
SERVICES

Repro Images
243 Church Street
Vienna, VA 22180
(703) 938-2604
Attn: Jeff Whatley
 Produces dupes in 35mm and 70mm for
 many large stock shops.

VIDEO RESOURCES

Maria Piscopo Videotape Series
How to Get Paid What You Are Worth
How to Find and Keep New Clients
How to Get Clients to Call You
How to Create More Time and Less Stress
Turner Video Communications
(800) 382-9417
 Provide helpful marketing strategies and
 business management techniques.

INDEX